ART, IDEOLOGY,

AND ECONOMICS IN

NAZI GERMANY

ALAN E. STEINWEIS

ART, IDEOLOGY, & ECONOMICS IN NAZI GERMANY

THE REICH CHAMBERS

OF MUSIC, THEATER, AND

THE VISUAL ARTS

The University of North Carolina Press

Chapel Hill & London

© 1993
The University of
North Carolina Press
All rights reserved

Manufactured in the
United States of America

The paper in this book meets the
guidelines for permanence and durability
of the Committee on Production
Guidelines for Book Longevity of the
Council on Library Resources.

Library of Congress Cataloging-in-
Publication Data
Steinweis, Alan E.

Art, ideology, and economics in Nazi
Germany : the Reich chambers of Music,
Theater, and the Visual Arts / by
Alan E. Steinweis.

p. cm.

Originally presented as the author's
thesis (doctoral—University of North
Carolina, Chapel Hill).

Includes bibliographical references and
index.

ISBN 0-8078-2104-7 (cloth: alk. paper)
ISBN 0-8078-4607-4 (pbk.: alk. paper)
1. Arts, German. 2. National
socialism and art. 3. Arts—Economic
aspects—Germany. I. Title.
NX550.A1S75 1993
700'.943'09043—dc20 93-7059
CIP

00 99 98 97 96 6 5 4 3 2

Portions of this book originally appeared
in somewhat different form in "The
Professional, Social, and Economic
Dimensions of Nazi Cultural Policy: The
Case of the Reich Theater Chamber,"
German Studies Review 13, no. 3
(October 1990): 442–59; "Weimar
Culture and the Rise of National
Socialism: The *Kampfbund für deutsche
Kultur*," *Central European History* 24,
no. 4 (1991): 402–23 (published by
Humanities Press International, Inc.,
Atlantic Highlands, N.J.); "German
Cultural Imperialism in Czechoslovakia
and Poland, 1938–1945," *International
History Review* 13, no. 3 (August 1991):
466–80; and "Hans Hinkel and German
Jewry, 1933–1941," *Leo Baeck Institute
Yearbook* 38 (1993): 209–19, and are
reprinted by permission of the
publishers.

FOR MY PARENTS

CONTENTS

A section of photographs can be found following page 72.

ACKNOWLEDGMENTS

While researching and writing this study I benefited from the advice of mentors, friends, and colleagues. I am especially grateful to Professor Gerhard L. Weinberg of the University of North Carolina at Chapel Hill, who directed the doctoral dissertation on which this study is based, and who continues to set an example through his scholarship and humanity. I am also deeply indebted to Professor Konrad H. Jarausch, whose scholarship and suggestions have influenced my own work immensely. Also at Chapel Hill, Josef Anderle, Donald Reid, and Lloyd Kramer graciously served as readers for the dissertation and made many valuable suggestions.

Charles W. Sydnor, Jr., and Sybil Milton carefully critiqued earlier drafts of this manuscript, pointing out problems and opportunities for improvement. Geoffrey Giles of the University of Florida has on many occasions shared with me his insights into the society and culture of Nazi Germany. I am also grateful for advice, comments, and support from Donna Alexander, Dolores Augustine, Earl Beck, Doris Bergen, Rich Bodek, Bruce Campbell, Lamar Cecil, Karen Clarke, Glenn Cuomo, Volker Dahm, Jürgen Falter, Carole Fink, Johnpeter Grill, Gerald Heberle, Larry Eugene Jones, Michael Kater, Joseph Klaits, Bob Kunath, Brian Ladd, Daniel Mattern, John Mendelsohn, Ursula Mertin, Carl Pletsch, Pamela Potter, Doris Reif, George Riordan, Ron Shearer, Bernd Sösemann, George Stein, Ralph Turner, Wolfgang Wippermann, Ed Wynot, and Rainer Zitelmann.

At archives in Germany I almost always encountered friendly and helpful staff members. This holds true especially for the Bundesarchiv Koblenz and the Berlin Document Center. The present director of the BDC, David Marwell, and his immediate predecessor, Daniel Simon, placed their collections and staffs at my disposal during several long visits. I would also like to express my appreciation to the library staffs at the University of North Carolina and at Florida State University. The interlibrary loan specialists at the latter institution have shown great resourcefulness in tracking down esoteric items.

I was fortunate to receive financial support from several sources. The German Academic Exchange Service awarded me a doctoral research grant that enabled me to spend the 1984–85 academic year in Berlin and Koblenz. In 1988–89 I returned to Germany for fifteen months as a postdoctoral fellow at the Free University of Berlin in the Berlin Program for Advanced German and European Studies, a program sponsored by the Social Science

Research Council and financed by the Volkswagen Foundation and the German Marshall Fund. I am particularly grateful to program coordinators Claudia Wörmann and Monika Medick-Krakau, who cut through red tape so that the fellows could get things done. A first-year faculty summer grant from Florida State University enabled me to spend an additional two months in Berlin in 1990, and a grant from the FSU Council on Research and Creativity gave me the opportunity to prepare the final manuscript in the summer of 1992. Support from the Norman and Bernice Harris Center for Judaic Studies at the University of Nebraska at Lincoln helped bring the book to fruition.

I am grateful to the University of North Carolina Press for taking on this project. Lewis Bateman lent his encouragement from an early stage, Ron Maner shepherded the manuscript through the publication process, and Christi Stanforth carefully copyedited my prose.

At home, Catherine Clarke patiently abided my preoccupation with the completion of this book. Finally, my greatest debt is to my parents, to whom this book is dedicated. Their integrity, compassion, dignity, and goodness, which survived the camps of Nazi Europe intact, provide compelling proof of the ability of the human spirit to overcome evil and adversity.

ABBREVIATIONS

The following abbreviations appear in the text. For a list of abbreviations used in the notes, see page 177.

ADMV	Allgemeiner Deutscher Musikverein
ASSO	Assoziation revolutionärer bildender Künstler
BDA	Bund deutscher Architekten
DAF	Deutsche Arbeitsfront
DeMuV	Deutscher Musiker-Verband
KdF	Kraft durch Freude
NSBO	Nationalsozialistische Betriebszellenorganisation
NSDAP	Nationalsozialistische deutsche Arbeiterpartei
NSKG	Nationalsozialistische Kulturgemeinde
RDOO	Reichsverband deutscher Orchester und Orchestermusiker
RVbK	Reichsverband bildender Künstler Deutschlands
SA	Sturmabteilung
SD	Sicherheitsdienst
SS	Schutzstaffel

ART, IDEOLOGY,

AND ECONOMICS IN

NAZI GERMANY

The arts occupied a central position in the ideology and propaganda of National Socialism. Yet despite the existence of a number of fine scholarly and popular studies of the subject, the research potential of the Nazi regime's policies toward the arts remains largely untapped.[1] The Reich Chamber of Culture, or Reichskulturkammer, in particular, stands out as an institution that merits far more attention than it has received.[2] Created by the Reich Cabinet in September 1933 upon the initiative of Propaganda Minister Joseph Goebbels, who became president of the mammoth new organization, the Kulturkammer was designed to "promote German culture on behalf of the German Volk and Reich" and to "regulate the economic and social affairs of the culture professions." Subdivided into separate chambers for music, theater, the visual arts, literature, film, radio, and the press, this organization encompassed several hundred thousand professionals and influenced the activities of millions of amateur artists and musicians as well. Most of what we know about the Kulturkammer and its chambers relates to the purge and censorship dimensions of their responsibilities, although even these require far more investigation.[3] Meanwhile, the economic, social, and professional dimensions of chamber policy have been largely overlooked. During the years of Nazi rule, the culture chambers implemented, or attempted to implement, numerous measures designed to ameliorate the material hardships that had long confronted German artists and to secure a modicum of long-term economic stability for the traditionally crisis-ridden art professions.

It is hoped that this study of the Chamber of Culture will contribute to an emerging scholarly literature on Nazi artistic and cultural policy, which aims at achieving a more nuanced understanding of the relationship between the Nazi regime and the German art world.[4] One of the most persistent generalizations to have emerged from almost five decades of postwar research on Nazi Germany is the notion of a German artistic and cultural establishment at the mercy of a totalitarian regime determined to mobilize the arts in pursuit of its own ideological ends. Explicitly or implicitly, historians have characterized the relationship between the regime and the art world as one in which a powerful state-party apparatus manipulated malleable and sometimes enthusiastic artists. According to this view, a regime exercising absolute power engineered the "de-Jewification" *(Entjüdung)* of German cultural life, carried through the purge of Marxists,

imposed blacklists and other forms of censorship, and promoted a "Germanic" aesthetic. The regime is understood as having "steered"[5] the activities of German artists into ideologically acceptable channels, employing subventions, prizes, and titles as incentives and resorting to monetary fines, professional bans, and even concentration camps when it became necessary to discipline wayward artists. Although diverse patterns of resistance, collaboration, and adaptation on the part of German artists have been acknowledged, the picture usually painted is one in which the regime acted and German artists *re*acted.

Although there is much truth in this characterization, it runs the risk of obscuring a more complex reality. It devotes insufficient attention to continuities in the professional and economic agenda of the German cultural establishment from the Weimar Republic through the Nazi period. Moreover, it presupposes a clearer distinction between officialdom and cultural elite than actually existed during the Nazi years, and thereby overestimates the degree to which policy affecting artists originated *outside* the art world. By extension, it overlooks key areas of consensus between official policy and prevailing sentiment in the art world. Consequently, it tends to place too much emphasis on the regime's reliance on coercion and not enough on factors accounting for artists' passive compliance and active collaboration with the regime's cultural policies.

Several attributes of the existing scholarship account for these interpretational shortcomings. Historians have focused mainly on the careers of prominent artists while devoting little attention to the institutional and economic factors that shaped cultural policy. In particular, the trend toward unionization and professionalization in the arts, already far advanced in several fields at the time of the Nazi seizure of power, has received little attention.[6] The predominant and somewhat romantic image of the artist as loner, although no doubt applicable in numerous cases, conflicts with a historical reality in which professional associations and unions played a significant role. The "coordination" of the German art world in the first years of the Third Reich involved not so much the expansion of state power directly over individual artists as the radical reform of an existing constellation of occupational organizations. From the very first, the Nazi strategy for cultural administration entailed not the atomization of individuals but rather the consolidation of a nascent professional "estate" system inherited from the Weimar Republic. In remolding existing organizations into the Kulturkammer and its subsidiaries after 1933, the Nazi regime transformed what had been primarily a system of occupational representation into a means for cultural regulation by the state. By focusing on this process, this

study also hopes to contribute to the growing literature on the history of German professionalization.[7]

Having taken insufficient account of institutional continuities, historians have not been prompted to evaluate the connections between the goals and policies of the pre-1933 professional organizations and those of their Nazi-era successors. Consequently, whereas censorship, purges, and the ideological instrumentalization of the arts in the Nazi era have been subjected to thorough (though hardly conclusive) investigation, a plethora of urgent problems that confronted the German art world both before and after 1933 have been examined only superficially. These problems included severe unemployment among professional artists in all fields, uneven and insufficiently rigorous systems of professional education and certification, and a social insurance system that was fragmentary at best.

Focusing on the Chambers of Music, Theater, and the Visual Arts, this study seeks to examine the Nazi-era experiences of the German art professions in the parallel and interrelated contexts of purges, censorship, professional reform, economic regulation, and social policy. It is, therefore, not an exercise in cultural history in the traditional sense. Its emphasis is less on the substance of artistic and cultural life in the Nazi years than on the political, professional and economic environment in which German artists were compelled to function. It concentrates in part on the structure of decision making, seeking to ascertain where and in whose interest cultural policies were formulated. Additionally, it emphasizes concrete, material issues, such as work creation, social insurance, minimum wage statutes, and certification guidelines, all of which had been matters of high priority to the art professions before 1933 and which remained at or near the top of the art world's agenda during the Nazi era.

Despite an emphasis on nonaesthetic questions, this study will offer conclusions with significant implications for the long-term impact of National Socialist rule on German culture. By examining the cultural establishment's record of successes and failures in professional, social, and economic reform in the early years of Nazi rule, the study will contribute to an understanding of the response of German artists to cultural *Gleichschaltung,* or "coordination." More generally, by elucidating the economic and professional context of cultural life, the study will help to explain the widespread acquiescence of German artists in artistic censorship and racial and political "purification."

The study's simultaneous concentration on three of the Culture Chamber's seven subsidiaries allows for a comparative approach while avoiding too diffuse a focus. The selection of the Chambers of Theater, Music, and

Table I.1
Membership of the Reich Chamber of
the Visual Arts, ca. 1937

Professional Groups	Members
Architects	13,750
Landscapers	520
Interior designers	500
Sculptors	3,200
Painters and graphic artists	10,500
Commercial graphic artists	3,500
Pattern designers	1,000
Copyists	230
Art and antique dealers	1,500
Art print dealers	360
Total	35,060

Source: Wulf, *Die bildenden Künste*, p. 109.

the Visual Arts, to the exclusion of the others, is by no means arbitrary. These three chambers encompassed individuals whose main activities directly involved the arts, whereas the members of the Chambers of Radio, the Press, and Literature engaged in a variety of activities that were often only tangential to the arts. Although the Film Chamber would have made a logical fourth institutional component of this study, I have decided to leave that chamber to historians who specialize in the relatively highly developed field of National Socialist film studies.[8] The groups contained in the three chambers under analysis represent diverse historical patterns of occupational and professional development prior to 1933. Whereas the Chamber of Visual Arts consisted by and large of free professionals, the membership of the Theater Chamber was composed mainly of salaried employees, while the Music Chamber comprised a mixture of free professionals, salaried employees, and wage workers. These distinctions, rooted in the institutional structure of the German art world inherited by the Nazi regime, become important in attempting to explain the varying degrees of success attained by the chambers after 1933 in the areas of economic and professional reform.

As illustrated by Tables I.1–3, which summarize membership figures for 1937, each of the three chambers under examination was a large and diverse organization in its own right. This study, therefore, does not attempt to examine chamber policies and operations in their totality. Instead, it concentrates on a limited number of specific issues—an approach which can

Table I.2
Membership of the Reich Music
Chamber, ca. 1937

Professional Groups	Members
Composers	3,000
Entertainment musicians	60,000
Serious musicians	27,000
Concert managements	2,000
Music publishers	600
Music dealers	3,000
Total	95,600

Source: Ihlert, *Die Reichsmusikkammer.*

help elucidate general patterns and which, it is hoped, can suggest a fruitful approach for further research. More concretely, this study focuses mainly on chamber subgroups composed of members who were directly involved in artistic creation or performance, such as musicians, actors, painters, and sculptors. In contrast, it offers a much more limited examination of the technical occupations and business entrepreneurs (e.g., publishers) encompassed by the chambers.

Unpublished documentation, augmented by published primary and secondary sources, serves as the main basis for this study. Unfortunately, much chamber documentation was destroyed in the war. The surviving chamber subject files are deposited primarily in the German Federal Archive (Bundesarchiv) in Koblenz, as are collections of several Nazi state and party agencies whose activities impinged directly on the chambers, most notably the Propaganda Ministry. The files in Koblenz are supplemented by a large collection of chamber personal files stored in the Berlin Document Center. These hitherto underexploited membership files furnish the researcher with a wealth of information about the impact of official policy on German artists. Based on these files, this study seeks to provide answers to questions that have not previously been subjected to empirical analysis. For example, biographical data contained in the files has been used to analyze the politicization of artists as reflected in membership in the NSDAP and affiliated organizations both before and after 1933. Materials from the Document Center's collection have also made it possible to reconstruct the Nazi racial and political purge of the art world with a good deal more precision than has heretofore been possible.

Also of value to this study are the well-preserved records of the Baden state government, deposited in the General State Archive in Karlsruhe, as

Table I.3
Membership of the Reich Theater
Chamber, ca. 1937

Professional Groups	Members
Artistic theater personnel	22,000
Variety and cabaret artists	12,000
Dancers	5,000
Puppeteers and "show people"	2,000
Theater publishers	100
Total	41,100

Source: Hinkel, *Handbuch*, pp. 253–59.

well as those of the Bavarian government, found in the Bavarian Main State Archive in Munich. These regional collections contain copies of documents that did not survive in the central files of the chambers or the Propaganda Ministry. These German archives were supplemented by captured German records available in the United States as microfilm publications from the National Archives and by official Kulturkammer publications available in German and American libraries.

ART AND CULTURE IN

THE WEIMAR REPUBLIC

THE ECONOMIC, INSTITUTIONAL,

AND POLITICAL CONTEXT

By 1933, Germany's long tradition as a land of *Kultur* had left its mark on the occupational structure of the nation. In the Weimar Republic, the number of Germans officially designated as artists or entertainers exceeded the combined figures for those designated as doctors and lawyers. Despite ambiguous census categories, a fairly precise quantitative profile of the German artistic and cultural professions can be reconstructed. According to the 1933 occupational census,[1] the German work force contained 14,750 visual artists (painters, sculptors, illustrators, graphic artists); 36,088 architects, probably about one-third of whom engaged in "creative" design as opposed to purely technical tasks;[2] 84,362 musicians, music teachers, and *Kapellmeister*; 9,499 singers and voice teachers; 5,129 dancers and dance teachers; 10,264 actors; 1,070 theater directors; and 8,301 variety performers (*Artisten*). Especially in German cities, artistic and cultural enterprises served as significant sources of employment. Based on 1925 census figures, the art and culture professions, excluding technical and support personnel, accounted for an average of about 1 percent of all employment in German cities, and for even higher percentages in cultural centers like Dresden (1.14 percent), Karlsruhe (1.14 percent), Munich (2.04 percent), and, of course, the great cultural metropolis of Berlin (1.29

percent). In 1925, the Reich capital was home to over 28,000 employed artists.[3]

To be sure, the art professions were highly diffuse entities, characterized by status and income disparities far more severe than those typical of the so-called academic professions, such as medicine, law, education, and engineering. The label "musician" could be applied to anyone from a journeyman cabaret accompanist to the concertmaster of a major symphony orchestra; "actor" could signify a struggling two-bit player or the star of a major stage in Berlin or Munich; "painter" could designate an artist with an impressive list of exhibitions or an anonymous commercial graphic artist or even a street artist of questionable ability who earned quick cash by hawking postcards or watercolors, as Adolf Hitler once had. Depending on employment status, German artists could be classified in any of the main occupational categories of German society, namely wage earners (*Arbeiter*), salaried employees (*Angestellte*), civil servants (*Beamte*), or members of the free professions (*freie Berufe*). Whereas about 79 percent of musicians and about 95 percent of stage actors were either wage earners or salaried employees, 80 percent of painters and sculptors were independent free professionals. Many Germans whose official occupation was listed as one of the art occupations could not sustain themselves exclusively from artistic income; even in good times, a high percentage required additional sources of income in order to survive.

Despite such heterogeneity, the German art professions did possess clearly identifiable contours in the Weimar Republic, largely because political and economic conditions had compelled artists to organize and, within limits, to professionalize. Artists had been profoundly affected by the unionization and professionalization trends of the Imperial and Weimar periods. In the nineteenth century, artists had begun to recognize the value of occupational associations as vehicles for influencing legislators, state regulators, and employers. Moreover, only in combination with occupational colleagues could most individual artists find, or afford, the specialized kinds of job counseling, legal representation, and social welfare programs required for a secure economic existence.[4] The pressures of war, economic difficulties during the immediate postwar period, and the Weimar Republic's legislative promotion of institutionalized collective bargaining all accelerated the process of interest group formation.

Economically speaking, the early years of the Weimar Republic did not bode well for the arts. The end of the German monarchies, the difficult transition to a new form of government, and the omnipresent inflation all resulted in diminished professional opportunities for artists. The plight of artists in the early 1920s was seen as symptomatic of a more general, widely

recognized "crisis of intellectual workers."[5] In a book devoted to explaining the systemic nature of the crisis, George Schreiber, a professor at the university at Münster and a Center party Reichstag deputy, ascribed the hardships of artists to the decline of the German middle classes. Especially hard hit by the political instability and monetary inflation of the founding years of the republic, the German *Bürgertum* could no longer patronize the arts as it had in the days of the empire. Moreover, the Reich, the federal states, and individual communities could no longer maintain traditional levels of financial support for the arts. The costs inherent to new social welfare programs forced communities to cut back drastically on subsidies for theaters, orchestras, and museums. Higher property taxes discouraged new construction and therefore led to fewer opportunities for architects. Monetary instability resulted in a general decrease in publishing activity in the early 1920s, hurting both publishers and authors. Increased costs for freight transportation rendered art exhibitions more costly and therefore less frequent, depriving artists and sculptors of this outlet for selling their products.[6]

Some artists responded to the crisis by calling on their colleagues to overcome traditional divisions of function, income, and status in order to form a unified front of German artists, which could collectively pressure the government for favorable legislation and budgeting. In the early 1920s, activists organized regional pressure groups that cut across the traditional boundaries between the artistic occupations. But ideological fragmentation, tactical disagreements, and a lack of political skill and experience rapidly undermined such ambitious attempts at unity.[7] Throughout the Weimar era, occupational heterogeneity and class/status divisions, exacerbated after 1929 by intense ideological conflict, continued to pose obstacles to unity among German artists. Nevertheless, chronic economic difficulties did result in collective action, as the unions (*Gewerkschaften*) and professional associations (*Berufsverbände*) inherited from the empire took on increasingly decisive roles within each sector of German artistic and cultural life.

The Weimar System of Professional Representation

The artistic unions and professional associations of the Weimar era constituted the raw materials from which the Reich Chamber of Culture gradually took form after the Nazi seizure of power. During the initial years of Nazi rule, the culture chambers assimilated organizational features and functions that had evolved in the economic and political context of pre-1933 Germany. From the Nazi point of view, the very existence of these

organizations proved greatly convenient in the "coordination" of the cultural sphere. Influential elements in the Nazi government, particularly Joseph Goebbels, understood that the aspirations of German artists toward collective organization could be exploited to the regime's advantage.

The case of Germany's professional musicians perhaps best illustrates the organizational fragmentation of German artists in the Weimar era. A plethora of unions and associations represented musicians. The largest of these, the German Musicians' Association (Deutscher Musiker-Verband, or DeMuV), had been founded in 1872. Affiliated since before World War I with the Allgemeiner Deutscher Gewerkschaftsbund, the umbrella organization of the Social Democratic–oriented trade unions, the DeMuV operated "for the protection of the interests of practical musicians." Although the DeMuV contained a few "serious" (ernste) musicians, who possessed formal training and geared themselves to classical performance, the majority of the union's members were "entertainment musicians" (Unterhaltungsmusiker). The DeMuV offered its members pension and funeral funds, an employment agency, and legal counseling on professional matters. The DeMuV also published the Deutsche Musiker-Zeitung, which, in addition to the all-important want ads, featured articles on economic developments in the music profession and on government economic and labor policies affecting musicians.[8] In 1928 the DeMuV claimed about 40,000 members, organized into 180 locals. Attrition in the ranks of professional musicians, induced by the depression, reduced DeMuV membership to only 15,617 by the end of 1931.[9]

From the DeMuV's inception, its paramount task had been to lobby for modification of the national commercial code (Gewerbeordnung), which had left the music labor market largely unregulated. Through alteration of the code, the DeMuV intended to insulate professional musicians from the considerable competition generated by amateurs and military musicians, as well as by so-called double earners (Doppelverdiener), state-employed musicians who padded their regular incomes with earnings from periodic gigs and concertizing. Although the Weimar version of the code represented an improvement over its imperial predecessor, the twin problems caustically referred to as Dilettanterei and Doppelverdienertum remained the focus of the DeMuV's lobbying. In the early 1930s, with unemployment among professional musicians running especially high, the DeMuV intensified efforts to de-liberalize the music market for the benefit of professional musicians.[10]

The majority of formally trained musicians and music teachers rejected the DeMuV's connections with labor unionism, choosing to organize separately in the Reich Association of German Music Artists and Music Teach-

ers (Reichsverband deutscher Tonkünstler und Musiklehrer, or Tonkünstlerverband). Founded in 1922, by 1928 the Tonkünstlerverband comprised about ten thousand members in two hundred local branches. Criteria for membership were far more restrictive and elitist than those of the DeMuV. Limited to musicians who could offer "proof of sufficient specialized or academic training," the Tonkünstlerverband meant to provide "professional representation for German musicians whose main criterion was emphasis on quality."[11] The Tonkünstlerverband offered its members a great variety of services, including job placement, professional counseling, social welfare support, and health insurance.

Musicians employed either by state-run orchestras or by music academies formed a kind of aristocracy within the German music world. As civil servants, they enjoyed enviable pay scales, benefit packages, and job security. Their privileged position, however, came under attack during the inflation of the early 1920s, when state and local governments adopted extraordinary austerity measures. Faced with the threat of layoffs and massive reductions in public support for orchestras, in 1923 orchestral musicians founded the Reich Association of German Orchestras and Orchestra Musicians (Reichsverband deutscher Orchester und Orchestermusiker, or RDOO). As an affiliate of the politically neutral Deutscher Beamtenbund, the RDOO pledged to rise above party conflict and to promote the "maintenance and extension of the position of German orchestra musicians as civil servants."[12] But the organization achieved only limited success in recruiting members. By 1930 the RDOO had attracted only 609 members, whereas a "civil servants' section" of the DeMuV claimed a membership of 2,000 in the same year.[13]

Several smaller organizations represented musicians whose special needs could not be met by the major groupings. Musicians who performed primarily as guest artists could turn to the German Association of Concertizing Artists (Verband der konzertierenden Künstler Deutschlands, or VdkKD) for representation.[14] Music directors and conductors formed the Association of German Orchestra and Choir Directors (Verband deutscher Orchester- und Chorleiter), whose membership in 1928 totaled 272.[15] Meanwhile, the German Choirmaster Association (Deutscher Chormeisterverband) united about five hundred choirmasters who could "present proof of their specialized and artistic calling."[16] The Society of German Composers (Genossenschaft deutscher Tonsetzer) represented about eight hundred composers, whose paramount concern was reform of German copyright laws.[17] In the Weimar Republic, protection of musical copyrights had grown more complicated with the emergence of "mechanical music"— music reproduced on phonograph records or broadcast on the radio.[18] More-

over, Germany remained one of the few countries that had not yet adopted a copyright period of fifty years after the death of the composer. Efforts during the Weimar era to extend the period of copyright protection brought into focus an inherent financial conflict between composers, or "creative" (*schaffende*) musicians, and performers, in this context referred to as "reproductive" (*nachschaffende*) musicians.[19]

In contrast to the pluralistic situation in the music world, two organizations dominated occupational representation in the German theater. The German Theater Association (Deutscher Bühnen-Verein) served as an employers' association, representing theater managements and intendants, while the Society of German Theater Employees (Genossenschaft deutscher Bühnenangehörigen, or Bühnengenossenschaft), worked to "secure and elevate the spiritual and material interests of German theater employees." In May 1919 the two organizations had signed a collective agreement that committed the Bühnen-Verein to employ only Bühnengenossenschaft members while forbidding Bühnengenossenschaft members to work at theaters not connected with the Bühnen-Verein. This arrangement remained in effect throughout the life of the Weimar Republic.[20]

The Bühnen-Verein comprised over six hundred personal and institutional members in 1932. Although the primary function of the Bühnen-Verein throughout the Weimar Republic remained the negotiation of collective agreements with the Bühnengenossenschaft and other interest groups, the group also administered funeral and welfare funds for intendants who were not civil servants and who therefore did not receive such benefits.[21] The Bühnengenossenschaft was affiliated with the Allgemeiner freier Angestelltenbund, the umbrella organization of socialist-oriented white-collar unions; it comprised 15,300 members at the end of 1928 but only 6,100 three years later, a decrease that reflects the desperate situation of the German theater in the depression.[22] Separate professional branches encompassed actors, directors, stage designers, and various other categories of skilled personnel, although performers clearly dominated the organization. The Bühnengenossenschaft offered medical services to disabled members, supplied legal counseling, ran an old age home in Weimar, and administered a voluntary pension fund.[23]

Four cooperative bodies carried out joint Bühnen-Verein–Bühnengenossenschaft regulation of professional matters. A joint committee on compensation (*Tarifausschuss*) served as the forum for negotiations on collective agreements. A system of arbitration courts (*Bühnenschiedsgerichte*) handled disputes between theater employers and employees. A limited-liability company, the Bühnennachweis, provided job placement services. Finally, a

joint committee oversaw matters of theater education. The committee advised governments on theater academy curricula and on the certification of private theater instructors. Similar joint committees passed judgment on the credentials of job candidates who did not possess diplomas from approved theater academies.[24]

The visual arts remained the most loosely organized sector of German artistic life. An occupation dominated by self-employed, often part-time practitioners did not lend itself to the unionization or professionalization processes employed by music and the theater. Consequently, visual artists often identified more with ideologically oriented organizations than with occupational interest groups. Among the occupational associations, the Reich Association of Visual Artists of Germany (Reichsverband bildender Künstler Deutschlands, or RVbK) stood at the forefront. Founded in 1921, and ten thousand members strong by 1933, the RVbK promoted the "economic and social interests of visual artists."[25] It sponsored a purchasing cooperative, from which members could buy art supplies at discounted prices; issued publications that kept members informed about meetings, competitions, exhibitions, stipends, and prizes; and lobbied for tax code adjustments that would benefit artists. However, numerous attempts to secure official state recognition of the RVbK met with failure in the Weimar era. The Reich, *Länder*, and local governments generally refused to entrust the RVbK with the administration of publicly financed competitions and exhibitions. The Reich government turned down an RVbK proposal to establish a national foundation for visual artists, funded by a special tax on art auctions. The Reich government also declined to support RVbK attempts to integrate self-employed, or "free," artists into the national unemployment insurance scheme.

Among architects, the structure of professional representation reflected divisions in employment status and training. Self-employed architects sharply distinguished themselves from publicly employed architects. Whereas free architects sustained themselves almost exclusively from commissions, their counterparts in the civil service could rely on a predictable, steady source of income. Free architects also took pains to separate themselves from construction entrepreneurs (*Bauunternehmer*), who designed buildings despite their lack of formal architectural training. Composed of three thousand free architects in 1929, the League of German Architects (Bund deutscher Architekten, or BDA) sought to protect its members against competition from civil servants and *Bauunternehmer*.[26] During the Weimar Republic, the BDA unsuccessfully lobbied for guaranteed participation quotas for free architects in publicly commissioned construction projects.[27]

The Impact of the Depression

Even during the middle, so-called Golden Years of the Weimar Republic, the sense of economic crisis that had prevailed in the arts during the early 1920s persisted in many circles.[28] From an objective viewpoint the situation had undoubtedly improved, but any basis for optimism proved short-lived. The onset of the Great Depression, and the deflationary economic policies instituted under the Brüning government, created a catastrophic situation. Severe cuts in government support for the arts compounded the diminished purchasing power of the general population. Unemployment rates among artists climbed higher than those affecting most other branches of the economy. However, artists constituted less than 1 percent of the total unemployed[29] and therefore lacked a strong political voice. The fragmentation of their interest group structure further undermined their ability to pressure governments for relief measures.

As public employees, orchestral musicians were especially vulnerable to budget cuts. Their situation had deteriorated so seriously by the beginning of 1931 that the editor of the *Allgemeine Musikzeitung* warned that "German musical life is facing collapse." Along with empty state coffers he blamed "the impoverishment of the middle class, which up to now has been the pillar of musical life."[30] Conditions worsened during 1931 and 1932 as orchestras all over Germany instituted massive program and personnel cuts. The city of Cologne reduced its orchestra appropriation by 38 percent between the 1931–32 and 1932–33 seasons. In Düsseldorf the city orchestra laid off 42 of its 105 musicians before the 1932–33 concert season. In Aachen the city orchestra was cut from 60 to 52, and those musicians who were kept on lost permanent employment status and instead were hired on six-month contracts. The city orchestra in Dortmund was slashed from 94 to 56 musicians. In Koblenz the city orchestra was simply dissolved. These examples, all from the Rhineland region, were more or less typical for the entire Reich.[31] By late 1932, the emergency funds of the occupational associations had run out, as had government appropriations for needy musicians. Thus the Tonkünstlerverband had nowhere to turn in late 1932 to address the "catastrophic emergency situation" among its musician members. "In previous years," a Reich Interior Ministry official informed the Reich chancellor's office, "I have been able to support the [Tonkünstlerverband], whose 10,000 members come from all parts of Germany. To my regret, I am no longer in that position on account of the budget cuts."[32]

The increasing prominence of radio and phonographs exacerbated job shortages among musicians, in turn intensifying the backlash against the

new technologies in some music circles.[33] The general music director of Münster equated the threat posed by the so-called mechanization of music to that posed by communism, the "barbaric principle from the east that seeks to destroy all foundations of western culture." All musicians had the "duty" to resist the spread of radio and phonographs, rooted as they were in capitalist materialism and commercialism.[34] Although most observers were less apocalyptic, there was widespread discussion of the problem's diverse ramifications. For instance, in order to alleviate themselves of the burden of royalty payments, musicians turned increasingly to older, noncopyrighted music. Through this practice, the crisis affecting the musicians worked to the financial detriment of the composers.[35] Experts wondered how a system rigged against contemporary compositions might affect German musical culture over the long run.[36]

For entertainment musicians, the most pressing grievance continued to stem from the absence of restrictions on the activities of amateur, semi-professional, and military musicians. Employment opportunities for professionals, already diminished by the general economic situation, underwent further erosion by competition from Dilettanten, whose services were either free or relatively inexpensive.[37] In January 1930, the DeMuV cried for help "against the competition of various ensembles that take bread away from professional musicians. Not only do civil servants have their own music groups, so do Stahlhelm and Jungdo, soldiers' associations, the Reichsbanner, gymnastic organizations, postal carriers, police—every single organization believes that it must have its own orchestra."[38] In January 1933, professional choir directors bemoaned their impotence in the face of an army of ten thousand amateurs who undermined their livelihoods.[39]

German theater faced a crisis of similar proportions. In April 1932, the Bühnengenossenschaft published detailed statistics describing unemployment in the theater profession. The "frightening" statistics reflected a "decimating form of unemployment." Joblessness for all categories of theater personnel had climbed to 44 percent. In almost all job classifications, unemployment among women exceeded that among their male colleagues. For example, 606, or 43.5 percent, of the 1,392 male opera soloists were without work, whereas the rate among female soloists was 57.3 percent, or 868 out of 1,514. The published statistics also pointed out that of those employed in the theater profession in Germany, 8.6 percent were Austrian and a further 6.8 percent were of other foreign citizenships.[40] Although not especially high for a profession in which some cosmopolitanism is to be expected, such figures seemed significant enough to lend some credence to the xenophobic arguments of Nazis and others who clamored for official protection against competition from foreigners.

Of the 242 theaters in operation in Germany during the 1929–30 season, only 199 opened in the 1932–33 season. In order to stay open at all, many theaters drastically shortened their seasons. In 1932–33, only 69 theaters could afford seasons between ten and twelve months long, as compared to 90 theaters three years earlier. According to one expert's calculation, German theaters accounted for a total of 1,567 "theater-months" during the 1932–33 season, down 25 percent from 1,957.5 in 1929–30.[41] Reductions in season length meant that theater professionals who were lucky enough to find work often had to settle for pared-down salaries. Many who had enjoyed the security of long-term contracts were compelled to accept employment on a single-engagement basis. The Bühnengenossenschaft reported that almost 50 percent of its members who were working earned less than RM 300 per month during the 1931–32 season. Part-time employment became so common that by the beginning of 1933, only one-third of German theater personnel had full-time work.[42] Though the Bühnengenossenschaft and the Bühnen-Verein were often at odds over austerity measures, both groups warned state and local governments that contraction of theater life and distress among theater professionals could inflict irreparable damage on German cultural life.[43]

Statistics on the plight of visual artists are much harder to come by. No unemployment figures were compiled for painters, sculptors, and similar classifications, as such artists were more loosely organized than were musicians and theater people, and many were officially counted as practitioners of other occupations. Nevertheless, painters and sculptors clearly considered themselves on the brink of collective disaster. In a letter to Chancellor von Papen in September 1932, the RVbK asserted that "the visual artists have been the hardest hit by the economic crisis" because "the business of art is the first to be curtailed or neglected when the income of individuals or of the *Länder* and the state is reduced."[44] The Reich, state, and local governments severely curtailed or altogether eliminated many of the grant programs that had provided a modicum of support to thousands of artists.[45] Even before the depression, relatively few visual artists had managed to earn a living solely from purveying or teaching art. Many of these relatively fortunate artists now faced the prospect of seeking other jobs. Desperate artists in Berlin took to bartering their paintings for groceries and clothing.[46]

The general economic crisis also hit architects particularly hard. The years between 1924 and 1929 had seen a general expansion of building activity. But in 1929 governments and private entrepreneurs were compelled to cut back on new construction, and many architects suddenly found themselves without work. In August 1930 over 30 percent of Berlin's

architects were completely unemployed, while many others found short-term work only after frantic searches.[47]

The Neocorporatist Impulse

The economic crisis led to intensified and more frequent demands for structural reform in the German art world. Despite a wide diversity of opinions about the causes of the crisis and possible solutions, one common thread ran through most reform proposals, connecting those from the extreme left with those from the extreme right: a rejection of the applicability of economic liberalism to the artistic and cultural spheres. Although a vocal minority of German artists expounded a Marxist revolutionary solution, the ideas that held the greatest sway among professional artists may be classified as corporatist or, better, neocorporatist.[48] Neocorporatism represented a non-Marxist alternative to a failing liberal social and economic order. It envisaged a society divided into self-regulating estates (*Stände*), each composed of members of the same profession or occupation. The estates would establish qualifications for professional practice and safeguard market monopolies for their own members. Such regulatory powers would be constitutionally and legally recognized.

Neocorporatist thinking among artistic and cultural professionals manifested itself primarily in the form of calls for the creation of officially recognized professional chambers, which would replace the fragmented, messy system of unions and professional associations. In fact, Austrian artists had already advanced far beyond their German colleagues in this regard, for a proposal for the establishment of a massive *Künstlerkammer* had already been brought before the Austrian Bundestag by 1930. This body would encompass a variety of occupations, finance itself, and exercise authority over "all matters concerning the legal protection of intellectual property of artists, copyright law for works of literature, music, or the visual arts, artistic education, and individual and old-age insurance for creative artists."[49] As the German economy deteriorated after 1930, discussion of neocorporatist solutions gained momentum in German artistic circles as well.

The notion of a musicians' chamber had arisen in the German music world as early as 1912, when prominent musicians had advocated the establishment of "an authoritative, expert central body for the supervision, regulation, and convalescence of musical life." The idea ran aground, however, when representatives of the existing occupational associations failed to agree on details and when no solution could be found to the problem of

financing.[50] The prestigious Prussian Academy of Arts revivified the idea in 1925 but produced only an inconclusive study of the matter. Advocates of the chamber sought to maintain some momentum by forming a special study committee under the auspices of the General German Music Association (Allgemeiner Deutscher Musikverein, or ADMV).[51] Concrete progress, however, remained elusive.

The economic disasters of the depression breathed new life into proposals for neocorporatist reform. One journalist observed, "The events of the year 1931 have opened the eyes of even the most dreamy visionaries among musicians. They finally see that music is not an imaginary structure, iridescent in magical colors independent of all real things. They have learned how closely the ethereal art of music is bound with economic and social conditions."[52] Only as a unified "estate" would professional musicians be able to regulate the supply and demand of talent in their own economic interest. For serious musicians, the rate at which new musicians entered the profession could be controlled through stringent educational and performance standards. For entertainment musicians, encroachment by amateur and military musicians could be limited by a tighter system of licensing. And for composers, deficiencies in the copyright and royalty collection systems could be corrected.

In 1930 an ADMV study committee produced a draft proposal for a national music chamber. Acknowledging the great practical difficulties inherent in fostering cooperation among the music world's diverse organized interest groups, the committee suggested as an interim solution the unification of the existing music associations into an umbrella organization. This move would pave the way for the long-term goal: "the obligatory cooperation of the associations in all questions that affect the common interests of the music world." Debate over the wisdom of the chamber idea intensified in German music circles through the depression, as advocates found themselves continually frustrated by the inertia and divergent interests of the existing unions and professional associations.[53]

In the theater profession, advocates of neocorporatist reform intended to expand the regulatory power of existing structures. They identified the liberal framework of German theater life as the main source of the economic problems plaguing theater people. The notion of a "planned theater economy" (Theaterplanwirtschaft) regulated by a central authority gained wide acceptance. At the core of this critique lay the theater profession's inability to enforce an equitable, socially responsible distribution of income among theater people. Left to the vicissitudes of a free market, theaters competed among themselves for talent, and as a result the profession became polarized into a large proletariat and a small cadre of well-paid

"stars." The profession's inability to prevent poorly trained and untalented novices from entering the employment pool made matters worse. A large number of unqualified dilettantes populated the theatrical proletariat, overburdening the network of theater agencies and all too often depriving the genuinely talented of work. Another structural defect aggravated this *Dilettanterei*: the theater world lacked central leadership in matters of theater education and training. Leaders in the profession often complained that ill-staffed academies, poor teachers, and even charlatans churned out too many inferior performers.[54]

In the Weimar era it had been not merely a social problem but also a major point of embarrassment that thousands of artists lived in indigent retirement in the land of *Kultur*. While the absence of a satisfactory retirement system affected almost all categories of professional artists, it seemed to generate the most lively discussion among theater people. Experts had attributed the problem both to the absence of a central professional authority and to the highly skewed distribution of wealth in the theater world. Widespread poverty and the impossibility of compelling subscription by the financially comfortable had combined to prevent the formation of an actuarially viable insurance pool. Furthermore, many theater people with civil service status, who were generally well paid, had already been integrated into local or provincial pension systems for civil servants. Support from philanthropic foundations made old age more secure for some but could barely begin to address the broader, systemic problem.[55]

Among visual artists, the neocorporatist impulse manifested itself primarily on the local and provincial levels, where artists sought official recognition of professional chambers. Artists in Karlsruhe had advocated such a measure as early as 1924.[56] During the depression, visual artists became increasingly vocal in their demands for de-liberalization and official restrictions on access to the art market. In Saxony artists submitted a twelve-page list of demands to the state parliament, stressing the need for "unified governance" in artistic matters, reductions in the number of students at art academies, restrictions on the activities of strictly amateur artists, and an end to "double dipping" by securely employed art teachers.[57]

Meanwhile, German free architects were united and resolute in their advocacy of an architects' chamber. The BDA had submitted a draft law creating such a body to the Reich Economic Council as early as 1920. The chamber would "advance the architectural interests of the population, protect the practice of the architectural profession, and regulate professional matters." The architecture chamber would be officially recognized as the profession's sole representative; government authorities would be compelled to consult and employ chamber architects only. Competition pro-

cedures, fee schedules, and other key regulations would be established by the chamber, subject to government approval. Notably, membership would be restricted to architects "not in the business of construction." Resistance offered by architects who *did* engage in such business may have accounted for the Reich government's refusal to approve the BDA proposal either in 1920 or on subsequent occasions during the Weimar period.[58]

Within the art world, proponents of neocorporatism believed that de-liberalization would help bring about prosperity and security. Professional chambers embodying "estates" of artists would provide the means to achieve greater collective professional independence and self-determination. Few neocorporatists, if any, advocated forfeiture of professional prerogatives to the state. Rather, they believed that the chambers, as officially recognized public law institutions, would be able to rely on the state to legitimize and enforce their claims to authority. In 1933, the National Socialist–dominated government succeeded in harnessing the neocorporatist aspirations of the German art world. When the Nazi regime created cultural chambers in 1933, assuring culture professionals that their autonomy would be respected, advocates of neocorporatism heard what they had long wanted to hear. Once the dust of Nazi "coordination" had cleared, however, harsh realities shat-tered the illusion that the National Socialist version of neocorporatism could tolerate genuine artistic and cultural autonomy.

National Socialism and the Arts in the Weimar Era

Perhaps more profoundly than in any other historical setting, art and culture became a political battlefield in the Weimar Republic. Saturated by art at many levels of its everyday life, and nurtured on a long tradition of reverence for the arts, German society lent itself especially well to politici-zation strategies employing pictorial, theatrical, musical, and even architec-tural weapons. The decay and collapse of political liberalism during the course of the Republic's life was reflected in the demise of the notion that art could exist neutrally in a sphere separate from ideology and politics. Among the proponents of ideological truth, art could powerfully and emo-tively evoke the inherent legitimacy of a preferred worldview, while at the same time illustrating the bankruptcy of dissenting viewpoints. Even if the majority of German artists remained beside (or above) the political tumult, taking refuge in their artistic endeavors, in their careers, or in their smug "apoliticism," the minority that did become politically active helped shape and define the larger struggle.

For the National Socialist movement, artistic and cultural issues offered

far more than a propaganda opportunity; they were central to the ideology. Like most other elements of its ideology, the Nazi conception of the relationship between art, the nation, and the state did not originate with the Nazis but evolved from the ideas of earlier racialist and *völkisch* theorists. Figures such as Arthur de Gobineau, Richard Wagner, Julius Langbehn, and Houston Stewart Chamberlain had all dealt extensively in the nineteenth century with issues of the politics of art (*Kunstpolitik*).[59] By the outbreak of the First World War, ideas developed by these men had become common currency in pan-Germanic and anti-Semitic circles in Germany and Austria. In postwar Germany the NSDAP was initially but one of several *völkisch* parties and formations conforming to this tradition. The special skill of the NSDAP lay not in the area of original ideological formulation but rather in the communication of such notions to a mass audience.

Rooted in the concept of *Volk*, the spiritual and biological organism of the German nation, National Socialism called for a process of domestic social and cultural purification. Adulterated by the infestation of alien racial stock, particularly that of Jews, German culture had supposedly entered an advanced stage of decay. A major task of the National Socialist state would be to expurgate alien tendencies from German art and culture.[60] This tendency to look to the state for active intervention in the arts was combined with a more or less consistent set of antimodernist aesthetic principles, which were in large part a reaction to cultural developments of the late Empire and the Weimar Republic. The revolution of 1918 had paved the way for the full efflorescence of experimental, avant-garde trends in literature, painting and sculpture, architecture, music, and theater. The German public, however, showed great reluctance in accepting the new artistic perspectives.[61] Cultural conservatives regarded the new forms as excessively intellectualized, aesthetically alien, un-German, debased, or decadent. Some, including many adherents to National Socialism, went a step further, interpreting modernism as a manifestation of *racial* decay, equating the supposedly unhealthy trends with liberalism, Marxism, and Judaism. Artistic decay thus confirmed the predominance of hostile political and cultural forces in Germany. From the National Socialist perspective, the struggles for racial, political, and cultural renewal would be identical. The politics of art would be integral to the creation of the "people's community" (*Volksgemeinschaft*).

These ideas resonated in the basic documents of the National Socialist movement and in the speeches of Nazi leaders. In its twenty-five-point program of February 1920, the party had already demanded the "legal prosecution of all those tendencies in art and literature which corrupt our national life, and the suppression of cultural events which violate this demand."[62] Between the NSDAP's inception in 1919 and its seizure of

power in 1933, the party newspaper, the *Völkischer Beobachter*, consistently devoted ample space to artistic criticism.[63]

Hitler's keen interest in the arts during his political career perhaps represented an effort to overcome personal failure as an artist during his Vienna days. During the Nazi "era of struggle" before 1933, Hitler's speeches often stressed the necessity of a new national *Kunstpolitik*.[64] In *Mein Kampf* (1924–25) Hitler elaborated on his conception of the relationship between art and a *völkisch* state. "It is the business of the state," he wrote, "to prevent a people from being driven into the arms of spiritual madness" and to guarantee "the preservation of those original racial elements which bestow culture and create beauty and dignity of a higher mankind."[65] This racialist conception of culture remained a core principle in Hitler's worldview. Throughout his years in power, Hitler was actively involved in the details of cultural policy, even to the point where he decided personally on cases of artists and entertainers with ambiguous racial credentials.

Other Nazi spokesmen frequently elaborated on National Socialist cultural principles. Alfred Rosenberg, "the administrative clerk of National Socialist ideology,"[66] explained that the *völkisch* state had the responsibility to cultivate the healthy and to root out the decadent in the nation's cultural life. "There arises from the idea of a cultural community the duty to nurture culture. Biologically as well as spiritually understood, this means that we have the duty above all to promote organic growth, to promote that which is inwardly strong and necessary to life, that which serves the values of Germans and their beauty ideal. At the same time, the community must keep as far away as possible any growth which is sick or inwardly foreign, and which does not act in the best interests of Germandom but in the interest of undermining the German being."[67] In the same vein, Joseph Goebbels often articulated the main difference between the National Socialist conception of culture and the "liberal" principles that had prevailed in Germany during the Weimar era. The cultural and spiritual welfare of the *Volksgemeinschaft*, Goebbels liked to emphasize, took priority over the rights of the individual artist. The liberal notion of "art for art's sake" was, therefore, inconsistent with the tenets of National Socialism. As Goebbels explained, "we have replaced individuality with *Volk* and individual people with *Volksgemeinschaft*." The state had not only the right but also the obligation to advance art in the interests of the *Volksgemeinschaft*. "Culture is the higher expression of the creative power of a nation," and the artist as a "giver of meaning" is "as indispensable to the state as those who provide its material existence."[68]

Despite the frequent references to artistic and cultural issues in Nazi

rhetoric and propaganda since the earliest days, only in the late 1920s did the movement begin seriously to incorporate such themes into its recruitment and mobilization strategies. In 1928, the Combat League for German Culture (Kampfbund für deutsche Kultur) was founded with the aim of broadening the movement's appeal among artists and among the educated middle class.[69] Although the Kampfbund's leader, Alfred Rosenberg, was a prominent National Socialist, the organization was not at first, strictly speaking, a subsidiary of the NSDAP. The Kampfbund's first board of directors included influential members of the German neoconservative movement, such as J. F. Lehmann, Philipp Lenard, Paul Schultze-Naumburg, and Othmar Spann.[70]

The Kampfbund's founders regarded its mission as one of *völkisch* consciousness raising. It was to "defend the value of the German essence" in the "midst of present-day cultural decadence" by promoting every "authentically native expression of German cultural life." It would "enlighten" the German people about the "connections between race, art, and science." Through lectures and publications, it would promote the work and thought of "important" Germans who had been "silenced" by the forces of decay.[71] The list of enemies of Germanic culture included the usual suspects: Jews, Communists, modernists, feminists, and the exponents of "nigger jazz." Public lectures were relatively inexpensive and easy to organize and therefore quickly became the most common form of Kampfbund function. Early lecturers included Othmar Spann, a well-known theorist of authoritarian corporatism, and Alfred Heuss, the editor of the prestigious *Zeitschrift für Musik*. Most often, however, it was Rosenberg himself who appeared on the podium to denounce the cultural manifestations of Judaism, Marxism, liberalism, and feminism.

Targeting its propaganda at a narrow, well-defined segment of the population, the Kampfbund did not seek to attract a mass membership. By January 1932 it had attracted around 2,100 members nationally.[72] The membership was drawn almost exclusively from elite segments of the German bourgeoisie. Twelve percent of members were university instructors, 19 percent professionals, 15 percent artists and intellectuals (writers, editors, performing artists, visual artists, and architects), 6 percent businessmen, and 6 percent middle- to high-ranking civil servants. Small businessmen and lower civil servants together accounted for about 19 percent of the membership. Elements of the former German nobility showed an affinity for the Kampfbund as well; among the members was Walter von Bogen u. Schöstedt, the executive director of the German Society of Nobility. Women constituted about 16 percent of the membership, suggesting a level of female representation in the Kampfbund roughly double that in the Nazi party. With activity centered on Munich, Dresden, Bonn/Bad

Godesberg, Düsseldorf, Heidelberg, and later Berlin, the organization drew its following mainly from people in common social or occupational environments who joined in groups.[73]

On only one occasion before 1933 did the Kampfbund enjoy an opportunity to exercise political power. When Nazi Wilhelm Frick became minister of the interior and culture in a right-wing coalition in Thuringia in 1930–31, he appointed Hans Severus Ziegler, leader of the Thuringian Kampfbund, to the post of "Culture, Art, and Theater Specialist." Ziegler engineered a purge of modern art from museums and public buildings under his jurisdiction. Emphasizing the need to protect "moral forces" against "alien racial influences" and the "glorification of Negroidism," Frick proclaimed restrictions on performances of "Jazz band and percussion music, Negro dances, [and] Negro songs."[74] Frick and Ziegler also called in Paul Schultze-Naumburg to head the State Academy of Art in Weimar. Schultze-Naumburg is known primarily for his notorious book *Art and Race*, published in 1928, which argued that the images depicted in abstract or expressionist painting were authentic manifestations of the racial decay infecting the artists.[75]

Although the events in Thuringia contributed to the merging of the Kampfbund's public identity with that of the NSDAP, the party continued to derive advantages from a formal separation. As a party document from 1932 explained, the Kampfbund "struggles for the promotion of German culture as defined by Adolf Hitler, but does not restrict its work to members of the Nazi party."[76] The Kampfbund could therefore "appeal to persons active in German cultural life who decline a formal connection with the party." The Kampfbund would "agitate and assemble" culturally active Germans, drawing them into a circle that would ideally "prepare them for entry into the Nazi party," or at least into an atmosphere imbued with the "principles of the National Socialist movement." The party, then, intended for the Kampfbund to function as a kind of back door for the reluctant bourgeoisie.

Developments in the Kampfbund's Berlin chapter in 1932 further blurred the clear line of separation that had been maintained between the NSDAP and the Kampfbund. Hans Hinkel, a Nazi activist and propagandist from the earliest days of the movement, had founded the Berlin chapter in 1930. In 1932, the impetuous Hinkel struck a deal with Joseph Goebbels, the Gauleiter of Berlin, according to which the Kampfbund would serve as the party's "major bearer of the struggle for German culture" in Berlin. Goebbels ordered all NSDAP members in his Gau who were artists and "culture creators" to join the Kampfbund.[77] It was still possible to be a Kampfbund member without joining the party; a short time after Goebbels's order,

however, the Berlin Kampfbund intensified its propaganda and programs aimed specifically at professional artists, seeking to transform the chapter into a shadow *Berufsverband* modeled on other NSDAP professional auxiliaries.[78]

These organizational maneuvers had several major repercussions, in addition to formalizing the relationship between the NSDAP and the Kampfbund. They made Hinkel a prominent party figure on the Berlin cultural scene, positioning him strategically for powerful appointments after the seizure of power; they gave Gauleiter Goebbels a major say over the affairs of an organization that was nominally under the leadership of his competitor Alfred Rosenberg;[79] they transferred the center of Kampfbund activity from Munich to Berlin; and they significantly increased the size of the Kampfbund's membership. During 1932, total Kampfbund membership for the entire Reich rose from 2,100 to around 6,000.[80] Although a good portion of this increase must be attributed to the overall growth of the Nazi movement's popularity (especially as reflected in the Reichstag elections of 1932), one must surmise that the Hinkel-Goebbels arrangement in Berlin played a major role as well. Under Hinkel's leadership, the Berlin chapter attracted the participation of several prestigious figures from the local cultural scene, including Gustav Havemann, professor of violin at the Academy of Music in Berlin; Clemens Krauss, musical director at the Berlin City Opera; Max Trapp, a teacher of composition at the Berlin Academy of Music and member of the Prussian Academy of Arts; and Paul Graener, director since 1930 of the prestigious Stern Conservatory in Berlin. An early issue of a journal published by the Berlin chapter, the *Deutsche Kultur-Wacht*, contained a declaration of support for Adolf Hitler signed by fifty-four university instructors, forty-five of whom were full professors.[81] Many of the signatories were scholars in the fields of ethnography, cultural history, art, music, and literature.

Both in and outside Berlin, the Kampfbund stepped up its own cultural programming in 1932. Its concerts highlighted the music of great German and Austrian composers, such as Händel, Bach, and Mozart, and also gave exposure to the compositions of contemporary exponents of traditionalism, including Paul Graener, Max Trapp, and Hans Bullerian, whose music had supposedly been suppressed by the dominant Jewish-Bolshevik cabal. The Berlin chapter went so far as to found its own symphony orchestra, under the direction of Gustav Havemann, which drew on the talents of unemployed musicians. In the realm of theater, 1932 saw the Kampfbund initiate a theater subscription plan in Munich. The plan was designed to enable the Kampfbund to sponsor its own productions, which would play before full houses of subscribers who had purchased tickets at substantial discounts.

This was not an original plan; the efficacy of the subscription arrangement had already been demonstrated by the Volksbühne and similar theater organizations of the Weimar era.[82] The Kampfbund's mediocre productions of obscure pieces, however, drew small audiences, lost a good deal of money, and were halted after only a few months. Yet the failed experiment did not discredit the theater subscription concept, which the Strength through Joy (Kraft durch Freude, or KdF) organization revivified with immense success during the Nazi regime.

Kampfbund propaganda, as transmitted through the *Deutsche Kultur-Wacht*, displayed two important characteristics of the National Socialist cultural agenda that are crucial for understanding the policy of the regime after January 1933. First, the selection of articles represented a mix of crude racial theory with more mainstream, conservative perspectives on culture. Racist treatises, exposés on Jewish-Marxist influence in the arts, and demands for the elimination of foreigners from German cultural life appeared side by side with feature articles on such personages as Schiller. This hybrid of tradition and radicalism would become a hallmark of Nazi cultural policy between 1933 and 1945. A second dimension of Nazi cultural policy reflected in the *Kultur-Wacht* was an emphasis on economic and organizational issues affecting the arts. Numerous *Kultur-Wacht* pieces displayed sensitivity to the concrete socioeconomic impact of Weimar era developments (both real and imagined) on artists, calling attention to the ravages of capitalism on cultural life. For example, many articles sketched out ideas for rationalization of the German theater economy, emphasizing the theme of de-liberalization, which usually entailed a combination of professionalization measures, work creation programs, and audience mass-subscription arrangements.[83] Similarly, in the field of music the Kampfbund called for greater official regulation of the progressive "mechanization" of music through radio, film, and records, and for replacing the existing labor unions and professional associations, which were fractious and increasingly impotent, with a neocorporatist "unified representation of the music estate" that would look out for musicians' economic interests and social concerns more effectively.[84]

The neocorporatist framework for the arts championed by the Kampfbund reflected an attempt to exploit similar sentiments that, as we have seen, had gained wide currency in the art professions by 1932. But neocorporatism was also deeply rooted in the history of the Nazi movement.[85] Point 25 of the party's 1920 program had called for "the formation of corporations based on estate and occupation for the purpose of carrying out the general legislation passed by the Reich."[86] To the Nazis, neocorporatism represented a "Third Way," an alternative to both the liberal order and the

Marxist model. It appealed to the romantic, *völkisch* impulse for an organic social structure that rejected class struggle. This impulse also represented an important link between National Socialism and the authoritarian conservatism of the non-Nazi right. Although neocorporatist thinking within the party tended to be nebulous and sometimes even contradictory,[87] its influence both before and after 1933 should not be underestimated.

Among National Socialists, neocorporatism merged logically with xenophobic and anti-Semitic attacks against the supposed flooding of the German cultural marketplace with foreigners and Jews. Cultural renewal and structural de-liberalization of artistic life were seen as two sides of the same coin. Rooted in racial decay, the economic crisis of cultural life could be attacked only through structural reforms that would lead to the permanent exclusion of "destructive" or "dangerous" elements. Not only were "non-Germans" depriving "Germans" of jobs, but the "alien" influences on German culture were scaring audiences away from theaters and concert halls. The NSDAP lobbied aggressively for legislation that would pave the way for a massive purge of Jews and foreigners from German artistic and cultural life. In 1932, for example, the NSDAP delegation in the Prussian parliament submitted a bill for theater reform embodying a combination of cultural and economic intentions. The reform would have prohibited the hiring of "ancestrally non-German stage artists" and banned "theater pieces with antinational, pacifist, or morally destructive tendencies."[88] Looking back on the Weimar era in 1937, Hans Hinkel observed that "the culture-destroying liberal system," which divided German artists into "countless groups and associations" lacking "unified, decisive leadership," had paved the way for the dominance of "instinctless" and "decadent" forces.[89] Fragmentation among "Aryan" artists had led to a "brutal Jewish hegemony among art dealers, in book, magazine, and newspaper publishing, in so-called art criticism, in commercial art, among music dealers and publishers, in the pivotal positions of the visual, the performing, and the creative arts."[90] "We were convinced," Hinkel recalled, "that the long-term art and theater crisis lay less in the material suffering of our people than in the increasingly destructive alienation between the *Volk* and the so-called art of the November state."[91]

In the spring and summer of 1933, the Kampfbund played an instrumental role in the process of Nazi coordination of the arts. But later in 1933, Kampfbund influence declined dramatically. Despite its eventual fall, the Kampfbund had left an important legacy. It had helped set much of the cultural agenda for the Third Reich, aggressively promoting neocorporatism, anti-Semitism, and a hybrid of artistic conservatism and "blood and soil" radicalism. It had also served as a training ground for many activists

who, after 1933, migrated to key positions in the Propaganda Ministry or in the Chamber of Culture. In 1940, Hans Hinkel, who had come to occupy several influential positions in the Propaganda Ministry and the Kultur-kammer, recalled that many "old activists" from the Kampfbund were "still around in this sector."[92] In addition to Hinkel, notable Kampfbund veterans included the writer Hanns Johst, who went on to become president of the Reich Literature Chamber from 1935 to 1945; Otto Laubinger, who led the Reich Theater Chamber from 1933 until his death in 1935; and Heinz Ihlert, who became executive director of the Reich Music Chamber.

In a move parallel to their party's sponsorship of the Kampfbund, activists within the NSDAP endeavored after 1930 to acquire influence within the established artistic occupational associations. These associations tried to steer a more or less neutral course, out of a justified fear that political partisanship would alienate many members and thereby further erode an already meager political influence. After 1930, however, it became far more difficult to find insulation against the increasingly pronounced political and ideological polarization of German society.

Resistance to politicization of the occupational associations had forced radicals on both ends of the spectrum to seek alternative channels for political activism. Radical artists could retain membership in occupational associations out of economic or professional necessity and simultaneously pursue ideological agendas as members of "revolutionary" or "combat" leagues of the left or right. For example, in October 1928 forty painters and sculptors had founded the German Association of Revolutionary Visual Artists (Assoziation revolutionärer bildender Künstler, or ASSO). In the tradition of the earlier "November Group" and "Red Group," they rejected the notion of "art for art's sake," instead standing firmly "on the ground of the revolutionary class struggle." They emphasized that their work would not be incompatible with that of the Reich Association of Visual Artists, and even announced the founding of their new group in the Reich Association's organ, *Kunst und Wirtschaft*.[93] By 1933, the ASSO had evolved into the communist movement's most prominent artistic organization, with about eight hundred members, a substantial record of exhibitions, and significant participation in the production of agitprop materials for the party.[94]

In the theater world, the chief occupational association became an arena of intense political struggle. During the summer of 1931, a small group of communist theater professionals founded a Revolutionary Union Opposi-tion within the Bühnengenossenschaft. Unlike the ASSO, the Opposition launched a frontal assault on the legitimacy of the larger organization. Dismissing the moderation of the existing leadership, they called for "a determined, active struggle against the impotence of the reformist union

bureaucracy." Whereas the existing leadership dilly-dallied with professional reform proposals and pleaded with the government for emergency subventions, the Opposition promised to join the "most progressive segment of theater people" with "the class-conscious proletariat" in order to achieve "a revolutionary solution." In concerted actions with other art professionals, radicalized theater people could transform strikes into "a sharp weapon of the struggle."[95]

Although the group did not achieve a broad following among Bühnengenossenschaft members, the union's leadership took the challenge seriously, cognizant of the susceptibility of the chronically unemployed to radical solutions. The official Bühnengenossenschaft organ, *Der Neue Weg*, warned against the damage that such "crazies" could bring to an organization that had been carefully built "over two generations by us and our predecessors." The union leadership seemed particularly concerned that the left-wing opposition might provoke similar internal activism at the other extreme of the political spectrum.[96] Sure enough, signs of Nazi activism within the Bühnengenossenschaft began to emerge in early 1932, when the union received news that Nazi members had circulated letters urging "opposition" against the union leadership. Aside from the predictable attacks on Jews, the Nazis accused the Bühnengenossenschaft of having "disgracefully betrayed the social interests of actors and singers." The Bühnengenossenschaft leadership denounced the Nazis even more vehemently than it had the Communists and continued to press for a neutral membership. In September 1932, the union's administrative council issued a proclamation declaring that "the intrusion of radical political movements in the union" presented "a great danger" to the "existence of the German theater." The council approved use of "the strongest organizational methods" to counter partisanship, including the power to expel members who were too intent on rocking the boat.[97]

Existing quantitative studies of the composition of the Nazi party have not determined the frequency of party membership among artists prior to 1933.[98] The surviving personal files of Chamber of Culture members, deposited at the Berlin Document Center, suggest rather low party membership frequencies. Music Chamber files indicate that about 6 percent of professional musicians active during the Nazi era had joined the party or one of its affiliated organizations, such as the Kampfbund or the Women's League (Frauenschaft), before 1933. A further 10 percent jumped on board in 1933, with an additional 5 percent joining after 1933.[99] For professional theater people, the rate of party joining was slightly lower. Among those listed as Theater Chamber members in 1944, 3.6 percent had joined the NSDAP or an affiliated organization before 1933, 5.6 percent in 1933, and 10.6 percent between 1934 and 1944.[100] Unfortunately, the surviving per-

sonal files for the visual arts are too fragmentary and unsystematic to yield meaningful conclusions.

The relatively low pre-1933 joining frequencies estimated for the music and theater professions can be misleading. There were many artists who, despite National Socialist sympathies, refrained from joining the movement because of an impulsive aversion to organized politics. Some artists preferred purely artistic forums for displays of their commitment. The theater producer and director Otto Schöpf typified this segment of the profession. According to a political evaluation prepared by the NSDAP's Munich office in 1940, Schöpf was "of a pronounced artistic nature" and had "never been involved in politics in a strict sense." Nonetheless, "in his professional activity he had always conducted himself in a manner consistent with the goals of National Socialism," for during the Weimar Republic he had "battled against the decay of the theater." The evaluation concluded: "It is therefore understandable that he now affirms the Third Reich with a full heart, and has a positive attitude toward National Socialism."[101]

Any assessment of pre-1933 NSDAP membership levels among music and theater people must also take into account a pattern of localized activism, already observed in the case of the Kampfbund. Whereas the Nazi movement made few if any inroads in some locations, in others it established a powerful presence. Two major artistic companies in Berlin provide good examples of this pattern. At the German State Opera, seventeen performers joined the NSDAP before 1933 (most joined between 1931 and 1932), while twenty-two more joined the National Socialist Factory Cell Organization (Nationalsozialistische Betriebszellenorganisation, or NSBO). At the State Theater, seven performers joined the NSDAP before 1933, while three of their colleagues affiliated themselves with the NSBO.[102] The party's recruitment successes were all the more significant when concentrated in this way within prominent, elite ensembles. The movement's attraction for such relatively successful artists stemmed from National Socialist propaganda's glorification of the role of the artist in society, its promise of an active national policy for the arts, the unpopularity among many artists of modernist and experimental trends, and the frustration of numerous artists with what they regarded as an overly materialistic system.

Conversely, the Nazi movement could also exert a special attraction to less successful artists. Nazi attacks on the supposed manifestations of cultural "degeneracy" in the Weimar Republic appealed effectively to a constituency of frustrated artists who found it convenient to attribute hardship to a Jewish-Bolshevik conspiracy rather than to their own shortcomings. For example, theater director Konrad Meysel joined the NSDAP in 1930 after almost a decade of wandering from one temporary theater

position to another. He blamed his misfortune on the "ruling Marxist regime" of the 1920s, which, he claimed, would not permit the kind of true "German theater leadership" that Meysel was prepared to provide.[103] Another actor-director, Harry Moss, turned to National Socialism in 1930 after returning to Germany from a four-year professional stint in the United States. Unable to find work in the economically depressed German theater, Moss joined the party and lashed out against "Jewish or Jewish-influenced directors" who were attempting "everywhere in Germany systematically to contaminate the German *Volk*" with "pieces by Jewish authors." For Moss, ideological commitment translated into professional opportunity in 1931, when the NSDAP's South Hanover–Brunswick section permitted him to found a "National Socialist Theater" in Hanover. In 1933, the party further rewarded Moss with the top position at the radio station in Hanover.[104]

Viewed quantitatively, the Nazi mobilization of artists before 1933 enjoyed only limited success. Compared to other self-perceived German elites, such as university students, school teachers, or physicians, artists tended to remain aloof from the movement, at least formally. Nonetheless, in the Kampfbund and in concentrated cells of Nazi activists, the movement did succeed in attracting artists and art experts in numbers large enough to enhance National Socialism's image among the German middle and upper classes. Moreover, these activists constituted a cadre that was prepared to take the offensive when the political opportunity presented itself in early 1933.

CHAPTER TWO

NAZI COORDINATION

OF THE ARTS AND THE

CREATION OF THE

REICH CHAMBER OF

CULTURE, 1933

In the early months of 1933, it appeared as though the Kampfbund für deutsche Kultur would acquire a dominant role in German cultural life. Between January and October, Kampfbund membership rose from 6,000 to 38,000.[1] Most new members no doubt joined for opportunistic reasons, assuming that such an affiliation would enhance job security or improve future employment prospects, although quite a few of the new adherents probably felt genuinely grateful for the opportunity to join a movement with which they had quietly sympathized in the past.[2] In the spring of 1933, Kampfbund activists supervised the takeover of such cultural organizations as the Association of Free People's Theaters (Verband der freien Volksbühne)[3] and the German Craft League (Deutscher Werkbund)[4] and won oaths of loyalty from business enterprises like the German Gramophone Company (Deutsche Grammophon Gesellschaft).[5] In some localities, the Kampfbund captured almost complete control of organized cultural life.[6] Meanwhile, Nazi officials appointed Kampfbund activists to pivotal positions in cultural administration at the state and Reich levels.

Immediately after Hitler's appointment to the chancellorship, Hermann Göring, the new Prussian minister president, chose Hans Hinkel, chief of the Kampfbund's Berlin chapter, to head the Prussian Theater Commission, which in the spring of 1933 supervised the mass dismissals of Jews and other ideologically unacceptable theater personnel in Germany's largest state.[7] Hinkel and other Kampfbund colleagues also played instrumental roles in the coordination of professional associations and labor unions in the cultural sector.

Yet the triumph of the Kampfbund was ultimately short-lived. Its informal, decentralized structure, which encouraged independent local activism, was better suited to the circumstances of political opposition and revolutionary change than to the requirements of a permanent, institutionalized system of cultural regulation. Moreover, Hitler had never entirely trusted Alfred Rosenberg, whom he regarded as personally erratic, intellectually abstruse, and bureaucratically inept. In contrast, Hitler had grown to rely on Joseph Goebbels, who had shown himself to be a dependable, shrewd, and flexible political operative during the NSDAP's rise to power. The party's Reich Propaganda Leadership, which Goebbels had created in 1931, had been a well-managed and highly effective bureaucracy.[8] Although he held a doctorate in German literature, Goebbels could hardly have been considered an expert in cultural or artistic affairs. Nonetheless, on numerous occasions in 1932 he had expressed to Hitler his desire to be granted authority over "art, culture, and propaganda" in the event of a National Socialist takeover.[9] By January 1933 Hitler had probably already decided to entrust Goebbels, rather than Rosenberg, with the supervision of artistic and cultural life.[10]

Immediately after the Reichstag election of 5 March 1933, Hitler and Goebbels moved to transform the party propaganda apparatus into a governmental organ. In a cabinet meeting of 11 March, Hitler forcefully expressed his intention to create a propaganda agency on the ministerial level.[11] Two days later the cabinet created the Reich Ministry for Popular Enlightenment and Propaganda (Reichsministerium für Volksaufklärung und Propaganda.) The new ministry, Hitler stated, would be "responsible for all tasks relating to the spiritual development of the nation."[12] But several leading Nazis resented Goebbels's newfound power. The new ministry had been founded with the intention of centralizing propaganda functions that had been divided among numerous ministries and agencies of the federal states during the Weimar Republic. As minister president of Prussia, Hermann Göring led the resistance against the Propaganda Ministry. In the spring of 1933 Göring tried to prevent the transfer of authority over propaganda, culture, and the media from the Prussian government to

Goebbels's ministry. Hitler, who refused to tolerate a fragmentation of responsibility in such vital areas, intervened in Goebbels's favor.[13] Göring's resistance typified the residual particularism of the federal states. A number of the states were especially reluctant to surrender control of radio broadcasting to the Reich government.[14] Goebbels was compelled to draft a stern letter to the Nazi governors (Reichsstatthalter), which went out on 15 July 1933 over Hitler's own signature, an explicit and unambiguous expression of the Führer's intention to centralize control over both propaganda and cultural life in the Propaganda Ministry. The fulfillment of the "national revolution," the letter explained, entailed instilling in the nation "the idea of the movement." The "implementation and administration of all tasks of popular enlightenment" required the leadership of a "single will" embodied in the Propaganda Ministry. By "popular enlightenment," Hitler and Goebbels meant far more than propaganda in the narrow sense. The ministry, they asserted, would establish control over "organizations in the fields of radio, the press, film, theater, music, and other areas of propaganda, enlightenment, and advertising." They further envisioned a Reichskulturkammer that would provide the institutional mechanism for centralized ministerial control.[15]

Thus by mid-July 1933 the Propaganda Ministry had supplanted both the state governments and the Kampfbund as the regime's primary vehicle for artistic and cultural regulation. Despite the Kampfbund's important contribution to the Nazi coordination of the arts in early 1933, its demise as a key factor had become a foregone conclusion. Reorganized in 1934 under a new name, the National Socialist Culture Community (Nationalsozialistische Kulturgemeinde, or NSKG), the organization would from now on exercise only indirect influence on German cultural life. Removed from the center of power, the NSKG emerged, ironically, as a severe hard-line critic of the Kulturkammer's supposed moderation, accusing Goebbels of coddling modernists and of moving too slowly on the purge of Jews.

Nazification of the Arts

The Gleichschaltung of the artistic unions and professional associations following 30 January 1933 progressed through several overlapping stages. A political environment dominated by Nazi street violence and intimidation, coupled with the rapid Nazi seizure of the apparatus of government, cleared the way for the internal nazification of the majority of organizations in the spring and summer of 1933. National Socialists took over leading offices in the associations, imposed the authoritarian Nazi "leadership prin-

ciple" (*Führerprinzip*) and dismissed socialist and Jewish officials. This phase of coordination in the cultural arena unfolded along lines remarkably similar to those in other sectors, such as law and education.[16] Several factors interacted: coercion by Nazi authorities, collaboration with Nazis by conservative nationalists, psychological resignation among liberal and socialist officers, and opportunism on the part of artists who hoped that declarations of loyalty to the new regime might salvage autonomy and yield material benefits. Once the process of internal nazification had been completed, the regime gathered the organizations into "cartels," thus inaugurating the "professional estate construction" (*berufsständischer Aufbau*) of the arts. The founding of the Reichskulturkammer followed in September 1933, and a fundamental reorganization of the Reichskulturkammer in 1935 finalized the coordination process. Improvisation characterized the process every step of the way, with the outcome subject to the interaction of several factors: power struggles among Nazi leaders, the regime's desire to win the confidence and collaboration of non-Nazi artists, and the experimental nature of active neocorporatism.

The internal coordination of the music unions and organizations in the spring and summer of 1933 clearly illustrates both the pivotal role of the Kampfbund and the improvised nature of the process. Shortly after Hitler's appointment to the chancellorship, Gustav Havemann and several Kampfbund colleagues appealed to Bernhard Rust, the National Socialist now in charge at the Prussian Cultural Ministry, seeking Rust's support for the creation of a music chamber. "Through the establishment of a chamber," they asserted, "all cultural, legal, and economic problems of the music estate can be solved in a unified manner."[17] In the succeeding weeks, the major professional music associations succumbed to pressure from the NSDAP, placing themselves at Havemann's disposal. On 24 March the board of directors of the Association of Concertizing Artists agreed to grant "decisive influence" to NSDAP members. It formed a new board of directors with Havemann as chairman and National Socialists in two-thirds of the remaining positions.[18] The new board forged a working relationship with the Kampfbund and, "in accordance with the custom of the NSDAP," redrafted procedures to conform to the Nazi leadership principle.[19] On the following day, 25 March, the Reich Association of German Orchestras and Orchestra Musicians (RDOO) reconstituted its own board of directors, placing Havemann in charge of a Nazi-dominated board.[20] In April, the NSDAP authorized Havemann to supervise the creation of a party-authorized professional association for the entire music profession: the Reich Cartel of German Musicians (Reichskartell der deutschen Musikerschaft). Hinkel reinforced the party's sanction with one from the Kampfbund.[21]

By late June 1933, the Reich Cartel had grown to encompass most of the major professional music associations of the Weimar period, in addition to the Music Specialty Group of the Kampfbund. Membership in the cartel was declared mandatory for the practice of a music profession. Although Jewish members of the existing associations automatically attained membership in the cartel, new membership applications received from Jews would be evaluated according to the racial provisions of the Civil Service Law of 7 April. The NSDAP exercised the right to appoint all cartel officers, who would govern the organization according to the leadership principle. The cartel's charter made no mention of the Propaganda Ministry. At this early juncture, Havemann and his colleagues—professional musicians working out of the Kampfbund—had no intention of seeing the music chamber subordinated to Goebbels's new ministry.

Composers who had been frustrated by the inadequacies of the existing copyright system sensed an opportunity in the advent of the Nazi regime. In June, composers resolved to create a new, centralized framework for copyright enforcement and royalty collection, one that would be consistent with the "spirit of the new government" and National Socialism's "new idea of the state." Richard Strauss, inspirational leader for many composers, appealed to Goebbels for the necessary legislation. Sensing an opportunity to patronize a culturally influential group and to achieve state control over royalty collection and distribution, Goebbels engineered the promulgation of a new law. Announced on 4 July, the new law granted the propaganda minister the right to reorganize the copyright collection system. A new State-Sanctioned Society for the Accounting of Musical Copyrights (Staatlich genehmigte Gesellschaft zur Verwertung musikalischer Urheberrechte, or STAGMA) began operating late in 1933. While STAGMA would carry out the technical responsibilities of copyright collection and distribution, the remaining professional interests of composers would be represented by a sister organization, the Professional Estate of German Composers (Berufsstand der deutschen Komponisten). Composers met on 4 September 1933 to lay the necessary groundwork. The composers "placed themselves clearly behind the leadership principle" of the NSDAP. The president and directors of the organization would be elected by the membership, although the results of such elections would be subject to ratification by the Reich government. The composers also proved ready to comply with Nazi racial principles: membership in their new organization would be open only to members of "Aryan extraction." The racial categories instituted by the Civil Service Law of 7 April would be applied to "non-Aryans."[22]

The improvisational pattern of *Gleichschaltung* prevailed in the visual arts fields as well. The coordination of the RVbK began with its Berlin

branch and subsequently spread to other locals. Purely by coincidence, the Berlin local was holding its annual general assembly on 30 January 1933, the day of Hitler's appointment to the chancellorship. The proceedings of the assembly were interrupted by the entry of 100 to 150 uniformed SA men, an act of physical intimidation that resulted in the election of two Nazi sympathizers to the board of directors. The unexpected turn of events at the 30 January meeting forced the Berlin local to schedule an additional general assembly for 20 March. At this second meeting, the entire board of directors resigned and was replaced by a new board of five members, four of whom were Kampfbund members.[23] On 29 March the new board asked Hans Hinkel officially to approve the coordination of the "Gau Berlin" and to issue a warning against any possible resistance to future measures.[24] These events set the tone for the coordination of the other branches. In April, NSDAP or Kampfbund members took over RVbK locals in Munich, Nuremberg, Hanover, Karlsruhe, Cologne, Halle, Brunswick, Hamburg, Kassel, Frankfurt, Leipzig, and Wiesbaden.[25] The next step involved merging the Reich Association and other visual arts organizations into a larger entity. This task was supervised by Max Kutschmann, a professor at the Arts and Crafts Museum in Berlin. Kutschmann possessed impeccable National Socialist credentials: he had been a party member since 1927, a cultural expert in the SS, and an activist with the Kampfbund.[26] In June the NSDAP authorized Kutschmann to "implement the coordination of German artists and artists' associations, and to concentrate them in preparation for the . . . Reich Cartel of the Visual Arts." The cartel would be the "only umbrella organization of the visual arts recognized by the NSDAP."[27]

The takeover of the BDA was spearheaded by Eugen Hönig, an antimodernist architect from the Schultze-Naumburg circle. In the 1920s, Hönig had been a leading figure in the Association for Artistic Interests (Verein für künstlerische Interessen), a Munich-based group dedicated to combating modernism in the arts. Toward the end of the Weimar Republic, he had become active in the Munich chapter of the Kampfbund's auxiliary association for architects. In early March 1933, Hönig took over the national presidency of the BDA, then announced that all regional branches should hold new elections for officers.[28] A record of one such election, that for Brandenburg, suggests that physical intimidation was instrumental to the process. On 24 April, when regional members assembled for the election, Nazi architects appeared in their brown storm trooper uniforms. The vote resulted in a new board consisting of one Nazi and two non-Nazis. The Nazis in the hall then began to demand the immediate resignation of the two objectionable officers. After the officers refused, "a troop of about twenty SA men" entered the room and "gathered around the directors'

table," whereupon the two officers left the room. From that point on, "everything played itself out entirely without friction." After the new Nazi board received the "complete trust" of four-fifths of the architects in attendance, the meeting closed with a rendition of the Horst Wessel song.[29]

The Bühnengenossenschaft, the major theater employees' union, fell to National Socialist control at the beginning of April. The union's copresidents, Carl Wallauer and Erich Otto, stepped down on the first of the month and were replaced by two Kampfbund activists: Otto Laubinger, an actor engaged by the State Theater in Berlin, and Benno von Arent, a set designer. Emil Lind, editor of the Bühnengenossenschaft organ, *Der Neue Weg*, resigned his post as well, retreating "into the darkness of the masses" from where he hoped to continue working for the "idea of our Genossenschaft" as an "anonymous soldier." A few weeks earlier, Lind had published an editorial condemning the appointment of Kampfbund member Hanns Johst to the position of first dramaturg at the State Theater in Berlin. The cover of the 20 April issue, the first published after Lind's resignation, celebrated Hitler's birthday with a large photograph of "our Führer." Inside the issue, Goebbels committed himself to the Bühnengenossenschaft's continued existence, for as the "estate representative of German stage artists" it would be a "valuable participant in the service of rebuilding a national German theater."[30]

Toward a Kulturkammer

Even as National Socialists consolidated their control over the artistic unions and associations in the late spring and early summer of 1933, a major rift emerged within the Nazi leadership over long-term plans for artistic and cultural administration. Under whose authority would these nazified organizations be placed? Despite Hitler's anointment of Goebbels, the question had by no means been settled on a practical level. As the institutional influence of the Kampfbund dissipated, a challenge to Goebbels's growing authority over the arts emanated from a perhaps unexpected source: the German Labor Front (Deutsche Arbeitsfront, or DAF), the huge official union founded by the Nazi regime in May 1933. In the summer of 1933 DAF leader Robert Ley launched a campaign to capture several major art unions and professional associations. These included the DeMuV (the largest German musicians' union), the visual arts cartel, the Bühnengenossenschaft, and the German Choir Singers' Association and Dancers' League (Deutscher Chorsänger-Verband und Tänzer-Bund). Ley intended to integrate the members of these organizations into an Association of German

Theater Employees and Similar Professions (Verband der deutschen Theaterangestellten und ähnlicher Berufe), to be a subsidiary of the DAF.[31]

The artistic organizations did not remain passive during the political struggle over their fate. For instance, the DeMuV had refused to submit itself to Havemann's designs for a Music Chamber. When Havemann and an escort of uniformed SA men appeared at a DeMuV meeting in April to demand the union's entry into the music cartel, the DeMuV's new National Socialist leader insisted that the DeMuV "has been a union until now, and in the future will be regulated by the union law." Reacting angrily, Havemann stressed the importance of uniting "all of German musical life" in a "musician's chamber."[32] To be sure, the DeMuV had declared its loyalty to the new "people's community," but it had also rejected affiliation with the music cartel, seeking instead a connection with the NSBO, which supposedly could "most effectively represent the economic and social interests of German musicians."[33] Given the DeMuV's traditional links to socialist unionism, an alliance with the NSBO, which presented itself as the champion of working-class interests, may well have made more sense than an alliance with the more elitist music associations that had joined the cartel. In essence, then, Havemann's clash with the NSBO over the DeMuV reflected the divergent economic interests and occupational self-perceptions of serious musicians, who preferred the neocorporatist approach, and entertainment musicians, who wanted to keep their old union intact as much as possible. With the smashing of the independent unions at the beginning of May 1933, DeMuV leaders set their sights on membership in the NSBO's successor—the DAF, Germany's new official "union." DAF officials, keen to seize control of the DeMuV's ten thousand–odd members, went so far as to consider arranging Havemann's arrest on a trumped-up charge.[34]

In an attempt to outmaneuver the DAF, Goebbels and his deputy, Walther Funk, appealed to higher authorities. Funk told Rudolf Hess that the existing theater associations constituted potentially valuable "propaganda instruments of the government."[35] Goebbels elaborated on this argument in a 13 July letter addressed to Hitler. The propaganda minister believed that broadly based neocorporatist sentiments in the art world could best be channeled to the advantage of the new regime through a chamber system. In the giant DAF, Goebbels argued, artists would lose their sense of special calling. "Artists are not merely employees," Goebbels asserted, but rather "bearers of a special professional duty and professional responsibility." Ley's plans for the integration of these professions into the DAF, according to Goebbels, was based solely on the "representation of material interests" and took no consideration of the "inherent organizational life of the artistic professions." Goebbels argued that the existing unions and professional

associations should by no means be dissolved or submerged into the DAF, for they "are thoroughly coordinated and Nazi-led." Moreover, because these organizations had been "built on the basis of specialized experiences and necessities of cultural-professional life," they would best serve the economic and material needs of artists as well.[36]

On the following day, 14 July, Goebbels won a major victory in the Reich cabinet, securing promulgation of the Law for the Establishment of a Provisional Film Chamber.[37] Goebbels had already proposed a plan in April for the creation of a Film Chamber. The centralized structure of the film industry and the cooperation extended to the new regime by film company executives had paved the way for a relatively smooth coordination in that sector.[38] Promoting the idea of a Film Chamber, Goebbels reasoned that "an artistic upswing" in the cinema would not be possible "without a healthy economic foundation" and that such a foundation required a "professional estate concentration" (berufsständische Zusammenfassung) in the film trade.[39] The Film Chamber Law promulgated on 14 July provided for the founding of a self-financing, public-law corporation (Körperschaft des öffentlichen Rechtes). Membership was to be obligatory for "all professional groups of the film trade"[40] in the areas of film production, distribution, and presentation, including performers, producers, directors, composers, scriptwriters, musicians, and cameramen. Membership in the Film Chamber constituted an "authorization to work in the film trade in the territory of the Reich."[41] Membership could be denied to applicants, or taken away from existing members, when evidence existed that they did not "possess the required reliability for the practice of the film trade."[42] The presentation of a film could be forbidden either by the Film Chamber or by the police if the producer of the film could not prove that all production personnel were chamber members.[43] The Film Chamber could impose financial penalties in cases of unauthorized practice in the film trade.[44] In the area of economic regulation, the Film Chamber could "issue orders for the economically important questions within the entire film trade," particularly over contracts.[45] The Economics Ministry was granted the right to appoint a representative to the chamber's board of directors in order to ensure consistency in economic matters. Goebbels would appoint the other two board members.[46] Signed by Hitler, this law made clear that the provisional Film Chamber would be merely a step toward the establishment of an all-encompassing "chamber system" to be controlled by Goebbels.[47] Goebbels, too, took pains to emphasize the Film Chamber's provisional status as one stage in the development of a more comprehensive chamber for professional artists under Goebbels's direction.[48]

Hitler's support for Goebbels intensified after the promulgation of the

Film Chamber Law. On the day after the 14 July cabinet session, Hitler sent his forceful letter to the Reich governors, justifying the centralization of cultural regulation in the Propaganda Ministry and expressing his approval of Goebbels's plans for a Reich Chamber of Culture.[49] On 17 July, Lammers, chief of the Reich Chancellery, informed Rudolf Hess that according to Hitler's wish, the DAF was to be directed to cease all interference in artistic affairs.[50] Yet despite Hitler's support for Goebbels, the DAF continued its efforts to commandeer the artistic unions and associations. Goebbels complained to Ley that reports had been received "from all parts of the Reich" of legal, economic, and even physical intimidation by DAF activists.[51] In August, Goebbels complained to the other Reich cabinet members that Ley had failed to recognize that the existing organizations of the "national creative community" should remain intact as "a natural foundation of the state." Goebbels accused Ley of attempting "to shove corporative construction into the sphere of social struggle." According to Goebbels, Ley's plan to integrate artists into a giant workers' organization amounted to a "revivification of labor union mentalities" (*Wiederbelebung gewerkschaftlicher Gedankengänge*). In his diary, Goebbels called the DAF a hotbed of "much Marxism."[52]

On 12 August, Goebbels once again felt compelled to appeal directly to Hitler, for the DAF had not ceased its harassment of the artistic organizations. Goebbels asked Hitler for a further endorsement of a Kulturkammer under Propaganda Ministry auspices.[53] Two days later, Lammers informed Rudolf Hess that Hitler had again considered the situation and had again decided in Goebbels's favor.[54]

Bolstered by Hitler's support, on 18 August Goebbels submitted a draft of a Reich Chamber of Culture Law to a number of other cabinet ministers for their consideration. The draft law possessed the character of an enabling law. In its most important paragraph, it "commissions and empowers" the propaganda minister to "concentrate the professions under his jurisdiction into a public law corporation." Furthermore, it granted the propaganda minister the prerogative to promulgate the necessary decrees for implementation.[55] The draft law was accompanied by a seven-page philosophical and political explanation of Goebbels's intentions.[56]

The memorandum lends further insight into Goebbels's opportunistic strategy for winning favor among German artists. Since the spring, Goebbels had been attempting to woo artistic elites by reassuring them of his respect for genuine talent and true quality in the arts and of his distaste for kitsch.[57] Now, envisaging the Reichskulturkammer, Goebbels described a system of artistic administration that would be consistent with professional responsibility. Cultural regulation in the Third Reich, he asserted, had to be

accomplished not by "control through laws and the police" but rather through the "intellectual leadership" of the state. The art professions should carry out their "public tasks" in a framework of "self-administration under state supervision." Even if only for pragmatic reasons, Goebbels thought it best for the state to set general guidelines for cultural policy and leave the aesthetic and institutional details up to the artists themselves. "It is a healthy move in the development of the corporative construction," he observed, "that the new structures are not being formed merely from the formal will of the law" but rather from a "partially voluntary self-formation" on the part of artists. In other words, the new regime should exploit neocorporatist tendencies already present in the coordinated art unions and professional associations rather than force through a completely new organizational framework.

Hitler gave his personal, albeit unofficial, blessing to Goebbels's draft law in late August.[58] On 2 September, Goebbels's deputy, Walther Funk, told representatives of several Reich ministries that the creation of the Reichskulturkammer had to be approved quickly lest the "revolutionary" tendencies of the DAF cause irreversible harm to the art professions. But several ministers hesitated to accept what seemed like an unrestricted blank check for the propaganda minister. The interior minister, Wilhelm Frick, objected to the labeling of the organization as a Kulturkammer, for the term *Kultur* connoted religious, educational, and scientific affairs over which the Interior Ministry exercised some authority.[59] The economics minister, Kurt Schmitt, registered objections as well, insisting upon his ministry's participation in the formulation of the new chamber's economic policies. Goebbels appeased Schmitt with a revised draft of the law, submitted on 20 September, which stipulated cooperation between the Economics Ministry and the Kulturkammer.[60]

Confident that no major objections remained, Goebbels then arranged with Hitler to have the Chamber of Culture Law placed on the agenda for a cabinet meeting scheduled for 22 September.[61] The law was the first item on the cabinet's agenda.[62] Goebbels opened the discussion, stressing the importance of avoiding further delay in the "corporative construction" of the art professions. It was clear, however, that several ministers remained unenthusiastic. Johannes Popitz, the Prussian finance minister, expressed concern that the chamber might interfere in the cultural policies of the federal states, a sentiment echoed by Bernhard Rust, the Prussian education and culture minister. Hitler, evidently angered by such manifestations of particularism, vehemently came to Goebbels's defense. "There is," Hitler asserted, "no Anhältisch or Hessian culture, but only a universal German culture, which is determined not by ministries, but by the ideology." Hitler

and Goebbels had probably expected such particularist challenges. Although Hitler's resolute position helped clear the way for the Chamber of Culture Law at the cabinet meeting, it hardly settled the issue once and for all.

Further practical problems came up for discussion. Popitz maintained that Goebbels had failed sufficiently to define the scope of the individual chambers. As Popitz himself had written "half a library" of books, would he, a cabinet minister, have to join the Chamber of Literature? Hitler observed that he, too, frequently published and would therefore logically fall under Goebbels's authority as outlined in the draft law. Goebbels conceded that such details would have to be worked out, that the new regime would simply have to "learn from experience" and address unforeseen problems as they arose.

The version of the law actually approved by the cabinet[63] contained one modification of Goebbels's draft that would prove significant in view of later developments. Upon the insistence of the minister of finance, Schwerin von Krosigk, the cabinet stipulated that the financial burden of operating the Kulturkammer would not fall on the shoulders of the Reich, state, or municipal governments.[64] Instead, the chamber would be a self-financing entity. Goebbels, anxious to see the Reichskulturkammer approved as quickly as possible, did not resist this idea at the cabinet meeting. In later years, however, the propaganda minister came to regret this arrangement, as inadequate financial resources became a major source of irritation to the Reichskulturkammer. As early as 1936 it had become abundantly clear that the self-financing system would be intolerable in the long run. One Kulturkammer official characterized the system of self-financing as a "construction of necessity" that would have to suffice until "the ideal" of direct state support could be attained sometime in the distant future.[65]

Aside from marking an important point in the growth of Goebbels's power in the Third Reich, passage of the Chamber of Culture Law reflected a diminution of the DAF's influence over labor policy in late 1933.[66] Ley formally recognized his defeat in an agreement signed by him and Goebbels on 13 February 1934, according to which "all creating Germans" had "fulfilled their responsibility to the corporative construction [ständischer Aufbau] of the German Volk" through membership in the Reichskulturkammer. As a concession to Ley, the Chamber of Culture was declared a "corporative member" of the DAF.[67] This was, of course, little more than a symbolic gesture at the time. A further agreement, concluded between Goebbels and Ley in 1937, endowed the concept of "corporative" membership in the DAF with real substance: in exchange for a fee, Reichskulturkammer members were to be allowed to use the legal counseling services of

the DAF and to participate in activities sponsored by the DAF's cultural auxiliary, Strength through Joy.[68]

If the Reichskulturkammer Law was merely a blank check for Goebbels, then the First Decree for the Implementation of the Reich Chamber of Culture Law, promulgated on 1 November 1933, must be considered the real founding document of the Reichskulturkammer.[69] The First Decree established fundamental guidelines for the tasks, structure, and membership policies of the Reichskulturkammer and provided for the enforcement of chamber policies by police and administrative authorities. Henceforth, decrees and regulations promulgated by the Kulturkammer were almost always based on provisions of the First Decree.

The basic mission of the Reichskulturkammer, according to the decree, was "to promote German culture on behalf of the German *Volk* and Reich, to regulate the economic and social affairs of the cultural professions, and to bring about a compromise between [the groups] belonging to it" (Par. 3). The task of the Reichskulturkammer was thus one of both cultural and professional regulation. The use of the term "compromise" represented a rejection of the competition among interest groups that is supposedly inherent to liberal societies. Such competition had inspired much of the neocorporatist thought in the art professions in the Weimar period, and after 1933 the concept remained a frequent object of derision in Nazi cultural propaganda. As a corporation of cultural professionals "in a compulsory working relationship [*zwangsläufige Arbeitsgemeinschaft*] with the state leadership," the Reichskulturkammer would eliminate this competition once and for all.[70] The professional peace would be secured in part through a close supervision of relations between employers and employees. Borrowing language from the First Decree for the Film Chamber, this First Decree granted the Kulturkammer control "over the type and form of contracts between the professional groups" encompassed by the chamber (Par. 25).

The Kulturkammer's command structure would be based on the leadership principle. The propaganda minister would serve simultaneously as president of the Reichskulturkammer (Par. 11) and would appoint the presidents of the individual chambers (Par. 13). In turn, the presidents of the individual chambers would appoint administrative councils consisting of representatives of the various professional groups contained in their chambers (Par. 14). In accordance with the *Führerprinzip*, the president of the Reichskulturkammer reserved the right to negate all decisions made by officials of the individual chambers (Par. 22).

Membership in one of the individual chambers was to be required of all who participated in the "creation, reproduction, intellectual or technical

processing, dissemination, preservation, and sale of cultural goods [*Kulturgut*]" (Par. 4). The term "cultural goods" was defined to include "every creation or performance of art that is transmitted to the public" and "every other intellectual creation or performance that is transmitted to the public through print, film, and radio" (Par. 5). It was deemed "irrelevant" whether the cultural activity was "commercial or of public utility [*gemeinnützig*]" or whether it was carried out by "individual persons, societies, corporations or bodies of public law" or by "Reich citizens or foreigners" (Par. 6). This seemingly limitless jurisdiction would lead, in the years after 1933, to much confusion and to several power struggles between Goebbels and other Nazi leaders.

The members of the individual chambers would be grouped into "specialty associations" (*Fachverbände*). In most cases, these were identical to the coordinated *Berufsverbände* inherited from the Weimar period. Membership in an individual chamber, and hence in the Reichskulturkammer, derived from membership in such a *Fachverband* (Par. 15). Applications for admission into a chamber would therefore be processed by the *Fachverband*, although the decree provided for a right of appeal to the presidents of the individual chambers as well (Par. 18).

The Decree's most important provision governing conditions of membership was contained in Paragraph 10, according to which "admission into a chamber may be refused, or a member may be expelled, when there exist facts from which it is evident that the person in question does not possess the necessary reliability and aptitude for the practice of his activity." Paragraph 10 would serve as one of the main legal foundations for the exclusion of Jews and other undesirables from the German art world during the Third Reich. Significantly, those who drafted the First Decree did not include any explicit mention of Jews in Paragraph 10, or in any other clause, despite the well-known intention of the Nazi movement to eliminate "Jewish influence" from German cultural life and despite the purge of prominent Jewish artists, actors, directors, and musicians that had taken place in the spring of 1933 on the basis of the Civil Service Law. The details of the Kulturkammer's system of cultural eugenics will be explored further in chapter 5.

Finally, the First Decree provided for enforcement of Reichskulturkammer regulations by empowering the presidents of the individual chambers to impose penalties not only on members of their chambers but also on artistically active amateurs and other nonmembers (Par. 28). Moreover, the regulations were to be enforced with the assistance of the police, the civil service, and judicial authorities (Par. 29).

The legal existence of the Reich Chamber of Culture and its seven subchambers began on 15 November 1933, the date on which the First Imple-

mentation Decree took effect. The cartels that had already been founded for music and the visual arts were simply transformed into chambers, while the Theater Chamber was formed from the Bühnen-Verein and Bühnengenossenschaft. In each case, the members of the existing organizations, including many Jews, were automatically transferred into the new chambers. The transition was at first barely perceptible to the members themselves, one of whom later recalled about admission to the Music Chamber, "we were simply in it, without having noticed."[71]

Each individual chamber, like the Reichskulturkammer as a whole, possessed the quasi-official status of a "public law corporation" (*Körperschaft des öffentlichen Rechtes*). The juridical legitimacy of forcibly subsuming the existing organizations into the chambers derived from the first paragraph of the Reich Chamber of Culture Law, which had empowered the propaganda minister to "concentrate" artists into "public law corporations." In the political circumstances of late 1933, the dubious legality of this process presented no obstacle, although some Nazi legal authorities recognized that certain measures possessed an air of extralegality. Hans Schmidt-Leonhardt, a legal expert in the Propaganda Ministry, defended the process but admitted that certain measures had been "unusual and bold from the standpoint of a formal jurist of the liberal system."[72]

Splinter unions and professional associations that had not been integrated into the chambers at first came into the fold during the final weeks of 1933, throughout 1934 and, in a few cases, in later years.[73] This stage of the process usually involved organizations of minor size and significance. Thus, for example, the Theater Chamber's assimilation of the Reich League of Province Theaters (Reichsbund der Provinztheater), an association of small, touring theater troupes, was delayed while Theater Chamber officials debated over whether this association should be admitted into the chamber as a specialty association in its own right or as a subsidiary of an already extant *Fachverband*.[74] Also, the status of several professional groups hung in limbo while Nazi leaders bickered over jurisdiction.

The designation *Fachverband* was itself significant. It connoted continuity with the *Berufsverband* or *Interessenverband* of the past. This choice of terminology was not merely a symbolic gesture. Although each *Fachverband* was subsidiary to a Kulturkammer chamber, each retained its own legal identity. Most of the *Fachverbände* were "registered organizations" (*eingetragene Vereine*) endowed with organizational sovereignty (*Hoheitsrecht*) and authority over their own finances (*Finanzhoheit*). The *Fachverbände* inherited the financial assets and obligations of their predecessor *Berufsverbände*.[75]

During this early stage of the Kulturkammer's existence, Goebbels fre-

quently expounded upon his interpretation of neocorporatism as applied to the arts. Whereas the state had the responsibility to promote and to guide culture, it should avoid dictating it in the narrow sense. The chamber system, Goebbels maintained, would allow the regime to set German artistic life on the proper course, liberating German artists from the "competitive chaos" (*Konjunkturhascherei*) and "organizational mischief" (*Organisationsunfug*) of the bygone liberal system. The newly organized art world would be expected to cooperate with the regime and to police itself. In accordance with his position on artistic self-government, Goebbels promised that the regime would refrain from an intrusive censorship. Although the overriding goal of National Socialist cultural policy would be to "cultivate a German artist type," the regime would also have the "courage to be magnanimous" toward the art world. This flexibility, Goebbels hoped, would be reciprocated by a "similar magnanimity on the part of the art world." Goebbels assured artists that they would be "free and unbound" to pursue their chosen endeavors provided that they "acknowledged" the principles of the new state. "Art," Goebbels observed before an audience of Kulturkammer officials, "can flourish only when it is given the greatest possible freedom to develop [within] the framework and borders of the laws of national life."[76]

This notion of professional self-administration under the protective, guiding hand of the state resonated nicely even in non-Nazi artistic circles. The belief that a National Socialist state could play a positive role in the promotion of artistic life without resorting to excessive interference was at first widely accepted, even in the face of the massive cultural purges that took place during the first months of Nazi rule. The composer Richard Strauss, first president of the Music Chamber—and by no means an adherent to National Socialism—lauded the new chamber in February 1934 as proof of the regime's determination "to make possible a new vigor in our musical life." Creation of the chamber had demonstrated that, unlike the Weimar Republic, "the new Germany is unwilling to let artistic matters slide."[77]

The readiness of several prominent non-Nazis to accept important positions in the new chambers reflected broad approval, or at least acceptance, of the new institutional framework for the arts professions. The men Goebbels appointed to lead the chambers comprised an unusual mix of apolitical cultural figures and Nazi "old fighters." For the presidency of the Music Chamber he chose Strauss, a man of conservative but not National Socialist inclinations. Although Strauss later disseminated the myth that the position had been thrust upon him unexpectedly by Goebbels, recent research suggests that Strauss actively lobbied for the appointment behind the

scenes.[78] Goebbels valued Strauss as a legitimizing force for Nazi cultural policies, both within Germany and abroad. Strauss would serve as a symbol of the new regime's willingness to anchor the musical life of the Third Reich in German musical tradition. A similar motive drove Goebbels to appoint the acclaimed conductor Wilhelm Furtwängler to Strauss's presidential council, a move that was particularly notable in view of Furtwängler's earlier public clash with Goebbels over the persecution of several noted musical figures by the new regime.[79] In order to balance these overtly nonpolitical appointments, Goebbels also placed several Nazis or Kampfbund activists in key positions. Gustav Havemann, for example, was left in charge of the huge Reich Musicians' Branch (Reichsmusikerschaft) of the Music Chamber. Similarly, Goebbels entrusted the chamber's day-to-day operation to Heinz Ihlert, a Kampfbund veteran and NSDAP member since 1927.[80]

To the presidency of the Theater Chamber Goebbels appointed Otto Laubinger, an actor and director who had been organization leader of the Specialty Group for Theater of the Kampfbund's Berlin local since 1932.[81] The Theater Chamber council included the celebrated actor Werner Krauss, whose interpretation of Shylock in Shakespeare's *Merchant of Venice* was later praised during the Third Reich for its brilliant evocation of the "total external and internal uncleanliness" of the "eastern Jewish racial type."[82] Another council member was Rainer Schlösser, who had been active in *völkisch* politics since 1924 and had served as culture-political editor of the *Völkischer Beobachter*. As Reichsdramaturg in the Propaganda Ministry, Schlösser would remain a central figure in the state censorship apparatus for theater until the final days of the regime.[83] By contrast, leadership of both the Bühnengenossenschaft and the Bühnen-Verein, which continued to exist within the Theater Chamber, remained in the hands of non-Nazis. Otto Leers, a former minister of culture in Baden, retained the helm of the Bühnen-Verein he had held since 1931.[84] The new chief of the Bühnengenossenschaft, actor Ludwig Körner, took pride in his apoliticism; having never belonged to any political party, he asserted in 1935 that even after the Nazi seizure of power he had not regarded membership in the NSDAP as "compelling."[85] Körner would eventually serve as president of the Theater Chamber, from 1938 to 1942.

Eugen Hönig, the architect who had led the takeover of the BDA, was named president of the Visual Arts Chamber. Although a Kampfbund adherent, Hönig had by no means been among the most vociferous opponents of modernism.[86] By choosing Hönig rather than a more extreme figure such as Schultze-Naumburg or Kutschmann, Goebbels perhaps intended further to underscore his pledge to grant German artists some

"freedom to develop." Yet Hönig's presidential council consisted almost entirely of figures with Nazi or Kampfbund connections: sculptor August Kraus, who earlier in 1933 had participated in the Nazi purge of the venerable Prussian Academy of Arts;[87] Paul Ludwig Troost, a Hitler favorite who had redesigned the interior of the NSDAP headquarters in Munich in 1931;[88] and illustrator Otto von Kursell, a "political artist" who had won high praise from Hans Hinkel for his struggle against modernism and expressionism during the Weimar Republic.[89]

The leadership of the culture chambers embodied the broad antimodernist cultural coalition between National Socialists and conservatives that had emerged in the latter phase of the Weimar Republic.[90] The authoritarian framework of the chamber system, structured as it was according to the Nazi *Führerprinzip*, may have contradicted neocorporatist notions of professional autonomy, but the appointment of non-Nazis to responsible positions in the chambers suggested that Goebbels would exercise his power over the arts with restraint and respect for professional expertise. About eighteen months would pass before Goebbels would shatter this persistent illusion.

EVOLUTION OF THE

CHAMBER SYSTEM

Initial experiences confirmed confidence in the experiment of artistic neocorporatism. Throughout 1934 and during the first months of 1935, the chambers could indeed operate with a high degree of autonomy from the Propaganda Ministry. In late 1934, the Kulturkammer central office, responsible for oversight of the seven individual chambers, contained only eleven full-time employees, led by two Reich culture administrators (Reichskulturwalter), Franz Moraller and Hans Schmidt-Leonhardt. Acting primarily on their own initiative, the individual chambers instituted a vast spectrum of economic regulations aimed at de-liberalizing the artistic market, began the transformation of occupational certification processes, implemented programs for work creation and professional retraining, and moved forward on the expansion of social security coverage for artists. At the same time, the chambers pursued relatively moderate courses in the area of censorship, although the police and other agencies issued their own blacklists. Despite the fact that many Jewish artists had fallen victim to the racial stipulations of the Civil Service Law of 7 April 1933 and lost their positions in public cultural institutions, including orchestras and theaters, membership in the Kulturkammer remained open to non-Aryans well into 1935. Goebbels seemed to be living up to his pledge to conduct himself with "magnanimity" toward the art world. Such restraint may well have raised false hopes among moderate artists (and many other Germans) that the regime might concentrate on improving the economic condition of professional artists while devoting less energy to the potentially more controversial domain of ideological purification. Yet while Goebbels's approach succeeded in accommodating many in

the German art world to the new regime, it also alienated dogmatic Nazis, particularly Alfred Rosenberg, to whom Goebbels's pragmatism represented a sellout of National Socialism.

By mid-1935, Goebbels had grown wary of the system of neocorporatist autonomy he had so vigorously championed. Convinced that the chambers had not reciprocated his "magnanimity," Goebbels launched a thoroughgoing purge of the chamber leaderships, combined with a fundamental reorganization of the entire chamber system. To do the dirty work, Goebbels called on the help of an old ally, Hans Hinkel, who had found himself in need of a new job. Hinkel's two bases of power, the Kampfbund and Rust's ministry, had both lost much of the influence over artistic affairs they had exercised in early 1933. In May 1935, Goebbels appointed Hinkel as a third Reichskulturwalter in the Kulturkammer's central office. Having demonstrated both his capacity for hard work and his considerable personal ambition with the Kampfbund, Hinkel now began a steady rise within the Kulturkammer. His immediate task was to implement the purge and restructuring of the chambers. While the purges replaced moderate officials with figures deemed more ideologically reliable, the bureaucratic reforms produced a far more centralized framework of artistic administration. In the process, the chambers systematically expelled their Jewish members and began to clamp down on degenerate art. All in all, these measures were tantamount to a new phase of *Gleichschaltung* in the arts.

Neocorporatism and Second Coordination, 1934–1936

Goebbels's problems with the Music Chamber stemmed in large part from his difficult relationship with Richard Strauss. The collaboration between the two men had indeed produced notable reforms of the laws governing musical life. In 1933, on Strauss's urging, Goebbels pushed through a restructuring of the German system for collecting and distributing composers' royalties for copyrighted compositions. The new system, embodied in STAGMA, employed a formula that awarded a disproportionately high percentage of royalties to serious musicians, whose concerns had been closest to Strauss's heart. Additionally, in December 1934 Strauss was instrumental in winning Goebbels's support for the passage of a new copyright law that extended the period of protection from thirty to fifty years after the composer's death. Such an extension had been the issue at the top of German composers' agenda for decades.[1] Goebbels, in turn, was delighted to win the favor of so prestigious a group as Germany's serious composers.

Nonetheless, friction between Strauss and Goebbels gradually destroyed their collaboration. Strauss tended to work through trusted confidantes rather than with the Nazi functionaries who dominated the Music Chamber bureaucracy. The chamber's executive director, old fighter Heinz Ihlert, addressed this issue in a confidential letter to Hans Hinkel in May 1935. After reaching a decision, Ihlert alleged, Strauss would ignore Ihlert and the Music Chamber bureaucracy and instead entrust the assignment to a personal agent. Strauss knew nothing of the chamber's organization or procedures and paid little attention to the details of work creation measures and other vital economic programs. Instead, he remained content to sit at home in Garmisch and engage himself only in matters such as copyright reform that were primarily of concern to composers, who constituted only a tiny minority of the Music Chamber membership.[2]

More significant in Goebbels's alienation from Strauss, however, was their clash over the "Jewish question." Strauss refused to cooperate in the planning of anti-Jewish measures, declining as a matter of principle to sign documents that would have laid the legal groundwork for the purge of Jewish members from the chamber.[3] On one occasion Strauss informed Goebbels that he did not want "actively to participate" in such "disgraces" as the "intensification of the Aryan paragraph."[4] The incident that actually sparked Strauss's dismissal arose from the composer's refusal to end his collaboration with the Jewish novelist, poet, and dramatist Stefan Zweig, who at the time was living in the Netherlands. In early 1934 Nazi activists learned that Strauss had chosen Zweig to be the librettist for his new opera, *Die schweigsame Frau*. What then ensued has been thoroughly documented by numerous historians.[5] Strauss had in fact been working on the opera with Zweig since before the Nazi seizure of power. In mid-1934 Strauss managed to secure permission from both Goebbels and Hitler to continue the collaboration, a gesture of tolerance that reflected the importance attached by the regime to Strauss's incumbency as chamber president. But as the June 1935 premiere of the opera approached, Goebbels came to regret this decision. Alfred Rosenberg and several colleagues in the NSKG exploited the connection between Strauss and Zweig in their public attacks on Goebbels and the Kulturkammer. When Goebbels suggested to Strauss that the relationship with Zweig be severed, Strauss adamantly refused, grumbling privately that "these are sad times when an artist of my rank has to ask a brat of a minister for permission for what he may compose and perform."[6]

Goebbels preferred not to ban the opera, for an overt act of coercion would have reflected poorly on his own judgment in appointing Strauss in the first place. An outright prohibition would also have lent additional

credence to Alfred Rosenberg's increasingly vocal criticisms of the Kultur-kammer's moderation. One of Rosenberg's lieutenants, Walter Stang, had publicly questioned why "a composer active in the National Socialist state will not renounce his connection with a Jewish librettist." The continued collaboration with Zweig, Stang declared, could be interpreted only as an expression of "disdain for the National Socialist movement."[7] Just a few days before the scheduled premiere performance of *Die schweigsame Frau* in Dresden, Stang called for a boycott of the opera by all good Nazis. Justifying this measure, Stang observed: "The opera, like almost all works by Strauss, has been published by the Jewish music publisher Adolph Fürstner, Berlin. The text is by Austrian Jew Stefan Zweig, [who] has placed his share of royalties at the disposal [of] Jewish welfare institutions. The piano score of the opera is by the Jew Felix Wolf. The general intendant of the Dresden State Opera, Geheimrat [Paul] Adolph, is married to a full-blooded Jew."[8]

Responding to criticism by Rosenberg and Stang, Goebbels increased his pressure on Strauss. The composer soon reached his breaking point. On 17 June 1935 Strauss scathingly denounced Goebbels and the regime in a bitter letter to Zweig.[9] The letter was intercepted by the Gestapo and was passed on to Hitler at the beginning of July by Martin Mutschmann, the Gauleiter of Saxony, the region where *Die schweigsame Frau* had premiered on 24 June. In the meantime, a further scandal had begun to unfold in the Music Chamber: it was learned that Friedrich Mahling, editor of *Musik im Zeit-bewusstsein*, an official Music Chamber publication, had employed a non-Aryan, a Professor Herrenried, as an assistant. The chamber dismissed Mahling on 28 June on grounds of "culture-political unreliability."[10] Faced with this additional embarrassment, Goebbels, who could hardly contain his outrage upon learning of Strauss's letter to Zweig, decided that the time had come to jettison Strauss. The aggravating experience with Strauss also helped convince Goebbels to clean house at the Music Chamber, where insubordination seemed to be running rampant. In a diary entry dated 5 July 1935, Goebbels railed not only against Strauss but also against Gustav Havemann, whom he derided as a "characterless" artist.[11] Havemann's infraction had been to defend Paul Hindemith when the modernist composer had come under attack by Goebbels in late 1934.[12]

Soon after Strauss's resignation for "reasons of health" on 14 July,[13] Goebbels appointed Peter Raabe as his replacement. A versatile musician and musicologist, Raabe was most widely known for his standard biography of Franz Liszt.[14] Although Raabe had not been a party member prior to his appointment to the chamber presidency, his recent writings had exhibited pronounced nationalist tendencies.[15] The appointment was a shrewd one on Goebbels's part. As an official of long standing in the Allgemeiner

Deutscher Musikverein, Raabe had established a solid reputation as a champion of professional autonomy, having helped shape ADMV proposals for creation of a music chamber in the Weimar Republic. Initially, therefore, Raabe could hardly be perceived as a mere Goebbels puppet. Yet he did prove far more malleable than Strauss. After his first official encounter with the new Music Chamber president, Hinkel concluded that Raabe seemed very cooperative, having agreed to the appointment of "old National Socialists" to key Music Chamber posts.[16] In June 1938 Goebbels noted in his diary that Raabe was rather "easily won over."

Raabe would preside over the Music Chamber until 1945, although his relationship with Goebbels was not entirely free of friction. In 1936 and 1937, for example, Goebbels grew angry with Raabe's alleged toleration of compositions that had been denounced as "atonal" by Heinz Drewes, a dogmatic enemy of degenerate music who held a seat on Raabe's presidential council. Moreover, in 1938, Goebbels castigated Raabe for having "neglected much" in the area of "de-Jewification" (*Entjüdung*) in the chamber. For his part, Raabe complained incessantly about Propaganda Ministry interference in his chamber's membership, economic, and educational policies.[17] On several occasions Goebbels entertained the notion of replacing Raabe. In April 1940 Goebbels had Wilhelm Furtwängler in mind for the position. Several months later, when it appeared as though Raabe would actually resign, Goebbels nominated Professor Karl Leonhardt of Tübingen to succeed him, although Hitler lacked enthusiasm for this prospect. It seems that Raabe kept his position mainly by default.[18]

In 1935, Goebbels also had to contend with unwelcome developments in the Theater Chamber. In the spring the Berlin police and the Gestapo had begun to investigate several cabaret satirists who had allegedly ridiculed leading Nazis during their acts. According to a Gestapo agent, the most famous of these performers—Werner Finck of the "Katakombe" club—specialized in "Jewish-comedic" puns with barely disguised political messages. Since late 1933, the three occupational organizations representing such cabaret artists had been *Fachverbände* in the Theater Chamber. After these organizations had failed to act against the satirists, Hinkel arranged for the Gestapo to disband them in July 1935. Several of the satirists, including Finck, were dispatched to concentration camps.[19] "Investigations into several old associations," Hinkel claimed, "have revealed intentional or unintentional sabotage of the measures and expressed goals of the National Socialist state."[20] In addition to political heresy, Hinkel also suspected the cabaret associations of massive financial corruption.[21]

By mid-1935 Goebbels had also grown highly displeased by what he considered to be the failure of the Bühnengenossenschaft and the Bühnen-

Verein to dispense with the "interest association" mentalities that they had inherited from their Weimar days.[22] Goebbels and Theater Chamber president Laubinger were particularly critical of theater managements, represented by the Bühnen-Verein, whom they accused of seizing upon the creation of the Theater Chamber as a pretext for ignoring the complaints and suggestions of employees.[23] Furthermore, both the Bühnen-Verein and the Bühnengenossenschaft were criticized for failing to cooperate with a program to promote the employment of NSDAP old fighters.[24] Bühnennachweis, the official theater employment agency, was said to be pervaded with staff members who were politically "intolerable," "non-Aryan," and "related to Jews."[25]

A fundamental reorganization of the Theater Chamber occurred in September, an opportunity having been created by the death of chamber president Laubinger after a protracted illness. Goebbels turned to Rainer Schlösser to fill Laubinger's position. If Goebbels intended to signal that he would tolerate no further insubordination in the chamber, he could not have made a more appropriate choice. Head of the Propaganda Ministry's theater department, former culture-political editor at the *Völkischer Beobachter*, and member number 772,091 of the NSDAP, Schlösser had been active in *völkisch* politics since 1924.[26] Schlösser joined Albert Eduard Frauenfeld, an Austrian Nazi old fighter (NSDAP party number 115,114) who had recently been appointed executive director of the chamber.[27] In September 1935, Schlösser, Hinkel, and Frauenfeld engineered the formal dissolutions of both the Bühnen-Verein and the Bühnengenossenschaft. The memberships and financial assets of both organizations were transferred to a new entity, the Fachschaft Bühne, which would be directed much more closely by the political overseers in the Kulturkammer central office and in the Propaganda Ministry. To assure conformity between the chamber and the Propaganda Ministry's theater department, Schlösser would hold both positions in personal union. (In 1938, Ludwig Körner replaced Schlösser at the Theater Chamber, although Schlösser retained his powerful Propaganda Ministry position.) Justifying these extreme measures, Hans Hinkel somberly lectured a group of theater officials that the regime had shown great "humanity" in granting members of the theater profession "every chance" to demonstrate that their conduct was conducive to a National Socialist culture. After two years, however, the conduct of many had proved unsatisfactory.[28]

The creation of the Fachschaft Bühne paralleled structural reforms instituted throughout the Kulturkammer in 1935. Most of the existing *Fachverbände* were dissolved as legally autonomous entities; their members and assets were simultaneously transferred to chamber subunits designated as

specialty branches (*Fachschaften*), which were in turn subdivided into specialty groups (*Fachgruppen*.) The *Fachschaften* were not organizational entities in their own right but were rather, as their name implied, branches of centrally administered chambers. This metamorphosis in the legal status of the associations was accompanied by a similar transformation of their financial positions. Whereas the old *Fachverbände* had retained financial autonomy, the new *Fachschaften*, aside from a few exceptions, were merely components of financially unified chambers.[29] Thus, the notion of autonomous professional advocacy and representation implicit in the term *Verband* was eliminated along with its most visible organizational accoutrements.

The ostensible basis for the procedure was Paragraph 25 of the First Implementation Decree for the Kulturkammer, according to which the Kulturkammer possessed the right to issue orders regulating "important questions" of the commercial aspects of cultural life. Even in view of the considerable elasticity with which such clauses tended to be interpreted during the Nazi regime, the Kulturkammer legislation was by itself clearly insufficient to dissolve legitimate organizations. Therefore, additional legal foundations for the measures were sought and found in the charters of the old associations. For example, the Bühnengenossenschaft was dissolved in September 1935 on the basis not only of Paragraph 25 of the First Implementation Decree but also of Paragraph 19 of its own charter.[30]

This process provided yet another illustration of the Nazi penchant for adhering to the letter of the law while tossing its spirit out the window. On the propaganda front it proved advantageous to maintain a facade of legality, but there were also good practical reasons for resorting to these cumbersome procedures. The political and ideological revolution underway in Germany had not been extended to the sphere of German "private law" (*Privatrecht*), which governed procedure for most of the associations. The law required a formal dissolution process, which could have included a complex financial liquidation procedure even in cases where direct successor organizations existed. The individuals responsible for executing the dissolution of the *Verbände* were keenly aware of these legal requirements and devoted considerable energy to their fulfillment or effective circumvention.[31] In most cases the transformation of *Fachverbände* into *Fachschaften* transpired with few difficulties and little discernible resistance.[32]

The transformation of the chamber system did not end in 1935. The year 1936 saw a change in the leadership of the Visual Arts Chamber. President Eugen Hönig had long been under attack for granting too much latitude to supposedly degenerate elements in his chamber. Hönig had refused to take action against a small group of young National Socialists who had been championing the art of Emil Nolde, Ernst Barlach, and several other expres-

sionists. Hoping to "nationalize the avant garde," these Nazis had sponsored exhibitions and published a journal, *Kunst der Nation*. Whereas the flexible Goebbels defended their actions, at times even praising the revolutionary qualities of expressionism, the fanatical antimodernists around Rosenberg viciously attacked such permissiveness.[33]

It was in the context of this struggle over expressionism between Rosenberg and Goebbels that Visual Arts Chamber president Hönig came under vicious attack from Nazi ideological hard-liners in the art world. As early as December 1933, architect Paul Ludwig Troost, a favorite of Hitler's, had unleashed an anti-Hönig campaign. Troost and his allies alleged that Hönig had cooperated with the Marxist Eisner regime in Bavaria in 1919; had been a late and unenthusiastic convert to National Socialism (Hönig joined in 1933 with party number 1,200,305); had failed to enlist reliable Nazis as functionaries in his chamber; and had permitted new Jewish members into the chamber in late 1933 because the First Implementation Decree contained no "Aryan paragraph." An investigation conducted by the NSDAP in early 1934 cleared Hönig of the most serious accusations, although it did conclude that in admitting the new Jewish members Hönig had failed to live up to his National Socialist responsibility. To his credit, however, Hönig had "revised his position on the Jewish question" once Goebbels had expressed his displeasure. Having been cleared by the NSDAP in March 1934, Hönig received a strong endorsement from Goebbels, who took the offensive by demanding an investigation of Hönig's accusers.[34]

Despite the formal vindication of Hönig, the controversy over the Visual Arts Chamber's permissiveness ultimately forced Goebbels's hand. In September 1934, while speaking at the Nazi party congress, Hitler signaled that he did not consider expressionism to be consistent with the spirit of the Nazi regime. Goebbels acted accordingly. At the beginning of 1935, *Kunst der Nation* was suppressed. In April 1935, Goebbels charged the Visual Arts Chamber with the responsibility for approving all art exhibitions at private galleries.[35] Later in 1935, Hönig dutifully supervised the purge of Jewish members from his chamber. Like Goebbels, Hönig demonstrated that he could make major tactical adjustments to shore up the chamber's position. Nonetheless, Hönig had already made too many enemies, and his relaxed management style continued to generate problems for the chamber and for Goebbels. In July 1935, for example, the SS publication *Schwarze Korps* noted that a plaque inscribed with the names of prominent Jewish benefactors still adorned an entryway wall at the office of the Berlin Association of Artists (Verein Berliner Künstler). Not coincidentally, *Schwarze Korps* noted, Verein chairman Karl Langhammer was a "high-grade Freemason" whose first wife had been Jewish. Goebbels was compelled to order Lang-

hammer's dismissal.[36] By late 1935, after a succession of such minor scandals, Goebbels had come to recognize that although Hönig's heart was in the right place, he lacked the necessary leadership qualities.[37] The specific circumstances of Hönig's resignation remain obscure, but it is certain that Goebbels had decided to replace Hönig with a figure whose National Socialist credentials were more unassailable. The relatively late date of Hönig's "retirement" from the chamber, November 1936, may well be attributable to Goebbels's desire to avoid any connection between Hönig's departure and the embarrassing events in the Music and Theater Chambers during the previous year.

Hönig's successor, painter Adolf Ziegler, had been an obscure artist before 1933. A holder of the NSDAP's gold honor badge, Ziegler's connections to the movement reached back to the 1920s (party number 112,824). After having served the party as a cultural specialist, he accepted a teaching post at Munich's Academy for the Visual Arts in 1933.[38] In 1935, Ziegler led a campaign against degenerate art in the museums and galleries of Munich. During the Third Reich, Ziegler came to be celebrated for his idealized depictions of nude figures; supposedly he was known to some as the "master of German pubic hair."[39] Ziegler's appointment to the presidency of the Visual Arts Chamber marked the culmination of the Reichskulturkammer's institutional transformation and was the clearest signal of the regime's growing intolerance for nonconformity in the arts. Ziegler took his first, and most notorious, major action as president of the chamber in 1937: the massive purge of German museum collections and the subsequent staging of the huge "Degenerate Art" exhibition in Munich.

The Kulturkammer, then, had undergone a metamorphosis from a fairly loose confederation of nazified associations into a more highly centralized organ of the state. In the process, it had implemented the purification that its critics had been demanding. In April 1936 Hans Hinkel declared that the Kulturkammer had "put the stage of organization by and large behind itself." Referring to the personnel changes and to the systematic purge of Jews from the ranks of the chamber memberships in 1935, Hinkel added that the "cultural life of our nation is liberated from countless Jews and art Bolsheviks."[40]

The transformation of the chambers in 1935 and 1936 must be seen in part as Goebbels's response to what he regarded as an unsatisfactory unfolding of the neocorporatist experiment in his own domain. The autonomy he had granted to the art world had been, in his estimation, abused. Pressure from Rosenberg and other dogmatic Nazis had further narrowed his room for maneuver. Yet Goebbels's response to these pressures must also be

understood in the broader context of the general radicalization of the Nazi regime in the mid-1930s. Having consolidated their position of control, Nazi leaders no longer needed to practice the relative moderation and compromise tactics of the early years. During the two years after the death of President Paul von Hindenburg in August 1934, the Nazi regime's record represented a major thrust toward the realization of National Socialist ideological goals in many areas of policy. Immediately after Hindenburg's death, Hitler assumed the powers of the presidency, took the title of Führer, and demanded an oath of personal allegiance from the armed forces. In September 1934, Hitler issued his denunciation of expressionist art; the suppression of *Kunst der Nation* followed several months later. In March 1935, Germany began openly to rearm and introduced conscription. In May, Goebbels called Hinkel into the Kulturkammer to take charge of the impending shakeup. Richard Strauss was forced out of the Music Chamber in July. In the summer and fall of 1935, the chambers expelled their Jewish members. The Nuremberg racial laws of autumn 1935 provided the legal framework for all future actions against persons with "Jewish blood." In March 1936 Germany unilaterally broke the Locarno Treaty with the remilitarization of the Rhineland. In June 1936, Heinrich Himmler received complete control over the German police system. Hitler's August 1936 memorandum on the Four-Year Plan directed Germany's military and economic elite to prepare for a war of conquest. In November, Ziegler replaced Hönig at the Visual Arts Chamber. Thus, the developments in the Reichskulturkammer clearly fit the broader pattern. Having relied on a neocorporatist strategy during the period of National Socialist consolidation, by late 1936 the regime enjoyed a position strong enough for a far more intrusive official control of the arts.

Administrative Centralization, 1935–1941

After 1935, Goebbels tended more and more to distinguish between professional, economic, and social concerns (*Betreuung*) on the one hand and political matters, including censorship, on the other. Whereas responsibility for *Betreuung* would remain for the most part with the chambers (subject to Propaganda Ministry oversight, to be sure), major ideological and political decisions would remain the preserve of the ministry, although implementation of ministerial decisions would be entrusted to the chambers.[41] To ensure chamber adherence to the ideological, political, and economic priorities of the regime, beginning in 1935 the Propaganda Ministry increasingly superimposed itself onto the bureaucracies of the chambers.

This occurred both centrally, in Berlin, and regionally, through a framework of offices established in districts, cities, theaters, neighborhoods, towns, and villages.

As the regional and local organs of the chambers evolved after 1935, their structure and composition increasingly reflected the subordination of professional autonomy to state authority. This subordination was accomplished in part by means of the "personal union," a bureaucratic device to which the Nazis resorted frequently during their years in power. The triple role played by Joseph Goebbels as head of the Reich Propaganda Leadership (party), Propaganda Ministry (state), and Kulturkammer (professional corporation) represented one such application of the "personal union" concept. When the time came to extend the chamber bureaucracy into the provinces, Goebbels logically employed a similar mechanism. On 14 November 1934, Goebbels created a network of regional culture administrators (Landeskulturwalter)[42] in personal union with the already existing Landesstellenleiter of the Propaganda Ministry;[43] these offices had already been created in personal union with the Gaupropagandaleiter of the NSDAP. Therefore each Landeskulturwalter, in effect a miniature Goebbels, embodied the joint leadership of party organization, state agency, and professional corporation.[44] The chief responsibility of the Landeskulturwalter was to "provide for a consistent National Socialist cultural policy" in their regions. They were subordinate "exclusively to the president of the Reichskulturkammer," not to the presidents of the individual chambers.[45] As a consequence of the new network, a cadre of loyal party members—in many cases old fighters—was infused into the Kulturkammer command structure on the regional level. Of the thirty-five Landeskulturwalter in 1939, thirteen had joined the party before 1933.[46]

Within each region, affairs of the individual chambers were entrusted to regional leaders (Landesleiter), the vast majority of whom were appointed after 1935.[47] These officials acted as conduits of information, connecting the leaders of the individual chambers in Berlin with the general membership. The chamber headquarters in Berlin usually passed orders and regulations down to the memberships via the Landesleiter. Conversely, members and prospective members needing to conduct business with the individual chambers worked through the Landesleiter. All applications for membership were first submitted to the Landesleiter, who after confirming the inclusion of all necessary documents, such as a complete résumé and evidence of Aryan ancestry (Ariernachweis), would pass the application on to Berlin. Where it was important to assess occupational credentials, the Landesleiter were responsible for the evaluation of qualifications. Although final decisions on membership would be made in Berlin, the Landesleiter

could influence the outcomes through positive or negative political or professional recommendations.

A further set of responsibilities charged to the Landesleiter fell under the general rubric of professional counseling. The Landesleiter, who kept themselves abreast of regional and local market conditions, served as sources of information about jobs for unemployed or underemployed members. The Landesleiter provided or arranged for mediation or legal counseling in cases where members had professional grievances. They also represented their professions in dealings with local civil and party authorities over matters such as job creation and the awarding of prizes, stipends, and subventions. An additional responsibility was the coordination of special cultural events and festivals, such as the "Day of German House Music." To ensure that professional expertise was brought to bear on the regional implementation of chamber policies, and to guarantee representation to the broad spectrum of professional groups encompassed by each chamber, each regional leader presided over a small council of representatives from the various specialty branches within his chamber. Finally, the Landesleiter performed a monitoring and enforcement function. They ensured compliance with the myriad of professional, economic, and political measures promulgated by the chambers and, if necessary, initiated disciplinary proceedings against violators. The Landesleiter could not themselves expel members from the chambers but could recommend such action to the chamber leaders in Berlin. One responsibility related to enforcement was the processing of applications for exemption from chamber ordinances.

"Thoroughgoing professional knowledge" and an "absolutely reliable National Socialist attitude," in the words of Hans Hinkel, were the main qualifications for the Landesleiter position.[48] Landesleiter received their appointments only after the conclusion of thorough background investigations and, beginning in 1938, the approval of the pertinent NSDAP Gauleiter.[49] A high proportion of the Landesleiter cadre did indeed consist of pre-1933 NSDAP members. Among the 35 Visual Arts Chamber Landesleiter in 1937, for example, at least 19 were old fighters, while of the 35 Music Chamber Landesleiter, at least 14 were old fighters.[50] As wartime conscription caused a high rate of turnover among the Landesleiter, political affiliation remained a key criterion for selection. Between 1939 and 1944, 21 of 25 new Visual Arts Chamber Landesleiter were NSDAP members. For the Music Chamber, the figures were 8 of 13, and for the Theater Chamber, 23 of 26.[51] Moreover, a high percentage of the staff members in each Landesleitung had NSDAP membership.[52] Thus the apparatus of artistic administration remained overwhelmingly in the hands of party members.

In Berlin, organizational developments unfolded parallel to those in the

regional offices after 1935, as the Propaganda Ministry expanded its political oversight of the chambers' main offices. The chief agents of this oversight were the three Reichskulturwalter—Schmidt-Leonhardt, Moraller, and Hinkel—in the central office of the Reichskulturkammer. Between 1935 and 1939, the central office staff tripled in size, growing from eleven to thirty-two, while its budget grew from RM 28,000 to almost RM 3 million.[53] There were no pretensions about the nature of the Reichskulturkammer central office: it was a political rather than a professional agency. Whereas the leaderships of the individual culture chambers led an ambiguous existence, on the one hand representing artists with respect to the state, and on the other hand transmitting the will of the state to artists, the role of the central office, as "the direct organ of the minister,"[54] was clearly that of political monitor and enforcer.

Theoretically, the triumvirate of Kulturwalter were of equal rank, with each carrying out specific sets of tasks. Schmidt-Leonhardt, a Propaganda Ministry legal expert, supervised the drafting of regulations and dealt with other legal questions. Hinkel, who had been brought in to implement the 1935 purge and shakeup, dominated policy toward non-Aryans and other suspect groups. Shortly after Goebbels had appointed Hinkel to the Kulturwalter position in 1935, he also chose Hinkel to supervise the operations of the Reich Association of Jewish Culture Leagues (Reichsverband der jüdischen Kulturbünde in Deutschland), an umbrella agency for the officially sanctioned Jewish artistic associations that had arisen as a consequence of the purge of many Jews from theaters and orchestras between 1933 and 1935. Hinkel had been instrumental in the creation and monitoring of these associations while still a commissar in the Rust ministry.

Unlike Hinkel, Franz Moraller did not preside over a clearly delineated sphere of responsibility. Consequently, the aggressive Hinkel gradually expanded his own influence at Moraller's expense. Goebbels regarded Moraller as an ineffective administrator, whereas he highly valued Hinkel's capacity for hard work. But the minister was also wary of Hinkel's ambition, describing Hinkel at one point as a "born intriguer and liar."[55] Nevertheless, Hinkel's power continued to expand. In April 1941 Goebbels ordered a new set of major reforms in order to create a "more unified and efficient" administration in the Kulturkammer.[56] This move marked Hinkel's ascension to unchallenged supremacy in the day-to-day management of Kulturkammer affairs. Hinkel received the new title of general secretary of the Kulturkammer; he would remain its chief official until the demise of the Third Reich. In May 1944 Goebbels elevated Hinkel to the vice-presidency of the Reichskulturkammer.[57]

A look at Hinkel's immediate staff in 1941 dramatically illustrates the

political character of the Kulturkammer central office. Walter Owens, in charge of "professional estate affairs," had served with a Free Corps paramilitary unit in 1919–20, had joined the NSDAP in 1930, and had trained as an engineer and aircraft mechanic.[58] Erich Kochanowski, chief of the propaganda department, had joined the party in 1931 after having studied history at the university level.[59] Helmuth von Loebell, head of the cultural personalities department, which kept files on Kulturkammer members and conducted political and racial background investigations, had joined the NSDAP and the SS in 1932. His career training had been in agriculture.[60] Gerhard Noatzke, a specialist for Jewish and economic affairs, had joined the NSDAP in 1925.[61] Even Hinkel's secretary, Ursula Framm, was an old fighter from 1930, having joined while an employee at the *Völkischer Beobachter*.[62] Like Hinkel himself, these individuals were NSDAP loyalists who had joined the movement during the "time of struggle." None had professional experience in the arts; in fact, the available biographical information shows a remarkable absence of any experience, much less expertise, in artistic matters.

Moreover, Hinkel's entire staff, with the exception of Ursula Framm, were members of the SS. This concentration of SS members was by no means coincidental. As a party careerist and old fighter, Hinkel took great pride in his own SS affiliation, which began in 1935.[63] Hinkel persistently sought SS commissions and promotions for his existing staff members,[64] and when positions came open in the Kulturkammer central office Hinkel sometimes asked the SS to supply the appropriate personnel.[65] He also kept SS officials informed about personalities and bureaucratic machinations within the Kulturkammer.[66] Hinkel's close ties with the SS, while undoubtedly shrewd from a careerist point of view, also reflected his and his staff's high degree of ideological commitment. Moreover, the SS connection helped Hinkel's office establish a smooth working relationship with the Reich's secret police apparatus, which by 1939 had become almost totally subsumed under the SS. This relationship enabled the Kulturkammer to depend on the investigative resources of the SS, especially those of the Security Service (SD), to investigate the backgrounds and activities of Kulturkammer members and applicants.[67]

The Struggle for Control over Civil Servants

During the 22 September 1933 meeting at which the Reich cabinet had approved the Chamber of Culture Law, several ministers had predicted that the creation of such a huge and all-encompassing an organization as the

Kulturkammer would inevitably lead to clashes over jurisdiction. Over the following years, these predictions proved to be sound. In 1934 and 1935, a conflict between Joseph Goebbels and Bernhard Rust focused on jurisdiction over several categories of civil servants. Later, Goebbels, Robert Ley, and Alfred Rosenberg engaged in a complicated and protracted struggle over how best to organize the arts and entertainment for the masses.

The professional groups at issue in this conflict comprised professors and other instructors employed by art, music, and architecture faculties at arts academies and other state educational institutions; architects in the civil service (usually referred to as *Baubeamte*); and personnel employed at state museums. The incorporation of these civil servants into the Reichskulturkammer had not been mentioned explicitly either in the Reichskulturkammer Law or in the First Implementation Decree. The omission had probably been intentional on Goebbels's part, designed to minimize objections from Rust and the cultural ministers of the other German states during the earliest stages of the Reichskulturkammer's development. However, Goebbels could not have expected Rust to remain complacent while the latter's powers were usurped by the Propaganda Ministry. Nor could Goebbels have believed that the cultural authorities in the German states outside of Prussia, although largely under Nazi control by late 1933, would readily accede to the centralization of power in the Propaganda Ministry and the corresponding reduction of regional autonomy.

In fact, the evidence indicates that it was not Rust's Prussian Cultural Ministry but rather the government of Bavaria that first expressed suspicions about the potential impact of the nascent Reichskulturkammer on civil servants. In November 1933 the Bavarian Cultural Ministry demanded from Goebbels a guarantee that employees of municipal and state cultural institutions would be exempted from Reichskulturkammer jurisdiction.[68] That Bavaria could count on the support of, ironically, the Prussian Cultural Ministry became clear in early December, when Rust ordered civil servants under his own jurisdiction to refrain from joining the Literature Chamber. Rust's order also forced his civil servants who had already reported to the Literature Chamber to withdraw their memberships or applications.[69] Early in January 1934 Rust expanded his order, forbidding membership by his civil servants in any of the culture chambers.[70] Resistance to Kulturkammer encroachment into the jurisdictions of the state cultural ministries intensified in December 1933 and January 1934, when the governments of Baden, Saxony, Württemburg, and Hesse registered protests with the Propaganda Ministry.[71] The Reich Ministry of the Interior, which theoretically exercised control over civil service personnel policy at the national level, supported Rust and the other state cultural ministers.[72]

The Propaganda Ministry and the chambers countered with a series of orders instructing civil servants to file applications for membership. The Visual Arts Chamber informed the state governments that no distinction between free architects and those in public service would be made for purposes of membership in the chamber; all architects were obliged to join.[73] Similarly, Music Chamber proclamations on membership policy issued in 1934 allowed no exceptions for civil servants.[74] The Literature Chamber went to the furthest extreme, stipulating membership for all civil servants who "in the practice of their professions, or extraprofessionally, regularly engage in literary activity," a condition that could have been interpreted to include the vast majority of German professors and other academics.[75]

For their part, the civil servants found themselves caught between the conflicting agencies. In January 1934, Heinrich Besseler, a professor of music in Heidelberg, telephoned the Baden Culture Ministry in Karlsruhe to ask whether he should follow Rust's order instructing civil servants to withdraw from the Reichskulturkammer. The Culture Ministry officials assured Besseler that Rust's order did indeed apply in Baden as well as in Prussia. Besseler thereupon withdrew from the Music Chamber. A short time later the Music Chamber office in Heidelberg informed Besseler that Rust's order pertained only to Prussia; therefore, Besseler would have to reapply to the Music Chamber. In March 1934 the Music Chamber officials in Heidelberg ordered Besseler to appear before them in person in order to explain why he had not yet submitted his application.[76] Similarly, local Music Chamber authorities in Karlsruhe informed Hugo Rahner, a state-employed music teacher, that any objections by the Baden Cultural Ministry to Reichskulturkammer policies were "unimportant." They based this position on the contention that the Reichskulturkammer Law, as a law applicable to the entire Reich, took precedence over all provincial regulations.[77] In another case, the Bavarian State Academy of Music in Munich dismissed one of its instructors, Raimund Schmidpeter, in January 1934 on grounds of "substandard artistic performance." Schmidpeter thereupon turned to the Music Chamber, requesting that it review his case. The Music Chamber central office in Berlin contacted the Music Academy in Munich in search of more information. The Music Academy, however, refused to respond to the Music Chamber's inquiries, claiming that Schmidpeter's dismissal had been strictly a "matter of the state service." The Bavarian Culture Ministry supported the Academy's position, asserting in a letter to the Propaganda Ministry that "state authority must stand above the interest of all individual professions."[78]

Uncertainty about the chambers' jurisdiction affected state and municipal

museums as well. In early 1935 a number of museums received word from the Visual Arts Chamber that museum personnel would be expected to apply for membership.[79] Resentful of the chamber's intention to intervene in museum matters from Berlin, museum officials turned to their state governments for help.[80] Appeals from several states made their way to Rust's ministry in Berlin, which served as a rallying point for resistance to the Reichskulturkammer. On behalf of the states, Rust informed Goebbels that the Visual Arts Chamber had "overstepped" its jurisdiction. Rust coupled his objection with a more serious measure: he instructed all museums simply to ignore all inquiries from the Visual Arts Chamber.[81]

In search of a way out of this messy conflict, the Propaganda Ministry and the Prussian Culture Ministry opened negotiations in 1934. The Propaganda Ministry's case rested on two items of Reich legislation.[82] First, by virtue of the Reichskulturkammer Law of September 1933, the propaganda minister had been empowered to supervise "professional estate construction" in the arts. Second, all jurisdiction in cultural affairs rested not with the states but with the Reich government, an assertion grounded in the "Reich reform" of January 1934.[83] Taken together, these laws endowed the Propaganda Ministry with a legal mandate to organize all professional artists, including those employed by the states, within the Chamber of Culture. The Propaganda Ministry also maintained that it was acting in the best interests of the artists. The civil servants had to be included, it claimed, if a "coherent organization of the cultural-professional estate is to be implemented." Often, as with music and art teachers, the civil servants constituted the "most valuable" segment of the professions. Without them the chamber would be only the "torso" of a true professional estate. The Music and Visual Arts Chambers regarded control over state training academies as essential to their efforts to combat professional overcrowding. "Every day, more and more artistic proletariat is produced," Visual Arts president Eugen Hönig complained in February 1936. In the future, "at least 50 percent of all students of the visual arts must be held back," either by closing down existing schools or by severely restricting admission of students.[84]

Rust, for his part, insisted on maintaining an absolute distinction between the jurisdiction of the Reichskulturkammer and the "sovereignty of [the] state."[85] He argued that civil servants should not be accountable to two authorities at the same time; such a situation would lead to an "obscuring of clear responsibility and to frictions that would be injurious to the maintenance of an orderly administration." State cultural ministers, not the Propaganda Ministry, should decide whether their own civil servants should be

permitted or obliged to join the Reichskulturkammer; Rust added that he had no objections should his own civil servants choose to join the Reichskulturkammer as a completely voluntary matter. Rust again invoked the support of the Interior Ministry, which had adopted the position that the appropriate professional corporation for civil servants, regardless of specialty, was the Reichsbund der deutschen Beamten, and which in June 1934 instructed municipal authorities to obey Reichskulturkammer ordinances only when they were "unobjectionable."[86]

The Reich Theater Law, promulgated in May 1934, demonstrated that a middle ground could indeed exist between these divergent positions.[87] The Theater Law granted the Propaganda Ministry wide-ranging powers over personnel and artistic matters in both private and state-supported theaters. Goebbels's original draft for the law had contained no provision for a special status for civil servants. Not unexpectedly, both Rust and the Interior Ministry raised severe objections to this omission.[88] The version of the law ultimately approved by Hitler contained a clause requiring the Propaganda Ministry to receive approval from state or municipal authorities before taking disciplinary action against theater employees who were civil servants.

At the same time, the Theater Law reflected the ever-increasing power of the Propaganda Ministry over artistic matters. Goebbels now seemed less interested in compromise. Officials in the Propaganda Ministry formulated a proposal to transfer authority over all state music and art academies to the Propaganda Ministry. According to this plan, the "appointment, removal, promotion, and retirement of civil servants of the cultural administration by the state governments" would "require the permission" of the Propaganda Ministry.[89] Notably, on 1 June Rust was redesignated as Reich Minister of Education and Science; conspicuously absent from his new title was the word "culture."

Goebbels and Rust presented their respective cases at a 19 July 1934 meeting attended by Hitler, Deputy Führer Rudolf Hess, Interior Minister Wilhelm Frick, and other officials of this highest echelon.[90] Significantly, the issue of jurisdiction in cultural affairs was the sole topic for discussion. Although neither Goebbels nor Rust seemed to budge from their positions, Hitler refrained from decisive intervention. Observing that "the solution of the problem will not be easy," Hitler suggested that the Propaganda Ministry be given charge of responsibilities "embodying a positive artistic will," while authority in purely "scientific" areas would remain with Rust's Education Ministry. Although the Führer himself had little of substance to offer as to where or how the line between "artistic" and "scientific" could be drawn, the conference managed to produce a set of detailed recommenda-

tions for a practical delineation of jurisdiction. Implementation of the agreement, however, led to renewed bickering,[91] which Hitler noted but failed to stop.[92]

In the absence of a definitive decision by Hitler, the clash between Rust and Goebbels over control of art institutions and their personnel was never resolved in any comprehensive manner.[93] For a time, local confusion continued to result from the mixed signals emanating from Berlin. A particularly striking example of the now-familiar pattern occurred in late 1936, pitting Rust against the Visual Arts Chamber. On 29 August the chamber issued a proclamation instructing all "institutions of the visual arts" and their employees to apply for membership. The all-embracing scope of the proclamation was clear and explicit: it made no difference whether "a single individual, a society, an association or foundation[,] . . . a state agency, [or] a municipal agency" was involved. All were obligated to report to the chamber by 1 October 1936.[94] Rust responded with a circular letter to institutions under his jurisdiction, rejecting the chamber's claim to authority over state art institutions.[95] A few days later the Visual Arts Chamber raised the stakes, decreeing that its approval was mandatory for the establishment of new educational institutions for the visual arts.[96] Rust, in turn, simply rejected the applicability of the measure to state institutions.[97]

Exchanges of this nature reflect the absence of a comprehensive jurisdictional settlement between Goebbels and Rust; however, complete chaos was avoided by means of a series of improvised and limited solutions. Negotiations between individual culture chambers and state governments produced workable compromises. In late 1935, for example, the Bavarian government decided to permit, although not to *force*, state-employed architects to join the Visual Arts Chamber. Baden followed Bavaria's example, yet the government of Württemburg continued to insist on the exclusion of such architects from the chamber, at least until a uniform national policy could be instituted.[98]

By the outbreak of war in 1939 most questions of civil service membership in the Chamber of Culture had been resolved through some form of ad hoc arrangement, even though the fundamental dispute over principles between Goebbels and Rust continued. In the field of theater, the Theater Law of 1934 and a subsequent implementation decree[99] limited the Theater Chamber's disciplinary power over state employees, who constituted the vast majority of theater personnel in Germany. The Theater Chamber would nonetheless serve as the obligatory professional corporation for state-employed personnel. A similar dualism prevailed in music, as musicians and music instructors in public service were organized into special branches within the Music Chamber.[100] Likewise, by July 1936 it had been

agreed that all German architects should constitute a "unified professional estate." Architects in public service, however, were organized in a branch of the Visual Arts Chamber separate from that for free architects.[101] By virtue of a 1936 arrangement between the Visual Arts Chamber and the Education Ministry, instructors at visual arts academies required chamber membership, whereas art instructors in lower schools did not. Importantly, the Visual Arts Chamber failed to extend chamber control over art museum directors and personnel.[102] (In 1937, Visual Arts Chamber president Adolf Ziegler had to rely directly on Hitler's personal authority to carry out the purge of degenerate art from German museum collections.) Finally, membership policy for the Literature Chamber, the cultural corporation with the widest potential scope, embodied a fundamental distinction between literature for the general public and "purely scientific works," thus freeing most German scholars from the obligation to join the chamber.[103] In view of these arrangements, the Rust-Goebbels dispute over competency in cultural affairs should not obscure the genuine, albeit fragmented and improvised, stability actually achieved in the question of civil servants' membership in the Chamber of Culture.

The Struggle over Amateur Artists and Audiences

Although the Reich Chamber of Culture concerned itself mainly with the activities of professionals, it became involved in a series of controversies over control of amateur cultural organizations as well. The entire spectrum of amateur groups, from reading and lecture clubs to post office bands, had been "coordinated" in one way or another after January 1933. The potential for jurisdictional conflict in this arena was great, however, as no comprehensive plan for the long-term regulation of amateur groups had been approved at the party's highest levels either before or after the seizure of power. Two cases presented special problems: amateur choral and singing societies, and so-called theatergoers' organizations. The Reichskulturkammer, Alfred Rosenberg's NSKG, and Robert Ley's Strength through Joy group (KdF) all maneuvered to exercise influence over these organizations.

The Music Chamber had secured control of the choral societies in April 1934.[104] However, the chamber had not accomplished this takeover without some interference from Rosenberg, who protested that the incorporation of amateurs into the Reichskulturkammer contradicted the concept of "professional estate construction."[105] Rosenberg pointed out that the Music Chamber sought only the dues payments from the amateur singers. The eight pfennigs received annually by the Music Chamber from one million ama-

teurs, he pointed out, totaled RM 80,000 per year.[106] Rosenberg's observation had indeed been valid; the Music Chamber, a corporation of professionals, intended to finance its operations partially on the basis of compulsory contributions from amateurs.

The theatergoers' organizations served essentially as means for mass theater subscriptions at substantial discounts. In 1933, the Kampfbund had coordinated the two largest such organizations, the Verband der freien Volksbühne and the Bühnenvolksbund, which were later merged into the Deutsche Bühne, a newly formed organization under Rosenberg. In early 1934, Rosenberg and Ley arrived at an agreement whereby the Deutsche Bühne became a "corporative member" of Ley's KdF, a major sponsor of entertainment events. Like the Deutsche Bühne, the KdF arranged for discounted, mass-subscription theater and concert tickets for DAF members.[107]

This alliance gradually fell victim to squabbling between Rosenberg and Ley over management of the Deutsche Bühne. Increasingly alienated from Ley, Rosenberg sought a better arrangement with Goebbels, who just a couple of years earlier had been the target of Rosenberg's severe criticism. In the summer of 1936, Rosenberg and Goebbels initiated discussions about the prospect of creating an "eighth chamber" in the Kulturkammer.[108] Rosenberg intended to combine the Deutsche Bühne with amateur art organizations already under Reichskulturkammer oversight, such as the choral societies, into a new "Reichskammer für Kultur- und Volkstumspflege." According to Rosenberg's proposal, a new Reich Culture Office, under his own leadership, would be created within the NSDAP. The bureaucracy of the new chamber would exist in personal union with that of Rosenberg's new office. The president of the new chamber would be chosen by a joint Goebbels-Rosenberg agreement, although Rosenberg already had his assistant Walter Stang in mind for this job.[109]

The propaganda minister was genuinely pleased at the prospect of a rapprochement with Rosenberg, but he could not repress his deeply rooted suspicions of his old nemesis.[110] The three Reichskulturwalter—Hinkel, Moraller, and Schmidt-Leonhardt—reinforced Goebbels's doubts. "Frictions and struggles with the Reichskulturkammer would be unavoidable," they argued; the new chamber would grant nonprofessionals undue influence in the cultural life of the nation and cause major disruptions in the operations of the professional chambers.[111] Nonetheless, the prospect of a mass cultural organization for amateurs in the form of an eighth chamber remained attractive to Goebbels. It would greatly simplify the task of regulating the artistic marketplace, in addition to increasing the size of Goebbels's ministerial empire. If a merger of the Reichskulturkammer and Rosenberg's Deutsche Bühne was not feasible, an alliance between the

Kulturkammer and Ley's KdF soon emerged as a practical alternative. Such an arrangement made good economic sense: the Kulturkammer constituted a cartel of culture producers, whereas the KdF had already established itself as, in effect, Germany's largest cultural consumer cooperative. The vast entertainment programs sponsored by KdF served as a valuable source of work creation for Reichskulturkammer members. In turn, Ley wanted to secure a guaranteed reduced-fee participation of Kulturkammer members in KdF entertainment functions.[112] By late 1936, clear signs of a Goebbels-Ley alliance had emerged. In November, much to Rosenberg's dismay, the Reichskulturkammer and KdF held a joint annual meeting.[113]

Aside from its economic purpose, this arrangement also possessed symbolic value. During the Weimar era, Nazi cultural propaganda had bemoaned the alienation of the German masses from a German artistic establishment enamored of modernism and experimentation. A Kulturkammer-KdF alliance would represent a return of art to the people. It would reflect a new "unity between artist and people," embodying the "living connection of our new artistic life with the broadest layers of our awakening *Volk*."[114]

It was not until 1939 that Ley formally proposed designating the KdF as a new culture chamber. Goebbels approved of the plan in principle, despite serious concerns over the details of implementation.[115] Predictably, Rosenberg voiced objections to the transformation of the KdF into a Reichskulturkammer chamber, charging that it would violate the Reichskulturkammer Law by integrating nonprofessionals into a professional corporation (although his own proposal in 1936 had been essentially identical).[116] If opposition to the plan had been limited to Rosenberg, the Reichskulturkammer-KdF merger would perhaps have become reality. But opposition extended far beyond Rosenberg. Hans Hinkel feared that the Kulturkammer-KdF union would erode Propaganda Ministry influence over artistic affairs.[117] The presidents of the individual culture chambers, unconvinced of the economic logic of a cultural producer-consumer alliance, expressed anxiety about their own autonomy.[118] Perhaps most importantly, Rudolf Hess took exception to the merger,[119] as did Martin Bormann,[120] Hess's successor as the major arbiter in such controversies. Hess and Bormann were undoubtedly apprehensive about concentrating too much authority in Goebbels's domain—a sentiment that must have been reinforced by the continuous stream of complaints and warnings they were receiving from Rosenberg.[121] The two men probably also felt some hesitation to antagonize Rosenberg further by blessing a Goebbels-Ley alliance in the form of a new chamber. Although Rosenberg was often a nuisance from the chancellery's perspective, he remained a prominent Nazi figure who could not be ignored.

Despite the breakdown of plans for a formal Kulturkammer-KdF alliance,

the two organizations forged close working relationships in many areas. In the late 1930s, KdF-sponsored entertainment and cultural programs provided work for thousands of Kulturkammer members. During the war, the two organizations grew more interdependent as the KdF's civilian and military entertainment programs expanded.

Joseph Goebbels speaking at a Reichskulturkammer function in 1937. (Ullstein)

Hans Hinkel addressing an audience of Reich Theater Chamber officials in September 1935. (Ullstein)

Richard Strauss (right), first president of the Reich Music Chamber, in conversation with Wilhelm Furtwängler. (Ullstein)

Peter Raabe, president of the Reich Music Chamber, conducts during the September 1936 Nazi Party Rally in Nuremberg. (Ullstein)

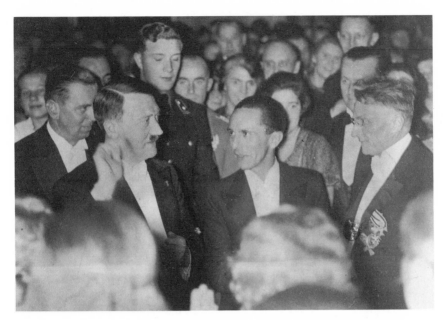

Hitler chats with Goebbels and Music Chamber president Peter Raabe during intermission at a performance of Wagner's Meistersinger von Nürnberg in Berlin, November 1935. (Ullstein)

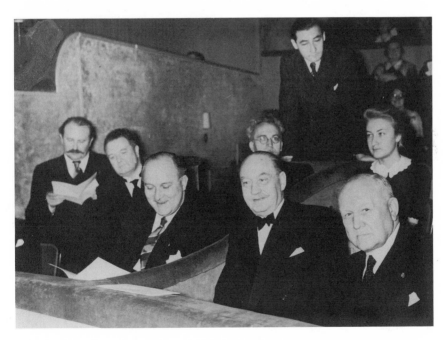

In the audience for a Reich Theater Chamber anniversary celebration in November 1939 were (front row, left to right) Theater Chamber president Ludwig Körner, composer Franz Lehar, and composer Paul Lincke. (Ullstein)

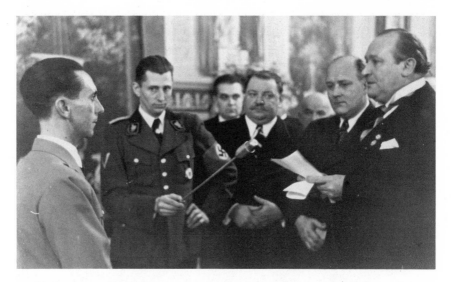

Goebbels receives birthday greetings from the German theater world, October 1938. Making the presentation is Eugen Klöpfer, intendant of the Völksbühne theater and one of Germany's most prominent actors during the Nazi era. To Klöpfer's right is Ludwig Körner, president of the Theater Chamber. (Ullstein)

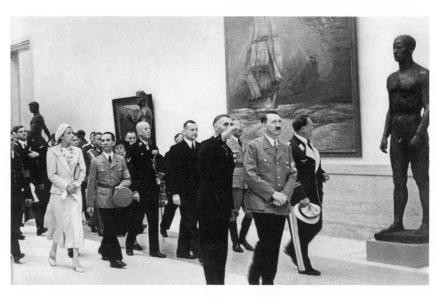

Hitler tours the Great German Art Exhibition in Munich, July 1937, escorted by Adolf Ziegler, president of the Chamber of Visual Arts. To Hitler's left, apparently admiring the statuary, is Hermann Göring. Several paces behind Hitler are (left to right) Gerdy Troost, an interior designer and widow of architect Paul Ludwig Troost; Joseph Goebbels; and Hans Heinrich Lammers, head of the Reich Chancellery. (Ullstein)

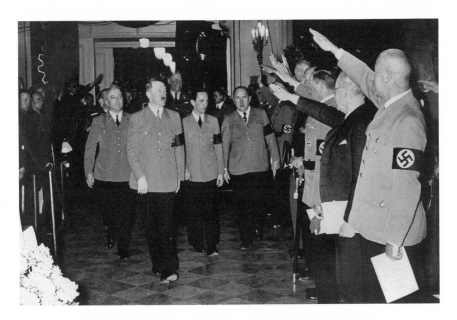

Hitler enters the Berlin Philharmonic Hall to attend the combined annual celebrations of the Reich Chamber of Culture and the German Labor Front's Strength through Joy organization, November 1936. To Hilter's right is Robert Ley, leader of the German Labor Front, and to his left are Joseph Goebbels and Walther Funk, representing the Chamber of Culture. (Ullstein)

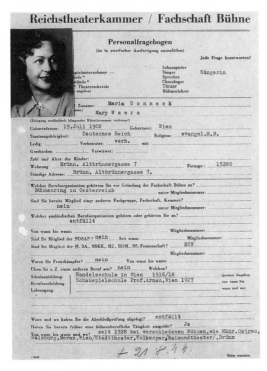

The first page of an application for membership in the Reich Theater Chamber, Fachschaft Bühne. This applicant, who resided in Brünn (Brno) in the Reich Protectorate of Bohemia and Moravia, was admitted to the Theater Chamber in March 1941. (Berlin Document Center)

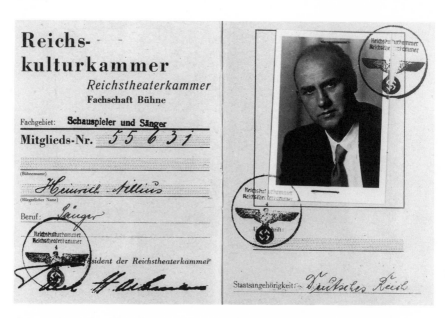

A typical member identification document for the Reich Theater Chamber, Fachschaft Bühne. (Berlin Document Center)

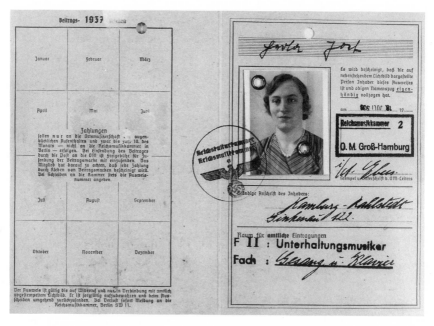

A typical Reich Music Chamber member identification document. Stamps affixed to the page at left verified monthly payments of membership dues. (Berlin Document Center)

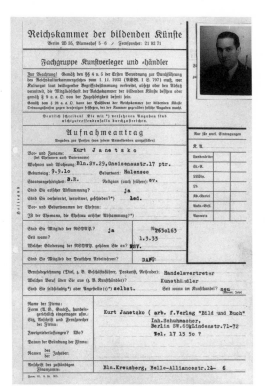

The first page of an application for membership in the Visual Arts Chamber's specialty group for art publishers and dealers. The questions concerning Aryan ancestry and Nazi party membership appear above those concerning professional activities. (Berlin Document Center)

Page 6 of a 379-page list of non-Aryans expelled from the Reich Music Chamber. For entries with two dates, the first date refers to the initial expulsion (Ausgliederung) by the Music Chamber, while the second refers to the Chamber of Culture's denial (Ablehnung) of a further appeal to restore membership. The list was prepared in 1936. (Berlin Document Center)

```
                                          RMK. ·

     K r o p f , Manfred                 J.L.4

     Stettin-Westeénd, Rankestr.5        geb.22.2.1902 Stettin

     Volljude                            Kapellmeister

                              Nach Mitteilung des Landesleiters,Gau Baden,
                              vom 23.10.44,ist  K r o p f am 29.1.44 in
                              Auschwitz O/S verstorben.(RKK - K 236)
```

A Reich Chamber of Culture file card for Manfred Kropf, a Jewish Kapellmeister *from Stettin. Kropf's death at Auschwitz in January 1944 is routinely noted. (Berlin Document Center)*

THE VARIETIES OF

PATRONAGE, 1933–1939

In November 1937 Joseph Goebbels went before the annual general meeting of the Reichskulturkammer to praise his own handiwork. The minister described a revivified national cultural life, attributing it in part to the efforts of the Reich Chamber of Culture. "The German artist of today," he claimed, "[is] a serious, working, modern person, with heart and soul open to all questions of our national and political existence." In the Chamber of Culture the artist learned "professional consciousness, discipline, and corporate honor." Furthermore, "the organization regulates his material needs [and] provides him, as far as possible, with security against old age and disease." The Reichskulturkammer "represents [artists] before the nation, and provides for the guarantee of their rights and for the fulfillment of their responsibilities." In general, in the pursuit of their corporate interests, artists have "obtained hitherto undreamed-of successes."[1]

As usual, the speech was full of half-truths. Contrary to the rosy picture painted by Goebbels, many in the German art world continued to experience severe difficulties in finding employment, while underemployment and job insecurity continued to plague those who were fortunate enough to have found work. A large proportion of artists still fell between the cracks in the German social insurance system, especially in the area of old-age pensions. Indeed, the "professional consciousness" and "corporate honor" of which Goebbels boasted frequently manifested itself in the form of bitter complaints about the regime's failure adequately to support chamber efforts at professionalization and market monopolization.

Nonetheless, Goebbels's claims were not entirely devoid of foundation. The National Socialist regime could, in fact, take some credit for concrete

progress in alleviating the economic crisis conditions in which professional artists had found themselves in the early 1930s. For their part, the culture chambers could claim to have contributed to the economic welfare of their members in several respects. First, by administering work creation programs of their own, and by promoting similar efforts on the part of other state and party organizations whose activities impinged on the cultural sphere, they stimulated German society's demand for the skills of artists. Second, the chambers acted as agents of *völkisch* paternalism by promoting the expansion of the social insurance system to several categories of hitherto unprotected artists. Third, in implementing neocorporatist notions of professionalism, they presided over a basic restructuring of the artistic and cultural marketplace, which resulted in the elimination of many liberal features of an economic order that by January 1933 had been widely perceived to have failed. Finally, the chambers preserved, and in some cases expanded, the various social and professional services offered to artists by the *Berufsverbände* of the Weimar Republic.

Work Creation

A particularly difficult methodological problem arises when one attempts to evaluate the accomplishments of the Reichskulturkammer in the economic sphere. Improved economic conditions in the cultural sector were in several important respects rooted in Nazi measures in other areas. It is especially difficult to disentangle the effectiveness of Culture Chamber programs from improvements in the broader economic context. The majority of positive developments in the cultural economy grew out of Germany's general economic recovery, which was brought about in large part by rearmament. The rejuvenation of industry, the growth of the armed forces, and the systematic reallocation of labor toward military and public works projects both stimulated the economy—hence the demand for cultural products and services—and siphoned off surplus manpower from the art professions. Full employment, combined with shortages of consumer goods, boosted consumer spending on entertainment and the arts. Even the war, which ultimately compelled the dismantling or disintegration of many areas of cultural life, at first produced windfall employment opportunities for several categories of entertainers whose services were needed for entertaining German soldiers.

The chambers participated in the work creation effort in both direct and indirect ways. Directly, the chambers sponsored or cosponsored concerts, theatrical performances, exhibitions, and other cultural programs. From

time to time the chambers were also able to set aside funds for stipends to support artists in need of work. Indirectly, the chambers fostered work creation through cooperation and joint planning with state and party agencies, such as the DAF or the Hitler Youth, whose activities might create opportunities for chamber members. On the whole, the Kulturkammer work creation efforts were carried out in an improvised fashion; there was no master plan for concerted, long-range job creation. Instead, the work creation program consisted of numerous specific initiatives, sometimes originating in the chambers, sometimes in the Propaganda Ministry, and sometimes in other agencies of the state or Nazi party.

Because theater was largely a state enterprise, the theater professions benefited directly from the Nazi regime's increase in direct subventions to the arts. According to the estimate of one historian, appropriations by the Reich government for theater alone climbed from just under RM 10 million in 1934 to almost RM 45 million in 1942.[2] Another factor accounting for increased opportunities for theater people was the extensive recreational program of the KdF group within the DAF. Partly to fulfill the "people's community" component of National Socialist ideology, and partly to pacify workers whose wages were kept artificially low during a period of rising employment, the KdF offered workers a wide variety of travel, sports, and entertainment opportunities. These programs, financed by funds raised through compulsory membership dues from DAF members, proved extremely popular.[3] In 1936, for example, theater events organized by the KdF attracted a combined audience of 300,000 per month in Berlin alone.[4] Nationally, during 1938 the KdF organized 54,813 "popular entertainments," 12,407 operatic performances, 19,523 theatrical events, 7,921 cabarets, and 10,989 evening variety shows. These and other KdF events attracted over 54 million participants that year.[5] During the war, KdF programs continued to expand even as state and local governments were forced to cut back outlays for cultural purposes.[6]

The contribution of the KdF to the stimulation of the theater economy reflected a broader effort by Theater Chamber officials to develop a loyal audience (*Stammpublikum*).[7] Convinced that cultural trends during the Weimar era had alienated the German public from the theater, it was not only culturally but also financially urgent to win the loyalty of German theatergoers and to make attendance at the theater affordable to all. In its pursuit of this strategy, the Theater Chamber made a special effort to win the cooperation of the Hitler Youth. Like the KdF, the Hitler Youth possessed an immense purchasing power that, when translated into theater tickets, could prove invaluable to theater companies. At the same time, the theater could be integrated over the long run into the "great cultural

education program of the Hitler Youth." German youth could become "accustomed to regular visits to the theater from early on." By the 1937–38 theater season, numerous local arrangements had been worked out between the Theater Chamber and the Hitler Youth. In Königsberg, the Hitler Youth accounted for 8,000 subscriptions for twenty special performances, while in Bremen 4,000 Hitler Youth members organized into six theater rings attended eight special productions. By the 1938–39 season, the Hitler Youth had enrolled 250,000 of its members in such programs. The Theater Chamber consulted with the Reich Youth Leadership to ensure that the productions were compatible with the ideological goals of the Hitler Youth.[8]

The same factors that aided recovery in the theater economy also produced some positive impact on the music world. Serious music—like theater, largely a state-supported field—benefited from vastly increased public spending. In addition to enhanced public funding of music through traditional channels, the Reich government set aside increased funds for direct grants to orchestras and musicians, channeled through the Music Chamber. In 1934, the Reich appropriated about RM 72,000 for direct grants to "culture orchestras," to "young talent and unemployed musicians," and to encourage early retirement of older musicians, thereby creating opportunities for the rising generation. In 1935, the Reich appropriation for these purposes doubled,[9] while an additional RM 850,000 was paid out to prop up existing orchestras and to found several new ones.[10] KdF entertainment programs provided additional employment opportunities for both serious and entertainment musicians. In 1934–35, the KdF sponsored 3,000 concerts and 7,000 folk music performances. By 1938, the number of concerts underwritten by the KdF had exceeded 5,000.[11]

The Visual Arts Chamber and other agencies had taken pains to ensure that funds generated by Germany's general recovery would be channeled in the direction of visual artists. Artists benefited from substantial increases in state subventions, and architects enjoyed opportunities arising from government-subsidized building projects, including new military installations. In May 1934 the Propaganda Ministry requested that all Reich agencies undertaking new building projects set aside a small percentage of construction costs for decorative objects produced by painters, sculptors, and craftsmen in the Visual Arts Chamber. The ministry asked that "special consideration" be granted to "free artists," as opposed to those in regular employment. The Reich Ministry of Finance refused to lay down rigid rules governing outlays for the arts in construction projects, but it did encourage its regional offices to do their utmost to allocate funds for this purpose. The Visual Arts Chamber would provide lists of artists and craftsmen who were "qualified" to receive the commissions. The Defense Ministry followed

with a similar measure, promoting the commissioning of art objects to ornament barracks, officers' quarters, staff headquarters, and military instructional facilities. Presumably, this move stimulated demand for artworks on military themes. In 1937 chamber president Adolf Ziegler boasted that these measures had already generated at least RM 7.6 million worth of commissions, providing "creative opportunities and bread" for "countless German artists."[12] Several ministries and agencies also agreed to reserve commissions for free architects in the Visual Arts Chamber,[13] while employment for chamber landscapers was stimulated by the giant Autobahn projects.[14]

Despite continuing complaints from artists about shortages of exhibition opportunities,[15] the number of exhibitions and commissions rose significantly, thanks in part to financial support offered by local governments, the NSDAP, and mass organizations. The KdF, for example, sponsored 144 art exhibitions in German factories in 1935; these shows featured "original works by living German artists" exclusively. The typical exhibition contained between seventy and two hundred objects. Special financial arrangements enabled factory workers to purchase exhibited works through a payroll deduction system. At one factory exhibition, workers purchased forty-one paintings and nine sculptures for a total price of RM 3,500. An apprentice with a weekly wage of five marks supposedly bought an object for RM 45, after borrowing the money from his firm and agreeing to reimburse it in 50-pfennig installments. Through such mechanisms, art could be brought closer to the people while money flowed into the pockets of artists.[16]

Officially sponsored art could simultaneously channel money to artists and produce art celebrating the accomplishments of the regime. In November 1936, for example, public agencies spent almost RM 75,000 on art at a Berlin exhibition with the theme, "The Roads of Adolf Hitler in Art."[17] In 1938 the chief of the Autobahn project, Fritz Todt, commissioned several dozen paintings to celebrate the progress attained on the highway system. The paintings would all feature Autobahn motifs.[18] In the same year, the city of Cologne doubled its budget for purchasing contemporary art, from RM 50,000 to RM 100,000. To lessen the financial burden borne by artists in transporting their work to exhibitions, beginning in 1935 the Visual Arts chamber arranged for automatic transportation insurance coverage for its members.[19] The Propaganda Ministry helped out with funds of its own. The ministry allocated RM 12,000 in 1934, and RM 55,000 in 1935, to support exhibitions by chamber artists. And between 1934 and 1937, ministry or chamber funds sponsored 235 competitions for architects, 35 for painters, 67 for sculptors, and 46 for graphic artists.[20] The ministry also commis-

sioned works directly. In 1934–35, purchases of specially commissioned works totaled about RM 100,000. Most of these works were used to decorate ministry offices in Berlin and in the provinces. In most cases, the chamber itself selected the participating artists. Direct ministry support for craftsmen was somewhat more substantial. In 1934 almost RM 85,000, and in 1935 almost RM 115,000, went to support arts and crafts projects. The projects receiving support included a complete refurbishing and redecoration of a young girls' home in the Frohnau section of Berlin; this project generated RM 2,000 in commissions for local chamber members.[21]

Many other government agencies acted in similar ways as patrons of the visual arts. At a single exhibition of contemporary art in Munich in October 1938, the Bavarian government purchased forty-six objects to be used to decorate public buildings. Created by forty-five different artists, the artworks sold for a total price of over RM 23,000, with the majority going for between RM 300 and 800. The Bavarian government intended the purchases not for the "acquisition of outstanding works of art for the state" but rather for the "support of suffering and needy artists."[22]

On the local level, Visual Arts Chamber offices cooperated with numerous state and party offices to create opportunities for its members.[23] In early 1934 the Reich government placed funds at the disposal of the Visual Arts Chamber for the purpose of helping painters, sculptors, and graphic artists "maintain their artistic activities." The money was allocated among the various administrative regions of the chamber. Individual artists applied for funds directly to the regional officials, who had the chief responsibility for evaluating the applications. Once approved at the regional level, applications were forwarded to Berlin, where the head office of the chamber would deposit stipend payments directly into the accounts of the artists.

The activities of the Visual Arts Chamber's regional office in Baden provide a good illustration of how this process functioned. In Baden, direct subsidies from the Visual Arts Chamber were supplemented by stipends provided by the Baden Ministry of Culture and Education. The ministry agreed to work together with the regional chamber office in dispensing its stipends. It agreed to grant funds only to chamber members and to consult with chamber officials before approving the grants. The regional chamber office set up a master card file in order to keep track of stipend recipients and to prevent artists from receiving duplicate grants. In effect, the regional chamber office would try to coordinate the channeling of funds to its members from a variety of Reich, state, and municipal sources.[24]

In addition to providing and encouraging such direct subsidies to artists, the Visual Arts Chamber office in Baden also attempted to persuade state authorities to provide commissions for chamber members. In 1934 the

Baden office proposed to provide the provincial Ministry of Culture and Education with a list of artists to whom the ministry could turn when it needed new paintings to decorate its buildings, especially the schools. This request bore fruit when the ministry decided that many more portraits of Hitler were needed for classrooms.[25] The chamber also sought the ministry's cooperation in securing employment for chamber members on the numerous state-sponsored construction projects then underway in Baden.[26]

Regulating the Arts

In the years after 1933 almost every form of economic activity in Germany became subject to an increasingly intrusive and complex system of regulation. Although the degree of actual nationalization was minimal, freedom of action in the economic sphere was gradually eroded by the expanding regulatory powers exercised by the Ministries of Economics and Labor, by ad hoc agencies such as Göring's Four-Year Plan office, and—the most important element here—by the state-sanctioned professional corporations established in fields like law, medicine, and culture. One of the Kulturkammer's foremost responsibilities was "to regulate the economic and social affairs of the culture professions" and to substitute an economic "compromise" for the individual and group conflicts inherent in a liberal system. Authority in this area derived from Paragraph 25 of the First Implementation Decree of 1 November 1933, which granted the Kulturkammer control "over the type and form of contracts between professional groups" in the chamber.[27]

But the fledgling cultural chambers did not entirely monopolize authority over the economic aspects of artistic life. Technically, the power to determine wages and working conditions for artists classified as workers (*Arbeiter*) and white-collar employees (*Angestellte*) resided with the Trustees of Labor (*Treuhänder der Arbeit*), a group of Labor Ministry officials created by a law of 19 May 1933. Briefly stated, the task of the trustees was to "ensure industrial peace" by dictating conditions of work to both employers and employees. Conditions that in the past had been determined through individual or collective bargaining between employers and employees would now be imposed from above by the trustees.[28] The all-important Law for the Ordering of National Labor of 20 January 1934 further embellished and institutionalized the powers of the trustees: they were to rule on disputes and dismissals, oversee the "development of social policy" for the labor force, and establish minimum employment conditions.[29]

Soon after the promulgation of the Law for the Ordering of National

Labor, the Propaganda and Labor Ministries initiated discussions about the appointment of a Special Trustee for the cultural fields. The regular trustees would inevitably be preoccupied with industrial matters and would lack detailed knowledge of the peculiar "social concerns" of culture professionals. The two ministries agreed to commission Hans Rüdiger, then serving as chief of the Propaganda Ministry's personnel department, as Special Trustee of Labor for the Culture-Creating Professions (*Sondertreuhänder der Arbeit für die kulturschaffenden Berufe*). Rüdiger retained this office until September 1941, when he was succeeded by Hans Hinkel, who was then in the process of consolidating his preeminent position in the Kulturkammer's political directorate. It is worth emphasizing that although the power to issue wage orders continued to reside in the Labor Ministry throughout the Third Reich, the Special Trustee for the cultural fields was at all times a direct subordinate of Goebbels. In most matters, the Special Trustee worked closely with the cultural chambers.[30]

Between 1934 and 1936, the Special Trustee and the chambers acted together in issuing a series of wage orders and other regulations intended to create a framework of minimum wages, fees, and prices. The chief goal was to guarantee a reasonable level of income for artists in employment. Individuals retained the opportunity to seek the best arrangement the marketplace could offer, but chamber regulations prevented competition from driving compensation levels down below legally established thresholds. New regulations also attempted to foster a modicum of uniformity and predictability in contract arrangements, working conditions, and vacation time.

The Theater Chamber was the first to take the initiative in the area of wage regulation. In February 1934, it mandated minimum salaries for theater personnel employed by Berlin theaters. As the cultural capital of Germany, Berlin tended to attract a disproportionate share of prospective actors and other theater people; in bad times this personnel surplus would inevitably exercise a deflationary pressure on theater salaries. The February order guaranteed theater employees a reasonable minimum salary of RM 225 per month and also stipulated minimum salaries for personnel employed for periods of less than one month.[31] In 1934 and 1935, the Visual Arts Chamber promulgated fee schedules applicable to a broad variety of professional groups, including architects,[32] commercial graphic artists,[33] and pattern designers.[34] Similarly, a Music Chamber order of August 1934 established minimum fees for private music teachers.[35] Professional musicians were prohibited from working without compensation; even charitable work required prior approval from local Music Chamber officials.[36]

The most comprehensive set of economic regulations implemented for

members of the cultural chambers were the wage orders for professional musicians in the Music Chamber. Beginning in 1935, the Special Trustee replaced the existing diffuse framework of collective agreements and state regulations with two universally applicable systems of wage orders, one for entertainment musicians and one for serious orchestral musicians. Both sets of orders spelled out minimum salary levels in great detail. The Special Trustee issued the basic wage orders for entertainment musicians in 1935 and 1936, with occasional updates and modifications continuing into the war years.[37] About sixty thousand musicians employed by clubs, cabarets, cafés, and restaurants fell under these regulations. Separate orders applied to each of the thirteen regions into which Germany had been divided for administration by the trustees system. The orders were essentially similar in format and substance. Provisions covering hiring procedures, breaks, holidays, vacations, sick leave, and travel expenses were, with a few minor exceptions, uniform for the entire country. The only significant variation was in the minimum pay scales, which were adjusted to regional and local conditions. Each region had its own scale, with towns and cities in that region assigned to one of three salary classes. The Bavarian order, for example, guaranteed a full-time employed musician a minimum monthly salary of RM 280 in Nuremberg, RM 270 in nearby Erlangen, and RM 250 in rural areas.

Officially, promulgation of the wage orders was greeted as a major event in the history of the German music trade: "An old, bitter struggle for the social rights of ensemble musicians, which are taken for granted by every other profession, has been secured by the National Socialist state; the first wage order is here." Such measures, the Music Chamber claimed, would eliminate the three greatest sources of hardship among entertainment musicians: amateur or semiprofessional "giggers" (*Stripper*), who would often work for RM 10 a night or less; "underbidders," professional musicians who were willing to work at almost any price; and exploitative emloyers, who ruthlessly played musicians off against one another in order to secure the lowest possible wage. The orders also addressed a host of lesser issues that had traditionally plagued entertainment musicians. They compelled employers to pay musicians promptly, to grant them regular breaks, and to partially compensate them for performances canceled through no fault of the musicians themselves.[38]

The basic wage order for culture orchestras, promulgated in March 1938, applied to about twenty-seven thousand musicians.[39] A single, blanket order covered all regions. The salary provisions of the order were more complicated than those contained in the regulations for entertainment musicians. On the basis of quality, each orchestra was placed in one of five

classes. An additional "special class" comprised elite ensembles. Each orchestra determined its own classification, although decisions required the ratification of the Special Trustee, who would solicit the advice of the Music Chamber and the music department of the Propaganda Ministry. Placement in the "special class" required the additional approval of the Finance Ministry.[40] Minimum salary scales for musicians in each class were computed according to a formula into which seniority, family size, expenses for accommodations, and individual performance (*Leistung*) were factored. Aside from salaries, all employment conditions would be, according to the letter of the order, identical for all orchestral musicians. While such uniformity had not been unusual in the past in the contracts and regulations covering other occupations, in the realm of orchestral music the wage order represented a major innovation.

Several practical problems soon developed in the implementation of the new system, however. Although the wage order had established artistic quality as the sole criterion for the classification of orchestras, financial considerations immediately began to intrude into the process. The Propaganda Ministry received numerous applications from orchestras wishing to be classified lower than their artistic quality would have justified, plainly in an effort to economize. The trustee was reluctant to refuse such requests lest his decision result in the dissolution of financially troubled orchestras. On the other hand, he was also reluctant to confer official approval on classifications that were manifestly unsound on artistic grounds. When this dilemma was called to Goebbels's attention, he removed the trustee from decisions concerning placement in the lower salary classes, thus leaving the matter entirely in the hands of the orchestras.[41] Ironically, under wartime conditions the classification system generated a severe inflation in musicians' salaries.

There was still another component to the framework created by the chambers to regulate professional conduct. This component involved measures aimed at standardizing professional procedures and practices in fields hitherto governed by a diffuse variety of informal traditions, local regulations, and individual preferences. The new orders for entertainment musicians, for example, imposed nationally uniform procedures for the hiring, firing, and payment of musicians. For its part, the Visual Arts Chamber implemented a set of guidelines standardizing procedures for competitions in the fields of architecture, landscaping, bridge and fountain design, painting, sculpture, and the graphic arts. Competitions were vitally important to architects and artists seeking recognition and work. These guidelines, issued in March and May 1934, governed such matters as the eligibility of participants, procedures for publicizing the competition, the composition of

juries, the exhibition of works entered in the competition, and the preparation of documentation relating to the entire event. Also stipulated in thorough detail were the form and content of the printed programs to be distributed to participants. If properly implemented, these guidelines would have brought a new degree of predictability, and probably a heightened perception of fairness as well, to a process that was pivotal to many artistic careers.[42]

Conflicts over Professionalization

While employment opportunities for artists could be created through enhanced public financing, work creation programs, and arrangements with the KdF, the chambers also had to grapple with the chronic problems of overcrowding and *Dilettanterei*. Even as jobs for artists multiplied, there were still far too many individuals competing for the opportunities. Many artists hoped that the authoritarian chamber system could successfully address these problems, something that the sloppy, fractious system of occupational representation during the liberal democratic Weimar period had failed to do.

Central to the very concept of the estate (*Stand*) as it was understood by the creators of the chamber system was a set of clear distinctions between individuals engaged in cultural activity as a primary occupation and those whose activity was of an amateur or semiprofessional nature. A set of clear and rigidly enforced classifications would improve the economic condition of full-time artists by circumscribing the pool of individuals eligible to engage in cultural activity. Professionals constituted the true *Stand*, thus they would be subject to compulsory chamber membership and would enjoy corporate rights and privileges. Meanwhile, amateurs and semiprofessionals would either be excluded from the *Stand* or granted some sort of second-class status within it.

In 1934 and 1935, the culture chambers launched a multifront professionalization effort. To combat *Dilettanterei*, they instituted evaluation procedures, often in the form of examinations, to root out unqualified members and applicants. At the same time, they set in place systems of regulation, monitoring, and enforcement which were designed to create and maintain monopolies over artistic activity. But practical and ideological obstacles soon arose to retard the professionalization project. In the arts, distinctions between professionals, semiprofessionals, and amateurs could be difficult to formulate and even more difficult to implement. Active participation in the cultural arts by broad segments of the population was a

well-established fact of German life. Official constraints upon such broad-based participation were bound to create practical problems of enforcement and contribute to popular alienation from the regime. Moreover, excessive constraints on artistic activity would not be consistent with the populist cultural component of National Socialist ideology and propaganda. Thus, although genuine and important reforms were indeed instituted by the chambers, in many cases the actual achievements fell far short of the expectations engendered by the enthusiasm that had accompanied the 1933 founding of the chamber system.

Limiting performance opportunities for amateurs and semiprofessional musicians was a high priority. In the summer of 1933, the Reich Cartel of German Musicians—an immediate forerunner of the Chamber of Music—pressured the Propaganda Ministry for regulations restricting amateur and semiprofessional musicians.[43] In the hope that the new regime would provide some relief, professional musicians from all parts of the country appealed directly to Berlin. One letter from musicians in East Prussia asserted that on a national scale, semiprofessional musicians deprived twenty thousand professionals of steady work.[44]

The Music Chamber responded to these grievances with a series of orders during the regime's early years, setting down rules regulating the relationship between professionals, semiprofessionals, and amateurs under its jurisdiction. The most important measure was the Second Order for the Pacification of Economic Conditions in German Musical Life, originally promulgated in April 1934 and amended later, in February 1935, as the Third Order.[45] Of "decisive importance to professional musicians," the order would supposedly create "a secure foundation upon which could be built the Reich Music Chamber's goal of professional purity and the improvement of economic conditions of suffering professional musicians."[46] The order excluded semiprofessional musicians from membership in the Music Chamber but not from Music Chamber jurisdiction. Nonprofessionals had to secure a permit from local Music Chamber officials before performing. Chamber officials reserved the right to decline the permit in the economic interest of professional musicians.

A companion order of May 1934 restricted opportunities for public performance by amateur musicians. Amateurs were obliged to limit performances to functions where attendance was restricted to members of the amateur music society and to outsiders present only by special invitation. Open publicity or sale of tickets for such performances was not permitted. As a concession to the amateurs, the guidelines provided for a maximum of two public performances annually by each amateur musician, provided that the performer secured prior approval from the local Music Chamber.[47] As a

general principle, Music Chamber local officials were encouraged to grant their permission for such performances so long as "damage to the commercial prospects of professional musicians" did not result.[48] Given the desperate economic circumstances of so many professional musicians, local Music Chamber officials readily exercised their veto power over amateurs. In the summer of 1935, for example, the Music Chamber's Dresden office refused to grant a permit to Hermann Graul, a poor laborer who wanted to supplement his meager income through occasional participation in a local ensemble. While expressing some sympathy for Graul, the chamber officials were far more concerned about the "large number of unemployed musicians" in Dresden, who lacked "even the basic necessities of life" and had to subsist on weekly payments of RM 12 from the welfare office. The chamber angrily maintained, "Graul cannot demand that these needy, unemployed musicians sacrifice themselves for his benefit."[49]

The Music Chamber similarly attempted to protect German professional musicians from foreign competition. Requests by foreign musicians for permission to perform in Germany were routinely channeled through the Music Chamber, although the authority to decide on such matters resided in the Propaganda Ministry. Alluding to the "economically very unfavorable" situation among German concert directors,[50] the inability of the chamber to meet even the "urgent wishes of German choir directors,"[51] and, in general, the "economic emergency situation of German professional musicians,"[52] the Music Chamber did its best to persuade the ministry to decline permits to foreigners. The ministry often heeded the objections of the chamber. In one case, the chamber succeeded in keeping an Austrian quartet out of the country despite the fact that its members were National Socialists.[53]

As a counterpart to its campaign to restrict amateurs and semiprofessionals, the Music Chamber initiated a process to systematically screen thousands of musicians who were listed as professionals. The chamber set up examination committees in local offices to hear auditions by musicians with questionable credentials or experience. Each examinee was required to play or sing several pieces and to answer questions designed to test knowledge of music theory and history. These examinations confirmed the fears of chamber officials: the German music profession was teeming with "incompetents" (*Nichtskönner*)—poorly trained, untalented, and ignorant musicians. One musician, a drummer, failed his audition because he "has no timing or rhythm" and "can't follow the notes." Another, a harmonicist, failed because he "shifted harmonies at his own discretion" and played like an amateur "village musician." One composer could not provide a coherent explanation of the term "E major." A musician, when asked to name any

opera by Wagner, responded with "the Bayreuth Festival." Another was under the impression that Beethoven had written the Unfinished Symphony. Still another, when asked whether he had ever heard *Lohengrin*, answered, "Yes, I once played a waltz that Lohengrin had composed." Numerous private music teachers demonstrated ignorance of basic concepts like intervals and chords. Such horrific examples underscored the urgency of carrying out the "professional purification" of music "as correctly and quickly as possible." In order to "avoid social hardship," the Music Chamber ordered its examination boards to extend "a certain leniency" to older musicians. Whereas older musicians would be expected to display only "practical competence" in order to remain in the chamber, younger musicians were to be subjected to a more rigorous test of practical and theoretical aptitude.[54]

Meanwhile, the Theater Chamber had also taken steps in the battle against overcrowding. Early in 1934, the Bühnengenossenschaft instituted a system of entrance examinations for newcomers to the stage. Graduation from a theater academy or a certificate from a private teacher would no longer suffice for membership as they had in the Weimar era. By administering its own examinations, the Theater Chamber could ensure that "only the genuinely above-average gifted" might attain membership and thereby enter the theater profession. The examination included an audition, queries about technical aspects of the theater, and a test of "basic knowledge of history of art and literature, especially drama." A purge of the "mediocre" talents who constituted much of the theater proletariat would make room for "genuine *Könner*." Dilettantism would be "unhesitatingly and uncompromisingly eradicated."[55]

For its part, the Visual Arts Chamber secured a monopoly for its members over participation in competitions and exhibitions of contemporary art, although exceptions were easy to arrange.[56] To screen members and applicants, the chamber did not institute a system of exams but rather assessed "achievement" and "aptitude" through a survey of portfolios.[57] The files of rejected applicants suggest that the chamber's decision could often be based on highly subjective, even arbitrary criteria. Many applications were rejected on the grounds that the applicants exhibited "purely technical ability" rather than true "creative power."[58] For painters and illustrators, disqualifying factors included "nonmastery of balanced composition," lack of the "ability to express oneself" in a "convincing illustration," and absence of "sensitivity to color balance." One artist who possessed all three of these deficiencies was also noted as suffering from "a heavy speech impediment," as being "lazy," and as exhibiting "effeminate" traits.[59] Craftsmen could be rejected for "dilettantism," "ineptitude for tastefully high-stand-

ing composition," a penchant for "national kitsch," and "deficient artistic sensitivity" as manifested in the "depraved taste of certain social groups."[60] Local chamber officials, who made the initial judgment before sending the application materials on to Berlin, could easily use such flexible criteria to exclude artists for personal or political reasons.

In September 1934, the Visual Arts Chamber began to fulfill a long-standing wish of free architects when it restricted membership in the architects' section of the chamber to trained architects whose work demonstrated "artistic-creative" (*künstlerisch-schöpferisch*) ability, thereby excluding a considerable number of architects employed by construction firms on mundane projects, as well as construction entrepreneurs and craftsmen who produced their own designs.[61] In early October 1934, Goebbels followed up with a directive to the *Land* governments, specifying that building inspectors (*Baupolizei*) permit the construction only of projects that had been designed by members of the Visual Arts Chamber.[62] Free architects were now positioned to take advantage of the Nazi construction boom.

The broad spectrum of professionalization measures inevitably generated opposition and unanticipated problems. Controls on amateur and semiprofessional musicians proved far easier to announce than to enforce. Open violations occurred on a massive scale. Nine months after the Music Chamber issued the Order for the Pacification of Economic Conditions in German Musical Life, about twelve thousand individual violations of the order were reported. Chamber officials bemoaned the widespread lack of "social sensitivity for the crisis of German professional musicians."[63] Although the main burden of guilt lay with amateur and semiprofessional musicians, professionals knowingly performed together with nonprofessionals "in hundreds and hundreds of cases."[64]

The violators were identified by Music Chamber "control officers" (*Kontrollbeamte*). Working out of local Music Chamber offices, the control officers routinely visited coffeehouses, restaurants, and other locales in order to verify the Music Chamber credentials of the musicians on duty.[65] "Everywhere people gather for social purposes," the Music Chamber Landesleiter for Berlin noted in 1937, "my control officials are on the spot."[66] The large number of reports that have survived in the records of the Berlin Music Chamber office testify to the omnipresence of the control officers, even at funerals.[67]

The Music Chamber control officers operated in small communities as well. One representative case is that of Weiden, a small city in the Upper Palatinate region of Bavaria, about a hundred kilometers east of Nuremberg. In the mid-1930s the Music Chamber office in Weiden was run by Max Döbereiner, a particularly energetic National Socialist. Döbereiner

attempted to keep track of even the most insignificant musical events in Weiden. He developed a network of informants who provided him with a steady stream of reports that covered musical performances ranging from orchestral concerts to solo recitals.[68] One report described a harmonica recital before an audience of a dozen listeners.[69] Döbereiner reviewed the reports received by his office, then summarized the state of the local music scene in a newsletter, paying special attention to violations of Music Chamber regulations. Typically, he would list the names of Jews who had performed in public, legally or otherwise, and report on other musicians who were allegedly violating Music Chamber censorship and economic regulations.[70] Döbereiner's office regularly reported violations of Music Chamber ordinances to the Weiden police, requesting police assistance in shutting down unauthorized musical activities.[71] On one occasion, the night of 14 April 1934, the police placed an officer at Döbereiner's disposal. Together, Döbereiner and his escort spent several hours visiting pubs, restaurants, and other meeting places in Weiden and the surrounding communities, demanding to see the Music Chamber credentials of the musicians they encountered. By the end of the evening's tour, eight musicians had been arrested.[72]

Ultimately, these far-ranging efforts at control met with very limited success. Although the Music Chamber could punish professional musicians with expulsion from the chamber, the monetary fines it could impose on nonmembers were not a sufficient deterrent. "The semiprofessionals do as they please," the Music Chamber Landesleiter in Königsberg reported in February 1936. Violators would simply scoff at control officers, saying "I won't be punished anyway." And because any action would be futile in the end, police forces began refusing to cooperate in the enforcement of chamber regulations on semiprofessionals and amateurs.[73] One of the most frequent violators of the regulations presented an even more intractable enforcement challenge—because it was the SA! The storm troopers, whose parades, ceremonies, and rallies usually involved music in one form or another, resented having to request clearance from a local cultural bureaucrat. The leader of one SA unit complained that the Music Chamber Landesleiter had "no understanding for the political soldiers of our Führer."[74]

Professionalization orders issued by the Visual Arts Chamber also produced some irritation in other segments of society. The market monopoly envisaged for free architects, for example, bode ill for construction entrepreneurs, who protested vigorously through the Chambers of Commerce and Industry. In Frankfurt, they raised the specter of "lasting disturbances in the construction economy"[75] while in Baden they voiced anxiety over the

"deprivation of rights" and employment opportunities for many categories of businessmen and craftsmen.[76]

Goebbels was well aware of the tensions that the chambers' professionalization measures were generating and he grew increasingly ambivalent toward the issue of professionalization in the artistic and cultural spheres. On the one hand, he recognized the necessity of maintaining standards, as well as the political utility of patronizing long-standing neocorporatist tendencies in the art world. On the other hand, he had an instinctive distrust of "organizations." Preoccupation with questions of professional definition, certification, and membership requirements, he believed, produced confusion and bureaucracy, distracting artists from their creative endeavors. He also worried about unreasonable restrictions on cultural participation by nonprofessionals. In October 1935 he sensed that the chambers were "organizing art too strictly" and that the regime should simply "let it grow more" by itself.[77]

In November 1935 Goebbels acted decisively to slow the momentum of the professionalization campaign: he prohibited the use of entrance examinations by the chambers.[78] Goebbels justified the prohibition both ideologically and pragmatically in a speech delivered at the annual Kulturkammer festival. The "value and meaning" of the chamber system, he explained, was "once again to place the artist in a direct union with the driving forces of modern German development, and thereby to restore that close feel [Tuchfühlung] with the German Volk that the artist, much to his own detriment, has lost." This goal meant that "it cannot be the task of the chamber to make entry into one of the individual chambers contingent on a performance test." Goebbels pointed to the difficulties inherent in distinguishing years in advance between "the future dilettante" and "the future genius" and warned that "shortsightedness, envy, or jealousy" may "all too easily exclude a future genius from the chamber."[79] As a later Kulturkammer guideline stipulated, "Aptitude is proved through living, not before the chambers."[80] Whether Goebbels heard from Hitler, a failed art examinee in his own right, must remain an open question, although the propaganda minister's diaries show that Goebbels kept Hitler fairly well informed about such technical details of cultural policy.[81]

Theater Chamber officials believed that the minister's ruling would have a devastating effect on their attempts to weed out inferior performers. Prohibited from administering examinations on which chamber membership would be contingent, the theater profession, now incorporated into the Fachschaft Bühne, pursued a different approach. The Fachschaft retained the examinations but now used them as part of a drastically reformed

system for job placement (*Vermittlung*). The examinations would no longer test eligibility for membership but rather priority for placement (*Vermittlungsfähigkeit*). Newcomers receiving low grades were permitted to join the chamber but stood little chance of finding work in the theater as long as the supply of performers far exceeded demand. Moreover, newcomers demonstrating little potential were routinely counseled to seek alternative career paths, or else, in the words of Executive Director Albert Eduard Frauenfeld, face "chronic unemployment accompanied by great privation and complete proletarization" in the theater.[82] Goebbels voiced no objections to this procedure.

Soon after this new system was instituted, the executive director noted a marked decline in the quality of new chamber members. Moreover, Frauenfeld claimed, discipline among theater students had broken down because they no longer had to fear the prospect of a rigorous examination at the conclusion of their training.[83] Sentiment in favor of a formal state examination remained strong in theater circles. In early 1940, Goebbels adamantly rejected a request by Ludwig Körner to reconsider the prohibition.[84] In late 1942, a Theater Chamber committee of experts resolved that "the coming generation of theater people, like those of all other professional groups, must be subjected to certain examinations; genius or a special gift will show through in any event." One committee member, the celebrated actor and director Gustaf Gründgens, complained that "nowhere else but in the theater is it possible to come into the profession off the street, without having properly learned."[85] Within a year the issue had become moot, as the Theater Chamber had turned its attention to the task of closing theaters down and mobilizing their personnel for armaments production and other wartime priorities.

In addition to the prohibition on examinations, pressure from Goebbels resulted in other significant reversals of chamber professionalization measures. In 1937, the minister forced the Music Chamber to relax the Third Order for the Pacification of Economic Conditions in German Musical Life, the foundation of the chamber's struggle to curtail activity by amateur and semiprofessional musicians. The order, although well-intentioned, had produced too many negative consequences, among them the "repression of artistic abilities that cannot be channeled professionally," the "destruction and endangerment of institutions of village and hometown [*Heimat*] culture," and the "embitterment of the population, which does not understand these issues."[86] The Music Chamber issued a modified order in April 1937, with most of the controls over amateur and semiprofessional activity removed.[87] The impact was dramatic and immediate. Although enforcement of the order had been extremely difficult and largely unsuccessful since

1934, the official relaxation opened the floodgates of "the most horrible dilettantism." The leader of the chamber's branch for entertainment musicians reported in January 1938 that the new regulation had shattered morale among his members. Since the relaxation of the Third Order, he said, the year 1937 had become summarized by the motto "Learn to suffer without complaining."[88] So vociferous were the objections of professional musicians that their grievances were included in the SD's annual domestic morale report for 1938.[89]

A worse problem, in the eyes of many musicians, was that the Music Chamber had not erected effective barriers against the employment of foreign musicians. In December 1938, the local chamber in Berlin informed the central chamber office that four hundred foreign musicians were active in its jurisdictions alone. "It is not understandable to professional musicians," the local officials pointed out, "that work permits are dispensed to foreigners without consideration of the general employment situation."[90] Employers often failed to heed Music Chamber warnings against such hiring practices.[91] The problem also stemmed in part from the Music Chamber's own decision quietly to exempt ethnic Germans with foreign citizenship from the normal restrictions on the employment of non-Germans.[92]

Like musicians, free architects were also forced to back away from their ambitious scheme for market monopolization. Early in 1936, opposition from chambers of commerce compelled the Visual Arts Chamber to rescind restrictions on building permits favorable to chamber architects.[93] In July, the chamber issued a basic revision of the architecture regulation. According to this revised regulation, the jurisdiction of the Visual Arts Chamber was to extend only over construction projects that were "visible in the cityscape or landscape" or that were "artistically or historically" significant. Projects that were not related to the so-called "architectural culture" (*Baukultur*), therefore, could be designed by craftsmen, construction entrepreneurs, and others without architectural training. Inasmuch as it made this distinction at all, the new regulation did indeed provide architects with a degree of official protection that they had not enjoyed previously. But it did not grant any special privileges to free architects. The July 1936 order guaranteed membership in the chamber to *all* architects "without respect to whether they are independent or active in a salaried position."[94] Hence, the old aspiration of free architects for market monopolization remained unfulfilled. As a consolation, the chamber tried to convince various agencies, such as the DAF and the Four-Year Plan office, to engage free architects in their construction planning whenever possible.[95] But the impact of such voluntary arrangements was minimal. Scrambling for commissions, many free architects did not hesitate to underbid officially prescribed minimum

fees. A survey conducted in Baden in 1937 disclosed that only in a "minority of cases were the fees respected or observed." In Heidelberg, architects had underbid the official minimum scale by as much as 80 percent. The chamber regarded such practices as "shameful for our estate."[96] Not surprisingly, then, by 1939 the SD had discerned widespread disillusionment with the Visual Arts Chamber among free architects. The chamber, the architects felt, "had failed in essential questions without exception."[97]

Many painters, sculptors, and other visual artists expressed similar disappointment over the chamber's failure to act decisively in the area of professionalization. The problem was that since Goebbels's denunciation of examinations and credentialism in 1935, the Visual Arts Chamber had gradually relaxed its membership standards to the point where almost any self-styled artist could join. "All of the dilettantes in the chamber can throw their cheap works onto the art market and thereby take away bread from professional artists," complained one professional from Munich. What was worse, the chamber had placed no restrictions on the freedom of publicly employed art teachers, who enjoyed secure incomes, to exhibit or to enter competitions.[98] According to an SD report summarizing the year 1938, widespread dissatisfaction with the Visual Arts Chamber existed throughout "almost the entire German art world," stemming in large part from the chamber's failure to exclude "amateurs and dilettantes" from its ranks.[99] Such complaints continued well into the war years. In 1942, the Visual Arts Chamber requested the Propaganda Ministry's permission to tighten up its admission procedures. The ministry acknowledged that something had to be done to address the widespread grievances of the membership but shot down all of the chamber's specific proposals, citing Goebbels's undiminished opposition to artificial restrictions on membership.[100]

Goebbels showed greater sympathy for attempts by the chambers to reform professional instruction. The Music and Visual Arts Chambers, after long struggles with Bernhard Rust's Education Ministry, won the right to compel membership for instructional personnel at state academies of the visual arts, although the chambers' powers over faculty hiring and curricular decisions remained indirect at best. Most chamber exertions in the area of education focused on private instructors. Goebbels agreed with the chambers' contention that the quality of arts instruction had to be improved, but he warned against investing undue faith in the value of formal training. Reiterating his belief in the immutability of natural aptitude, he told Theater Chamber officials in 1939 that talent "can neither be taught nor learned." Rather, "nature" places talent in the individual "already in the cradle." It would therefore be a mistake "to believe that artists can be educated in schools," Goebbels maintained. Schools and teachers can

only impart a "certain craft" that is an "absolute necessity in the hands of a genuine *Könner*, but only useless ballast in the hands of a *Nichtskönner.*"[101]

Notably, while Goebbels prohibited examinations for performers, he allowed exceptions in the case of private teachers. The Music Chamber had instituted a licensing system for music teachers in August 1934; the Theater Chamber followed suit in July 1935 with licensing procedures for theater and dance instructors; and in October 1936, the Visual Arts Chamber initiated controls over art teachers.[102] With the underlying motive of curtailing the flow of untalented and unqualified young people into occupations that were already terribly overcrowded, the chambers intended to raise the standard of instruction and, in the process, reduce the number of instructors. In the absence of controls in the past, private instructors had proliferated out of all proportion to the number of truly talented students. In the theater, for example, instruction had become the recourse of "used-up stage artists, in order to secure a source of earnings in their twilight years." Such instructors had an economic self-interest in attracting as many students as possible, even if that meant encouraging false hopes among youngsters without real promise. To put an end to these abuses, the Theater Chamber had to conduct "a hard but just selection." "To permit a bad teacher to give instruction for social, humane, or other reasons is to grant preference to one person while it harms many young people, indeed often destroys their future."[103]

With the intention of combining rigorous professional training and ideological indoctrination, the Theater Chamber initiated planning for a Reich Theater Academy in 1937. This academy, to be located in Berlin, would offer complete curricula in the dramatic arts, opera, and dance to between 150 and 200 of Germany's most promising young directors and performers. According to chamber president Ludwig Körner, the academy would once and for all bring an end to the problem of "rampant unqualified private theater teachers." As part of their professional preparation, students would also receive instruction in "elements of German history, racial science, history of the National Socialist movement, structure and goals of the Reichskulturkammer and the individual chambers, and the profession and calling of the German artist in the National Socialist state." Körner secured Goebbels's approval for the academy in 1938. The minister hoped that the academy could ultimately be housed in a fittingly monumental structure; he would see what could be arranged with Albert Speer, whom Hitler had commissioned to supervise the rebuilding of central Berlin. In the meantime, Körner and Goebbels arranged in 1941 to purchase the Aryanized villa of the Jewish Wertheim family as a temporary base for the academy. However, the war halted further progress, and the academy never opened.[104]

Control of education offered the Music Chamber an opportunity to merge the goal of market control with artistic and ideological aims. Through official, central regulation of private instruction, the chamber desired to "make it the duty of all future *Stand* comrades to enter the teaching profession with a training that will do equal justice to the educational requirements of the people and to the artistic goals of private music instruction."[105] In addition to screening prospective music teachers through examinations, the Music Chamber sponsored week-long training courses for private instructors. In March 1941, one hundred music teachers from Berlin attended a typical course. The curriculum focused on new teaching methods for voice, piano, and flute, as well as lectures on the structure and responsibilities of the Music Chamber, legal and ethical aspects of the teacher-student relationship, and National Socialist ideology. "I was most impressed by the effort to anchor the National Socialist idea in us music teachers," one grateful musician wrote in a follow-up survey. Another returned to her teaching with renewed enthusiasm for "carrying art to the people."[106]

Courses conducted for dance instructors by the Theater Chamber offered a similar combination of professional instruction and ideological indoctrination. At retreats held annually in Leipzig between 1937 and 1941, the chamber intended to influence not merely methods of dance instruction but also the "character formation of the complete person." Dance teachers were immersed in lectures, seminars, and workshops dealing with such themes as "Organization of Peasant Village Celebrations," "Art of Dance in its Relationship to the National Socialist Beauty Ideal," and "Fundamental Significance of Racial Policy."[107] One participant described the experience as follows:

> Rise early in the morning, then breakfast together, then movement training at eight o'clock, then swimming and a shower, then at ten o'clock specialized professional instruction and political, scientific, and artistic lectures by select, first-class speakers from all fields. Then communal lunches and suppers bring all of us together in joyous relaxation—and so it goes day in, day out, and all are enthusiastic.[108]

A Balance Sheet: Prosperity Amid Hardship

The available statistical data from which the economic progress of German artists must be reconstructed is fragmentary and uneven. Nonetheless, it strongly suggests that the work creation, economic regulation, and

limited professionalization measures of the 1930s produced mixed results for German artists.

The economic crisis of the arts before 1933 had been so deep and painful that the Nazi regime could seize upon any evidence of an upswing and present it as proof of a dramatic recovery. In January 1936, Theater Chamber officials, armed with an arsenal of statistics, boasted of the turnaround in theater life. Employment in the theater world had risen from 22,045 during the 1932–33 season to 26,364 during the 1935–36 season, an increase of almost 20 percent. Moreover, this pattern of rising employment was an across-the-board phenomenon, benefiting not only actors but also theater musicians, dancers, technicians, and management personnel. Another dimension of the trend was an increase in the number of year-round contracts, as opposed to the short-term contracts that had become common during the depression. In 1931–32 only 43 theaters had granted their employees contracts effective for 10 to 12 months, whereas in 1935–36 such contracts were in force at 67 theaters.[109] After 1936 the improvement in the theater economy continued apace. Total employment climbed to 30,733 in 1937–38 and to 36,441 in 1938–39.[110] Paralleling the growth in employment was a constant increase in the number of theaters in operation. The number of theaters operated by the Reich, state, and local governments rose from 147 in 1932–33 to 179 in 1937–38. During the same period, the number of private theaters declined slightly, from 56 to 51, but a compensating factor was a virtual doubling, from 17 to 33, of the number of "traveling theaters" (Wanderbühnen). In general, theater seasons were lasting longer as well. For example, in 1932 only 32.6 percent of state-supported theaters operated year-round, whereas by 1937–38 this figure had risen to 53.6 percent.[111]

Not all of the news was encouraging, however, and Theater Chamber officials avoided disclosing statistics that depicted a more disappointing reality. In June 1935, Bühnennachweis, the chamber's employment agency, reported that almost one-third of chamber members engaged at theaters had an annual income of less than RM 1,200 and that about one-half of the members earned less than RM 2,500 annually. Many members, therefore, "alternate between short-term periods of employment and the welfare office."[112] A year later, in May 1936, the Theater Chamber counted eight thousand completely unemployed actors.[113] Despite these persistent hardships, the financial position of theater people had undeniably become stronger, and their situation continued to improve in the late 1930s. By the early 1940s, wage inflation, rather than unemployment, had become the theater world's most pressing economic problem.

Table 4.1

Monthly Earnings from Musical Activity by Professional
Musicians in the Reich Music Chamber, 1934 and 1936

	August 1934		Late 1936	
Income per Month (RM)	N	%	N	%
"Minimal means"	12,155	14.4	12,569	13.7
Less than 100	53,031	62.6	54,912	60.0
100.01–200	8,841	10.4	10,219	11.1
200.01–300	6,232	7.4	7,679	8.4
300.01–400	2,835	3.3	3,747	4.1
400.01–500	1,079	1.3	1,633	1.8
500.01–600	255	.3	443	.5
600.01–800	81	.1	181	.2
800.01–1,000	32	.04	60	.06
More than 1,000	50	.06	52	.06
Total members	84,591		91,495	

Source: "Der Erfolg wird unser schönster Lohn sein," *Musik im Zeitbewusstsein*, 22 December 1934; Music Chamber budget, 1937, BAK, R2/4876.

The number of unemployed professional musicians fell from almost 24,000 in 1933 to about 14,500 in 1936.[114] On the whole, however, the recovery in the music world was a limited one during the 1930s. Particularly valuable sets of data exist for the years 1934 and 1936. A comparison of the data, presented in Table 4.1, enables us to gauge the financial progress of musicians with some precision.

The table clearly reflects stagnation within the huge musical proletariat between 1934 and 1936. Musicians in the "minimal means" category—those who could find no work as musicians—constituted about 14 percent of the total membership both in 1934 and 1936. Moreover, the vast majority of musicians who *did* have work both in 1934 and in 1936 were not particularly prosperous. Over 70 percent of the chamber's employed musicians earned less than RM 100 per month from their musical activities, and over 80 percent earned less than RM 200.[115] On the other hand, the income statistics show some improvement among musicians in the middle and higher income categories. Whereas 12.5 percent earned over RM 200 per month in 1934, 15.1 percent could be included in this category in 1936. In absolute terms, this increase of 2.6 percent represented higher earnings for over three thousand musicians. Music Chamber estimates suggest that the situation did not change markedly from 1936 to 1937.[116] Unfortunately, for

Table 4.2
Monthly Earnings from Artistic Activity by "Culture Producers"
under Visual Arts Chamber Authority, 1936 and 1939

	1936		1939	
Income per Month (RM)	N	%	N	%
Less than 80	24,000	48.5	13,000	25.0
80–150	6,050	12.2	11,000	21.0
150.01–200	3,100	6.3	10,000	19.0
200.01–300	7,000	14.1	9,000	17.1
300.01–400	4,600	9.3	5,200	9.9
400.01–500	2,300	4.6	2,500	4.7
500.01–700	1,700	3.4	1,200	2.3
700.01–1,000	530	1.1	500	.9
More than 1,000	235	.5	370	.7
Total artists	49,515		52,770	

Source: Visual Arts Chamber budget, 1937, BAK, R2/4876;
Visual Arts Chamber budget, 1940, BAK, R2/4879.

years after 1937 there is little systematic, detailed income data. Local data suggests that conditions remained extremely difficult for the music proletariat even as the German economy experienced virtual full employment. At the end of 1938, for example, Music Chamber officials reported that of the twelve thousand entertainment musicians in the greater Berlin area, eight thousand still earned below the "minimum subsistence" level of RM 100 per month.[117] The discrepancy between the stagnant condition of the music proletariat and the improvement enjoyed by a relatively small percentage of musicians generated bitterness over what some called "the crisis of the little musician."[118] The overwhelming consensus among musicians ascribed the continuing crisis to the chamber's failure to curtail amateur and semiprofessional music-making.

As for the visual arts, statistics conveniently contained in Visual Arts Chamber budget documents provide a basis for tracing a notable economic improvement during the late 1930s. Table 4.2 represents estimated income distributions among visual artists during selected years. The figures apply only to "culture producers" (Kulturschaffende), a term used to distinguish painters, sculptors, architects, and other creative persons from "culture intermediaries" (Kulturvermittler), such as art dealers and art publishers, whose incomes are not encompassed by this data. The figures do include several thousand amateur artists who paid chamber fees.

The most obvious conclusion to be drawn from the data parallels the one

applied to musicians: the vast majority of the Visual Arts Chamber members earned meager to modest incomes from their artistic pursuits. Nonetheless, the hardship at the lower end of the income spectrum was dramatically ameliorated during the late 1930s. In 1936, 48.5 percent of the artists fell into the lowest income category, whereas by 1939 this figure had dropped to 25 percent. Alluding to this trend in July 1938, chamber president Adolf Ziegler called it "especially fortunate" that the "income increases do not apply only to particularly significant artists, but that they are universally noticeable in the area of artistic activity."[119] Yet despite the upward trend, 65 percent continued to earn less than RM 200 per month from their artistic activities. Unable to eliminate hardship among artists on the bottom rungs of the income ladder, in 1939 the Visual Arts Chamber, in cooperation with the Labor Ministry, initiated a program to retrain "poorly employed visual artists" for alternative occupations.[120]

Altersversorgung: *Old-Age Pensions*

Like the selection and training of the "rising generation" (*Nachwuchs*), chamber measures in the sphere of "care for the elderly" (*Altersversorgung*) reflected the chambers' desire to achieve comprehensive solutions to the systemic social and economic problems afflicting artists. These intentions on the chambers' part reflected a more general tendency toward expansion of the German national social insurance system during the Third Reich. Such reforms were attractive to the Nazi regime for several reasons. They could enhance the regime's popularity in a manner consistent with the paternalistic component of National Socialist ideology. Also, the channeling of money into insurance funds could help reduce inflationary pressures and at the same time create financial reserves that could be tapped by the Reich government.[121]

The historical evolution of the German social insurance system since the time of Bismarck had extended protection to an increasingly broad spectrum of wage workers and salaried employees, but as of January 1933, most artists remained without coverage. Of the few artists in the system, most were civil servants employed by state-run cultural institutions. Several voluntary insurance schemes were also available to individuals not covered by the compulsory coverage mandated by the national system.[122] With low earning power and little job security, artists presented a poor insurance risk even under normal circumstances; during the depression their lack of insurance protection had become especially distressing. To overcome the problem, the chambers had to achieve two vital preconditions. First, a gen-

eral improvement in the economic fortunes of artists was needed to provide the necessary actuarial foundation for a workable insurance scheme. Second, an insurance framework could be effective only if subscription to the insurance were made compulsory. In a voluntary system, such as that inherited from Weimar, financially comfortable artists saw no incentive for helping to underwrite the retirements of their poorer colleagues. The Third Reich's authoritarian structure of professional regulation in the cultural sphere made the task of overcoming opposition to compulsory coverage much less complicated than it had been before 1933.[123]

Goebbels seems sincerely to have believed in the importance of expanding the pension system to artists. The "social question" should be solved "fairly and comprehensively," Goebbels noted in his private diary in reference to theater pensions.[124] On later occasions Goebbels noted in his diary that a comprehensive pension scheme would be both "a historic act that will benefit all artists"[125] and "one of the greatest cultural achievements of all times."[126] Moreover, Goebbels discussed the matter with Hitler several times and felt that he had the Führer's support: according to an entry in Goebbels's diary, Hitler "has so warm a heart for artists because he himself is an artist."[127] Present at the very pinnacle of the Nazi regime, therefore, was a genuine desire to instill in German artists a sense of confidence about future material security. Obviously, both Goebbels and Hitler also realized that the artists would be grateful for the favor.[128]

Until permanent arrangements could be formulated and implemented, elderly, disabled, and otherwise needy artists, as well as their widows and orphans, could receive financial support from an assortment of endowments and foundations, several of which predated the Nazi regime and fell under the control of the Propaganda Ministry or culture chambers after 1933. The most generous and well-funded of these foundations was the Spende Künstlerdank, founded by Goebbels in 1936, which soon came to administer an endowment of almost RM 4 million, drawn in large part from welfare funds of the old *Berufsverbände*. In a one-year period from October 1937 to October 1938, the Künstlerdank lent assistance to 3,884 theater people, 531 film artists, 3,105 musicians, and 2,239 visual artists. The support came in the form of one-time grants, normally ranging from RM 100 to RM 300, although a small number of artists received more generous gifts or steady pensions. Because the Künstlerdank was established primarily to assist retired artists, membership in a culture chamber was not required. However, the chambers had to attest to the "cultural significance" of each applicant, while the National Socialist People's Welfare reported on the level of economic need and the NSDAP assessed "political reliability." Of course, Jews, persons married to Jews, and "political suspects" were not eligible.

Other important sources of support were the Goebbels Foundation for Theater People (Goebbels-Stiftung für Bühnenschaffende), which took over the Bühnengenossenschaft's welfare fund and which dispensed aid to theater people from an endowment of about RM 1 million in 1938, and the Schiller Foundation, which provided assistance to needy writers.[129]

Numerous technical and financial obstacles stood in the way of universal pensions for artists, however. It was not clear in what proportions the necessary funds would come from employers, from the Reich government, from consumers, and from the artists themselves.[130] Unemployed artists would present problems as well.[131] Although he found the regulatory bureaucracy, especially the "little Philistines in the Finance Ministry," remarkably uncooperative when it came to working around such practical obstacles, Goebbels remained determined.[132]

Ultimately, though falling short of his expressed goal to bring *all* artists into the pension system, Goebbels did take important steps toward that goal. In 1938 he presided over the extension of pension insurance to two major groups in the Kulturkammer: artistic personnel in the Theater Chamber and orchestral musicians in the Music Chamber. In both cases, the implementation of compulsory insurance was made possible by the occupational uniformity that had been created by wage orders issued since the inception of Nazi rule. The regime continued to pledge to expand the pension insurance to other groups of artists, but that possibility was destroyed by wartime disruptions. Notably, the Kulturkammer and the office of the Special Trustee were still at work on the project as late as May 1944.[133]

The architect of the pension scheme for theater people was Ludwig Körner. In 1936 Goebbels appointed Körner to study the long-standing problem of providing for actors and other artistic members of the Theater Chamber in their old age.[134] As an officer in Bühnengenossenschaft, Körner had already been involved with such professional matters. Körner's labor bore fruit in late 1937 in the form of a comprehensive, soundly financed, compulsory pension plan, and a wage order of 27 October 1937 made the plan formal.[135] Körner's plan required theater managements to enroll their artistic employees[136] in a pension fund administered by the Support Institute for the German Theater (Versorgungsanstalt der Deutschen Bühnen), a Munich-based insurance agency that had carried the voluntary pension plan for theater artists since the Weimar years. Half of the contributions into the fund would come from the employees themselves; the other half would come from the managements. An order issued one month later permitted theaters to add a special tax of five pfennigs to the price of each ticket sold to the general public, with the proceeds from this so-called

Kulturgroschen helping to defray the cost of the theaters' pension fund contributions.[137] During the first four months of 1938 the special tax raised over half a million marks for the pension fund, and annual revenues from this source were at first expected to reach two million marks.[138] In fact, as a consequence of the theater economy boom during the early war years, payments into the pension fund exceeded expectations, enabling the Propaganda Ministry to authorize a retroactive raise in the pensions of retirees whose benefits had been reduced during the depression.[139]

The pension fund encompassed all eligible members of the Theater Chamber under the age of fifty-five. As of March 1938, therefore, the pool contained about twenty-two thousand persons. The plan guaranteed a minimum annual pension of RM 600 beginning at age sixty-five, or earlier in the event of disability; a death benefit of at least RM 300; and a widow's pension amounting to 50 percent of the normal retirement pension. Provisions for benefits to orphans were included as well.[140]

Compulsory pension insurance for orchestral musicians was stipulated by the comprehensive wage order for culture orchestras, promulgated on 30 March 1938.[141] The insurance was carried by the Support Institute for German Culture Orchestras (Versorgungsanstalt der Deutschen Kulturorchester), which, like its counterpart for the theater, had carried voluntary pension insurance before 1933. Most details of the new compulsory scheme resembled those of the theater pensions. However, orchestra managements did not receive permission to levy the *Kulturgroschen*, although the idea—originally promoted by Richard Strauss—came up for consideration from time to time.[142] By late 1943 over 5,400 musicians, employed by 172 orchestras, had subscribed to the pensions. This figure represented about half of the musicians employed by culture orchestras at that time. The others either had exceeded the maximum age or were covered by special plans for civil servants. During the fiscal year 1942–43, the fund presided over capital assets amounting to almost RM 7.5 million. Although it was still too early in the life of the fund for subscribers to collect retirement pensions, the insurance provided support for musicians wounded in the war as well as for survivors of thirty musicians who were killed during that year in the line of military duty.[143]

Although the politically utilitarian character of the theater and music pension plans was plain to see, the regime chose to tout the pensions as the fulfillment of the "people's community" idea at the core of National Socialism. Körner characterized the theater pensions as the very embodiment of "socialism, reason, and idealism."[144] According to Goebbels, the theater insurance "closes the ring between the people and artists. As thanks for a lifetime that has served art, the people return to the actor in the twilight of

his life what he has given to the people with his heart and talent." The deed demonstrated that unlike its predecessors, this regime was deeply concerned for its creators of culture. The Nazis had in short order brought to fruition "what a century did not accomplish"—an idea that the Weimar Republic, in its failure to appreciate the needs of artists, had ignored. All in all, Goebbels announced in a moment of unrestrained self-congratulation, the pensions represented a "cultural deed" unique in the world.[145]

It was Goebbels's intention to convince German artists that National Socialism had made their lives more comfortable in the present and more secure in the future; but many knew better. To be sure, by the end of the 1930s thousands of German artists had come to enjoy unprecedented prosperity. Compared to those at the conclusion of the Weimar era, unemployment levels were low and compensation rates were high. But most artists still struggled to earn a modest living. And although the Nazi regime had granted old-age insurance to thousands of artists who had not previously received it, thousands more remained unprotected. The professionalization measures promoted by the chambers had attained only limited successes, not least because of Goebbels's own persistent reservations about their wisdom and practical impact. During the first six years of its rule, the regime that had come to power posing as a generous patron of the arts had left a great many artists disappointed, frustrated, even impoverished.

GERMANIZING THE ARTS

I n 1941, a commentary on the Reich Chamber of Culture Law appeared in an updated edition of *Das neue deutsche Reichsrecht*, an authoritative guide to German law under Nazi rule. The commentary described the mission of the Reichskulturkammer as a two-pronged one, entailing both the "promotion of creative and productive forces" and the "eradication of unworthy and dangerous elements."[1] This succinct statement helps place the purge and censorship policies of the chamber in perspective. In a broad sense, the policies of the chamber can be regarded as a form of cultural eugenics. The distinction between "worthy" and "unworthy" forms of life that the Nazi regime applied in the biological sphere had its cultural counterpart in the differentiation between "racially pure" (*arteigene*) and "alien" (*artfremde*) art and artists. The task of eliminating "dangerous" and "undesirable" persons and tendencies from German cultural life formed a logical complement to the policies designed to place the art professions on a sounder economic footing. From the standpoint of National Socialist ideology, the eradication of the unhealthy went hand in hand with the promotion and "care" (*Betreuung*) of the healthy.

The Chamber of Culture performed its purification function in two distinct ways. First, it wielded the weapon of the professional ban (*Berufsverbot*) against Jews, other non-Aryans, and persons considered objectionable on other political or ideological grounds. Second, the Kulturkammer was one of the many components in the Third Reich's byzantine and continually evolving system of cultural and intellectual censorship. The professional purge was much more the exclusive responsibility of the Kulturkammer than was the task of censorship, which it shared with numerous other agencies.

The Purge of Non-Aryans

As with Nazi ideology in general, Nazi cultural policy recognized a variety of enemies but reserved a special place for the Jews. The high priority given to the task of eradicating "Jewish influences" from German cultural life reflected Nazism's general tendency to elevate the Jews to a special status as race enemy. A profound hostility toward Jewish participation in cultural life was already present in the outlook of Richard Wagner and other nineteenth-century figures from whom the Nazis drew inspiration. The rise to prominence of Jews in a variety of cultural and intellectual fields during the Weimar Republic fueled this animosity.

According to the census of 1925, Jews constituted .9 percent of the German population.[2] Nazi authorities, who employed a racial rather than a religious definition of Judaism, estimated in 1935 that the German population still contained 475,000 full-blooded Jews who were also members of the Jewish religion, 300,000 full-blooded Jews who were not members of the religion, and 750,000 mixed-bloods (*Mischlinge*), who, depending on the number of Jewish grandparents, were either one-quarter or one-half Jewish. In the Weimar Republic, Jews (defined by religion) accounted for 3 percent of those engaged in the combined theater and music trades, 4 percent of those engaged in the film industry, and 7 percent of a general category consisting of visual artists, "private scholars," and writers. More specific statistics are available for Prussia, where Jews accounted for 12.3 percent of writers, 5.5 percent of editors, 4.5 percent of painters and sculptors, 6.9 percent of actors, 10.9 percent of directors, and 2.2 percent of musicians.[3] This disproportionately high participation by Jews in the German artistic and intellectual professions provided anti-Semites with a factual foundation upon which the myth of Jewish cultural dominance could be erected. The Nazis' own ideological blinders led them to overestimate the cultural influence of what they saw as a Jewish conspiracy and therefore to regard the removal of Jews from cultural life as all the more urgent. An illuminating illustration of the Nazi obsession with supposed Jewish cultural dominance was contained in a study called *The Jews in Germany*, published in 1938 by the Institute for the Study of the Jewish Question.[4] More than two hundred of this book's 410 pages were devoted to elucidating the problem of the Jews as the scheming, string-pulling "administrators" of German culture who, devoid of creative inspiration of their own, controlled the arts from the shadows.

After 1933 the implementation of Nazi policy toward Jews in the cultural sphere conformed to a broader pattern evident in the evolution of anti-Semitic measures. Numerous historical studies have pointed to the im-

provised and vacillating character of the regime's assault on Jews.[5] Foremost among the reasons behind this pattern were concern about Germany's image and relations abroad, fear of economic disruption, and rivalries between numerous state and party agencies with jurisdiction over the Jewish question. Moreover, during its "time of struggle" the Nazi party had failed to formulate a concrete plan for de-Jewification. When the reins of power were in its grasp, the Nazi party had at its disposal only an incoherent assortment of potential anti-Jewish ordinances. Yet lest too careful an analysis obscure a fundamental reality, I should emphasize that the Nazi movement's strong commitment to solving the Jewish question in one way or another enabled it to overcome most of the practical obstacles, and within a span of only half a dozen years the Nazis succeeded in removing from German life a people who had contributed positively to German culture and society for many decades.

Nazi anti-Jewish policy evolved through several fairly distinct and increasingly radical phases. The first, from February to March 1933, was marked by political violence and terror, perpetrated primarily by the SA. The salient feature of this brief phase was an almost complete absence of central direction or systematic action. Nazi officials often characterized the terror as a spontaneous uprising by the people against their so-called Jewish oppressors. But Nazi authorities both encouraged and exploited the unofficial violence and intimidation, often citing the necessity of maintaining public order as justification for purging the Jewish targets. The victims of this phase of anti-Semitic activity were usually prominent or conspicuously successful Jews on whom the wrath of the storm troopers could be easily focused.

The purge of many prominent Jewish figures in the performing arts during the tumultuous months of February and March 1933 reflected this general pattern. In March, for example, the mayor of Frankfurt dismissed Jews employed by the city opera, theater, libraries, museums, and other cultural and intellectual institutions. He justified this action as retribution against "the libelous hate propaganda of world Jewry."[6] Often the maintenance of public order during the "national rising" was used as a pretext to make continued professional activity impossible for Jewish figures. In one case, Gustav Hartung, the Jewish intendant of the Hessian State Theater in Darmstadt, was forced to resign when his productions were banned by local authorities in response to irresistible "National Socialist demand."[7]

The case of the conductor Bruno Walter serves as a good example of how Nazis invested with official authority worked hand in glove with unruly Nazi mobs in order to block performances by Jews. Walter was scheduled to conduct performances by the Berlin Philharmonic on 19 and 20 March.

Goebbels, Berlin's NSDAP Gauleiter, publicly suggested that Walter be prevented from doing so. The orchestra management acceded to a ban on Walter in face of a rising tide of agitation that had undoubtedly been encouraged by Goebbels. Hinkel, who was serving at the time as commissar in the Prussian Cultural Ministry, later explained that the ban had been necessary since "it had been impossible to provide security for the concert."[8] The series of events, although probably not premeditated, in the end produced the intended result: agitation from below had provided a basis of legitimacy for official action from on high.

A process of gradual institutionalization began with the Civil Service Law of 7 April 1933, which eliminated Jews from most forms of government employment by means of an Aryan paragraph, according to which "civil servants who are not of Aryan ancestry" were to be dismissed. A subsequent implementation order defined as "non-Aryan" any person descended from a Jewish parent or grandparent. Although a more refined system of racial classifications would be implemented in late 1935, the racial stipulations of the Civil Service Law were frequently incorporated into anti-Jewish decrees issued between April and October 1933. During this period severe restrictions were placed on Jews' activity in the medical and legal professions, and a *numerus clausus* was placed on admission of Jews to universities.

The Civil Service Law also marked the beginning of a more systematic and orderly purge of Jews from the art professions, providing a solid legal foundation for the removal of numerous Jews employed by cultural institutions supported by state and local governments. Statistics on the number of Jews dismissed from the art professions on the basis of the Civil Service Law are not readily available. The impact was considerably greater in some fields than in others; it was most severe in fields dominated by public-sector institutions, namely theater, opera, and orchestral music. Jews employed by art, music, and theater academies were also hit hard, since most of these educational institutions were state-operated. Upon the insistence of Reich president Paul von Hindenburg, exemptions were granted to Jews who had fought in World War I and to those whose employment in the civil service had begun by August 1914; these exemptions, however, were withdrawn after Hindenburg's death in August 1934.

Several but not all of the nazified *Berufsverbände* adopted their own Aryan paragraphs in the months preceding the founding of the Kulturkammer. In June 1933, for example, the Reich cartel for music announced that all applications for new memberships would be evaluated according to the racial stipulations of the Civil Service Law,[9] although existing Jewish members would not be expelled. In late September the BDA issued a blanket prohibition on membership by Jews. After "negotiations" with the NSDAP

and the Kampfbund, the BDA resolved that "in the future only German citizens of Aryan ancestry can be members." Supposedly to spare Jewish architects the pain and humiliation of expulsion, a BDA regional official in southwest Germany requested that they submit their "voluntary resignations." "I consider this procedure to be easier to implement and more pleasant for both parties. I would need only to report to the head administration that an expulsion of colleagues of the Israelite religion is no longer necessary."[10]

Thus even before the creation of the Chamber of Culture, a considerable number of Jews had been denied employment in the cultural sphere. The founding of the Kulturkammer was the next major step in the creeping institutionalization of this cultural purge. The official basis of the Kulturkammer's exclusion of Jews was Paragraph 10 of the First Implementation Decree for the Kulturkammer Law. Paragraph 10 empowered the chambers to refuse membership to persons who did "not possess the necessary reliability [*Zuverlässigkeit*] and aptitude [*Eignung*] for the practice of [their] activity."[11] Paragraph 10 contained no direct reference to Jews; it was not, strictly speaking, an Aryan paragraph. The surviving documentation does not allow for a detailed reconstruction of the bureaucratic circumstances in which Paragraph 10 was formulated. The absence of expulsion or rejection provisions in early drafts of the First Implementation Decree suggests that the final phrasing of Paragraph 10 was somewhat of an improvisation.[12]

We do know a good deal about the internal disagreements that postponed the emergence of a uniform Jewish policy during the early phase of the regime. The influence of Hjalmar Schacht, president of the Reichsbank and, beginning in 1934, economics minister, was pivotal here. Schacht was no philo-Semite but rather a technocrat economist who feared that a sudden and complete elimination of Jews from German artistic life might hinder the recovery of Germany's devastated economy. In the particular case of the Kulturkammer, Schacht feared that an explicit and rigid Aryan paragraph would work to disrupt or close down the cultural sector's Jewish-owned business establishments, such as publishers and art dealerships. This action would not only exacerbate the problem of unemployment, Schacht believed, but might also adversely affect Germany's balance of trade and foreign currency reserves, as many of the firms in question engaged in extensive international trade.[13] Pressure from Schacht and other influential "moderates" prevented or at least slowed the implementation of anti-Jewish policies in the early years of the regime. Hitler, whose first priority was to turn the German economy around, on several occasions promised Schacht that the regime's anti-Jewish policies would not be allowed to stand in the way of economic recovery.[14] Although no direct evidence of Schacht's

impact on the formulation of Paragraph 10 is available, it seems probable that his influence was a factor. In this context it is important to remember that the Kulturkammer Law of 22 September 1933 had stipulated the participation of the economics minister in the formulation of Kulturkammer policies that might affect the economy.[15]

In the long run, Paragraph 10's vague phrasing proved useful. It provided a legal foundation for the systematic exclusion of Jews and other "dangerous" elements but at the same time preserved a degree of discretion, enabling the chambers to carry out their purge functions in response to dynamic political and economic conditions and to evolving conceptions of racial and ideological acceptability.[16] The absence of an explicit Aryan paragraph may also have contributed to the illusion that Jews might be tolerated in the Kulturkammer over the long term.

Paragraph 10 had an ironic immediate result. The Aryan paragraphs that had been instituted earlier in 1933 by the nazified artistic *Berufsverbände* had no legal foundation in the Kulturkammer Law or in the First Implementation Decree. As a consequence, on 24 November 1933, Visual Arts Chamber president and BDA leader Eugen Hönig removed barriers against membership of Jewish architects in the BDA. Jewish architects who had previously been expelled or who had "voluntarily" resigned could now rejoin the league.[17] In January 1934 the BDA instructed one of its regional offices that it was "obligated to admit all non-Aryans whose artistic achievement, aptitude, and reliability is recognized."[18]

In early 1934 Reichskulturwalter Hans Schmidt-Leonhardt, who was in charge of Kulturkammer legal affairs, conceded that the chamber legislation contained no basis for automatic expulsion of non-Aryans. If the chambers wanted to expel their Jewish members, they had to employ the specific provisions of Paragraph 10 regarding "reliability" and "fitness."[19] Goebbels soon signaled that this road would be the one to follow. In a public speech delivered on 7 February, the minister issued his personal interpretation of Paragraph 10. "If someone must be regarded as unreliable or unfit for specific reasons," Goebbels observed, "he can be refused membership in the *Verbände*." He then advanced to the next logical step: "In my opinion and experience a Jewish contemporary is, in general, unfit to be entrusted with German cultural assets."[20] In early March Goebbels publicly instructed the Theater Chamber that non-Aryan applicants were to be "routinely denied" admission into the chamber's *Verbände*.[21] And on 24 March, Goebbels informed all of the chamber presidents of his intention to exclude Jews as a matter of general principle.[22] In the same order the propaganda minister also took care to differentiate between Jews who were involved in the "direct

creation of culture" and those whose activities were of commercial impor-
tance.[23] Exceptions to the purge were to be made in the interest of Schacht's
plans for the economy. Later in 1934 Schacht extracted from Goebbels
further reassurance along the same lines.[24]

In the following weeks, chambers and individual *Verbände* introduced
new restrictions on Jewish membership. They employed the distinction
between Aryan and non-Aryan that had come to be embodied in the
implementation of the 1933 Civil Service Law. According to this system, a
non-Aryan was anybody who was at least one-quarter Jewish. In May, the
Theater Chamber ruled that Aryan ancestry would be considered a prereq-
uisite for "reliability" for theater teachers; this policy was expanded in July
to encompass dance teachers.[25] The Music Chamber summarily rejected
applications from Jews requesting licenses to offer music instruction.[26]

Meanwhile, Jews who continued on as chamber members were not
necessarily immune to special restrictions and harassment. In March 1935
the Bavarian police imposed close monitoring of Jewish performers. Al-
though public appearances by Jewish artists were considered to be "undesir-
able" (*unerwünscht*), they had not yet been legally proscribed. Therefore,
police had orders to intervene "as soon as there is the slightest sign" that
Jewish performers created "cause for concern."[27] In Berlin, Music Chamber
control officers routinely harassed Jewish musicians while making their
rounds through nightclubs and other locales. Anti-Jewish musicians and
audience members often lent assistance to the controllers. In July 1935, for
example, a control officer entered the nightclub *Budapest bei Nacht*, where
he heard the band's dulcimer player, Moritz Schubert, play what he thought
he recognized as a Jewish "ghetto song." After further inquiry, the control-
ler discovered that the musician was a Jew. The controller then had no
trouble producing two fellow band members who were willing to testify to
Schubert's "uncomradely conduct."[28] In another incident, Siegfried Krone,
a Jewish violinist employed in a café, had his work permit revoked by a
control officer after engaging in an angry exchange with a patron. Several
patrons who claimed to have witnessed the spat voluntarily stepped forward
to testify to the "unseemly conduct of this Jew."[29] Similarly, anti-Jewish
enthusiasm on the part of gallery owners could at times go far beyond
official state policy. Jewish members of the Visual Arts Chamber often
found themselves ineligible to participate in exhibitions. In one extreme
case in August 1934, chamber member Otto Schneider, a sculptor in Karls-
ruhe and a "50 percent war-handicapped" bearer of the Iron Cross, dis-
covered that he could not exhibit in Karlsruhe and Baden-Baden because his
wife was "one-quarter non-Aryan."[30]

Parallel to such systematic discrimination, the chambers undertook preparations for mass expulsions of their Jewish members. Each chamber followed its own set of procedures. In late 1933 and early 1934, the Music Chamber ordered non-Aryan members to submit special questionnaires pertaining to ancestry.[31] Based on the information received, local chamber offices compiled master lists for later use. By June 1934, for example, the Berlin office of the Music Chamber had prepared a list of the names and addresses of 1,104 non-Aryan chamber members in the Berlin area.[32] This procedure, which relied on voluntary disclosure of ancestry information, enabled a few non-Aryans to prolong their careers by submitting false information. On her Music Chamber application, musician Johanna Glock conveniently omitted a Jewish paternal grandfather. The Gestapo, acting on a denunciation, uncovered her false disclosure in December 1935.[33] Similarly, Paul Gruson, a Berlin sculptor, indicated one Jewish grandparent on his application, which permitted membership in some cases. In the summer of 1935 Gruson won a competition to design a monument to martyrs of the Nazi movement, to be erected in Horst-Wessel-Platz. A short time later, a racial investigation concluded that Gruson had lied on his application; he was really *half*, rather than one-quarter, Jewish. Under normal circumstances, Gruson would have been subject to automatic expulsion, like most half-Jews. But to avoid embarrassment, Goebbels ordered that Gruson be awarded a special dispensation excepting him from Kulturkammer racial regulations.[34] It was also possible for Jews to exploit relatively relaxed control procedures in some occupations. Felix Simmenauer, a full Jew, simply avoided submitting the compulsory application to the Visual Arts Chamber. The chamber did not catch up with him until May 1936.[35] Manfred Kropf, a theatrical music director in Stettin, managed to evade detection for much longer. Kropf, a full Jew, used forged ancestry documents to fool both the Music Chamber and the Gestapo until 1943. Once his secret had been discovered, Kropf met a fate far worse than expulsion from the chamber: his file in the Berlin Document Center shows that on 29 January 1944, Kropf "died in Auschwitz, Upper Silesia."[36]

Most non-Aryans, however, did not have the audacity to falsify or ignore application documents. Once the chambers had collected detailed ancestry information from thousands of non-Aryan members, they initiated systematic mass expulsions. The process unfolded more rapidly in some chambers than in others; consequently, the purge was not an entirely synchronous action. The purge of Jewish writers from the Literature Chamber, for example, took place mainly between February and April 1935, whereas the mass expulsion of musicians from the Music Chamber got underway

only in June and lasted through September. The Visual Arts Chamber moved against its Jewish members in the summer. Most Theater Chamber expulsions began in the autumn and continued well into 1936.[37] Thus, during most of 1935 and much of 1936, a systematic cultural purge of non-Aryans was in progress.

Expulsion lists recently discovered in the Berlin Document Center offer a fairly precise quantitative profile of the victims. The list for the Visual Arts Chamber contains 1,657 names, among them 1,328 full Jews, 180 half-Jews, 23 quarter-Jews, and 126 Aryans with Jewish spouses (*Versippte*); 1,279 were male, 378 female; and 821, slightly less than half, resided in or near Berlin.[38] (Because the list is dated 1938, it also includes about 150 non-Aryans who survived the purge of 1935, for reasons to be examined shortly, but who were expelled later.) The Music Chamber list, dated 1936, contains 2,202 names: 1,738 full Jews, 413 half-Jews, 48 quarter-Jews, and three *Versippte*. This last figure suggests that the Music Chamber was somewhat more tolerant of *Versippte* than the Visual Arts Chamber. Of the 2,202 expellees, 938 were female, and 973 had addresses in Berlin and the immediate vicinity.[39] The Theater Chamber's expulsion list, dated 1938, contains 535 names. The ancestry information provided is too incomplete to construct a breakdown of the victims by racial category. Of the 535 purge victims, 197 were female. While 444 were stage artists (members of Fachschaft Bühne), 78 were variety entertainers (members of Fachschaft Artistik) and 13 were dancers (members of Fachschaft Tanz).[40]

Although it was common knowledge, the German press and official chamber publications studiously avoided allusions to the unfolding purge. An unusual departure from the official silence occurred in July 1935, when Hinkel alluded to the expulsions in an interview with *Der Angriff*, the Nazi newspaper controlled by Goebbels. In allowing membership by non-Aryans for so long, Hinkel claimed, "we have allowed great freedoms," but the time had come to institute a "most pure separation" of Aryans and non-Aryans as a step toward the "construction of a culture of our own blood."[41] As Hinkel put it, Nazis wanted to "protect our culture from the Jewish infection." On 15 November 1935, at the Kulturkammer's annual festival in Berlin, Goebbels jubilantly declared the Culture Chamber "free of Jews" (*judenrein*): "There is no Jew active in the cultural life of our people."[42]

Goebbels most certainly knew that this claim was untrue. Although the expulsions of 1935 had encompassed the vast majority of the Kulturkammer's Jewish members, several had survived. Again the key factor was the intervention of Economics Minister Hjalmar Schacht, whose fear of the potential economic dislocation had probably been largely responsible for the

absence of a cultural Aryan paragraph in the first place. In June 1935, as the purge was unfolding, Goebbels, under pressure from Schacht, had issued the following instruction:

> Jews, non-Aryans, and those related to Jews (*jüdisch Versippte*) who are still members of the Reich Chamber of Culture are to be gradually eliminated; new members are not to be admitted in principle. Should weighty artistic, domestic policy, foreign policy, or economic disadvantages that affect public life arise from this, each case should be reported specifically. The implementation of the rejection or expulsion orders must temporarily occur in such a fashion that economic assets not be lost on a large scale and that a loss of jobs can be avoided as much as possible.[43]

As a consequence of this concern for economic repercussions, several categories of non-Aryan chamber members were excepted from the purge, at least temporarily. At least 115 non-Aryan composers (91 full Jews, 19 half-Jews, 5 quarter-Jews) were expelled from the Music Chamber but allowed to retain their membership documents in order to ensure that foreign royalties generated by their compositions continued to flow into STAGMA, the German mechanism for musical copyright collection and distribution.[44] At the same time, the chamber prohibited public performance of their compositions within Germany's borders.[45] The Music Chamber also allowed exceptions in the cases of 17 non-Aryan music publishers (11 full Jews and 6 half-Jews) and 7 music dealers (4 full Jews, 1 half-Jew, 1 quarter-Jew, 1 unknown).[46] That two of Germany's most prominent music publishers, Fürstner and Peters, remained in Jewish ownership was somewhat of an embarrassment to the Propaganda Ministry, which directed the German press to avoid calling attention to it. In 1937, a Visual Arts Chamber list of "full, three-quarters, and half-Jews" contained a total of 156 names, of whom 135 were full Jews. Most were art dealers, art publishers, and antique dealers.[47]

Goebbels, who regarded Schacht as a "cancer on our policy,"[48] was determined to rescind these exceptions as soon as possible.[49] "I will not rest," Goebbels pledged in his diary in May 1937, until the Kulturkammer is "free of Jews."[50] Indeed, his diaries for the period between September 1935 and January 1939 contain numerous indications of impatience with delays and of resolve to overcome all obstacles; they suggest that Goebbels did indeed maintain constant pressure for de-Jewification within his own administrative empire.[51] The frequency of these entries, and the level of frustration they reflect, are all the more remarkable in view of the relatively tiny number of Jews who remained in the chambers after 1935. A complete purge of Jews, then, was clearly a very high priority for the president of the

Reich Chamber of Culture. At one point, when he mistakenly believed that the task had been accomplished, Goebbels noted that the de-Jewification constituted a "grandiose achievement of which I am proud."[52]

Between late 1935 and late 1938 several important developments with broad significance for Nazi anti-Jewish policy enabled Goebbels to overcome the economic obstacle to de-Jewification of the chambers. In September 1935 the Reich government promulgated the Nuremberg Laws. One of these, the Reich Citizenship Law, revoked German citizenship from non-Aryans. The end of the 1936 Olympic Games, and the departure of the many foreign spectators and journalists who had been in attendance, removed an important foreign relations barrier to the continued intensification of anti-Jewish measures in all spheres of public life. Even more important was the dismissal of Schacht from the Economics Ministry in November 1937. Schacht, whose influence had been on a steady decline since 1935, was replaced by Walther Funk, a close ally of Goebbels who had served as vice president of the Kulturkammer since 1933. The appointment of Funk paved the way for the Aryanization of Jewish-owned business in all sectors of the economy, which began in earnest in early 1938 and was accelerated by the notorious *Kristallnacht* pogrom of 9 November.[53]

As the regime's anti-Semitism gained momentum, the chambers incrementally removed the economic exceptions. The Music Chamber expelled its remaining non-Aryan composers in early 1937,[54] while the non-Aryan music publishers and music dealers were gradually Aryanized in the late 1930s. By late 1938, the Visual Arts Chamber had revoked the exceptions granted in 1935 to most non-Aryan (and *all* full Jewish) art dealers, art publishers, and antique dealers.[55]

As part of the same de-Jewification drive, the chambers moved to close what loopholes remained for Jews in the cultural sphere. In 1938 Hinkel approached Rust's Education Ministry with the recommendation that all art and music academies refuse entrance to Jewish students. Previously, the Rust ministry had established a 1.5 percent maximum quota for Jews in the student bodies of German universities and academies. Such an admissions policy no longer made sense, Hinkel argued, because the professions for which the art and music academies prepared their students had been closed to Jews entirely.[56] Moving forward on a different front, the Theater Chamber decided to exclude Jews from its funeral fund, despite the fact that Jews who were members of the pre-1933 Bühnengenossenschaft had made payments into that fund.[57]

The chambers took great pains to prevent expelled non-Aryans from circumventing restrictions. Music Chamber control officers in Berlin were particularly vigilant. In March 1936, a control officer caught Hugo Strauss,

a Jewish composer, performing as a pianist at a function at Treptow Park. Although Strauss, like many other non-Aryan composers, had been allowed temporarily to retain his Music Chamber membership card, he was not entitled to perform. After pulling Strauss from the piano in the middle of the performance, the controller asked his superiors to remove Strauss's remaining privileges as a composer.[58] In the absence of control officers, the chambers often acted on the basis of denunciations by dutiful, or self-interested, citizens. After his expulsion from the Visual Arts Chamber in August 1935, Georg Pniower, a half-Jewish landscape architect, managed to carry on his professional activity using his Aryan wife, who practiced the same occupation, as a front. But when a business deal between Pniower and a Berlin architect named Heinrich Horvatin soured and a lawsuit resulted, Horvatin denounced the Pniowers to the Visual Arts Chamber, which then fined and expelled Frau Pniower.[59] Sally and Louis Rochelson, Berlin Jews who operated a dry goods shop near Alexanderplatz, had never been members of the chamber, but even so they were not immune to harassment. In September 1938 chamber officials were informed that the display in the Rochelsons' shop window included several ceramic figurines and marble busts, one of which was marked for sale. For this infraction, the chamber ordered the Rochelsons to appear for an interrogation.[60] The Visual Arts Chamber did not hesitate to intrude into the private affairs even of Germans whose connections to the arts were tenuous at best. In July 1939, the chamber reprimanded Ella Adler, owner of a home in the Friedenau borough of Berlin, for failing to report that a studio in her home had become vacant after its previous user, a Jewish artist, had departed.[61] The chambers also took steps to discourage their Aryan members from social, economic, or professional interaction with Jews. The Music Chamber prohibited Aryan musicians from performing in establishments operated by Jews, threatening violators with expulsion.[62] In one instance in 1938, the Theater Chamber investigated Berlin actress Maria Johanna Collm after she was seen climbing into the automobile of a Jewish physician known for having film and stage actors among his patients.[63]

Although Jews had largely been eliminated from the art professions by the end of 1935, they could still freely attend performances and exhibitions open to all members of the general public. Hitler, who found this repugnant, in November 1937 authorized Goebbels to devise a law that would ban Jews from most cultural establishments.[64] Legal experts in the Propaganda Ministry came up with a plan that would use the Kulturkammer as a chief mechanism for enforcement. Jews who violated the new law would themselves be subject to arrest by the police and prosecution by the criminal justice system. The chambers' role in the system would be to discipline,

and, if necessary, to expel any member—e.g., theater and concert managers, gallery owners, and cinema operators—who failed to enforce the ban on Jews. The plan soon ran into difficulties, however. Police enforcement of the ban could occur only if an "endangerment of security and order" were present, and it was not within the Propaganda Ministry's purview to declare such a condition. Moreover, those who would be most directly involved in enforcing the prohibition, like ticket-sellers and ushers, were not chamber members.[65]

A year later, two days after the *Kristallnacht* pogrom which he had played a major role in instigating, Goebbels issued an order banning Jews from theaters, cinemas, concerts, lectures, varieties, cabarets, circuses, dance performances, and exhibitions. Unlike the 1937 draft law, which was slated for Hitler's signature, this measure was simply an order issued by Goebbels in his capacity as president of the Reichskulturkammer. It specified no enforcement mechanism.[66] Eager to please the minister, Music Chamber president Peter Raabe proposed to issue his own implementation stipulations. All musical events under Music Chamber jurisdiction would be clearly marked with the sign "No entry to Jews." Tickets would be similarly marked. The Propaganda Ministry objected to Raabe's proposal, however, mainly on the grounds that in so important a matter universal guidelines covering all chambers would be necessary.[67] Yet, inexplicably, the ministry ordered no further guidelines, probably because of the gross impracticality of forcing theater operators and the like to demand identity papers from patrons. The measure became truly enforceable only in September 1941, when German Jews were ordered to display yellow stars.

Under increasing pressure from Goebbels, in the late 1930s the chambers also adopted stricter guidelines for documentation of Aryan ancestry. Until 1935, chamber membership questionnaires had for the most part relied on disclosure of ancestry information by members and applicants. The long-term institutionalization of the exclusion of non-Aryans, however, required a more rigorous procedure by which secret non-Aryans—those who had lied on their applications—could be rooted out. After the chambers announced several relatively limited ancestry verification measures for applicants and foreigners in 1935 and 1936, they launched a major program in 1937 to check the documents of all existing members.[68] This was a momentous bureaucratic task for which the chambers were not entirely prepared. The Music Chamber estimated that the increased workload generated by the verification process would boost its personnel expenses by RM 40,000 per year, money it simply did not have.[69] Moreover, all of the chambers encountered difficulties and delays in receiving the expected documentation from members. In early 1939 the Visual Arts Chamber

began a systematic expulsion of members who had failed to submit the documents.[70] But meticulous verification of ancestry documents proved to be an arduously slow process. By October 1939, the Music Chamber's regional office in Berlin had checked the ancestry documents for only 789 of its 13,085 musicians.[71]

Chamber policy toward non-Aryans was complicated by significant numbers of *Mischlinge* and *Versippte* among German artists. Nazi definitions of and policies toward these groups changed over time and were never entirely uniform from agency to agency. Individual ministries and professional corporations formulated their own approaches to the matter. As of May 1938, for example, *Mischlinge* were allowed to be apothecaries and craftsmen, but not veterinarians or tax advisers.[72] Until 1937 the Kulturkammer used the distinction between Aryan and non-Aryan that had become standard during the implementation of the Civil Service Law of 1933. According to this system, a non-Aryan was anybody who was at least one-quarter Jewish. As a general policy, such non-Aryans were expelled from the chambers, or denied membership, until mid-1937. As far as *Versippte* were concerned, Aryans married to full and three-quarter Jews were excluded from the chambers, whereas those married to half or quarter Jews were accepted as members.[73]

Sometime in 1937 the Kulturkammer liberalized its membership policy for *Mischlinge* and *Versippte*. The reason is not entirely clear, but it seems likely that Volker Dahm's characterization of the change as a delayed reaction to the Nuremberg Laws of September 1935 is correct.[74] Administrative elaborations of the Nuremberg Laws had created the distinction between Jews, *Mischlinge* of the First Degree (essentially half-Jews), and *Mischlinge* of the Second Degree (essentially quarter-Jews).[75] The delayed reaction of the Kulturkammer to the new system of racial definitions was to permit chamber membership to *Mischlinge* of the Second Degree, or quarter-Jews. In a small number of cases, membership was now granted to such *Mischlinge* who had been excluded from the Kulturkammer under the old, stricter rules. A Music Chamber list for 1937 indicates that at least fourteen quarter-Jews who were expelled previously had their memberships reinstated. The guidelines in effect by mid-1937 also stipulated that in exceptional cases, *Mischlinge* of the First Degree (half-Jews) would be granted membership by special dispensation.[76]

A summary of the rules followed by the chamber beginning in 1937 was contained in a set of "Working Guidelines for the Reich Chamber of Culture" issued by Goebbels in January 1939.[77] The document was designed to clarify several major areas of chamber policy and procedure. The section dealing with the de-Jewification question stated the following:

Jews defined according to the Nuremberg Laws are to be excluded as a matter of principle; half Jews are to be permitted in the chambers only in very special individual cases and only with my express personal permission; quarter Jews may remain in the chambers, but not if they have offended the state or National Socialism, or if they prove that they are inclined toward Judaism; persons married to Jews are to be treated in principle like half-Jews; persons married to half-Jews in principle like quarter-Jews.

These guidelines preserved flexibility in cases involving any of the racial categories except that of full Jews. As of June 1939, 320 special exceptions were in effect in the entire Reichskulturkammer for half-Jews and *Versippte* who would otherwise have been banned from chamber membership.[78] In most instances, responsibility for decisions to grant exceptions fell to the Kulturkammer central office. Frequently, however, Goebbels was asked to make membership determinations himself. An especially illuminating dossier of Theater Chamber cases that Goebbels decided upon himself has survived in the Berlin Document Center. The Kulturkammer central office supplied the minister with a brief one- or two-paragraph summary of the essential details of each case. At the bottom of each sheet, Goebbels indicated his decision with a "ja," a "nein," or an instruction to defer to the opinion of the appropriate Gauleiter. For the minister, the paramount considerations were artistic ability, political reliability, and seniority. Goebbels gave a "nein" to Albert von Küsswetter, a thirty-two-year-old Aryan opera tenor in Freiburg, whose wife was a full Jew. Although Küsswetter's artistic ability was considered to be "above average," the NSDAP district office in Baden claimed that he "feels no political interest" and "gives only grudgingly" at charity drives. Moreover, Küsswetter refused to entertain the possibility of divorcing his wife. In contrast, Goebbels approved chamber membership for Paul Paulsen, a fifty-seven-year-old actor in Dresden who, like Küsswetter, was an Aryan married to a full Jew. Active in the German theater for over forty years, Paulsen had also performed important service for the theater union, and thereafter for the Theater Chamber, in Saxony. The minister approved a special dispensation for the half-Jewish sisters Eva and Irene Korolanyi, the daughters of Jewish composer Friedrich Korolanyi. Evidently, one deciding factor, in addition to "recognized achievement," was that "externally they exhibit no Jewish characteristics."[79]

The awarding of special dispensations was a potentially embarrassing practice, evidence of which the Propaganda Ministry sought to suppress at every turn.[80] Given the sensitive nature of such decisions, it is significant that on several occasions Goebbels asked his own superior, Hitler, to pass

judgment. In July 1938, for example, Goebbels asked Hitler to establish a policy for cases involving female members of the Kulturkammer who had violated the regime's racial code by engaging in sex with Jewish men. The Führer decided that disciplinary action should be taken primarily against the offending Jewish male.[81] Similarly, in May 1939 Goebbels asked Hitler to decide on the cases of twenty-one actors who were "not completely Aryan or who were married to Jews." Hitler decided to grant Theater or Film Chamber membership in several cases (the exact number is not indicated), one of which involved a half-Jewish actor whose wife was a full Jew, and another an Aryan whose wife was a full Jew.[82] Thus Hitler did not remain aloof to the details of racial policy but rather developed an intimate knowledge of the application of racial doctrines to artists.

In two ways, the provisions of the January 1939 guidelines described above could result in the need either for special judgment or for background investigation. The first issue was that of racial ancestry. Whether or not a grandparent was Jewish was sometimes difficult to ascertain. This determination was crucial because it could make the difference, for example, between a person's being classified as a quarter-Jew, who could attain membership in the Kulturkammer, or as a half-Jew, who under normal circumstances could not. The second issue was that of political orientation or moral deportment, which could secure membership for a half-Jew or, on the other hand, make even a quarter-Jew ineligible for membership.

The case of the opera singer Hulda Güden offers insight into the *Mischling* question in a variety of ways.[83] It illustrates some of the problems inherent in the application of racial definitions and in the evaluation of political reliability. The case also shows how the Kulturkammer central office, in attempting to decide on the case, interacted with the secret police and with the Third Reich's extensive network of racial specialists. From the point of view of a Kulturkammer functionary, the Güden case was an administrative nightmare in which numerous extraordinary circumstances converged. Güden, a Turkish citizen, was born in Vienna in 1917. Her father had been a half-Jew, but an investigation by the Reich Ancestry Office (Reichssippenamt) determined that her mother had been "of German blood." Güden, therefore, was classified as a quarter-Jew (*Mischling* of the Second Degree) and was accepted into the Theater Chamber in July 1941. But in January 1942 the Reich Ancestry Office changed its mind about Güden's mother. The mother was now reclassified as a *Mischling* of the First Degree, and Güden's own classification was in turn downgraded from quarter-Jew to half-Jew. The reclassification of the mother's ancestry was based on new evidence provided by the regional ancestry office (Gausippenamt) in Vienna, where Güden was born, and was confirmed by the

NSDAP's racial-political office (Amt Rassenpolitik) for the NSDAP region of Munich, where Güden was engaged by the opera at the time of her admission into the Theater Chamber. These were not the only offices involved in the investigation. The Aryanization commissioner of the NSDAP's Munich region looked into the matter as well, and concluded, on the basis of information received from the police president in Vienna, that Güden's mother had in fact been a full Jew. If true, this information meant that Güden herself was three-quarters Jewish, tantamount in the Nazi system of racial classifications to being a full Jew.

Hinkel, whose office had to evaluate the conflicting evidence, believed that the documentation supported only the conclusion that Güden's mother had been a half-Jew. Since Güden's father had been a half-Jew as well, Güden was a half-Jew herself, and, as such, not eligible for Kulturkammer membership except by special dispensation. But there was an additional complication. Güden had gone to court in Vienna in order to prove that her half-Jewish *legal* father had not been her *biological* father. The biological father, she claimed, had been an Aryan who had died in 1917, the year of Güden's birth. Hinkel's office reviewed the evidence Güden submitted to the court and concluded that she might well win her case. If Güden could prove that her biological father had indeed been Aryan, then Güden herself was only one-quarter Jewish by Nazi racial standards and could remain in the Theater Chamber. The Kulturkammer's decision on Güden's membership would therefore have to wait for the court in Vienna to make up *its* mind, which was expected to take quite a long time.[84]

There were still more complications. Güden had secured expert opinions from the Anthropological Institutes of the universities of Munich and Vienna; according to these opinions, Güden's "racial appearance exhibits no features that are characteristic of Jews." Moreover, Hinkel was approached on Güden's behalf by Dr. Dannemann, the Turkish consul general in Munich, who according to information received by military intelligence (OKW-Abwehr) may have been romantically involved with Güden at the time.[85] Apparently Dannemann also enlisted the aid of his friend Heinrich Hoffmann, Hitler's personal photographer, who took up Güden's cause with Hinkel.[86]

Finally, according to the Landeskulturwalter for Munich, individuals familiar with Güden's past life suspected that she was an "agent of a foreign power." The SD had begun an investigation of this possibility in late July or early August 1943. By this time, however, Güden had taken up residence in Rome, where political events of the preceding weeks[87] had made any German investigative operation there extremely difficult.[88] The Kulturkammer's interest in the veracity of the espionage accusations against Güden

related directly to the question of her ancestry. If Güden could succeed in proving that she was merely quarter-Jewish, rather than half-Jewish, then chamber membership could be denied to her only on grounds of disloyalty to the Nazi state.[89] With access to Güden cut off, the Theater Chamber decided in September 1943 simply to expel her.

The Güden case reflects how seriously the nuances of Nazi racial policies were regarded by Hinkel and his staff in the Kulturkammer central office. On one hand, despite the intervention of influential friends and the possibility that the court in Vienna might take years to decide on the question of paternal ancestry, the officials in the Kulturkammer (and the Propaganda Ministry) were not ready to ignore racial guidelines and smooth the way for Güden's continued membership. On the other hand, they hesitated to expel Güden as long as the evidence of her ancestry remained ambiguous. Only when Güden had left Germany and relocated to a city inaccessible to German investigators did the chamber absolve itself of the case by means of expulsion.

A Jewish Chamber

For Jewish purge victims who wished to continue their artistic careers, there were two main alternatives. Many, of course, chose emigration. For those who could not leave, or who wished to weather what many thought would be a storm of limited duration, the Jewish Culture League (Jüdischer Kulturbund) served as an outlet for creativity and as a source of employment.[90] The Kulturbund originated in the spring of 1933 as an initiative by Jewish civic leaders in Berlin, including Leo Baeck, who sought to grant some relief to economically and spiritually desperate Jewish artists who had lost their positions. The plan envisaged an officially tolerated cultural association that would provide employment for Jewish artists and entertainers and serve as a source of cultural enrichment for Jewish theater- and concertgoers. In May, Hinkel received a proposal from Dr. Kurt Singer, a trained physician whose interest in music had propelled him to the intendancy of the Berlin City Opera (from which he had been dismissed in March 1933). After securing Göring's blessing, Hinkel approved Singer's plan for a Kulturbund in Berlin that would operate one theater, employ only Jews, and offer performances before audiences composed exclusively of Jews.

The plan had appealed to Hinkel for several reasons. It encouraged Jews who had been dismissed from state cultural institutions to seek employment with the new Kulturbund rather than with other private theaters or orchestras, which were not covered by the Civil Service Law and therefore

had not yet been legally closed off to Jews. A Jewish cultural organization would also generate grist for the German propaganda mill, which needed evidence to counter allegations about mistreatment of Jews. Finally, Hinkel recognized the plan as an opportunity to expand his own authority. Here his instinct proved particularly keen. After the Kulturbund experiment had proved successful in Berlin, many additional local chapters began to spring up. In March 1935, the forty-six existing local organizations were placed under a supervisory umbrella agency, the Reich Association of Jewish Culture Leagues (Reichsverband der jüdischen Kulturbünde). By 1937, the Jewish organizations supervised by Hinkel had grown to encompass about fifty thousand people.

Hinkel possessed the experience, skills, and knowledge needed to help Goebbels stake his claim to jurisdiction over the Jewish cultural organizations, just as Hinkel's dynamic role in the coordination of cultural organizations in 1933 had made him a natural choice to force through organizational and policy reforms in the Kulturkammer. In July 1935, several weeks after Goebbels had appointed Hinkel to become one of the triumvirate of Reichskulturwalter at the Kulturkammer's helm, Goebbels added to Hinkel's portfolio the responsibility for supervising non-Aryan culture; the press release announcing this latter appointment reported Hinkel's title as that of Special Commissioner for the Supervision and Monitoring of the Activities in the Cultural and Intellectual Spheres of Non-Aryans Living in the Territory of the German Reich.[91]

Goebbels had based his choice not merely on Hinkel's obvious qualifications but also on the fact that Hinkel had already attained the rank of Sturmbannführer in the SS. The SD, an SS agency, had recently begun to express close interest in the regime's management of the Jewish question. The SD favored ghettoization of Jewish cultural and intellectual life, believing it would discourage assimilationist optimism among Jews and thereby promote emigration. Goebbels, a virulent anti-Semite in his own right, probably had few grounds for ideological disagreement with the SD's Jewish experts and recognized that coordinating policy with them would preclude interference from those quarters.[92]

Hinkel's supervision of the increasingly ghettoized Jewish cultural life formed a logical complement to his oversight of the Reichskulturkammer expulsion process; in effect, Jews falling victim to the Reichskulturkammer purge were transferred from one sphere of Hinkel's jurisdiction to another. In the fields of music and theater, the Hinkel-controlled Reichsverband provided the sole refuge; the Jewish press and publishing industry, although not formally incorporated into the Reichsverband, also gradually came under the direction of Hinkel's office.

Hinkel's office exercised "comprehensive prophylactic program supervision" over the content of Jewish artistic and cultural programming.[93] In practical terms, self-censorship was carried out by Jewish officers at the Reichsverband level; Hinkel exercised a veto power and, in questionable cases, made final decisions. For the Jews involved, Hinkel's stamp of approval could be used as protection against police officials, the Gestapo, and other Nazi agencies who may have wished to prohibit Reichsverband functions.

The censorship policy toward the Reichsverband constituted an effort at enforced artistic and cultural dissimilation. It intended to negate the German component of the German-Jewish identity. From the very beginning, the repertoire available to the Jewish cultural associations excluded the works of German romantics such as Wagner and those of composers particularly valued by the regime, such as Richard Strauss. With the passage of time, Hinkel's office steadily constricted the range of possibilities. Goethe's works and other classics of German literature were added to the blacklist in 1936; Beethoven's turn came in 1936 as well; Mozart and Händel were added relatively late, in 1938. Works by non-German authors and composers were generally tolerated, provided that they were not objectionable on political grounds. Hinkel particularly encouraged the Jews to perform pieces by Jewish authors and composers. The pattern was established as early as July 1933, when the Kulturbund's theater in Berlin chose Lessing's *Nathan* as its very first production. Thus by the late 1930s, Hinkel's office was seeking to enhance a stereotypical image of Jewishness while it systematically programmed out the ostensible artistic manifestations of German-ness.

In speeches and publications, Hinkel frequently tried to interpret this progressive ghettoization as evidence of the regime's enlightenment and magnanimity. In effect, he argued, the Jews had been granted special recognition as a minority, permitted to cultivate their own cultural heritage. "Jewish artists are working for Jews," he pointed out in a speech in 1936. "They may work unhindered so long as they restrict themselves to the cultivation of Jewish artistic and cultural life, and so long as they do not attempt, openly, secretly, or deceitfully, to influence our culture." Furthermore, Hinkel observed, how could foreigners criticize measures that had received the blessing of the Jews who were most directly affected? "The leadership of the Reich Association of Jewish Culture Leagues has repeatedly assured us," Hinkel claimed, "that the measure we have taken is a humane one," both "for Jewish artists and for the cultivation of Jewish art." At the same time, Hinkel covered himself against Nazi hard-liners' potential accusations of deviationism: The Reichsverband, he emphasized, was a

"practical solution to the Jewish question in National Socialist cultural policy" entirely consistent with the basic principles of National Socialism.[94]

Although transparently disingenuous in retrospect, Hinkel's rhetoric and patronizing manner seem to have won him respect, even gratitude, from the leaders of the Jewish artistic community. In an interview in 1960, Hinkel portrayed himself as a protector of the Jews, a moderate who shielded them from the designs of radically anti-Jewish elements in the regime.[95] The postwar account of Herbert Freeden, a Jewish cultural official who dealt with Hinkel in the Nazi era, offers a somewhat less charitable view but confirms the apparent ambiguity of Hinkel's conduct. According to Freeden, the Jews saw Hinkel both as promoter and oppressor, protector and tyrant. On the negative side, Hinkel most directly personified the German Jews' cultural disenfranchisement. On a less symbolic level, in the late 1930s he presided over a steady tightening of the artistic restrictions governing the Reichsverband. But on the positive side, Freeden recalls Hinkel's intervening on behalf of the Jews when police or other local officials attempted to prevent Reichsverband productions from taking place. Hinkel also seemed to have genuine respect for the Reichsverband's Jewish officers, especially Kurt Singer. Freeden describes Hinkel's demeanor with his Jewish underlings as polite, even considerate.[96] This image of Hinkel as a paternalistic dictator attained wide currency among Jews in Germany after the war; even Hinkel's 1960 obituary in the *Allgemeine Wochenzeitung der Juden in Deutschland*, which otherwise stressed Hinkel's function as an "outspoken Jew hater," felt obliged to mention Hinkel's strange benevolence.[97]

In the wake of the *Kristallnacht* pogrom of November 1938, the Propaganda Ministry ordered Hinkel to close down the Reichsverband and, with it, all Jewish cultural activity. But as the foreign policy implications of the brutal pogrom and its attendant repressive measures became clear, the ministry reversed itself.[98] On 12 November, only two days after the violence, Hinkel convened a group of Jewish leaders and ordered them to resume cultural programming. So urgent was this matter that Jewish performers were released from the concentration camps to which they had been dragged only a couple of days earlier. Nevertheless, after November 1938 Jewish artistic and cultural life continued on a much narrower basis than had been the case before *Kristallnacht*. The mechanism for a more intrusive official supervision was set in place in January 1939, when the Reichsverband, which had been essentially an umbrella organization for the local associations, was dissolved and replaced by the Jewish Culture League in Germany (Jüdischer Kulturbund in Deutschland), a single, centralized organization.

In general, *Kristallnacht* had spurred a radicalization of the Nazi regime's policy toward the Jews. Hinkel experienced little difficulty in adjusting to the new conditions. He had come to be generally acknowledged as one of the Propaganda Ministry's foremost experts on the Jewish question. Hinkel seemed to savor this reputation and did much to enhance it. In 1939 he edited and published *Judenviertel Europas*, a collection of essays about "the Jews from the Baltic to the Black Sea." Hinkel's own contribution to the collection, "Germany and the Jews," contained the familiar vitriol and stereotypes, although it also emphasized the vitality of the cultural life that the Jews had been permitted to pursue in Germany since 1933. Yet the Jews, Hinkel claimed, had exhibited little gratitude for the regime's generosity, as evidenced by the "Jewish murder" of Ernst vom Rath. Writing as though he had been personally betrayed by his Jewish wards, Hinkel concluded his piece with the observation that "the present struggle of world Jewry against National Socialist Germany as the heart of Europe is nothing more and nothing less than a struggle against the thousand-year old culture of the west!"[99]

This post-*Kristallnacht* propaganda was designed to accompany and to justify intensified anti-Jewish measures. As the Propaganda Ministry's foremost Jewish expert, Hinkel inevitably became involved in the formulation of these measures. In 1938, Hinkel had emerged as an intermediary between the Propaganda Ministry and the SS-SD. The Propaganda Ministry had been confronted by the threat of the SS-SD's aggressive campaign to monopolize authority over Jewish policy. To protect the Propaganda Ministry's position, Hinkel opened negotiations in May 1938 with the SD's Section II 112, which specialized in Jewish matters.[100] Despite the institutional rivalries, the liaison offered practical advantages to both sides. Hinkel provided the SD with sensitive information about Jews, homosexuals, and other ideologically tainted persons still active in the cultural sphere; in return, Hinkel hoped for SD assistance in racial and political investigations of Reichskulturkammer members and applicants. One factor allowing for cooperation between the two rival agencies was that both favored an accelerated purge of the vestigial Jewish presence in German public and economic life.[101] Hinkel certainly showed little personal resistance to cooperating with the SS; he encouraged his immediate staff to join the SS and on several occasions met personally with Himmler in order to discuss censorship and personnel policy in the Reichskulturkammer.[102] His liaison with the SD may have helped advance Hinkel's personal ambitions for promotion within the SS. In September 1940, Himmler approved Hinkel's promotion from SS-Oberführer to SS-Brigadeführer.[103]

As we have seen, Goebbels had often expressed frustration with what he

regarded as the slow pace of the de-Jewification process. The outbreak of war presented new opportunities. In July 1940, bolstered by the recent humiliation of France, Goebbels—who was Gauleiter of Berlin as well as propaganda minister—directed his chief assistants at the Propaganda Ministry to expedite planning for the evacuation of Jews from Berlin to German-occupied Poland. Goebbels expressed hope that "within a period of at most eight weeks immediately after the end of the war, . . . all 62,000 of the Jews still living in Berlin" would have been deported to the east. The report of this meeting goes on to state: "Hinkel reported on the evacuation plan already worked out with the police. It should make certain above all else that Berlin would be first in line to be purified, as the Kurfürstendamm will retain its Jewish face . . . until Berlin is really free of Jews. Only after Berlin will the other Jewish cities (Breslau, etc.) receive their turns."[104] At a 6 September meeting of Goebbels's staff, Hinkel issued an updated report on evacuation plans for both Berlin and Vienna. He noted that while good progress had already been made in Vienna, Berlin still had 71,800 Jewish residents. Hinkel assured the conferees, however, that sixty thousand Jews would be removed from Berlin to the east "within four weeks" of war's end, while the remaining twelve thousand "would also disappear" within an additional four weeks.[105] Except for the records of these conferences at the Propaganda Ministry, documentation is lacking on the nature of Hinkel's involvement with these plans. The precise numbers cited in his presentations suggest that his involvement was more than casual.

Hinkel's most thorough briefing for his colleagues at the ministry (including Goebbels) came at a conference on 17 September 1940. Hinkel supplied a demographic breakdown of the "72,327 Jews still in Berlin," as well as more general statistics on the four million Jews living in German-occupied Europe. Hinkel then reported on the Madagascar Project, which envisaged the transfer of "about three and a half million Jews" to the remote island in the Indian Ocean. The Madagascar plan, which had originated in the Foreign Office in the late spring of 1940, had been approved by Himmler and Hitler in summer 1940. Further particulars were worked out by Adolf Eichmann's staff in the Reich Security Main Office (RSHA), which submitted its detailed plan in mid-August.[106] It seems likely, then, that Hinkel had been assigned the task of maintaining contact between the RSHA and the Propaganda Ministry. Unfortunately, the available documentation tells us little else about Hinkel's role in these events.

As the war dragged on, plans for the deportation of Jews to the east or to Madagascar proved unrealistic and were shelved in favor of the "final solution." In connection with the decision to perpetrate mass murder, the SS was granted a virtual monopoly over Jewish policy at end of July 1941.

By this time, German forces were driving deep into the Soviet Union, enabling German *Einsatzgruppen* to carry out large-scale massacres of Jews in the east. On 14 October, Germany began to deliver its own Jews to the ghettos, concentration camps, and extermination centers in the east. In these circumstances, the Kulturbund had lost its utility to the regime. In 1940 and 1941, constraints on Kulturbund activity intensified considerably. In September 1941, the Gestapo dissolved it.

Other Victims of Paragraph 10

The National Socialist conception of "dangerous" or "undesirable" extended well beyond those "tainted by Jewishness" (*jüdisch belastet*). Several other categories of persons were also systematically expelled or rejected by the Kulturkammer. Paragraph 10 served as the basis for these exclusions as well. We have seen how the Kulturkammer applied the flexible language of Paragraph 10 in the face of pressure from Schacht and in response to changes in the system of racial classifications. The evolution of Kulturkammer policies toward several other targeted groups was marked by an essentially similar improvisation.

The case of the gypsies is a good example. During the first several years of Nazi rule, gypsies were treated essentially as an "asocial element," along with vagrants, prostitutes, and others deemed to be useless to society. Gradually, however, official policy toward gypsies shifted to accord with the party's "scientific" racism. At the same time, the authority to deal with the gypsy "nuisance" was centralized in the SS. In March 1939 Himmler elaborated upon the importance of the German "struggle" against gypsies: "the aim of the measures taken by the state must be the racial separation once and for all of the gypsy race from the German nation."[107]

The cultural sector most directly affected by Himmler's decree was the Music Chamber, which contained several dozen gypsy musicians. The chamber's president, Peter Raabe, vowed in May 1939 that he would act in the "spirit" of Himmler's policy. But he added that existing directives from Himmler should not be interpreted to mean that gypsies should be automatically excluded from the chamber. Instead, the Music Chamber would examine the "reliability" of its gypsy members and would invoke Paragraph 10 accordingly.[108] Raabe's statement may well have been intended to provide legal camouflage for an expulsion process that from the very outset was intended to purge gypsies on purely racial grounds. In February 1940 the Music Chamber began to run lists of expelled gypsy members in its official newsletter.[109] Similar lists appeared through much of 1940. The reason for

expulsion of each person listed was indicated by the simple word "gypsy" (Zigeuner), which suggests that mere classification as a gypsy had come to be regarded as sufficient justification for exclusion under Paragraph 10.

Unlike the relatively precise classifications that governed treatment of non-Aryans like Jews and gypsies, guidelines covering "political unreliability" were often very vague and therefore quite flexible. Political cases were indeed usually considered on their own individual merits. Evaluation of an applicant's political tendencies left greater latitude for interpretation by Kulturkammer officials than did the iron logic of racial definitions. A letter sent by the Landeskulturwalter for South Hanover–Brunswick to the local NSDAP office in August 1938 provides an especially succinct summation of the Kulturkammer's philosophy toward expulsions on political grounds. The Kulturkammer resorted to expulsion only in cases where the "people's comrade in question" continued to "show that he is not aware of his obligations to the people's community" or continued to "abuse his activity for destructive purposes" despite having received the "most diverse and emphatic warnings."[110] Consequently, before the war, the Music, Theater, and Visual Arts Chambers expelled members only rarely on grounds of political misconduct, either in their art or in their private lives.

Most prominent leftists and exponents of artistic modernism had, of course, fled from Germany in 1933, before the Kulturkammer's creation. For the few who remained, permissive chamber membership guidelines offered the possibility of rehabilitation, provided that they were prepared to channel their creative energies in directions acceptable to the new regime. Barbara Miller Lane has shown how several architects connected with the Bauhaus movement, one of National Socialism's cultural bêtes noires during the Weimar era, quietly carried on with their careers, although not with their preferred brand of architecture, in Germany after 1933.[111] Even Ludwig Mies van der Rohe attempted a reconciliation with the regime before his emigration in 1938.[112] "Internal emigration," a concept often applied to intellectuals, was possible for artists as well. Hannah Höch, an original member of the Dada movement, continued to paint quietly, without exhibiting, during the entire course of the Third Reich. In order to gain access to rationed art supplies, made sparse by the war economy, Höch applied to the Visual Arts Chamber in 1942 and was admitted.[113] Hanning Schröder, a violist, relates a fascinating tale of how he "passed the winter" of the Third Reich. In the Weimar Republic, Schröder had been involved with the communist workers' choir movement in Berlin, where he had befriended composer Hanns Eisler and had met Communist party leader Ernst Thälmann. After the Nazi takeover, both Schröder and his wife Cornelia, a half-Jewish musicologist, were expelled from the Music Chamber. Later, how-

ever, because he was recognized as a high-quality musician, Schröder received a special dispensation to earn his living through music. He found work as a violist in several ensembles and spent the war recording musical soundtracks for film and performing in the orchestra of Berlin's Nollendorf Theater.[114]

The chambers' treatment of persons with communist pasts could indeed be remarkably flexible. In 1935, the thirty-nine-year-old illustrator Carola Gärtner was convicted of treason as a consequence of her activity in the illegal Communist party in 1934. After serving a three-year sentence, Gärtner proposed to resume her artistic career, for which she needed membership in the Visual Arts Chamber. No less a personage than Reinhard Heydrich, chief of the SD, signed a letter on Gärtner's behalf, testifying that she had been rehabilitated during her incarceration and that she possessed "talent, taste, diligence, and the necessary artistic ambition." The chamber admitted her in 1941.[115] Although Gärtner's case was exceptional in that it involved the intercession of an extremely powerful official, it was by no means the only instance in which a chamber granted membership to a convicted "traitor." The Visual Arts Chamber readmitted commercial artist Alfred Gravenhorst in May 1942 after he had served a least one year in prison for treason.[116] Hanns Minnich, an actor and dramatist, was convicted in 1933 for distributing communist propaganda. After his release from prison, Minnich applied for Theater Chamber membership. In June 1936, the chamber rejected him on grounds of his prior conviction. The chamber had also suspected that before 1933 Minnich had distributed communist "directives and literature" behind "the cloak of a harmless actor." Yet by April 1937 the chamber had reconsidered Minnich's case and had reversed its decision, mainly on the recommendation of the intendant of the theater in Heilbronn. Minnich had "conducted himself upstandingly" since his release from prison, and the chamber believed that he should receive the opportunity to work lest he become dependent on the welfare system.[117]

This approach also reflected a belief in the possibility for rehabilitation of political offenders, an option that was unavailable to people of the wrong race. Higher authorities in the Third Reich reinforced such generosity to ex-convicts. In 1938, when interceding in a specific case involving a sculptor, the NSDAP party chancellery issued a *general* philosophy to be followed by the chambers. As a Kulturkammer official noted in a memorandum several years later, the party chancellery had "demanded that under all circumstances" the chambers should follow the "principle according to which ex-convicts (*Vorbestrafte*) have atoned for their guilt with the serving of their sentences, and no obstacles should be placed in the way of the further practice of their profession."[118]

The elasticity of the Kulturkammer's policy toward political suspects is further illustrated by guidelines applicable to the evaluation of former Freemasons.[119] Masonry, it seems, had become quite popular over the centuries among German artists, a fact that led the exasperated Goebbels to lament in his diary, "What is one to do with all of the former Freemasons!"[120] In 1936 the Reich Ministry of the Interior had issued regulations governing the employment of former Freemasons in the civil service. The Kulturkammer soon adopted these guidelines for use in its own membership decisions. The guidelines fundamentally differentiated between ex-Freemasons who had left their lodges after 30 January 1933 and those who did so before the Nazi seizure of power. Persons in the former category were to be considered highly suspect. Those in the latter category were to be evaluated on the basis of whether they had joined or "deserved well" of the NSDAP prior to its seizure of power, whether they had held leading positions in their lodges, whether they had attained a high "degree" in the Masonic organization, and whether they had retained connections with the Masons since their departure. "Mere prior membership in a lodge" was not in all cases to be "viewed as a deficiency of the reliability necessary for practice of the profession"; rather, "the condition of unreliability" had to be proven by the "existence of broader circumstances."[121]

Perceived sexual deviants fared worse than those who had strayed politically. During the Weimar years, Nazi propagandists and other cultural conservatives had repeatedly pointed to the decadent influence exercised by supposed cliques of homosexuals in the art and entertainment fields. From the Nazi standpoint, homosexuality represented a highly threatening form of social deviation. Equally important, homosexuality constituted a serious offense against Nazi racial doctrine, often resulting in severe eugenicist solutions, as recent research into sterilization measures has established.[122]

In the Third Reich, (male) homosexuality was a crime prosecutable under Paragraph 175 of the Reich Criminal Code. For its part, the Chamber of Culture treated homosexuals in much the same way that it did other categories of criminals. Generally speaking, the Kulturkammer took no drastic measures against members who were merely suspected of homosexual activity, though its functionaries did meticulously record for future reference any reports of alleged homosexual encounters that it received from the SD or the Gestapo.[123] The Kulturkammer took action on the basis of Paragraph 10 only after it had received confirmation of a conviction on the basis of Paragraph 175.[124]

Subsequent to their conviction, numerous so-called 175ers were expelled from the Kulturkammer. But conviction did not automatically mandate exclusion. The Propaganda Ministry, in a quiet "internal directive" in effect

until 1942, instructed the chambers that members who received Paragraph 175 sentences of less than six months should not, as a general rule, be subject to expulsion.[125] Accordingly, the chambers seem to have employed a system of disciplinary measures modulated according to the seriousness and circumstances of each case. For example, in 1936 painter Egon Adam was convicted under Paragraph 175 and sentenced to four months in prison. The Visual Arts Chamber permitted him to retain his membership, albeit with a clear warning that recidivism would result in certain expulsion.[126] In 1937, ballet director Edgar von Pelchrzim received a two-month sentence for his Paragraph 175 conviction. The Theater Chamber allowed him to keep his membership, issued him a warning, and, for good measure, fined him RM 300. When von Pelchrzim was convicted again in 1944, the chamber kept its word and revoked his membership.[127] In 1939, opera singer Boris Greverus, who had received a nine-month sentence, retained his Theater Chamber membership but was forbidden by the chamber from participating in entertainment programs for German army troops.[128] Presumably the intention here was to keep persons with homosexual "predispositions" away from the German armed forces, which were busily attempting to root out homosexuals from their own ranks.[129]

The flexible approach to the purge of homosexuals is perhaps best exemplified by the case of the celebrated actor and director Gustaf Gründgens, whose homosexuality was an open secret in the Third Reich. Both Goebbels and Hitler were "aghast" by what the former characterized as the "swamp" of homosexuality that Gründgens had ostensibly encouraged at the Berlin State Theater.[130] But Hermann Göring, who as minister-president of Prussia oversaw the State Theater, interceded to insulate Gründgens from the consequences of Paragraph 175. Hinkel, whom Göring had severely reprimanded for attempting to discipline Gründgens,[131] was incensed at Göring's protection of supposedly incorrigible perverts at the center of German theater life.[132] Most gay targets of the cultural purge possessed neither Gründgens's talent nor his good fortune. Nonetheless, because the Gründgens case so clearly underscored the potentially embarrassing ramifications of purging homosexuals from the arts, it may well have exerted a moderating effect on chamber measures against other gay artists. One indication of the regime's sensitivity to such embarrassment was an unusual order issued by Heinrich Himmler in October 1937, which required German police to secure Himmler's permission before arresting artists or performers for sexual offenses, unless the culprits were caught "in the act."[133]

The chambers' approach to homosexuality conformed to the general pattern of gay persecution in Nazi Germany that has been described by Richard Plant: hardcore "libidinal felons" were treated more severely than

persons for whom homosexual encounters were deemed aberrational. The Kulturkammer showed little mercy for persons convicted on multiple counts or for those whose convictions involved "seduction" or "attempted seduction" of a minor. Both sorts of behavior reflected an incorrigibility that could not be tolerated. Moreover, even the tolerance initially granted to first offenders who had received short prison sentences seems to have evaporated during the later stages of the war. Infractions that probably would have provoked warnings in 1936 regularly resulted in speedy expulsions in 1944.[134]

Although in most cases the chambers received information about homosexuality convictions (or suspicions) from the police or the court system, occasionally they uncovered such illicit activities through their own control networks. In 1937, Music Chamber control officers in Berlin claimed to have uncovered two separate homosexual rings. In one of the cases, a female piano teacher and two assistants allegedly orchestrated "sadistic and homosexual functions" behind "the cloak of piano instruction." With help from the police, the Music Chamber caught the group "in the act." In the other case, Music Chamber controllers stumbled upon two "homosexual women's clubs" while investigating Jewish musicians who had been expelled from the chamber. Acting on the Music Chamber's tip, the Gestapo broke up one of the groups, the Sportverein Sonne, taking "a bunch of Jewish women and persons of minor age" into custody.[135]

Conviction for routine, non-sexual or -political crimes could also leave chamber members vulnerable to expulsion. As an essential component of the effort at "professional purification," the chambers systematically rooted out members who threatened to bring "shame" or "dishonor" to their Stand. The chambers' personal files in the Berlin Document Center contain many cases involving disciplinary measures imposed on members convicted of fraud, embezzlement, theft, and so on. If the files can be believed, some artists displayed a remarkable propensity for common criminality. In 1936, the Music Chamber expelled musician Hans Rabe, who had amassed eleven convictions for theft, fraud, and embezzlement. Peter Raabe, who signed the expulsion letter, noted a lack of "required moral reliability" as the grounds for expulsion.[136] Willi Wepner, a musician convicted of "document falsification" in 1936, was informed that his expulsion from the chamber was necessary lest he again damage the "professional honor" of the "German musicians' estate."[137] The chambers did not always allow for the possibility of rehabilitation. In 1938, Adam Seitz applied for membership in the Visual Arts Chamber, hoping to become an art dealer. When the chamber discovered that Seitz had been convicted on nine separate occasions between 1923 and 1931 for crimes including fraud, embezzlement,

and illegal export, it refused even to process the application, even though Seitz had served his time.[138]

In the artistic and cultural sphere, as in other influential professional and economic sectors, the Nazis were driven by a highly developed anti-Jewish paranoia, which had been fueled by the conspicuous success of people with Jewish backgrounds in German cultural life prior to 1933. Although Jews constituted a small minority of the population professionally active in cultural affairs, they were sufficiently noticeable and numerous to become a preoccupation for Nazi cultural theoreticians and propagandists. The same did not hold true for the other groups examined above—with the exception of communist cultural figures, for whom the iron logic of Nazi racial doctrine did not apply as it did for Jews. Without diminishing the personal tragedy that befell any other victims of Paragraph 10, we may conclude that the purge of Jews was the most thorough and inexorable. With the exception after 1939 of the gypsies (at any rate a very small group), ostracism of non-Jewish people was subject to case-by-case interpretation, whereas Jews were regarded a priori as unacceptable and were eligible for special dispensations in only a tiny number of cases. The purge of Jews was pursued more vigorously and was undertaken from the very beginning of the regime with a greater sense of urgency than was the elimination of any other group. This plain fact ought not to become obscured at a time when historians are, justifiably, devoting increased attention to the non-Jewish victims of National Socialist persecution.[139]

The Apparatus of Censorship, 1933–1939

The Third Reich's omnipresent system of artistic censorship has remained strangely elusive to the historian. Far from the stereotype of the coldly efficient, centralized, totalitarian model of control, it was a fluid and amorphous agglomeration of official proscriptions, unofficial pressures, and self-imposed constraints. Improvised amid the early power struggles of the Nazi era rather than erected from a master plan, its structures were asymmetrical, ambiguous, and often contradictory. Hitler, Goebbels, Rosenberg, and other members of the Nazi elite set the boundaries of ideologically acceptable art in speeches, articles, and directives. General guidelines were occasionally implemented through the means of detailed blacklists issued by the Propaganda Ministry or the culture chambers. This form of direct coercion by the state had the notable effect of creating an environment of anxiety in which self-censorship by artists became the norm. Knowledge

that the regime was prepared to use its coercive power deterred most artists from giving it the opportunity to do so. Although systematic precensorship became increasingly common as time passed, the artists' own self-imposed ideological discipline remained the key to the system.

After 1935, the Propaganda Ministry steadily expanded its censorship prerogatives and asserted them with increasing frequency and boldness, often using the Kulturkammer to enforce restrictions. But despite progressive centralization under the Propaganda Ministry, a plethora of public and party agencies continued to carry out censorship functions throughout the Third Reich. State and local governments, which controlled the pursestrings of most orchestras, theaters, museums, and training academies, could influence the direction of artistic creation and performance through hiring policies, repertoires, exhibition guidelines, and curricula. Nazi Gauleiter, who had the power to intrude into almost every domain of public life, could profoundly affect cultural institutions located in their districts. Nazi mass organizations such as the SA or the Hitler Youth sometimes decreed artistic taboos applicable to their own members. Alfred Rosenberg's NSKG, although devoid of formal authority, could bring aggressive propaganda to bear on the Propaganda Ministry and other agencies.

Thus the chambers constituted but one element in a broad institutional framework of censorship. Initially endowed with considerable autonomy, after 1935 they became increasingly subject to the will of Goebbels and the Propaganda Ministry. But because the chambers retained a good deal of discretion over the details of policy implementation in the area of censorship, they remained far more than a mere transmission and enforcement mechanism for Propaganda Ministry directives.

In 1933, police censorship, informal terror, and National Socialist control of state and local government combined to put an end to the most pronounced manifestations of "cultural bolshevism" in Germany. The smashing of the Communist party brought with it the suppression of agitprop theater and the activities of such groups as the ASSO. In the more mainstream cultural institutions, the new regime implemented massive dismissals of theater intendants, orchestral directors, and museum directors even before the Civil Service Law of 7 April 1933.[140] In established theaters, leftist pieces quickly disappeared from the stage. Konrad Dussel, who has conducted a quantitative analysis of theater programming at five provincial theaters between 1919 and 1944, has demonstrated that leftist and modernist works, which had accounted for over 15 percent of theater programming between 1928 and 1932, virtually disappeared during the 1933 season.[141]

Nonetheless, in its early years the regime's approach to objectionable art was uneven and ambiguous. Disagreeing over tactics and sometimes over

aesthetic interpretation, Nazi officials transmitted mixed signals to the German art world. We have already seen how in 1933 and 1934 Goebbels tolerated, to an extent even championed, certain strains of expressionist painting, even as Alfred Rosenberg, Paul Ludwig Troost, and other dogmatic antimodernists publicly condemned the propaganda minister's permissiveness. Goebbels was not the only target of the extremists' wrath. Bernhard Rust's ministry, which retained jurisdiction over art museums, also attracted severe criticism for failing to remove modernist objects from state art collections. The collection of modern works housed at the Crown Prince Palace in Berlin was perhaps the best example of the Rust ministry's toleration. The museum's director, Eberhard Hanfstaengel, had been placed in charge by the Rust ministry in early 1933. Although a conservative by inclination, Hanfstaengel was a professional who recognized the validity of modernism. Until the summer of 1937, Hanfstaengel successfully resisted pressure to close the museum's permanent exhibition of twentieth-century art, which included works by Nolde, Beckmann, Klee, and Kandinsky. Even as the modernist pictures remained on public display in Berlin, museums elsewhere in Germany had not only taken down their own modernist works but in several cases—in Karlsruhe, for example—had included them in local exhibitions of "degenerate art."[142]

In the absence of a central censorship authority, the mixed signals sent by the Nazi leadership fostered insecurity among local cultural administrators. To insulate themselves against political attacks, local officials took it upon themselves to request written opinions from higher authorities. In August 1933, for example, Hinkel, serving as head of the Prussian Theater Commission, received an inquiry from Hamburg's Thalia Theater about the acceptability of Franz Arnold's *Da Stimmt was nicht*. There had been a rumor that Goebbels had responded negatively to the play. The theater wanted Hinkel's blessing before moving forward with the production; Hinkel obliged.[143] Similar inquiries inundated the office of Rainer Schlösser, the newly appointed *Reichsdramaturg* and head of the Propaganda Ministry's theater department.[144] Not surprisingly, Hinkel and Schlösser sometimes worked at cross purposes. In March 1934, Hinkel informed theaters and concert managers that the works of Meyerbeer and Offenbach could still be performed, despite the Jewish backgrounds of the composers. Schlösser, however, disagreed with Hinkel and informed theaters to that effect. (Schlösser did, however, allow an exception for *Tales of Hoffmann*.) The confusion generated by such disagreements at the top confused and aggravated local officials. Acting on Hinkel's advice, the theater in Koblenz performed three operettas by Offenbach. Outraged local Nazis lodged vociferous complaints with Schlösser.[145] To Goebbels, such ambiguities

pointed up the urgent need for central direction in the area of artistic censorship. Goebbels pleaded with theater operators to accept only Propaganda Ministry guidance on prohibitions.[146]

It was in the realm of theater that Goebbels won his first major victory in consolidating censorship authority in the Propaganda Ministry. On 15 May 1934, the Reich Cabinet—in effect, Hitler—issued the Theater Law.[147] This law invested the Propaganda Ministry with complete authority over all theater licensure, encompassing both public and private theater enterprises. Whereas in the past theater censorship had been a matter for the police and the judicial system, under the Theater Law it became the administrative responsibility of the Propaganda Ministry, which would act in conjunction with the Theater Chamber, the institutional representative of the theater estate. Henceforth, police could prohibit performances only when there was "an immediate danger to public security and order." All licensees, whether individual or institutional, required Theater Chamber membership. The ministry reserved the right to reject or revoke a license when "reliability, aptitude, or economic viability" was wanting. Theater operators were expected to conduct themselves "according to the best artistic and moral convictions" and with a "consciousness of national responsibility." In addition, the law empowered the ministry to prohibit productions or to demand the performance of certain works that were deemed "necessary" for the "fulfillment of the cultural mission of the theater." Appointment of directors, intendants, and music directors required ministry confirmation.[148] In an Implementation Decree to the Theater Law,[149] Goebbels assigned to the Theater Chamber the responsibility for processing license applications. This move was made in the neocorporatist spirit, for as one ministry official explained, the "investigation of reliability and aptitude of applicants" should take place "in [a] framework of professional estate self-administration." Of course, in cases of disputes or appeals, the minister reserved the ultimate judgment for himself.[150]

Goebbels jealously protected his authority over the theater. In October 1936 he informed the governments of the German states about cases in which certain NSDAP and government agencies had attempted to influence theater programs. Goebbels did not identify the guilty agencies but asserted that theater intendants had been subjected to "intimidation." The force of Goebbels's reaction to these incidents is instructive. Invoking the "express approval of the Führer," Goebbels reminded the state governments that the power to prohibit or to demand performance of specific pieces resided "singly and alone with me." Attempts by other agencies to exercise this power were "against the law and forbidden." Goebbels warned: "Measures of this kind are not allowed and will be rescinded without exception."[151]

The ministry-chamber system for theater licensure was tantamount to a comprehensive framework for precensorship. Beginning early in 1935, all license applications had to include complete programs for the upcoming season as well as comprehensive data on theater personnel. In practice, theater licenses were granted for periods ranging from one to six months.[152] Yet the available evidence suggests that the system was not uncomfortably intrusive for most theaters. Most license applications were approved routinely. From April to August 1936, the Theater Chamber processed 124 applications, turning down only three. Two of the three rejections were justified on economic, not political grounds. The chamber prohibited Karl Bürstlein from founding a new theater company in the Hessen-Nassau district because officials believed that the theater lacked sufficient startup capital. In the second case, the chamber revoked the license of Willy Hünnes, director of an operetta theater in Cologne, for reasons of economic mismanagement: Hünnes could no longer pay his actors. Unfortunately, the file provided no reason for the third rejection.[153]

This high rate of licensure approval in 1936 reflected the fact that the regime had already brought the German theater into line through its selection of leading personnel at theaters. With "reliable" people in place, the regime no longer needed to struggle with extreme manifestations of degeneracy or "cultural bolshevism" but needed only to fine-tune theater programming. Little had to be banned formally, because the licensure system deterred theaters from placing potentially problematic works on their season programs. Moreover, publishers of theatrical scripts had developed the habit of routinely clearing new works with the *Reichsdramaturg* before publication.[154] Although this procedure was not formally required, it insulated publishers against the political and financial consequences of a postpublication ban. These practices enabled Schlösser to boast of his own self-restraint. Speaking to a public assembly of Theater Chamber officials, Schlösser maintained that "[to] direct, not command" was his guiding principle.[155] Privately, Schlösser observed in 1939 that the centralized structure and relatively small size of the German theater world had given him the luxury of avoiding the kind of crude blacklisting to which music and literature censors had been forced to resort.[156]

Schlösser had provided a good example of "directing" in April 1935. After reviewing upcoming theater programs, Schlösser bemoaned excessive foreign influence over the German theater, evidenced by the "disproportion in the number of foreign to German authors." He observed, "This situation stands in direct contradiction to the goals of National Socialist cultural policy." Contemporary German drama had been especially disadvantaged. In the future, therefore, theater programs would have to contain a four-to-

one proportion of German to foreign pieces.[157] Similarly, in 1939 Schlösser compelled German opera companies to pay more attention to contemporary German music, insisting that every opera company stage at least one new production of a German opera composed after 1900.[158]

Just as the theater licensure process could dissuade theater operators from moving outside the ideological bounds established by the regime, it could be used to promote the economic interests of the theater profession. Theater Chamber officials, addressing the still severe problem of unemployment and underemployment among chamber members, exploited the Theater Law to harass or to close down amateur theater ensembles. In Baden, for example, local chamber officials denied licenses to amateur theater ensembles in 1934 in order "to protect the domain of the professional artist against abuses by artistically unprepared persons." Amateur performances could not be accessible to the general public but had to be restricted to members of the sponsoring organization. Acting on the chamber's request, the minister of the interior in Baden gave teeth to the restrictions by ordering the police to prevent performances that had not been authorized by the chamber.[159]

Inevitably, police interference with amateur performances caused friction, especially in towns and villages in the countryside. As the Reich governor in Baden complained to the Propaganda Ministry, "the population in the countryside does not understand" why amateur performances had from now on to be closed to general access. Amateur theater had become an established social custom in which all segments of society, especially youth organizations, participated. Because of their emphasis on local *Volkstum*, the plays served as "an excellent medium for education in a combative-heroic sense, which National Socialism should not let escape." In March 1935, in response to similar complaints from all corners of the Reich, the Propaganda Ministry overruled the Theater Chamber, stipulating that amateur theater performances could be banned only on political grounds.[160]

Even more invasive into the realm of grassroots culture were Theater Chamber measures targeted at the Catholic church. In 1935 Nazi authorities began to suppress theater performances sponsored by Catholic congregations and organizations. Nazi officials believed that these productions, which often served as fund-raising functions, impeded the success of similar programs underwritten by the KdF and other Nazi organizations. Moreover, they suspected that the church productions had the aim of "alienating" young Catholics from the Hitler Youth. Thus, in May 1935 the Reich Interior Ministry prohibited churches from producing theatrical events that were not directly related to the spiritual responsibilities protected by the Concordat of 1933.[161]

As the regime's efforts to destroy the social and cultural infrastructure of German Catholicism intensified in the late 1930s, much energy was devoted to monitoring and, when possible, suppressing church-sponsored musical and theatrical programs.[162] The Theater Chamber collaborated with police in curtailing such church activities. Because the Theater Law stipulated minimal police interference in the affairs of theaters licensed by the chamber, it was theoretically possible for a church organization to insulate itself from the police by receiving a chamber license. The Theater Chamber assured the Gestapo that it would refuse to issue licenses to church organizations,[163] although exceptions were possible for groups that had demonstrated support for National Socialism "without reservation"—a standard that few Catholic organizations could meet.[164] In an attempt to forestall negative publicity arising from the rejection of license applications, the chamber avoided any reference to political objections and instead relied on the pretext that religious organizations lacked the legal standing to hold theater licenses.[165] The chamber thus sought to camouflage even this most blatant form of ideological censorship.

During the Christmas season of 1937, the Theater Chamber broadened its role in the suppression of Catholic theater performances. Schlösser, with Goebbels's approval, extended the ban to plays performed in conjunction with Christmas holiday festivals. The plays often contained subtle, and sometimes not-so-subtle, criticism of the regime. The Reich Propaganda Office in Munich pointed out the urgency of not permitting the Catholic church to become an "oasis" where the normal controls on theater did not apply.[166] In Schlösser's view, the Catholic church was "exploiting" holiday activities "for the purposes of political Catholic propaganda."[167] From this point onward, the Theater Chamber would routinely refuse to grant licenses for such performances. However, Schlösser recognized the practical necessity of allowing exceptions for traditional events that were "long-standing" and "rooted in the soil," such as the Oberammergau passion play.[168]

A comprehensive licensure system similar to that established for theater would not have been practical for music, as musical activity in every German community was far too decentralized and extensive. The regime instead relied on close monitoring of concert programming, combined with the deterrent effect of Paragraph 10. In order to avoid embarrassing implications, both the ministry and the Music Chamber preferred not to rely on blacklists. Official proscriptions were uncommon and, early in the regime, were issued quietly. In September 1935, the ministry issued a list of "musical works allowed under no circumstances."[169] The list contained the names of 108 composers, primarily non-Aryans, whose compositions could

be neither publicly performed nor broadcast. The proscribed composers included Alban Berg, Ernst Bloch, Aaron Copland, Jascha Horenstein, Otto Klemperer, Serge Koussevitzky, and Arthur Schnabel—but, notably, not Felix Mendelssohn. The list was not published, not even in the official Music or Theater Chamber gazettes. Goebbels wanted the list distributed to theater intendants and concert managers only.[170] In the following month, October 1935, the Music Chamber openly announced an Order Concerning the Publication and Distribution of Emigrant Works.[171] This was the chamber's first effort at precensorship screening. The order stipulated that publishers and dealers had to receive chamber clearance before the publication or dissemination of sheet music for works composed by "persons who have left the German Reich after the seizure of power by National Socialism."

It was also in 1935 that the Visual Arts Chamber instituted its first formal censorship procedures. On 10 April, Goebbels empowered the chamber to approve all art exhibitions in advance.[172] The scope of the order was all-encompassing. Interpreted literally, the order introduced systematic Visual Arts Chamber precensorship of all public exhibitions, whether commercial, communal, permanent, or temporary. Bernhard Rust acted quickly to fend off this clear effort by Goebbels to expand Propaganda Ministry authority over state museums through such an order. Rust issued explicit instructions to subordinate agencies to ignore the 10 April order. Goebbels soon backed off, allowing public museums to organize exhibitions without chamber approval or oversight.[173]

A scarcity of Visual Arts Chamber documentation makes it very difficult to reconstruct how rigorously the chamber reviewed applications for exhibition licenses. One file that has survived in the Berlin Document Center contains paperwork dealing with exhibitions in Berlin between 1935 and 1940. The vast majority of the applications seem to have been routinely processed and approved. When major reservations arose, the cause tended to be economic rather than ideological in nature. The chamber showed special concern for exhibitions that would feature works by non-chamber artists, sponsored by such organizations as the National Socialist Teachers League. The chamber often approved such exhibitions by amateur artists on the condition that none of the exhibited objects be put up for sale.[174]

The Propaganda Ministry's powers of censorship began to expand at an accelerated rate after 1935. Goebbels moved boldly to outmaneuver competing agencies, especially the Rust ministry, and then used his enhanced authority to enforce a more orthodox National Socialist agenda in the arts. In 1936 and 1937, the minister used the Reichskulturkammer in a multifront campaign against musical atonality, jazz, degeneracy in the visual arts, and political humor in the cabaret. Ironically, then, Goebbels, who in

the regime's early phase had been branded by Nazi hard-liners as too liberal, emerged in the late 1930s as the regime's chief enforcer of the artistic hard line. Although he would have preferred to preserve a modicum of pluralism in German cultural life, Goebbels ran the risk of alienating himself from radical elements of the National Socialist movement who did not share his vision. He therefore increasingly adjusted his own approach to conform to the radicalization that began to take hold in the regime after the conclusion of the 1936 Olympic Games and the attendant departure of large numbers of foreign visitors.

Goebbels was confronted with an unfortunate by-product of his leniency in the early summer of 1936. In June, Peter Raabe presided over the annual new music festival sponsored by the ADMV in Weimar, at which Goebbels was to be an honored guest. The festival's program included works by several composers whom Nazi fanatics had denounced as "atonal," such as Hermann Reutter, Hugo Herrmann, and Heinz Tiessen. Reutter's music, for example, had been condemned by the *Völkischer Beobachter* in February 1933 for possessing "all of the characteristics in order to be placed in the category [of] bolshevism in music."[175] Upon his arrival in Weimar, Goebbels was informed about the festival program by Hans Severus Ziegler, a powerful Nazi cultural functionary. Goebbels canceled his plans to attend the festival, reboarded his airplane, and flew back to Berlin.[176] To spare himself such potential embarrassments in the future, Goebbels resolved to disband the ADMV.[177] The venerable organization, which had been founded by Robert Schumann, held its last festival in 1937. The Music Chamber developed the "Reich Music Days" as a replacement for the ADMV festival; the first such event, held in 1938, celebrated music grounded in military and nationalist traditions and was accompanied by an exhibition documenting the history of degenerate music.[178]

In conjunction with the dissolution of the ADMV, the Music Chamber attempted to achieve greater influence over the direction of contemporary serious music. In 1937 the chamber initiated a program for subsidizing the purchase of sheet music for compositions by living, ostensibly underappreciated German composers. Between 1938 and 1942, the chamber dispensed over RM 50,000 for this purpose, drawing on royalties collected from performances of pieces by more popular and financially successful composers. The bulk of the assistance went to orchestras outside of Germany's major cultural centers—for example, those in Koblenz, Rostock, Flensburg, and Liegnitz.[179]

Further fueling the trend toward greater political oversight of music was the persistent popularity of jazz, especially among German youth. In this respect, Goebbels had an ally in Peter Raabe, who detested jazz and pledged

to expunge it from Germany.[180] At first, Goebbels's sensitivity to Germany's international image had been an obstacle to the ambitions of antijazz Nazis who wanted to stamp out this "nigger music." Because Goebbels allowed jazz to be played on the radio, Raabe could hardly ban live performances. But in the absence of official measures, antijazz elements in the Music Chamber did what they could to make life difficult for jazz musicians. For example, one Music Chamber control officer named Woschke consistently harassed jazz ensembles during his rounds through Berlin locales. Such harassment, tolerated by the Music Chamber leadership, constituted a form of censorship "from the bottom up" that went beyond officially stated policy.[181]

Goebbels allowed the Music Chamber to institute formal controls on jazz music beginning in late 1937. In December, the Music Chamber issued an Order Concerning Undesirable and Dangerous Music.[182] The order extended the prepublication screening of sheet music that had been imposed on works by emigrants in October 1935. This new order stipulated that all foreign music required clearance before publication or distribution with a newly created Reich Music Examination Office (Reichsmusikprüfstelle) in the Propaganda Ministry. Little is known about how the Reichsmusikprüfstelle functioned. It was certainly never a very large bureau: its budget for 1942 provided for only four employees, including a secretary,[183] although it may have had a larger staff in earlier years. The Musikprüfstelle may well have prevented the publication of many musical works, but this is difficult to verify from extant ministry or Music Chamber records. The most visible products of the agency's work were its lists of "undesirable" compositions. The first such list, dated 31 August 1938, appeared in the Music Chamber's official gazette on 1 September. It contained only twelve entries and was obviously aimed at jazz, for the entries consisted mainly of American and American-inspired popular works. The number of compositions actually proscribed was somewhat higher than the number of entries, for the list included the complete works of Irving Berlin.[184]

In March 1939, Raabe expanded the jurisdiction of the Reichsmusikprüfstelle. Originally assigned to screen foreign works, the agency could now review *all* music planned for German distribution. Because of the enormity of the task, however, a comprehensive prepublication screening was out of the question. German music publishers were obliged only to submit those works specifically demanded by the Prüfstelle.[185] Notably, in 1942 Raabe suggested universal mandatory submission of newly published music to the Prüfstelle, but the Propaganda Ministry judged such a procedure to be too burdensome and expensive.[186]

In April 1939, the Propaganda Ministry confidentially informed repre-

sentatives of the German press that the Musikprüfstelle, with Music Chamber assistance, had assembled a list of "undesirable music" that would be published shortly.[187] But the list did not appear until 1 September, perhaps reflecting a continued reluctance at a high level to resort to official blacklisting. Moreover, the long-awaited list was remarkable for its brevity: it contained only fifty-four entries, several of which were carryovers from the August 1938 list. Most of the indexed compositions were popular, jazz, or swing-oriented works, although the list also contained the complete works of Fritz Kreisler.[188] In this and subsequent lists and individual proscriptions published during the war, the Musikprüfstelle formally banned a total of about 150 composers or individual works of music.[189]

In conjunction with the listing of "undesirable" compositions, restrictions were placed on dancing. On 13 May 1939, the Music and Theater Chambers issued a joint decree on degeneracy in dance.[190] "Certain manifestations in social dance, in particular several new foreign dances," which would not be "compatible with a racially conscious culture," necessitated official controls. Thus henceforth the "propagation of new-style domestic or foreign dances" would now be made contingent on an "unobjectionability declaration" by the Music and Theater Chambers, to be published in music publications. In the absence of such a declaration, neither a new dance nor the "corresponding music" could be performed or taught.

Although jazz remained an important channel for rebellious, educated, middle-class youth, official measures largely succeeded in driving it underground. As it became increasingly difficult to perform the forbidden music in public locales monitored by the Music Chamber and the police, jazz enthusiasts sought to insulate themselves against official controls by forming secret cells. At the same time, the authorities tolerated, even encouraged, a watered-down, tamed, Germanized form of ensemble dance music that was supposed to function as an ideologically acceptable ersatz jazz but lacked the spontaneity and sensuality of the real thing.[191]

In the late 1930s, political cabaret presented Goebbels with a problem similar to that posed by jazz. Despite the Gestapo's closure of several Berlin locales in 1935, the cabaret had continued to provide a forum for barely disguised ridicule of the Nazi regime. Several of the satirists who had been arrested in 1935, including Werner Finck, had been allowed to return to the stage after their acquittal in October 1936. As a form of entertainment that had become firmly established in the night life of Germany's major urban centers, especially Berlin, cabaret could not be abolished summarily. The Propaganda Ministry explained its position confidentially to the German press in February 1937: "For reasons of work creation" and "for prestige

reasons abroad, the cabaret can not be killed or silenced." Instead, "it will be gradually cleaned up."[192]

The Theater Chamber, which regulated the activities of cabaret performers through its Fachschaft Artistik, took the work creation factor very seriously. In May 1937, chamber officer Ludwig Körner described to his colleagues a case involving a cabaret satirist who had been expelled from the chamber for having a non-Aryan wife. The expulsion adversely affected innocent persons, however. As Körner explained, the expelled member had been the linchpin of his troupe; after the expulsion, the house canceled the contract, hence "four people are lying on the street" without work. In addition to political considerations, Körner believed that chamber officials should review potential "economic and social" consequences before ordering an expulsion.[193]

Goebbels, for his part, wished to grant Finck and the other satirists an opportunity for self-rehabilitation. In March 1937, the minister even attended one of Finck's performances.[194] This magnanimity, however, was short-lived. By December Goebbels had decided to lay the legal groundwork for the "cleansing" promised by the Propaganda Ministry. On 8 December, in his capacity as Reichskulturkammer president, Goebbels issued an order to theater and cabaret operators: "A series of unpleasant occurrences, which have aroused the extreme displeasure of theater, cabaret, and variety audiences, causes me herewith to prohibit every political allusion and every reference to political developments or persons in performances, monologues [Conférencen], announcements, etc." Goebbels's sensitivity to negative publicity that might stem from a crackdown on the cabaret was evidenced by the method used to disseminate the order: it was sent directly to the Theater Chamber and to German state governments with the emphatic stipulation that it not be published. Theater and cabaret operators were to be quietly warned to keep their performers in line. Noncompliance would be punished by expulsion on the basis of Paragraph 10. Goebbels requested that police inform him "immediately" of any violations.[195]

Goebbels's patience with Werner Finck ran out in early 1939. Finck had published a piece full of double-entendres in the Christmas 1938 issue of the Berliner Tageblatt and had mocked the minister in his act at the Cabaret of the Comedians in Berlin. In January, Goebbels expelled Finck and several colleagues from the Theater Chamber on grounds of "unreliability." According to the Völkischer Beobachter, Finck had failed to exhibit a "positive attitude toward National Socialism" and had "thereby given the strongest offense to the public and to party members in particular." In his own front-

page article in the *Völkischer Beobachter*, Goebbels implied that he had intended Finck's expulsion to serve as an example for other political humorists who might be tempted to make National Socialism the object of ridicule.[196]

Goebbels had issued his December 1937 restriction on political humor in cabaret only ten days before the Music Chamber announced its Order Concerning Undesirable and Dangerous Music, which aimed at suppressing jazz. Not coincidentally, both the anticabaret and antijazz measures unfolded in the midst of the Goebbels-led campaign against degeneracy in the visual arts. With the appointment of Adolf Ziegler to the presidency of the Visual Arts Chamber in November 1936, Goebbels had signaled an important shift in his own approach toward the visual arts. Having formerly protected the moderate Eugen Hönig, Goebbels would now use Ziegler to lead a crusade against the remaining manifestations of modernist degeneracy. In the process, Goebbels would extend de facto Propaganda Ministry and Visual Arts Chamber authority over state museums and galleries, which had hitherto operated under the supervision of the Rust ministry and state governments.

Early in 1937, Goebbels decided the time was ripe for a large-scale art exhibition that would emphasize the differences between National Socialist art and the degenerate art of the Weimar Republic. The Propaganda Ministry hoped that the Visual Arts Chamber could organize the exhibition but soon realized that the chamber did not possess formal authority over the degenerate objects in state museums and galleries. To help Goebbels overcome this obstacle, Hitler assented in late June to a special commission for Ziegler. "On the basis of an express commission of the Führer," Goebbels announced, "I hereby empower the president of the Reich Chamber of the Visual Arts, Professor Ziegler, Munich, to select and secure works of German artistic degeneracy in German Reich, state, and municipal possession in the areas of painting and sculpture for the purpose of an exhibition." In early July, a five-man commission headed by Ziegler toured state collections in numerous cities, seizing objects they deemed degenerate both from storage and from public display. The objects were then rushed to Munich for quick installation at the Hofgarten arcade. Goebbels and Ziegler meant for the exhibition to complement the "Great German Art Exhibition" already scheduled to open on 18 July in the new House of German Art. With a scant few days for preparation, the "Degenerate Art" exhibition opened on 19 July, featuring six hundred objects by 110 artists.[197]

Both the sponsorship and the preparation of the exhibition reflected the increasingly hazy delineations between state authority and the "professional estate" of artists. As president of the Visual Arts Chamber, Ziegler confiscated the objects and presided over the exhibition, yet the NSDAP's

Reich Propaganda Leadership, not the chamber, acted as the official sponsor. The hastily prepared exhibition catalog made no mention of the chamber at all.[198]

At the dedication of the House of German Art on 18 July, Hitler issued his most emphatic condemnation of artistic modernism to date. In conjunction with the "Degenerate Art" exhibition, Hitler's speech inaugurated a new phase of the regime's policy toward the visual arts, in which all vestiges of modernism were to be eliminated from German collections. Accordingly, in August Bernhard Rust ordered a thoroughgoing purge of German state collections. The fact that Visual Arts Chamber officials played a central role in this process reflected Rust's inability to resist the encroachment of Goebbels's empire into his own domain. Jäger, the Visual Arts Chamber Landesleiter for Munich, and Emil Stahl, the Landesleiter for Franconia, supervised the purge of collections in south Germany,[199] while in Berlin a chamber Landesleiter named Lederer pressured reluctant museum and city officials to turn over the unacceptable objects.[200]

In March 1938 the Propaganda Ministry announced that the purge had encompassed twelve thousand drawings and five thousand paintings and sculptures.[201] The Visual Arts Chamber held the confiscated works in a storage facility in Berlin until June 1938, when it transferred control of the objects to the Propaganda Ministry.[202] Meanwhile, the chamber tried to arrange the sale or trade of the confiscated objects abroad. Even though unwanted in Germany, the art might fetch some much-needed foreign currency. To remove technical obstacles that might arise from the question-able confiscation of the objects from the state collections, in May 1938 Hitler issued a Law Concerning the Confiscation of Products of Degenerate Art, which retroactively legalized the confiscations and negated all claims to financial compensation.[203] In the years after definitive confiscation, much of the art was auctioned off or sold through dealers at bargain-basement prices. An American purchaser, Alfred Frankfurter, picked up one of van Gogh's self-portraits for 175,000 Swiss francs at an auction in Luzern. Another American collection picked up seven Max Beckmann paintings for $325 in 1941. Financial records show that the works sold or auctioned brought in at least RM 681,394 in foreign currency. The money raised was to be allocated to museums for the purchase of appropriate art. In 1940, the Munich painting collections received RM 100,000 for acquisitions.[204] An unknown number of confiscated objects by obscure artists, which could not be auctioned off, were regarded as "unnecessary ballast" and destroyed. As late as August 1942, however, the Propaganda Ministry still had in storage many works thought to possess potential for sale or auction sometime in the future.[205]

The Visual Arts Chamber benefited financially from the disposal of the degenerate works. Chamber representatives acted as official consultants for transactions involving the confiscated objects. For this service, the chamber received a commission of 7.5 percent of the final sale price. Surviving financial records offer a somewhat confusing picture of how profitable this activity proved to be. Budget projections for the years 1938 to 1941 suggest that chamber revenues generated by the consultation fees amounted to about RM 120,000.[206]

The crusade against degeneracy in state collections did not satisfy all fanatical Nazi critics of the Visual Arts Chamber. An SD report for the first quarter of 1939 summarized a number of complaints about tendencies among contemporary artists.[207] A disturbing number of exhibitions manifested "confessional, communistic, and art-Bolshevik influences." At an exhibition on the "German West" held in Düsseldorf, several objects on display had been produced by artists "who were earlier known as 'art Bolsheviks.'" The report neither identified the artists nor explained what it meant by "art Bolshevik," a highly elastic term often used by Nazis to condemn anything they did not like. The report was similarly vague in its derision of an exhibition sponsored by the Silesian Culture League, which featured a "series of works in the expressionist and impressionist style." In Berlin, several "extremely objectionable exhibitions" were held in private galleries, whose operators clearly "did not always show an understanding for a National Socialist conception of art." An exhibition of works by young artists sponsored by the Prussian Academy of Arts was itself the very "picture of degeneracy." Nonetheless, the report notes that the vast majority of exhibitions investigated had been "unobjectionable."

Inasmuch as censorship had become formalized and institutionalized, the chambers played a vital role in keeping the activities of German artists within the boundaries of ideological acceptability and in gradually narrowing those boundaries as the 1930s progressed. Judging by the scarcity of prewar cases involving expulsions for censorship violations, it appears that the chambers reserved this ultimate disciplinary measure as a last resort. The low frequency of expulsions for such transgressions might also suggest a high rate of compliance by chamber members, despite persistent whining by intemperate Nazis about alleged chamber moderation. Degenerate jazz musicians and "art-Bolshevik" painters were not as prominent by late 1939 as complaints lodged with the SD might indicate, and to the extent that they did exist, they were the exception rather than the rule. Notable instances of defiance should not overshadow the cooperativeness of the vast majority of German artists.

CHAPTER SIX

MOBILIZING ARTISTS

FOR WAR

In August 1940, Joseph Goebbels called upon German artists to contribute to the defense of the Fatherland in its hour of need: "I expect that every German art creator who receives the call for help will readily and happily place himself at the disposal of the great mission. Whoever shirks from this is not worth living in these historic times."[1] For German artists, the war presented both new professional opportunities and unprecedented challenges. From the very beginning, the impact of the war was profound. Economically, the initial effect was mainly an adverse one, but by late 1941 the situation had completely turned around. For artists who were not called into military service, the middle years of the war turned out to be a genuine economic boom. Several factors contributed to this phenomenon. Generously financed art and entertainment programs for German troops, known as *Truppenbetreuung*, stimulated demand for performers just as thousands of young able-bodied (primarily male) artists were being drained out of civilian society. The KdF, which administered many of the functions for the troops, also expanded its cultural offerings to the civilian population. For its part, the German public turned more and more to the arts and to entertainment as diversions from the ordeal of war and as substitutions for the material consumer goods that were becoming increasingly scarce.

Yet the wartime boom was not an unqualified blessing. Shortages of qualified talent led to a significant inflation in the wages and salaries of performers, which not only increased the financial burden on German communities, the KdF, and other sponsors of cultural events but also led to mounting popular resentment against artistic "war profiteers" (*Kriegsge-*

winnler).[2] Progressively acute manpower shortages also forced German theaters, orchestras, and cabarets to depend more and more on the services of foreigners, an ironic and somewhat embarrassing trend in view of past antipathies toward foreign artists. In conjunction with the Propaganda Ministry and the Special Trustee for the Culture-Creating Professions, the Kulturkammer's individual chambers attempted to control wage inflation and the employment of foreigners but met with limited success. Thus the pressures of wartime often overcame the authorities' ability to control professional affairs in the artistic and cultural fields. Only in their last major task could the chambers claim to have achieved a major success: beginning in September 1944, they dismantled most of the institutions of German artistic and cultural life and funneled chamber members into noncultural tasks that were vital to the "defense of the Reich."

Economic Bust and Boom

Upon the outbreak of war, states and communities throughout the Reich were compelled to drastically cut back their outlays for the arts. The war saddled governments with new burdens, such as providing subsidies to families deprived of regular income and hiring temporary replacements for civil servants who were in the military. The Reich government, too, had fewer financial resources at its disposal for support of the arts. Barely two months into the war, the Reich Interior Ministry warned that it would be "nearly impossible" to continue national theater life at the prewar level.[3] In the same month, the city of Berlin made drastic cuts in its subsidies for cultural programs, temporarily closing down the Youth Music School, eliminating all funds for official purchases of paintings and sculptures, and placing most new building construction on hold.[4] Ongoing efforts to ameliorate the still desperate situation of many visual artists were seen as especially endangered.[5] Fortunately, during December 1939 the German public increased private purchasing of inexpensive art objects intended as Christmas gifts.[6]

Throughout the winter of 1939–40, many German theaters and concert halls were compelled to cut back operations due to shortages of coal for heating. Unable to provide warmth for employees and audiences, several theaters in Kassel, Schwerin, Würzburg, Halberstadt, Nuremberg, and even Berlin closed down entirely.[7] That spring, the economic disruptions of war continued to cause severe difficulties for cultural life, especially in towns and smaller cities. Transportation constraints arising from fuel shortages made it difficult for people in the countryside to travel into cities

to attend theater and concert performances. Travel became next to impossible for orchestras and theater companies.[8]

After the steady progress achieved in the cultural economy during the late 1930s, this downturn induced by the war focused new attention on the problem of professional overcrowding. The Kulturkammer central office now attempted to exploit wartime mobilization to address this problem anew. Hans Hinkel pledged to accelerate chamber programs for occupational retraining. Both for their own good and for the good of the "people's community," untalented and poorly trained artists were to be systematically prepared for other occupations. In 1940 Hinkel declared, "The artistic proletariat is being eradicated!" At a time when *Leistung* is demanded of all Germans in every area of life, he said, and where labor shortages exist in many key areas, "we cannot afford to let unemployed, solitary, and supposedly misunderstood artists sit around in attics and studios."[9] By May 1940, 660 members of the Theater Chamber had already been retrained for alternative occupations. The chamber paid for the program itself, while the living expenses of the participants were covered by the National Socialist People's Welfare organization (NS-Volkswohlfahrt).[10] Similarly, the Visual Arts Chamber used the war as an opportunity to place unemployed and "artistically insignificant" architects in war-related technical positions, designing military and war production facilities.[11]

The economic outlook for German artists gradually brightened, however, especially for musicians, actors, and other performers still in civilian life. The improvement can in large part be attributed to employment opportunities generated by the massive program of wartime *Truppenbetreuung*. The KdF had initiated such cultural and entertainment functions for Wehrmacht units as far back as 1936, and their importance to the soldiers' morale had been widely acknowledged. In November 1939 the programs began for German troops in Poland. Early in 1940, Goebbels created a special office in the Propaganda Ministry to coordinate vastly expanded *Truppenbetreuung* efforts, placing Hinkel in charge. During that first winter, troop entertainment took place on an unprecedented scale, with some fifteen thousand shows or functions. By the summer of 1940, about 150 entertainment events were programmed daily for German troops stationed in Poland, France, the low countries, and Norway. These programs provided work for about seven thousand Reichskulturkammer members.[12] Whereas the functions sponsored in 1940 represented a continuation of prewar KdF *Truppenbetreuung*, in 1941 the Reich government channeled an additional RM 6 million into the effort through Hinkel's office.[13] By the summer of 1942, the programs had expanded to the point where about fourteen thousand German artists and entertainers were participating in them at any given time.[14]

The artists engaged in the programs included actors, dancers, musicians, and humorists.[15]

Official propaganda attempted to elevate *Truppenbetreuung* to a level of importance almost on a par with actual combat. Hinkel characterized the "cultural *Betreuung* of soldiers" as an "essential part of modern war and human leadership in National Socialist Greater Germany," which constituted "in the truest sense a realization of our German socialism." In their common allegiance to the Führer, soldiers and artists formed an "indivisible unity," a "community of sword and lyre" that served as a most powerful symbol of the "German victory over the hostile, plutocratic world."[16] The Music and Theater Chambers constantly reminded their members of the importance of *Truppenbetreuung* to the war effort, hoping to win the voluntary participation of as many members as possible.[17] Evidently, voluntary participation did not entirely suffice. To ensure that troop entertainment did not become the preserve of low-quality entertainers who could not find work elsewhere, in 1942 Goebbels granted Hinkel the power to order any member of the Theater, Music, or Film Chamber to devote six weeks per year to *Truppenbetreuung*.[18]

Aside from *Truppenbetreuung*, the war stimulated employment for performers in other important ways. The territorial expansion of the German Reich led to growth in the number of German theaters and orchestras. New theaters were founded or "reclaimed" as a result of Germany's acquisition of large regions of Czechoslovakia and Poland. For example, new German theater companies were started up in Kattowitz, Gleiwitz, Prague, Pilsen, Litzmannstadt (Lodz), Cracow, Lublin, Warsaw, and several other locations in German-occupied Eastern Europe. Additionally, new German theater companies opened in Oslo, Lille, and several locations in the Netherlands.[19] As the war expanded, total employment in the theater world rose from 36,441 in 1938–39 to 41,269 in 1941–42, and then to 42,678 in 1942–43. By March 1943, the German Reich and its adjacent satellites contained 340 German-speaking theaters, of which 251 were year-round operations. In 1938–39, only 128 theaters in the German Reich had operated year-round.[20] Although such precise statistics are not available for the music world, several new German culture orchestras were also founded as a result of the Reich's expansion.

Visual artists, mainly painters, also experienced a boom. According to the Propaganda Ministry, during 1941 the number of art exhibitions held in the Greater German Reich rose to 1033, almost double the number from 1939.[21] Numerous references in SD reports to developments on the visual arts scene validate the ministry's claim. Private purchases of inexpensive objects produced by local artists had begun to pick up as early as January

1940. In subsequent months the SD reported a significant increase in the number of sale exhibitions sponsored by communities, local museums, art associations, and the KdF. Most of the exhibitions emphasized themes of *Heimat*; the predominant genres were landscapes, depictions of town and village life, still lifes, and animal portraits. Although the quality of this low-priced art left something to be desired (in the opinion of the SD informant), the increasingly frequent exhibitions offered good income opportunities to local artists. The SD consistently expressed disappointment over the works' inattention to current political themes. "The mass of visitors unanimously prefer good, cleanly crafted works of art depicting healthy contents and decidedly reject all memories of the *Systemzeit* in color, composition, and content." But the majority of objects also lacked a "positive acknowledgment of National Socialist ideology," concentrating instead on "home-cooked, bourgeois art with little dynamism." This rejection of politicized art suggests that for the purchasers the art tended to function more as pleasant decoration for the home than as an overt expression of national pride.[22] And unlike theater or concert tickets, paintings satisfied a consumerist urge for physical possession and offered a possible hedge against currency inflation.

This phenomenon turned out to be a windfall for quite a few artists. As demand for works of contemporary art increased, so did the prices of the objects. Complaints about price inflation for normally inexpensive objects began to mount in late 1940. Workers and lower-middle-class Germans turned increasingly to generic, low-quality "department store art." In response to accusations of profiteering, artists retorted that their incomes still lagged below those of most skilled workers. By 1943, in the SD's estimation, most new artworks cost about four times as much as identical objects would have cost in 1939. Many Germans who in 1940 or 1941 had funneled surplus purchasing power into art now found themselves priced out of the market. In a case reported from Munich, a painter who had found it difficult to sell his paintings for RM 100 before the war could now insist on prices over RM 1,000 for objects of similar quality. Lower-income people complained bitterly that art purchasing had once again become a privilege of the "upper ten thousand" of German society, despite the regime's egalitarian theory that "art should serve the people." Many wondered why the Visual Arts Chamber neglected to impose price controls or at least encourage artists to exercise greater self-restraint.[23]

Although the chamber made no apparent attempt to impose price controls on art objects, it did take action to eliminate a disturbing by-product of the price inflation. Seeking extra income, businesses not licensed by the chamber began to engage in impromptu art dealing. Stationery stores seem to have resorted to this practice on a large scale, but even unlikely enter-

prises got into the act: the SD cited one case involving a tailor shop and another involving a fuel company. Aside from the unwelcome competition for established art dealers who were chamber members, the unlicensed activity openly challenged the chamber's authority over the art market. The chamber imposed severe fines on many of the violators, which it often tracked down with the help of denunciations. In January 1943, for example, it fined a Berlin furniture dealer RM 500 for attempting to sell oil paintings.[24]

Wartime conditions also led to inflation of the salaries commanded by theater people. Conscription of numerous performers into the military provided those remaining in civilian life with opportunities to demand extremely high salaries, as did the extensive troop entertainment programs sponsored by the Propaganda Ministry and other agencies. Nazi bigwigs, including Hitler and Göring, contributed to the salary inflation by granting special privileges to the performers and companies they favored.[25] Actors and opera singers of more modest talents were demanding new contracts incorporating salary increases on the order of 100 percent. In one case, an actor in Dessau who had accepted a salary of RM 300 per month in 1940 insisted the next year on a monthly salary of RM 1,000. Theater managements, faced with a shortage of qualified performers, often felt compelled to knuckle under to such demands.[26] The Propaganda Ministry and the Theater Chamber responded to such war profiteers beginning in 1940 with a series of "salary cap" (Gagenstop) orders.[27] These measures were only minimally effective. Many performers circumvented the controls by providing false information about the provisions of their contracts.[28] However, performers did not bear the sole responsibility for the escalating confusion in the theater world. Theater operators also tended increasingly to disregard official controls over contracts and salaries, acting unilaterally without first waiting for Special Trustee approval.[29] In late 1942 and early 1943 the chamber repeatedly imposed fines for noncompliance with the salary controls.[30] In one case, the chamber fined a booking agent RM 20,000 for repeated violations.[31] The effectiveness of central controls suffered a severe blow in November 1943, when Allied bombs destroyed the Theater Chamber's main office in Berlin, which held the chamber's entire collection of member files.[32]

Attempts to control salaries were further undermined by a lack of coordination between the various agencies that sponsored the troop entertainment programs, namely the Propaganda Ministry, the KdF, and the military services themselves. The KdF in particular tended to offer contracts far in excess of what officials in the Propaganda Ministry deemed appropriate.[33] As the war dragged on, the Wehrmacht complained of the negative impact

that high salaries for performers could have on the morale of the troops. Many soldiers suspected, quite justifiably, that many of the third-rate performers who had come to entertain them had been show business washouts before the war.[34] How should soldiers who were risking their lives for the Fatherland react upon learning that an inexperienced young musician with no discernible talent was receiving RM 75 for a single accordion recital?[35] In May 1944, Robert Ley promised Goebbels that the KdF would do more in the future to keep *Truppenbetreuung* salaries within reasonable bounds.[36]

Among culture orchestras, the classification system implemented in the late 1930s unexpectedly produced an inflationary effect during wartime. By 1941, after the initial downturn of the cultural economy that accompanied the beginning of the war, the manpower shortage had begun to exert an upward pressure on salaries. Before the war the Special Trustee had felt compelled to permit artificially low orchestra classifications in order to enable municipalities to economize. But wartime competition among orchestras for increasingly scarce musicians created a situation in which orchestras sought higher classifications, hence higher salaries, in order to prevent talented musicians from migrating to other orchestras. The Special Trustee received many applications from orchestras wishing to gain acceptance into the higher classifications, particularly into the Special Class, hitherto the preserve of the Berlin Philharmonic, the Prussian State Orchestra, and the Vienna Philharmonic. The pressure on the Special Trustee was in part attributable to Hitler himself. The Führer had personally ordered the elevation of the Bavarian State Orchestra into the Special Class. This move in turn encouraged the State Orchestra in Dresden, the Gewandhaus Orchestra in Leipzig, and the orchestra of the Berlin Opera to request a similar promotion into the Special Class. At the same time, numerous orchestras were trying to push their way up into Class I, just below the elite group. The Special Trustee solicited the advice of various parties, including the Finance Ministry, the German Community Council, the music department of the Propaganda Ministry, and the Music Chamber, before deciding on the matter. There was a general consensus that salaries could not be permitted to get out of hand. The Special Trustee finally approved several applications for admission into Class I and left the Special Class applications undecided. The issue of the Special Class, it was felt, could be settled "finally and forever" only by Hitler, since he had already shown himself ready to intervene in this process. The records indicate that a letter to Hitler was drafted, although whether the letter was actually sent remains unclear.[37] At any rate, by late 1944 the number of orchestras in the Special Class had grown to nine.

As demand for musical and theatrical performers grew more intense, many performers succumbed to the temptation to break existing contracts in order to accept better offers. Although profitable for the artist in question, this practice was both illegal and professionally disruptive. Theater and music directors who suddenly found key ensemble members missing had to scramble for hard-to-find replacements. Prodded by Goebbels, who bemoaned the growing unpatriotic "egoism" among performers,[38] the chambers treated the matter seriously, at times invoking their ultimate disciplinary measure. In April 1942 the Theater Chamber expelled August Holler, an actor at the city theater in Braunau, on grounds of "unreliability." Holler had left town without the theater's permission, failing even to notify his employer where he could be found. The chamber made Holler's case into a public example, publishing a copy of the expulsion letter in one of its official gazettes, *Die Bühne*: "Especially at this time, when the greatest discipline is expected from all people's comrades, your conduct weighs heavily. The German theater cannot work with unreliable people of this sort."[39]

As cases like Holler's multiplied, the need for stricter official controls over the activities of German artists grew more apparent. With the steady expansion of the war, a more thorough mobilization of Kulturkammer members would be necessary. Mobilization efforts had remained quite weak until the end of 1942. Since late 1939, many Kulturkammer members who would normally have been subject to conscription had received "indispensability deferments" (*UK-Stellungen*). In October 1939, Hitler had ordered that artists who could not be "sacrificed" during or after the war should be "reclaimed" from military service.[40] The Propaganda Ministry interceded with the Wehrmacht in order to obtain deferments for many Kulturkammer members. As a general principle, the Wehrmacht would issue deferments only in cases where the "existence of the theater or the orchestra" would be "endangered" by the absence of the performer. But orchestras and theaters quickly developed the habit of exaggerating the importance of each applicant, and artistic deferments soon proliferated even as the Reich government terminated deferments for thousands of skilled craftsman and workers.[41] To avert negative public reaction, in April 1941 the Propaganda Ministry instructed theaters and orchestras to revoke deferment requests for nonessential performers.[42]

In order to combat all forms of artistic war profiteering and to ensure that sufficient high-quality performers could be made available for *Truppenbetreuung*, Hinkel, acting as Special Trustee, imposed new official controls over artistic employment in August 1942. The measures were designed to combat the notion that artists constituted a privileged class in German

society, a perception that had become untenable as the war expanded and demanded greater sacrifices from all Germans. Hinkel told German journalists that "artists should not be better off than members of other professional estates." Henceforth Hinkel could order any member of the Music, Theater, and Film Chambers who had secure employment to a new workplace in Germany or in German-occupied areas for up to two months per year. Hinkel could thus funnel performers to regions where shortages of performers existed either because of war-related hazards or because of low salaries.[43]

Such obligatory service to the Fatherland did not appeal to all artists. Out of fear, greed, or egoism, many performers refused to submit to compulsory assignments. In November 1943, the Theater Chamber expelled variety entertainer Anna Olschewski for refusing to perform at a soldiers' recuperation home in Leipzig and thereby violating "the honorable duty of every artist" to perform before German soldiers.[44] In March 1944, the Theater Chamber expelled actor Manfred Heitmann because of his cowardly flight from Berlin after an air raid. "All stage artists of air emergency regions are obligated to remain on the stage," the Theater Chamber admonished its members.[45] As Berlin became the target of intense air raids, numerous such cases of "extreme lack of discipline" arose at theaters in the capital city. After expelling eight actors from the Theater Chamber and issuing stern warnings to several more, Hinkel informed the intendants of Berlin theaters that future cases of this sort would be handled "mercilessly."[46]

The Führer himself, in May 1943, had helped set the harsh tone for treatment of ungrateful artists. Constantin Gerhardinger, a prominent painter in Munich, had refused to take part in the upcoming "Great German Art Exhibition" because he feared for the safety of his paintings. Having seen his Munich studio damaged twice in air raids, Gerhardinger had resolved to move all of his paintings to the safety of his country house. When informed of Gerhardinger's intentions by the director of the House of German Art, Hitler fumed. "The Führer," wrote Martin Bormann, "points out that countless artists are performing their duty as soldiers in the Wehrmacht on all fronts, that other artists similarly put their lives on the line in the area of *Truppenbetreuung*, and that yet more artists are working and creating in air-raid districts just like all other German *Volk* comrades." Through his "scandalous" selfishness, Gerhardinger had "excluded himself from the German *Volk* community." Hitler ordered that Gerhardinger's name never again be mentioned in a German newspaper or magazine and that his art be forever banned from all German exhibitions. Goebbels acted accordingly, instructing the Visual Arts Chamber to designate Gerhardinger a persona non grata.[47]

Despite the steadily expanding framework of official controls, serious salary inflation continued. In the middle years of the war, the inflation that had already been driving up the salaries of serious musicians began to work in favor of entertainment musicians as well. Many musicians did not hesitate to exploit their situation. In 1944, officials in East Prussia reported that "no civilian musicians are available." Consequently, café and nightclub operators were forced to rely almost exclusively on semiprofessional musicians and on "double earners," professionals who possessed secure employment elsewhere. In both cases, the musicians demanded—and usually received—extravagant wages. A violinist employed by the radio orchestra in Königsberg earned RM 40 for an easy gig at a local club. Not only were such wages in direct violation of Music Chamber regulations, they were also widely regarded as excessive and potentially damaging to general morale.[48] From Darmstadt officials complained that employers often completely ignored established procedures for approving wages and hired semiprofessionals without seeking approval from the Music Chamber. The entire Music Chamber/Special Trustee control apparatus, it seemed, had broken down under the pressures of war.[49] In Thuringia, where musicians' wages had risen 50 percent in wartime, local employment office officials characterized the inflation as an "unhealthy wage-political development" that had engendered resentment among local workers whose wages had stagnated. Further exacerbating the indignation was the fact that many of Thuringia's handsomely paid musicians were foreigners.[50]

Indeed, the conspicuous proliferation of foreign performers in Germany presented the chambers with a most sensitive problem during the second half of the war, as the available pool of German talent diminished. In December 1939, the Propaganda Ministry had confidentially instructed the chambers to hold employment of foreigners to the minimum level necessary for maintaining politically important cultural exchanges with other countries. Shortages in qualified personnel should not lead to a situation where "the German theater is inundated with foreign, stateless, or ethnically non-German artists."[51] Early in 1940, the Theater Chamber tightened its procedures for screening foreigners who would appear on German stages.[52] But as German male talent grew scarce, dependence on foreign replacements increased. Most of the foreign talent originated in neutral or satellite states like Sweden, Rumania, Holland, Hungary, Croatia, and the "Reich Protectorate" of Bohemia and Moravia. By the beginning of 1943, complaints about the inundation of the German theater by foreigners had become commonplace,[53] and the Theater Chamber repeatedly castigated theater operators for hiring foreigners without chamber approval.[54] In January 1944 the Landeskulturwalter in Graz informed Berlin that theater

operators in his region had begun almost as a rule to ignore chamber guidelines for engaging foreigners.[55] In some instances, the proportion of foreigners in theater companies reached alarming levels. How could it be, the Theater Chamber demanded to know, that in February 1944, 23 of 119 artistic employees at the State Theater in Salzburg were non-Germans?[56] Nationalistic Germans in particular were up in arms over this practice. In August 1944 a Nazi party member denounced the city theater in Thorn to the Theater Chamber: the theater had engaged several foreigners in its chorus without receiving chamber clearance and without requesting checks on their political and racial background. The theater's intendant unapologetically explained that he had been "forced" to resort to foreign labor because of a complete absence of German singers.[57] The music field grew similarly dependent on foreign labor; the situation was especially pronounced among smaller orchestras. In 1943 the orchestra in Mülhausen found itself forced to engage an Italian and five Belgians in addition to four women, twelve amateurs, and nine beginners.[58] In many cases, the foreign musicians had to be actively recruited, and such musicians agreed to relocate to Germany only if granted high salaries. In turn, this situation contributed to the broader problem of salary inflation and inevitably led to complaints from German musicians.[59]

The Purge Intensifies

The gradual emergence of manpower shortages in the arts did not undermine the regime's resolve to continue, even to accelerate, the racial and ideological purge of artistic and cultural life. In wartime, the process of cultural purification took on added urgency as the ideological war aims of National Socialism became more and more apparent. In effect, the onset of war elevated the issue of cultural and intellectual conformity, as well as that of racial purity, to a question of national security. The conquest of living space, the subjugation of racially inferior peoples, and the destruction of "Jewish bolshevism" lent new impetus to the program of cultural Germanization. The chambers wielded Paragraph 10 against a wide array of both old and new targets. Under pressure from Goebbels, the chambers moved forward with de-Jewification, a process which by this point was targeted not at full Jews, the expulsion of whom had been completed by September 1939, but rather at mixed-bloods (Mischlinge) and at Aryans married to Jews (Versippte). At the same time, the chambers had to deal with the consequences of German territorial expansion, which by the end of 1939 had already brought millions of non-Germans into the borders of the Reich.

The magnitude of the wartime purge is reflected in an SD report dated April 1942.[60] Although the report deals primarily with the Literature Chamber, it nevertheless offers a particularly revealing glimpse of how the chambers' use of Paragraph 10 coincided with broader tendencies in the Reich's treatment of its perceived internal and external enemies. The report summarizes the specific grounds for Paragraph 10 rejections or expulsions of about four hundred persons in 1941. The descriptions "Jewish extraction" or "Jewish-related" constituted the grounds for sixteen rejections or expulsions. Another forty-eight rejectees were classified as "former Marxists and other enemies of the state." Forty-seven were "previously convicted" and "seriously criminally tainted," while twenty-nine were "not seen as mentally normal," "drunkards," "elements with an aversion to work," "mental patients," or "elderly people from whom culture-creative activity is no longer to be expected." About a hundred were people whose "aptitude for positive cultural activity" was "doubtful" and "foreigners" (e.g., Americans, Danes, Poles, and Czechs) for whom "cultural activity in the service of German cultural policy" could not be expected. Another 150 possessed a strong "confessional connection," a statistic reflecting the Literature Chamber's role in the Nazi campaign against refractory clergy during the early war years. Eighteen were rejected or expelled on account of affiliations with certain "Christian sects and occult groups," which at the time were also being subjected to intense persecution by the secret police.[61]

As early as August 1940, the chambers initiated a major action to purge Jewish *Mischlinge* and *Versippte* who had previously received special dispensations of one form or another. Between August 1940 and April 1941, the Music Chamber expelled 147, and the Theater Chamber 61, such "Jewish-tainted" members.[62] This purge did not lead to the revocation of all special dispensations, however. As of January 1943, the Visual Arts Chamber still counted 110 *Mischlinge* or *Versippte* among its members; the Theater Chamber held 122, and the Music Chamber held 126.[63] No single factor seems to explain why the exceptions were allowed. Undoubtedly the growing shortage of musicians and theater performers played a role. Notably, the chambers systematically revoked many of the remaining special dispensations during 1944 as conversion to a "total war" economy accelerated and the need thus disappeared for the artistic services of *Mischlinge* and *Versippte*.[64] No new dispensations were issued after July 1944.[65]

Holders of special dispensations were compelled to function under various restrictions. In the case of Klare Gille, a talented young dance student who was one-quarter Jewish, the Theater Chamber revoked a stipend on racial grounds but nonetheless permitted her to complete her training and then to join the chamber in 1943.[66] Another general but flexible rule

stipulated that *Mischlinge* and *Versippte* were not allowed to participate in *Truppenbetreuung*, a guideline that Hinkel justified on grounds of national defense.[67] In cases where Hinkel's office allowed exceptions to this rule, the artists were scrutinized hypercritically. Felicitas Albers, for example, who was merely suspected of having partial Jewish ancestry, was recalled from entertaining German troops in Warsaw after the SD denounced her nightclub act as "uncouth and dirty."[68] Because special dispensations were awarded on a case-by-case basis, administrative arbitrariness and inconsistent application of guidelines could profoundly affect the careers of artists. When Ruth Rosemann, an 18-year-old half-Jew, queried the Theater Chamber in 1940 about her future prospects for a stage career, the chamber informed her that she would easily qualify for the needed special dispensation. Two years later, however, after Rosemann had completed her training, the chamber rejected her on racial grounds. Her emotional appeal of the chamber's decision apparently found little sympathy with Goebbels.[69]

During the war, the Visual Arts Chamber actively participated in another aspect of the Third Reich's approach to the Jewish question: the systematic plundering of the property of German Jews. As early as May 1939, according to procedures established by the Economics Ministry to prevent Jewish emigrants from leaving Germany with valuable art objects, German customs officials had been required to solicit advice from experts appointed by the Visual Arts Chamber and the Education Ministry. Following the standard Nazi practice for squeezing wealth from German Jews, the procedures stipulated that the emigrants had to pay the fee for this expert consultation.[70] In 1941, when the Reich initiated the forced deportation of Jews to the east, the Economics and Propaganda Ministries instituted new procedures to govern the Aryanization of art objects owned by the "evacuees." The ministries jointly designated the Visual Arts Chamber as the main supervisory agency for property transfers. All Jews were ordered to apply to the chamber for licenses to sell their art objects. Records of previous sales and other supporting documentation had to accompany the application in order to assist the chamber in determining the objects' value. Before issuing sale licenses to the Jewish applicants, the chamber circulated lists of the objects to the "highest Reich authorities," who exercised a right of first refusal. Even if no ministers or high party officials were interested, the chamber could stipulate that an object be sold to a specified German museum. When the chamber issued a license for private sale of an object, the Jewish owner was compelled to abide by the sale price determined by the chamber. For each transaction, the chamber received a commission equal to 10 percent of the sale price.[71] The chamber enriched itself considerably

through this process. Chamber budgets projected that the commissions would generate RM 50,000 in income between 1942 and 1944.[72]

Many Jews never bothered to sell their art objects before evacuation to the east. Unwilling to pass up the spoils, the chamber moved aggressively to profit from the objects left behind. For example, in January 1943 Anna Schlesinger of Berlin applied to the chamber for permission to sell several paintings, vases, and porcelain figures before her departure from Berlin. The chamber responded in May, setting the total sale price of Schlesinger's objects at RM 1,510. On learning that Schlesinger had "reregistered in the east" without having sold her possessions, chamber officials in Berlin tried to lay claim to her art objects. They were surprised to discover that the main economic office of the Berlin city government had seized Schlesinger's possessions itself and had turned the art objects over to a furniture dealer for sale to the general public. The chamber quickly tracked down the dealer in an attempt to secure a percentage of the profits.[73] The Schlesinger case was not unique. In the spring of 1943, the chamber ascertained that art objects left behind by Jewish deportees had been routinely transferred by Berlin city officials to furniture dealers who did not hold chamber licenses. This practice not only deprived the chamber of its sales commissions but also undermined chamber efforts to safeguard its members' monopoly over the sale of art objects.[74]

The Visual Arts Chamber also went after plundered Jewish property that did not possess artistic value but could be used to assist in alleviating serious shortages of art supplies. For example, in May 1944 the chamber received from Berlin authorities 230 oil paintings that had been seized from the property of Jewish painter Hans Oppenheimer. Deemed not to possess artistic value, the paintings were cannibalized for frames and canvases, which the chamber distributed to members.[75] No category of Jewish property was exempted from the Visual Art Chamber's plunder program. To help alleviate shortages of suitable housing for artists, some local chamber officials seem to have been constantly on the prowl for apartments vacated by Jews. In one case in 1940, the chamber Landesleitung in Munich stooped so low as to arrange for the eviction of an old Jewish widow from her studio-equipped apartment in order that a "productive artist" could move in. Much to its disappointment, the Munich chamber office was informed that the racial political office of the NSDAP had established the widow's unassailable Aryan credentials.[76]

Questions involving *Mischlinge*, *Versippte*, and the disposal of Jewish property were the wartime residue of an anti-Jewish policy that had already been realized in most respects before 1939. In contrast, a new racial screening program of immense magnitude emerged as a direct result of German

territorial acquisitions. The Reichskulturkammer moved into every region formally annexed by Germany before and during the war: Austria; the Sudetenland; Alsace-Lorraine; Eupen-Malmedy; and large sections of western Poland. Purges of Jews ensued immediately after each annexation. Because chamber membership policy toward Jews had been clarified through years of practice, the purges represented a relatively straightforward bureaucratic task in the newly acquired territories. De-Jewification of the arts was accomplished especially rapidly and smoothly in Austria, where chamber officials had given it top priority after the *Anschluss* of March 1938.[77] In contrast, formulating chamber membership policy toward ethnic non-Germans who were *not* Jewish could often involve a myriad of ideological and practical complications.

In the territories annexed from Poland, the establishment of German cultural hegemony entailed the introduction of the existing German domestic cultural infrastructure, including the Reichskulturkammer. Chamber jurisdiction was formally introduced into the newly annexed areas at the end of December 1939.[78] In early 1940 the Propaganda Ministry issued special instructions regarding chamber membership for ethnic Poles. The goal of chamber membership policy would be that "within this year the new eastern regions will have a purely German character in the intellectual sphere." Consequently, Poles would be excluded from the chamber because "as a general principle [they] do not possess the necessary reliability for the practice of activity that would require membership in the Reich Chamber of Culture."[79] In March 1940 Goebbels ordered that Poles could not join the chamber even in cases where exclusion adversely affected a "German-blooded" spouse.[80] By late summer 1940, the chamber had expelled many Poles who had enjoyed chamber membership in previous years.[81]

In the newly annexed areas, two obstacles stood in the way of completing the purge of Poles by the end of 1940. First, there were delays caused by applications received from persons of uncertain or mixed descent. This problem was especially acute in West Prussia, where German authorities had divided the population into three categories: ethnic Germans, Poles, and an "intermediate layer" of so-called West Prussian Germans. Sorting out the population would naturally take some time, especially since ancestry documents had to be secured by all new applicants.[82] The Music Chamber in West Prussia decided to admit applicants who could clearly prove that they were ethnic Germans but to defer reviewing other cases until applicants had received official word of their racial status.[83] The second complication involved a shortage of qualified Germans in some cultural fields. Chamber policy was to handle such cases pragmatically. Membership applications from Poles whose services were required would be neither ac-

cepted nor rejected. Instead, Poles would be allowed keep their jobs while the chamber "postponed" consideration of their applications. Official rejections would ensue as soon as qualified Germans were available to replace them.[84] To stimulate the supply of potential German replacements, the German government encouraged decommissioned soldiers to settle in the new territories in order to take advantage of new career opportunities in the cultural fields.[85]

Whereas Nazi racial doctrine (and traditional German prejudice) excluded the possibility of assimilation by Poles, Czechs were generally held in a somewhat higher regard.[86] The January 1941 decision to expand the jurisdiction of the Reich Chamber of Culture into the Reich Protectorate of Bohemia and Moravia reflected a long-term expectation of racial and cultural assimilation of the Czechs.[87] The protectorate was the only territory not formally incorporated into the Reich in which the chamber set up operations. Although the primary aim of this measure was to regulate the activities of ethnically German artists in the protectorate, it also opened up chamber membership to Czech artists who possessed Reich citizenship. (As an inducement to collaboration, Reich citizenship had been offered to ethnic Czechs in the protectorate—provided, of course, that they could pass racial muster.[88]) For Czech artists who could qualify, chamber membership brought a variety of economic and professional advantages, including access to the German cultural marketplace. The attraction grew especially strong for musicians in 1943 and 1944, as German orchestras and theaters were increasingly forced to rely on foreign personnel to fill gaps created by enlistments. Although it is not known how many Czechs actually joined the Reichskulturkammer, the significant point is that they could exercise this option far more easily than any other category of non-Germans.

If the differing approaches to Poles and Czechs reflected racial and cultural alignments envisaged for the future, chamber membership policy toward other groups reflected more immediate political and diplomatic considerations. As of May 1940, the Kulturkammer blacklisted citizens of the United Kingdom, Canada, Australia, New Zealand, South Africa, France, the Netherlands, Belgium, Egypt, the Sudan, and Iraq, as well as all French and Belgian colonies.[89] In the context of these exclusionary measures, in August 1941 the Theater Chamber formally prohibited the employment of blacks and *Negermischlinge*.[90] By May 1942, U.S. citizens, Russians holding Soviet passports, and Latin Americans (except citizens of Chile and Argentina) had been added to the list. In accordance with German policy in Yugoslavia, Serbs were prohibited, whereas Croats were deemed acceptable.[91] Similarly, after the opening of the conflict with the Soviet Union, Ukrainians received chamber approval.[92] In fact, in July 1942 Hitler

instructed the Wehrmacht to pay special attention to the personal needs of Ukrainian performers who were participating in troop entertainment programs.[93]

Wartime Censorship

Much like membership policy, the chambers' approach to wartime censorship grew out of an interaction of ideological and pragmatic factors. Amid expectations that the war would not last very long, the earliest measures avoided radical departures from peacetime patterns. In a decree issued on 15 September but back-dated to 1 September, Goebbels forbade all music deemed "offensive to the national sentiment."[94] Music programming was to be appropriate to the "gravity of the times" and sensitive to the "national sensibilities of the people." While cheerful music was by no means outlawed, Goebbels insisted that it be kept free of "indignity and exaggeration." In another decree dated 1 September, Goebbels announced that theater programs already approved by the *Reichsdramaturg* could go forward, although theaters were instructed to exercise restraint in their productions of comedies and other light pieces and to make substitutions if necessary.[95] Explaining the guiding principle to the German press, Propaganda Ministry officials noted that both soldiers and civilians appreciated a good mix of serious and light cultural offerings. Moreover, in order to ensure that theaters remained receptive to the wants and needs of their audiences, the prewar practice of permitting theaters to determine their own programs was continued. Thus, from the very beginning of the war, Goebbels recognized the importance of avoiding excessive and potentially counterproductive censorship and of striking a balance between art's political and entertainment functions.[96]

In the theater, the *Reichsdramaturg* continued "incorruptibly" to safeguard the "great political and culture-political line" established before 1939. Avoiding the transformation of his office into a "theater-bureaucratic institution," Schlösser claimed that his intention was to "to help and to consult, not to regiment or unnecessarily to aggravate."[97] Continuing the prewar pattern, theaters determined their own programs, while the *Reichsdramaturg* engaged in fine-tuning. After reviewing programs routinely submitted to Berlin, Schlösser would occasionally issue directives to discourage objectionable tendencies. In April 1941, for instance, the *Reichsdramaturg* instructed theaters to avoid some forms of modern dance that had recently been noticed on some stages.[98] There were frequent guidelines governing the performance of foreign works. In September 1939, for exam-

ple, Schlösser ruled that Shakespeare in German translation was to be seen as a "German classic," although given Germany's conflict with England it would be more appropriate to produce *Macbeth* or *As You Like It* than *Richard II*.[99] In addition to disseminating directives throughout the theater world, the *Reichsdramaturg* also corresponded directly with each stage. As in peacetime, uncertainty about the appropriateness of certain pieces would prompt theaters to seek advance clearance from Schlösser's office,[100] which issued prohibitions only rarely. Konrad Dussel's quantitative analysis of theater programming in Coburg, Karlsruhe, Bielefeld, Dortmund, and Ingolstadt confirms a high level of continuity between prewar and wartime repertoires. The only significant change that occurred after 1939 was a rise in the frequency of performances of light and comic works. Whereas between 1934 and 1939 such works accounted for 48 percent of performances, between 1939 and 1944 they totaled 56.5 percent. There was a corresponding decrease in performances of politically oriented nationalistic works.[101]

Despite widespread recognition of the social utility of popular entertainment in wartime, some German officials were loath to tolerate what in their view were lewd or sexually indecent performances. As early as February 1940, Berlin's chief of police complained of a marked increase in the frequency of "public performances by naked female dancers" in Berlin nightclubs and theaters. The police chief expressed disapproval of such a "relaxation of morality" in wartime and asked the Theater Chamber, through its Fachschaft Artistik, to impose a blanket prohibition on nudity.[102] Hitherto the chamber had avoided a general ban on nudity, preferring to evaluate cases on their individual merits. Whereas the Fachschaft had as a matter of course forbidden crude displays of flesh before mass audiences, it had tolerated some nudity in "refined artistic performances" before "exclusive" audiences.[103] This policy reflected the chamber's grudging acceptance of the artistic validity of *Nacktttanz,* a current in the modern dance movement that shared at least a few characteristics with the Nazi cult of nature and physicality.[104] Thus a blanket prohibition on nudity threatened to eliminate the ability of Theater Chamber officials to apply their own definitions of art and obscenity to the censorship of dance.

Both Schlösser and Theater Chamber president Ludwig Körner shared the opinion of Berlin's chief of police that existing controls were too relaxed. Schlösser informed Goebbels that Fachschaft Artistik's policy had failed to prevent a "frightening increase" in unacceptable public nudity. Although before the war it had been appropriate to approach the question of nudity "generously," Schlösser argued that wartime conditions necessitated stricter controls. Schlösser also warned Goebbels that failure to act might

well provoke the police into instituting and enforcing their own blanket prohibition on nudity, a move that would seriously challenge the Propaganda Ministry's authority over cultural policy.[105]

Goebbels decided to launch his own investigation into the matter. The minister ordered his state secretary, Leopold Gutterer, to assemble a team of investigators who would attend the controversial performances and then report back to Goebbels personally. Gutterer's team concluded that Schlösser and the police had grossly exaggerated the extent of the problem.[106] Although nudity could be seen on several stages, the team witnessed only two performances that it considered objectionable. One of these was the "fantasy dancing" of the "pronouncedly decadent" couple Florence and Ben Roger; their act took place at the Frasquita club before an audience of "businessmen, representatives, building entrepreneurs, civil servants, and middle-class ladies." It was not so much the partial nudity that disturbed Gutterer as the heavy makeup worn by Ben Roger, which gave him the "absolute appearance of a homosexual." Gutterer was also certain that both performers were "morphine and cocaine addicts," although he did not explain how the dancers' chemical dependencies could be divined from their physical appearance. Goebbels banned the act immediately, and Körner pledged to find "ways and means" to expel the Roger couple from the Theater Chamber as soon as possible.[107]

Occasional isolated cases like this one did not, in Gutterer's view, justify a general proscription of nudity. A "world-class city" like Berlin, with its four million inhabitants, must, he maintained, tolerate a certain level of nudity in its nightlife "for reasons of international tourism." Moreover, the majority of the population of a city like Berlin, which consisted of "healthy people" who would "never take offense" from a little nudity, should not have its tastes dictated by a few "old aunts and churchwomen." Goebbels evidently agreed. In general guidelines issued in April 1940, the minister codified Fachschaft Artistik's established procedures on performance involving nudity.[108] Goebbels instructed his subordinates to tolerate performances that were "artistic," "decent," and "aesthetically unassailable." On the other hand, officials were to move against performances that were "decadent" or "effeminate" or appealed to the "lowest instincts." This phraseology intentionally left much open to interpretation by Propaganda Ministry and Theater Chamber officials who were called upon to apply the guidelines in culturally disparate regions. Standards were far stricter in small towns and in the countryside than in major urban areas.[109] In Berlin, the new guidelines failed to satisfy police officials, who continued to inundate the Propaganda Ministry with complaints about bare breasts and buttocks.[110] The high command of the armed forces registered its own

objections, asserting that nudity presented a "danger to manly discipline" and declaring nude performances off-limits to all soldiers.[111] Continued haggling never resolved this tension between the permissive realism of the Propaganda Ministry and the prudish anxiety of the armed forces and the police.

In music, new official dictates and proscriptions proliferated as the war dragged on and widened. In February 1940, Music Chamber president Raabe announced a complete ban on the compositions of Stravinsky.[112] Condemned by Nazi and conservative activists during the Weimar era on account of its sensuality, Stravinsky's music had until now managed to escape blanket proscription in the Third Reich, in part because the Reich government did not want to damage lucrative cultural exchanges with France, where the Russian-born Stravinsky had become a naturalized citizen.[113] Similarly, Germany's collaboration with the Soviet Union between August 1939 and June 1941 inhibited the proscription of Russian and Soviet composers. In July 1941, however, Goebbels banned all works by Soviet composers.[114] By 15 August 1941, comprehensive bans had been placed on music composed, arranged, and published by Jews, British subjects, Poles (except Chopin), Russians, and French citizens (except Bizet).[115] To further Germanize music programming, Goebbels and Raabe encouraged orchestras to pay added attention to the compositions of relatively obscure German composers, such as Spohr, Lortzing, von Suppé, and Millöcker.[116]

The war also occasioned the elevation of several German nationalistic tunes to a special level of sanctity. An Order for Protection of National Songs and Symbols, issued in January 1940, prohibited musicians from playing the *Deutschlandlied*, the *Horst-Wessel-Lied*, and several other nationalistic tunes in dance halls, cabarets, and other locales that lacked "solemnity."[117] From time to time, the ministry or the Music Chamber announced new additions to the official list of "solemn patriotic songs." *Denn wir fahren gegen Engelland*, for example, was placed on the list in April 1940, just in time for the opening of the German offensive in the west.[118]

The campaign against jazz also gradually intensified. In January 1940 Raabe banned the use of English phrases, such as "yes sir," that were commonly associated with jazz performance, a measure quite narrow in scope but highly indicative of the xenophobic mentality at the core of the antijazz crusade.[119] On a broader level, in April 1940 all music publishers were ordered to submit copies of newly published entertainment and dance music to the Reichsmusikprüfstelle. Although not precensorship in theory, as the submission to the Prüfstelle was required only after publication, such screening undoubtedly deterred publishers from taking chances.[120] In Au-

gust 1941 the Propaganda Ministry promulgated a new, broader prohibition of swing, jazz, and music composed by blacks.[121]

As in peacetime, official attempts to proscribe jazz were not entirely successful. In February 1942 a major Music Chamber control effort in Berlin locales uncovered numerous performances of the forbidden music. Chamber officials confiscated the sheet music, and the offending musicians were "held responsible."[122] An August 1942 SD report explained why musicians "in various large cities" were succumbing to the temptation to perform jazz. Reportedly, the musicians often could not resist the strong requests from a "minority" of audience members, primarily young people, who begged to hear jazz and rejected entertainment music "corresponding to German taste." Clearly, there were also quite a few musicians who required little cajoling from the audience before letting loose with "hot" jazz tunes. The SD report describes how band leader Willy Artelt attained a state of "ecstasy," with "arched back and crazy eyes," while performing in Hamburg.[123] Despite SD vigilance and Music Chamber control measures, chamber president Raabe remained frustrated by the persistence of jazz musicians.[124]

Although the Visual Arts Chamber received complaints from the SD and other ideologically orthodox quarters about the supposed reemergence of degenerate tendencies in the visual arts,[125] the chamber aimed its most extensive wartime censorship effort at a different target: kitsch. In 1940, SD monitors noted a disturbing increase in the availability of cheap, mass-produced decorative articles and art reproductions in German art dealerships and other retail stores. The consequences of this trend, the SD maintained, were both cultural and economic. The "boundless stream of cheap kitsch" threatened to inundate German homes with "trash" at precisely the time when Germans should be conscious of their "cultural mission in the world." Moreover, German artists complained that mass-produced kitsch "sabotaged" their own economic prospects. Artists throughout Germany demanded that the Visual Arts Chamber impose restrictions on the sale of such items.[126]

In response to the complaints of its members, on 1 October 1940 the Visual Arts Chamber issued an order designed to inhibit the distribution of "inferior art." Henceforth the chamber could demand that artists or dealers submit for evaluation "certain products of painting, sculpture, and the graphic arts, or their reproductions." Further "sale, dissemination, or reproduction" of the items in question would require the chamber's written permission. When permission was refused, the chamber reserved the right to confiscate the items as well as related molds and printer's blocks.[127]

Within six months of the order's promulgation, the SD reported that

chamber artists had responded "extraordinarily favorably" to the campaign against inferior art.[128] Chamber files in the Berlin Document Center suggest that the chamber did indeed conduct its crusade against "inferior art" with great energy and persistence. Always on the prowl for kitsch, chamber Landesleiter regularly scrutinized the merchandise in local art dealerships and antique shops, in addition to furniture stores, stationery shops, and other businesses not under chamber jurisdiction. In August 1942, for example, while making his routine "service rounds" on the Badestrasse in north Berlin, a chamber official noticed that Johannes Meissner was selling oil paintings out of his upholstery workshop. The paintings, the chamber official reported, were "so kitschy and amateurishly dashed off that they make a mockery of any people's comrade who buys these paintings at such an enormous price."[129] Similarly, in September 1943 the Landesleiter in Posen informed the chamber central office that an "art workshop" in Berlin was inundating his region with "pronouncedly inferior art products": framed hand-painted miniatures intended as inexpensive home decorations. The chamber quickly forbade the Berlin firm from further distribution.[130]

Landesleiter also kept close tabs on the artists under their jurisdictions, scrutinizing objects for sale in studios, at local galleries, and at exhibitions. In cases of suspected "inferiority," the Landesleiter arranged for the objects to be submitted to a chamber committee in Berlin made up of experts appointed by the chamber president. For the artists in question, the process could be highly disruptive. Berlin painter Adolf Friedrich, for example, had to turn over to the chamber twenty-two oil paintings that he otherwise could have put up for sale.[131] In the early stages of the campaign against inferior art, the Landesleiter collected the objects and then sent them on to Berlin for evaluation. Beginning in late 1943, as a cost-saving measure, the committee traveled through the country for on-site inspections of the questionable objects. The process could be cumbersome and time-consuming either way, and several Landesleiter suggested that they themselves be authorized to declare objects "inferior." However, Goebbels refused to allow such decentralization, fearing the chaos of forty-two different conceptions of valuable and inferior art.[132]

Mobilization for Total War

Having resisted a total social and economic mobilization for as long as possible, in early 1943 the leadership of the Third Reich initiated steps toward placing Germany on a total war footing. In late January, the Reich

government ordered all German men between 16 and 65 years of age, and all women between 17 and 45, to register at local employment offices, which would determine the suitability of each registrant for industrial or civil defense duties. For most members of the Reichskulturkammer still in the civilian sector, these measures ultimately meant an end to a sheltered and privileged status. Soon after the January 1943 registration order, the Kulturkammer established guidelines for the transfer of artists from their normal occupations to war-related jobs, a process that was referred to at the time as *Künstlerkriegseinsatz*. The Landesleiter of the individual chambers were to provide the employment offices with information about the artistic significance of each local chamber member. The Landesleiter would distinguish between members who were "indispensable to the continuation of cultural life" and those who were not, a decision that invested the Landesleiter with tremendous power over the fate of the artists in their districts.[133] In April 1943 Goebbels further enhanced the authority of the chambers by decreeing that they could order the closing of cultural establishments, provided that such actions did not endanger the "continuation of cultural life necessary for war."[134]

Yet the importance Nazi leaders attached to culture and entertainment meant that total war mobilization in the cultural sector would take place far more slowly than in most others. Despite the reversal of Germany's military fortunes on the eastern front, and the increasing frequency and intensity of Allied air raids on German cities, the German public's demand for all forms of cultural diversion remained undiminished. According to a December 1943 SD report on the impact of Allied bombing on cultural life in Berlin, the city's residents generally resumed their normal patronage of theaters, concerts, and cinemas within two weeks after each air raid. In parts of the city that were not directly affected by the bombing, attendance at cultural events underwent little perceptible change.[135]

By August 1944, conscription and *Künstlerkriegseinsatz* had reduced the number of Germans employed in all artistic spheres under Reichskulturkammer jurisdiction to about 140,000. Of these, about 22,000 were in the visual arts, 35,000 in music, and 45,000 in theater.[136] Although by April 1944 Allied bombing had destroyed 72 German theater buildings, or about one-quarter of the nation's stages,[137] theater life had so far survived surprisingly intact. Where theaters had been destroyed, companies performed in makeshift facilities or in bunkers.[138] In the provinces, theaters carried on without incident, in many cases offering expanded performance schedules. Between April and August 1944, for example, the Mainfranken theater presented 229 performances before a combined audience of 90,000. The schedule included 78 performances for KdF audiences, 54 for soldiers stationed in

Germany, and 88 for soldiers at the front. Similarly, another provincial company in Bad-Kissingen presented 103 performances to 56,000 patrons between May and August 1944.[139]

It was in August 1944, however, that the Reich leadership decided that Germany's rapidly deteriorating military and economic situation necessitated a total war mobilization of artists. All able-bodied Germans now had to be made available for the armed forces, for civil defense, and for war industry. On 22 August, Goebbels issued an Order for Total War Mobilization in the Area of the Reichskulturkammer. The order empowered chamber presidents to close down art and entertainment establishments and to place their personnel at the disposal of employment offices. The massive shutdown of organized professional artistic activity, including most KdF and *Truppenbetreuung* programs, took effect on 1 September. Goebbels assured the German people that the measures only marked a "temporary standstill in the entire cultural life of our people." In the music field, culture orchestras and entertainment ensembles ceased operations, and all music schools were closed. In the visual arts, all competitions and exhibitions were prohibited and all instructional facilities were closed. Art auctions were to be curtailed by at least 90 percent. All theater companies, both public and private, ceased operation immediately, as did cabarets, variety shows, and circuses. For all three fields, all but a tiny handful of *UK-Stellungen* were terminated. The Kulturkammer warned members sternly that failure to cooperate with these national security measures would be dealt with severely and reminded members that conduct deemed deleterious to the war effort could be subject to punishment by death. Goebbels excepted radio and film from the shutdown measures in order that these media could continue to provide Germany with "relaxation." These exceptions provided some reprieve for Theater Chamber members who occasionally crossed over into film, and for musicians in radio orchestras.[140]

This total mobilization effort did not put an end to official favoritism. The Propaganda Ministry stipulated that "top elements" of the art fields, artists who had been "truly blessed by God," should be spared from the mobilization measures. Wherever possible, the excepted artists were to be engaged in cultural and entertainment programs in factories. Hitler personally approved many of the exceptions.[141] Major orchestras in Berlin, Vienna, Munich, Hamburg, Linz, and Leipzig were exempted so that the Reich could "maintain a high German musical culture" even in such trying times. All other orchestras were given over to the arms industry as whole units; this arrangement offered the orchestra members opportunities to practice in their time away from factory work and to entertain fellow workers during pauses. Older musicians who were not capable of physical labor were

allowed to form ad hoc ensembles for popular entertainment.[142] Aside from exemptions granted to Theater Chamber members who were to work for the film industry, dozens more were issued to prominent stage artists connected with leading companies, such as the Prussian State Theater in Berlin.[143] In the visual arts, exemptions were granted to a small number of artists who possessed *Spitzenkönnen* (the highest of abilities) and who were regarded as pioneers of a National Socialist aesthetic. A list of visual artists found in Hinkel's files included a dozen names in the "indispensable" category, including Arno Breker, Josef Thorak, and Paul Schultze-Naumburg.[144]

Artists who could not escape factory assignments did not necessarily have to endure great hardships on the job. Goebbels had received the assurance of Armaments Minister Albert Speer (Germany's most prominent architect) that artists would not be given heavy, hazardous tasks that might damage "abilities necessary to continue their professions" after the war.[145] Thus, in view of Germany's increasingly dire circumstances, many artists got off fairly lightly. In Dessau, for example, the employees of the city theater were transferred as a unit to the Junkers Corporation, for which they would manufacture a part for aircraft engines. The city authorities conveniently arranged for the production facility to be constructed in the basement of the theater. Similarly, the employees of the city theater in Magdeburg were entrusted with the manufacture of small machines— "light, clean work" which could be carried out on theater premises and which involved a "certain manual dexterity" so that it would not be perceived as "dull."[146]

Many artists found even such soft treatment to be somewhat demeaning. Numerous complaints from artists flowed into Hinkel's office and to higher authorities as well. Julius Schaub, Hitler's personal adjutant, telephoned Hinkel in late September 1944, informing him about the large number of complaints that the chancellery had received from artists who found their work assignments unsatisfactory. Evidently, after reporting to their work stations, many artists would just sit around for hours waiting for work that sometimes never came. Schaub's advice to Hinkel reveals how highly the leaders of the Third Reich had come to value the potential contribution of artists to the armaments industry: "It would be better to send the artists home so that they can go for walks or lie in bed."[147]

As the circle closed on the German Reich in 1944 and 1945, artists, like other Germans, were subjected to draconian penalties for conduct or utterances deemed "defeatist," "hostile to the state," or deleterious to the nation's "capacity to fight." Conviction for any one of these offenses triggered automatic expulsion from the Reichskulturkammer. As early as February

1943 a court in Breslau had sentenced opera singer Margot Devens to four months in prison for several remarks made before an acquaintance, including "Hitler is an idiot" and "I used to live much better under Jewish domination." In its written judgment, the court reminded Devens of the generosity the Nazi regime had extended to her "professional comrades" in the theater and of the progress achieved by the German theater since its de-Jewification. On the basis of her conviction, the "unreliable" Devens was expelled by the Theater Chamber in March 1943. Devens appealed the expulsion, asking the chamber to show compassion for a woman suffering from financial insecurity and poor health. The chamber rejected the appeal.[148] Supposedly unpatriotic conduct could take on many forms. Early in 1944 the Theater Chamber expelled actress-dancer Ehrentraut Grüner for fraternizing with a French prisoner of war assigned as a laborer in her theater.[149] In July 1944, the Music Chamber expelled musician Adolf Oeckler, who had told friends about the content of "inflammatory" English broadcasts to which he had illegally listened.[150] In August 1944 the Theater Chamber expelled Johann Pössenbacher, an actor in Graz. In a letter to a friend serving at the front, Pössenbacher had written of severe shortages and rumors of German retreats, concluding that "the war cannot last much longer."[151] In January 1945, the Theater Chamber expelled actress Katrina Rudolph, who had opined before several acquaintances that the war would have ended sooner had the 20 July assassination attempt against Hitler succeeded. A chamber memorandum noted that Rudolph had selflessly assisted with the care of wounded German soldiers while living in Plauen and that she was considered a politically reliable person who meant no harm. Nonetheless, in view of Rudolph's conviction by the People's Court, the Theater Chamber had no choice but to expel her.[152]

Within a few short years during World War II, German artists had experienced extremes of prosperity and hardship. For several years, many had enjoyed the opportunity to contribute to the Fatherland's struggle against foreign enemies without having to don a uniform. They had benefited financially from the value that both the regime and the German people placed on culture and entertainment as a reprieve from the anxieties and daily hardships of war. German citizens, for their part, had turned to their artists not just for psychological reasons but also because of a lack of consumer alternatives. For some artists, the opportunities generated by wartime manpower shortages may well have provided unexpected consolation for the disappointments of professionalization efforts in the 1930s. One of the most urgent problems facing artists before the war—professional overcrowding—had virtually disappeared during the war's middle phase. But the price for this improvement was high: never in German

history, not even in 1939, had artists been so dependent on and so closely controlled by the state. Toward the end of the war, more and more artists had grown resentful of the regime and particularly of its embodiment in the Reichskulturkammer; this resentment was more the result of the compulsory and intrusive nature of economic regulation and *Kriegseinsatz* than of official attempts to control the content of art. Accommodation to censorship had come far more easily than accommodation to the exigencies of total war.

The fate of German artists, then, had swung with the fate of the Reich. Having prospered during much of the war, artists were ultimately deprived of their profession by the expanding conflict. By 1945, the Reichskulturkammer, an institution that had been designed to serve artists' economic and social needs, had come to concentrate its energies on dismantling cultural institutions, setting artists to work in factories, and lashing out at artists who dared to doubt the final outcome of the war.

The Reich Chamber of Culture originated as an attempt to reconcile the totalitarian impulse of the National Socialist movement with the neocorporatist aspirations of Germany's professional artists. In 1933 the tactically flexible Joseph Goebbels recognized the utility of pursuing a strategy for artistic and cultural *Gleichschaltung* that would lure the existing professional art associations into cooperation with the nascent National Socialist regime. Signaling the regime's readiness to reward loyalty to the state with opportunities for material gain and latitude for professional autonomy, Goebbels succeeded in winning the cooperation of conservative (or apolitical) non-Nazis; these artists believed that a chamber system consisting of self-regulating corporations would help promote professional agendas that had remained unfulfilled during the economically troubled Weimar years.

The internal dynamics of the Nazi movement also helped shape the circumstances in which the Kulturkammer was born. During the initial months of Nazi rule, Goebbels posed as a moderate realist, depicting Robert Ley's plan to integrate artists into the DAF as a radical measure that would deprive artists of their autonomy and their special social identity. To many in the art establishment, therefore, the creation of the Kulturkammer in late 1933 seemed like a victory of moderation and continuity. Between 1933 and 1935, Goebbels's seeming toleration of modernism, his readiness to cooperate with non-Nazis, his temporary (and unavoidable) toleration of membership by Jews, and his support of professionalization measures all reinforced the impression that the Reichskulturkammer represented the fulfillment of the neocorporatist aspirations of German artists.

By 1935, Goebbels had grown dissatisfied with the structure of "self-administration" that he himself had built into the Reichskulturkammer. Frustrated by insubordination, especially over the Jewish question, and feeling pressure from doctrinaire Nazis such as Alfred Rosenberg, the propaganda minister saw no choice but to expand political control over the Kulturkammer. Changes in both the personnel and structure of the chamber system shifted the balance between self-administration and political control in the direction of the latter. The decisive role in most major questions came to reside increasingly in the political directorate of the Reichskulturkammer or in the Propaganda Ministry. Thus, within a few

years of the Third Reich's advent, the experiment in neocorporatist professionalization in the art world had failed.

Deprived of autonomy, after 1935 the chambers could no longer pursue their ambitious schemes for de-liberalization of the art marketplace. Acting in the name of popular access to cultural participation, Goebbels blocked chamber attempts to impose strict talent qualifications for potential members and forced the chambers to revoke restrictions that had been placed on amateurs. At the same time, Goebbels centralized powers of artistic censorship in his own ministry, delegating to the chambers some responsibility for monitoring and enforcement. By the outbreak of war, the art professions had lost much of the autonomy that they had still possessed as late as 1935. This tendency toward "deprofessionalization"[1] intensified after 1939, as the chamber members became subject to an increasingly intrusive system of central economic regulation and as the regime expanded its definition of ideological nonacceptability.

Achievements on the economic and social fronts provided partial consolation for the loss of autonomy. Because the conditions of the Great Depression served as the basis for comparison, it was easy for the regime to laud its accomplishments in ameliorating the material hardship facing artists. Although Kulturkammer work creation programs had not even come close to eradicating the artistic proletariat by 1939, thousands of chamber members did experience a significant rise in income and job security after 1933. Of course, it may very well be that this improvement would have occurred even without the Reichskulturkammer; perhaps the combination of full employment and shortages of consumer goods would have inevitably resulted in a channeling of society's resources toward culture and entertainment. By contrast, progress in the area of *Altersversorgung* could not have taken place without the active intervention of the state. All indications are that Goebbels—and Hitler too—sincerely sought the expansion of social insurance for German artists, even though the progress actually achieved during the Third Reich was limited to only a couple of categories of chamber members.

All chamber efforts toward *Betreuung* of German artists must be evaluated in the context of the National Socialist regime's broader ideological goals. The exclusion of Jews and other supposed enemy groups from the culture chambers was integral to the Third Reich's improvised but purposeful program of racial and political persecution. While practical and economic obstacles delayed completion of the purge, the goals of exclusion policy, especially with regard to Jews, remained clearly in view at all times. Although the purge of Jews was not as immediate as some Nazi radicals would have preferred, the fact remains that this purge, when viewed in the

context of the long and rich contribution of Jews to German culture, was both thorough and extremely rapid.

Silence in the face of this "purification" represents the greatest failure of German artists in the Third Reich. Aryan artists like Wilhelm Furtwängler who actually spoke up on behalf of their Jewish colleagues were far outnumbered by those who passively accepted what was taking place, whether out of indifference, professional opportunism, fear, or sympathy for the regime's anti-Semitic goals. At the same time, the system of official censorship was sufficiently nuanced so that most artists subjected to it could rechannel their professional endeavors with little inconvenience. If passivity in the face of censorship and systematic ostracism was typical for German society as a whole between 1933 and 1945, then we can only conclude that German artists possessed no greater civil courage than did farmers, or carpenters, or department store clerks. Like most of their countrymen, many artists were concerned with family, career, and personal survival. Speaking out against the regime's ideological policies was hardly an act that could be carried out with impunity. Thus, though the professional representatives of German *Kultur* may have failed to distinguish themselves as the champions of tolerance, we must take into account the extraordinary extenuating circumstances of the Third Reich when we assess the dimensions of this moral failing.

To what extent, then, must German artists bear responsibility for the National Socialist regime? Prior to 1933, artists joined the Nazi movement in lower frequencies than did other important professional groups. Nonetheless, through their association with the party and with the Kampfbund für deutsche Kultur, artists bestowed a certain cultural legitimacy on the movement. After the Nazi seizure of power, the illusion of professional autonomy wooed many more artists into collaboration with the regime. Again, what the regime most needed from them—especially during the early, often tumultuous, period of consolidation—was a stamp of legitimacy. The Nazi regime very rapidly destroyed the progressive, experimental current of "Weimar culture" and disenfranchised its chief exponents. Even though the racial and political purge had forced numerous cultural luminaries into external or internal emigration, the vast majority of German artists managed to accommodate themselves to the new conditions. For the duration of the Third Reich, the continuation or, in fact, the expansion of artistic and cultural life provided a modicum of normalcy for millions of Germans. Whether working for their own sakes, for the sake of the *Volk*, or purely for the sake of art, German artists reassured their countrymen that the land of Hitler could indeed still be the land of Goethe, Schiller, and Beethoven.

NOTES

In addition to the abbreviations that appear in the text, the following abbreviations appear in the notes.

AMRMK	Amtliche Mitteilungen der Reichsmusikkammer
BAK	Bundesarchiv Koblenz
BAP	Bundesarchiv, Abteilung Potsdam
BayHStA	Bayerisches Hauptstaatsarchiv
BDC	Berlin Document Center
DBV	Deutscher Bühnen-Verein
DS	Deutscher Sängerbund
GDBA	Genossenschaft deutscher Bühnenangehörigen
GDT	Genossenschaft deutscher Tonsetzer
GLAK	Generallandesarchiv Karlsruhe
Goebbels Tagebücher	*Die Tagebücher von Joseph Goebbels*, 1987 edition
KfdK	Kampfbund für deutsche Kultur
MdRdbK	*Mitteilungsblatt der Reichskammer der bildenden Künste*
PMfWKV	Preussisches Ministerium für Wissenschaft, Kunst und Volksbildung
RdbK	Reichskammer der bildenden Künste
RdRKK-1	*Das Recht der Reichskulturkammer*, 1935–37 edition
RdRKK-2	*Das Recht der Reichskulturkammer*, 1943 edition
RFK	Reichsfilmkammer
RKK	Reichskulturkammer
RMfVuP	Reichsministerium für Volksaufklärung und Propaganda
RMfWEV	Reichsministerium für Wissenschaft, Erziehung und Volksbildung
RMK	Reichsmusikkammer
RPK	Reichspressekammer
RRK	Reichsrundfunkkammer
RSK	Reichsschriftumskammer
RTK	Reichstheaterkammer
T-70	National Archives Microfilm, Records of the Reich Ministry for Public Enlightenment and Propaganda
T-175	National Archives Microfilm, Records of the Reich Leader of the SS and Chief of the German Police
T-580	National Archives Microfilm, Captured German Records Filmed at Berlin (American Historical Association)
VdkKD	Verband der konzertierenden Künstler Deutschlands

INTRODUCTION

1. Standard works include Bollmus, *Amt Rosenberg*; Brenner, *Kunstpolitik*; Drewniak, *Theater im NS-Staat*; Heister and Klein, *Musik und Musikpolitik*; Lane,

Architecture; Prieberg, *Musik im NS-Staat*; Thomae, *Propaganda-Maschinerie*; and Wulf, *Die bildenden Künste, Musik im Dritten Reich*, and *Theater und Film*.

2. On the need for more extensive systematic research on the *Reichskulturkammer* see Dahm, "Die Reichskulturkammer."

3. The most thorough treatment of the so-called *Entjüdung* of German cultural life is Dahm, "Das jüdische Buch."

4. Among the more notable recent works are Brock and Preiss, *Kunst auf Befehl?*; Dussel, "Provinztheater"; Kater, *Different Drummers*; Rathkolb, *Führertreu*; and Splitt, *Richard Strauss*.

5. Note, for example, Joseph Wulf's use of the term "gesteuerte Kunst" and Volker Dahm's reference to "kulturpolitische Steuerung."

6. Notable exceptions are Newhouse, "Artists, Artisans, or Workers?," and Nungesser, "Als die SA in den Saal marschierte."

7. The best introduction and general treatment is Cocks and Jarausch, *German Professions*. A masterful monographic study is Jarausch, *Unfree Professions*.

8. For a good introduction to the field see Welch, *Propaganda*.

CHAPTER ONE

1. "Berufszählung," pp. 177, 192–94, 217, 219. The figure for physicians was 51,527 and for the combined legal professions about 55,000.

2. This estimate is based on the Visual Arts Chamber membership figure for architects in 1937.

3. As calculated in Herterich, *Theater*, pp. 22–23. Herterich included persons employed in music, theater, radio, and the film trade, as well as writers.

4. See Nungesser, "Als die SA in den Saal marschierte," and Newhouse, "Orchestral Musicians."

5. The term "geistige Arbeiter" was employed to connote not only artists but also university professors and members of certain academic professions, such as law and medicine. See Schreiber, *Not*; Weber, *Not*; and Jarausch, "Not."

6. Schreiber, *Not*, pp. 108–15.

7. Ibid., pp. 131–32. Kurt Tucholsky, for one, attributed the failures to what he saw as the artistic temperament. "An artist must stand alone," Tucholsky complained in 1920, and thus "declines to unite with his colleagues who create alongside him, for that would not be dignified." Kurt Tucholsky, "Solidarität," *Der Schriftsteller* 8 (January 1921), Doc. 20 in Kaes, *Weimarer Republik*. Ironically, in 1936 Joseph Goebbels expressed a similar opinion when discussing the difficulties inherent in organizing artists. "It is known," he said, "that the art-creating person is minimally suited to organization on account of his particularly strongly pronounced individuality." Goebbels speech of 27 November 1936, in *Dokumente der deutschen Politik*, vol. 4, doc. 54.

8. *Hugo Riemanns Musik Lexikon*, p. 1921; *Neuer Theater Almanach*, 1914, p. 207.

9. *Statistisches Jahrbuch*, 1932, p. 560.

10. This summary is based on the general argument presented by Newhouse, "Orchestral Musicians."

11. *Hugo Riemanns Musik Lexikon*, pp. 1923–24.

12. Ibid., p. 1923.

13. *Jahrbuch der Berufsverbände*, p. 233.

14. A good capsule summary of the priorities and activities of the VdkKD in the Weimar period is in VdkKD to Schulz (Reichsmin. d. Innern), 27 December 1926, BAK, R55/1125.

15. *Hugo Riemanns Musik Lexikon*, p. 1922.

16. Ibid.

17. *Die Musik in der Geschichte und Gegenwart*, 5:2.

18. GDT, "Geschäftsbericht," 1926, BAK, R55/1149.

19. The battle over copyright reform between 1925 and 1933 is documented succinctly in BAK, R43I/824.

20. On negotiations leading up to the *Tarifvertrag* see *Deutsches Bühnen-Jahrbuch*, 1917, pp. 118–21, 124; 1918, pp. 115–16, 118–22, 125; 1919, p. 95; 1920, pp. 114–24.

21. Ibid., 1933, pp. 123–38.

22. *Statistisches Jahrbuch*, 1928, p. 593; 1932, p. 560.

23. *Deutsches Bühnen-Jahrbuch*, 1933, pp. 143–48.

24. Ibid., pp. 150–53.

25. This summary of the history of the RVbK is based on Nungesser, *"Als die SA in den Saal marschierte,"* pp. 9–14.

26. *Wasmuths Lexikon der Baukunst*, 1:169–71; Gaber, *Entwicklung*, pp. 37–38.

27. Gaber, *Entwicklung*, pp. 83–157.

28. See, for example, the desperate appeal for public assistance from composers in GDT to Reichsmin. d. Innern, 20 March 1928, BAK, R55/1149; a similar appeal from writers in Lilienfein (Schillerstiftung) to Reichsmin. d. Innern, 19 February 1926, BAK, R32/120; and the appeal from musicians in VdkKD to Reichsmin. d. Innern, 17 March 1928, BAK, R55/1128.

29. Official statistics conflate several classifications. In 1932, unemployed persons in the "arts and crafts professions" and in the "theater, music, and performance" professions amounted to .7 percent of the total German unemployed. *Statistisches Jahrbuch*, 1933, p. 291.

30. Paul Schwers, "Deutsches Musikleben im Not!," *Allgemeine Musikzeitung*, 16 January 1931. The article further observed that the "replacement" of the middle class "by 'the art-hungry proletariat' is a utopian idea; the hunger of the working masses is doubtless present, but aside from some exceptions, it aspires only in a materialistic direction."

31. Alois Weber, "Die Abbaumassnahmen im Musikleben des Westens," *Allgemeine Musikzeitung*, 14 October 1932.

32. Reichsmin. d. Innern to Reichskanzlei, 14 November 1932, BAK, R43I/829.

33. Schwers, "Deutsches Musikleben im Not!"

34. Richard von Alpenburg, "Zur Neugestaltung des musikalischen Lebens," *Allgemeine Musikzeitung*, 6 March 1931.

35. "Der Schaffende Musiker," July 1929 and June 1931, BAK, R55/1149.

36. Ernst Schliepe, "Die Situation der Schaffenden," *Allgemeine Musikzeitung*, 14 October 1932.

37. "Die Notlage der Berufsmusiker und ihre Ursachen," *Deutsche Musiker-Zeitung*, 7 December 1929.

38. "Aus anderen Verbänden," *Der Neue Weg*, 1 January 1930.

39. "10,000 Nebenberufler auf dem Tätigkeitsfeld der Chordirigenten," *Deutsche Musiker-Zeitung*, 25 February 1933.

40. "Bericht des Direktors des Bühnennachweis Hans Nerking," *Der Neue Weg*, 16 April 1932.

41. Herterich, *Theater und Volkswirtschaft*, pp. 12–14.

42. Emil Lind, "Die Wirtschaftliche Situation der deutschen Theater," *Deutsches Bühnen-Jahrbuch*, 1931, pp. 56–58; "Die Lage der deutschen Theater in der Spielzeit 1930/31," *Deutsches Bühnen-Jahrbuch*, 1932, pp. 56–60; Emil Lind, "Theaterwirtschaft," *Deutsches Bühnen-Jahrbuch*, 1933, pp. 56–62.

43. DBV to Landtage, Senate, and Stadtverordneten, 28 April 1931, GLAK, 235/30989.

44. RVbK to von Papen, 9 September 1932, BAK, R43I/829.

45. For example, the 1928 budget for the Reich Interior Ministry had provided for a "Fund for the Alleviation of the Emergency Condition of German Art," which set aside RM 153,000 for grants to visual artists. "Zum Haushalt des Reichsministeriums des Innern," 14 February 1929, BayHStA, MK 40 897.

46. *Bayerische Staatszeitung*, 10 November 1931, and *Kunst und Wirtschaft*, 1 February 1933, both reproduced in Nungesser, *"Als die SA in den Saal marschierte,"* p. 27.

47. "Briefe an die Bauwelt," 10 August 1930, in Teut, *Architektur*, pp. 29–30.

48. Both terms have been employed by historians of the Weimar Republic to describe the same ideas. I have chosen to follow Konrad Jarausch, who, in his pathbreaking work on German professions, prefers the term "neocorporatism" in order to distinguish this twentieth-century phenomenon from its historical antecedents. Jarausch, *Unfree Professions*, pp. 22–24. Also useful on this phenomenon are Stark, *Entrepreneurs of Ideology*, pp. 141–43; Bowen, *German Theories*; Lebovics, *Social Conservatism*, pp. 109–38; Mosse, *Germans and Jews*, pp. 116–43; Sontheimer, *Antidemokratisches Denken*, pp. 199–201; and Struve, *Elites against Democracy*, pp. 321–26.

49. Hermann Quistorf, "Eine Künstlerkammer," *Der Auftakt*, 1930, Heft 1.

50. Heinz Pringsheim, "Die Deutsche Musikergemeinschaft," *Allgemeine Musikzeitung*, 6 June 1930; Georg Graener, "Rund um die Musikerkammer," *Allgemeine Musikzeitung*, 10 June 1932.

51. Active on this project was Peter Raabe, the future president of the Reich Music Chamber. The ADMV was not a *Berufsverband* but rather an organization open to all interested in the promotion and study of music, especially contemporary compositions.

52. Article in the *Berliner Tageszeitung*, quoted in Walter Abendroth, "Organisation des Musikinteresses?," *Allgemeine Musikzeitung*, 25 December 1931.

53. Georg Graener, "Musikerkammern," *Deutsche Musiker-Zeitung*, 5 April 1930; "Musikergemeinschaft," *Deutsche Musiker-Zeitung*, 20 September 1930; "Rund um die Musikerkammer," *Allgemeine Musikzeitung*, 10 June 1932; Richard von Alpenburg, "Zur Neugestaltung des Musikalischen Lebens," *Allgemeine Musikzeitung*, 6 March 1931; "Organisation des Musikinteresses?," *Allgemeine Musikzeitung*, 25 December 1931.

54. Dr. Wagner-Roemmich, "Durch Theaterkrisen zur Theaterreform," *Der Neue Weg*, 1 March 1930; "Theaternot," *Der Neue Weg*, 1 April 1930; "Dilettanterei," *Der Neue Weg*, 1 February 1931; "Bochum und die Theaterplanwirtschaft," *Der Neue Weg*, 16 September 1931; Heinz Dietrich Kenter, "Neuregelung der deutschen Schauspielschulen," *Deutsche Kultur-Wacht*, 23 September 1933. Notably, references to the economic impact of the cinema on German theater life were relatively infrequent in these analyses.

55. "Selbsthilfe der Schauspieler," *Der Neue Weg*, 16 March 1930; "Die Al-

tersversorgung ist gesichert!," *Deutsches Bühnen-Jahrbuch*, 1938, pp. 1–10; and "Vermerk" by Reimer, 27 July 1944, BAK, R55/125.

56. "Protokoll der Mitgliederversammlung des Reichswirtschaftsverbandes bildender Künstler, Karlsruhe," 4–5 October 1924, BAK, R32/158.

57. Freie Künstlerschaft Sachsens, Dresden, to Sächs. Landtag, 20 March 1931, BAK, R32/387.

58. BDA to Reichspräsident et al., with appended "Gesetzentwurf zur Bildung von Architektenkammern," October 1925, BAK, R32/191; Gaber, *Entwicklung*, pp. 83–157.

59. Biddiss, *Father of Racist Ideology*; Schemann, *Gobineau*; Stein, *Racial Thinking*; Wagner, "Das Judentum in der Musik"; Stern, *Politics of Cultural Despair*, chap. 2; Chamberlain, *Grundlagen* and *Richard Wagner*; Field, *Evangelist of Race*.

60. Still useful for the historical background to Nazi *Kunstpolitik* are Mosse, *Crisis of German Ideology*; Stern, *Politics of Cultural Despair*; and Viereck, *Metapolitics*.

61. On the limited popularity of the avante-garde in Weimar see Gay, *Weimar Culture*, and Schulze, *Weimar*, pp. 123–38.

62. Noakes and Pridham, *Nazism*, 1:16.

63. Köhler, *Kunstanschauung*, p. 266. The yearly figures are as follows: 1920, 10.5 percent; 1921, 7.0 percent; 1922, 3.9 percent; 1923, 5.1 percent; 1925, 5.8 percent; 1926, 5.2 percent; 1927, 6.3 percent; 1928, 6.9 percent; 1929, 5.4 percent; 1930, 6.0 percent; 1931, 7.2 percent; 1932, 6.1 percent.

64. For examples see Hitler, *Sämtliche Aufzeichnungen*, pp. 137, 187, 189, 196–97, 313, 374, 424.

65. Hitler, *Mein Kampf*, pp. 258–59, 391.

66. Bracher, *German Dictatorship*, p. 281.

67. Pois, *Race and Race History*, p. 163.

68. The quotations are from the speech given by Goebbels at the inauguration of the Reichskulturkammer on 15 November 1933, which is reprinted in Goebbels, *Goebbels-Reden*, 1:131–41.

69. For a more thorough treatment of the Kampfbund see Steinweis, "Weimar Culture."

70. "Arbeitsgrundsätze und Gliederung des Kampfbundes für Deutsche Kultur," *Mitteilungen des Kampfbundes*, January 1929.

71. "Die Geisteswende," *Mitteilungen des Kampfbundes*, January 1929.

72. Bollmus, *Amt Rosenberg*, p. 29.

73. The membership analysis is based on lists of new members published in *Mitteilungen des Kampfbundes*. For further details see the appendix to Steinweis, "Weimar Culture."

74. "Wider die Negerkultur—für deutsches Volkstum," *Mitteilungen des Kampfbundes*, April–June 1930.

75. Schultze-Naumburg, *Kunst und Rasse*.

76. "Abmachungen zwischen der Abt. Volksbildung und dem *Kampfbund* für deutsche Kultur," 24 September 1932, BDC, Sammlung Schumacher, Binder 211.

77. "NSDAP für deutsche Kultur!," *Deutsche Kultur-Wacht*, 1932, Heft 3.

78. "Tätigkeit des KfdK—Gruppe Berlin," *Deutsche Kultur-Wacht*, 1932, Heft 4.

79. In fact, in 1931 Goebbels came to enlist Hinkel's services on the editorial staff of *Der Angriff*, the official organ of the Berlin Gau.

80. Bollmus, *Amt Rosenberg*, p. 29.

81. "Deutsche Hochschullehrer bekennen sich für den Führer der nationalsozialistischen Bewegung," *Deutsche Kultur-Wacht*, 1932, Heft 2.

82. Guttsman, *Workers' Culture*, p. 208.

83. Steinweis, "Professional, Social, and Economic Dimensions."

84. "Allgemeine Richtlinien des KfdK im Hinblick auf seine musikalischen Aufgaben," *Deutsche Kultur-Wacht*, 1932, Heft 2: 8–9; "Tätigkeit des KfdK—Gruppe Berlin," *Deutsche Kultur-Wacht*, 1932, Heft 4: 11–12.

85. Rämisch, "Der berufsständische Gedanke"; Turner, *Big Business*, pp. 69, 80, 137, 140, 145.

86. Noakes and Pridham, *Nazism*, 1:16.

87. Rämisch, "Der berufsständische Gedanke." In 1937 Robert Ley went so far as to assert that corporatism was an "absolute chaos of ideas" and a "philosophical muddle which nobody understands." Ley claimed that he had "never met two National Socialists who were of one opinion of the corporate system." Ley speech of 11 September 1937, quoted in Noakes and Pridham, *Nazism*, 2:225.

88. "Ein Dokument deutschen Kulturwillens," *Der Neue Weg*, 1 July 1932; Franz Lawaczeck, "Kultur und Wirtschaft," *Deutsche Kultur-Wacht*, 1933, Heft 1; Hans Scheller, "Deutsches Theater," *Deutsche Kultur-Wacht*, 1933, Heft 5; Hans Esdras Mutzenbecher, "Rede an die deutschen Bühnenvorstände," *Deutsche Kultur-Wacht*, 1933, Heft 12; Dr. Schroeder, "Ein Beitrag zur Reform des deutschen Theaters," *Deutsche Kultur-Wacht*, 8 July 1933; Friedrich Billerbeck-Gentz, "Die Ausschaltung des Liberalismus am deutschen Theater," *Deutsche Kultur-Wacht*, 28 October 1933. *Kampfbund* calls for the purging of foreigners were loud and very frequent. For a typical example see "Kampf der Überfremdung," *Deutsche Kultur-Wacht*, 1932, Heft 1.

89. Hans Hinkel, "Deutsche Kunst und Deutsche Künstler im Dienst am deutschen Volke," *N.S. Funk*, 21 November 1937, BAK, R56I/73.

90. "Schutz des deutschen Blutes und der deutschen Ehre durch nationalsozialistische Kunstpolitik," *Völkischer Beobachter*, Sonderbeilage zum Reichsparteitag, September 1937.

91. Hans Hinkel, "Deutsches Kunstschaffen," *Freiheitskampf*, 27 May 1934, in BAK, R56I/71.

92. Hinkel to Johst, 20 February 1940, BDC, RKK/Hans Friedrich Blunck.

93. "Aus Künstler- und Berufsvereinen," *Kunst und Wirtschaft*, 1 October 1928. Quotations from the ASSO statute, reprinted in *Künstler im Klassenkampf*, p. 92.

94. Guttsman, *Workers' Culture*, pp. 193–201.

95. "Schauspieler Rollkommando," *Der Neue Weg*, 1 July 1931; "Die Opposition," *Der Neue Weg*, 1 August 1931. These professionals should not be confused with amateurs involved in communist agit-prop theaters. See Guttsman, *Workers' Culture*, pp. 221–32.

96. "Zur Oppositionebildung," *Der Neue Weg*, 1 March 1933.

97. "Bekanntmachung," *Der Neue Weg*, 1 October 1932.

98. Kater, *Nazi Party*, p. 111.

99. BDC, random survey of 364 Music Chamber files.

100. BDC, random survey of 1,419 Theater Chamber (Fachschaft Bühne) files.

101. NSDAP, Gauleitung München-Oberbayern, to Biederstein, 16 September 1940, BDC, RTK/Otto Schöpf.

102. "Namentliches Verzeichnis derjenigen Mitglieder, die bis 31. Dezember 1932. . . . ," May 1934, BDC, RTK/Fritz Fuchs.

103. Meysel to Ausschuss f.d. preussische Theater, 26 June 1933, BDC, RTK/ Konrad Meysel.

104. Moss to Hadamovsky, 14 August 1934, BDC, RTK/Harry Moss.

CHAPTER TWO

1. Bollmus, *Amt Rosenberg*, p. 29.

2. On opportunistic joining see Stickl [Kampfbund leader in Greifswald] to Landesleitung Preussen, 27 June 1933, BAK, R56I/44.

3. Bollmus, *Amt Rosenberg*, pp. 39–42.

4. "Der Deutsche Werkbund im Dritten Reich," 3 March 1934, Geheimes Staatsarchiv, Berlin, Rep. 90, File 1793; Lane, *Architecture*, pp. 174–75.

5. Wuensch to Hinkel, 27 April 1933, BAK, R56I/66.

6. "Bericht über die Tätigkeit der Landesleitung Nord," 6 May 1933, BAK, R56I/44.

7. *Schwarzbuch*, p. 423.

8. Bramstaed, *Goebbels*. The effectiveness of Nazi propaganda in pre-1933 elections is examined in Childers, *Nazi Voter*.

9. *Regierung Hitler*, vol. 1, doc. 56, note 1.

10. Wagener, *Hitler*, p. 309.

11. "Ministerbesprechung vom 11.3.33," *Regierung Hitler*, vol. 1, doc. 56.

12. Schmidt-Leonhardt, "Die Reichskulturkammer," p. 5.

13. Bracher et al., *Die nationalsozialistische Machtergreifung*, 2:218–19.

14. Diller, *Rundfunkpolitik*, pp. 84–96.

15. Reichskanzler to Reichsstatthalter, 15 July 1933, *Regierung Hitler*, vol. 1, doc. 196. Note also Goebbels's observation in his diary: "Hitler has signed a letter to the Reich governors. Regarding my jurisdiction over the broadcasters. Very good for me. Above all against Prussia. Particularism must go!" *Goebbels Tagebücher*, 19 July 1933.

16. Jarausch, *Unfree Professions*, pp. 116–25.

17. Handwritten note, signed by Fritz Stege et al., 3 February 1933, BAK, R56I/66.

18. "Protokollarische Erklärung," 24 March 1933, BAK, R56I/66.

19. "Protokoll der Sitzung am 4. April 1933," 5 April 1933, BAK, R56I/66.

20. "Protokollarische Erklärung," signed by Havemann et al., 25 March 1933, BAK, R56I/66.

21. "Vollmacht," Verbindungsstab der NSDAP, 25 April 1933, with attached statements by Hinkel and NSBO, BDC, RMK/Gustav Havemann.

22. "Antrag auf Gründung einer einzigen reichsdeutschen Aufführungsgesellschaft," 15 March 1933, BDC, RMK/Leo Ritter; "Beschluss der IDK-Sitzung," 10 June 1933; "Begründung des Gesetzes über Vermittlung von Musikaufführungsrechten," June 1933, all in BAK, R55/1151; Von Keudell to Strauss, 18 July 1933; Goebbels to Strauss, 31 July 1933; GEMA to RMfVuP, 9 September 1933; "Protokoll über die Sitzung.," 4 September 1933, all in BAK, R55/1152; "Gesetz über die Vermittlung von Musikaufführungsrechten," *Reichsgesetzblatt*, 1933, 1:453.

23. Nungesser, *"Als die SA in den Saal marschierte,"* pp. 61–62, 100.

24. RVbK, Gau Berlin, to Hinkel, 29 March 1933, in Nungesser, *"Als die SA in den Saal marschierte,"* p. 92.

25. Ibid., pp. 84–85.

26. Ibid., pp. 102, 127, 133, 138; Wulf, *Musik im Dritten Reich*, p. 23.

27. "Zusammenschluss der bildenden Künstler," *Kunst und Wirtschaft*, 1 July 1933.

28. Lane, *Architecture*, pp. 149, 158, 174, 183, 255 n. 10.

29. Vogt to Hunke, 5 May 1933, BAK, R56I/92.

30. "Bekanntmachung," *Der Neue Weg*, 1 April 1933; "Die neue Intendanz des Staatlichen Schauspielhauses," *Der Neue Weg*, 21 January 1933; *Der Neue Weg*, 20 April 1933.

31. Goebbels to Reichskanzlei, 13 July 1933, BAK, R43II/1244.

32. "Protokoll über die Auflösung des Deutschen Musikverbandes. . . . ," April 1933, BDC, SS/Heinz Ihlert.

33. DMV to Reichskanzler, 28 April 1933, with attached "Erklärung," BAK, R55/1138.

34. Schaller to Ley, 9 May 1933, BDC, RMK/Gustav Havemann.

35. Funk to Hess, 23 August 1933, BAP, Promi 162.

36. Goebbels to Reichskanzlei, 13 July 1933, BAK, R43II/1244.

37. "Gesetz über die Errichtung einer vorläufigen Filmkammer," *RdRKK-1*, 1:11–12.

38. For background on the coordination of the cinema see Welch, *Propaganda*, chap. 1.

39. "Begründung" for the Film Chamber, 28 April 1933, BAK, R43II/388.

40. "Verordnung über die Errichtung einer vorläufigen Filmkammer," 22 July 1933, *RdRKK-1*, 1:11–12.

41. Ibid., par. 6.

42. "Gesetz über die Errichtung," par. 3.

43. "Verordnung über die Errichtung," par. 12.

44. Ibid., par. 11.

45. Ibid., par. 7.

46. "Gesetz über die Errichtung," par. 4.

47. This was indicated as early as April 1933 in the "Begründung" for the Film Chamber.

48. Ibid.

49. Note also that Hitler and Goebbels spent many private hours together on 14 and 15 July. *Goebbels Tagebücher*, 15 July 1933.

50. Lammers to Hess, 17 July 1933, BAK, R43II/1244.

51. Goebbels to Ley, 28 July 1933, BAK, R43II/1244.

52. "Grundgedanken für die Errichtung einer Reichskulturkammer," 11 August 1933, BAK, R43II/467; *Goebbels Tagebücher*, 23 August 1933.

53. Goebbels to Reichskanzlei, 12 August 1933, BAK, R43II/1244.

54. Lammers to Hess, 14 August 1933, BAK, R43II/1244.

55. Draft of "Reichskulturkammergesetz," 17 July 1933, BAK, R43II/467.

56. Ibid.; "Grundgedanken für die Errichtung"; Funk to Reichsmin. d. Innern et al., 18 August 1933, BAK, R43II/467.

57. Brenner, "Die Kunst."

58. *Goebbels Tagebücher*, 25 August 1933.

59. "Vermerk," 2 September 1933, BAK, R43II/467.

60. Draft of "Reichskulturkammergesetz," 20 September 1933, BAK, R43II/1241. Although the addition of the clause was chiefly a political compromise, it is interesting to note how a Nazi jurist rationalized the measure in ideological terms in 1937:

The Reich Minister for Popular Enlightenment and Propaganda together with the Reich Minister of Economics is empowered by means of decree to bring the Reich Chamber of Culture Law into correspondence with the Commercial Code, that is to say, to modify the Commercial Code, a Reich law. This would otherwise be possible only through a new law. The ministers should follow the path of joint decrees, for the modification of the Commercial Code is a necessity arising from the Reich Chamber of Culture Law.

Why? Because both laws stand in a conceptual opposition to one another. The Commercial Code (in its original version of 21 June 1869) based the economy on the foundation of freedom of trade. Freedom of trade is the state of affairs in which the individual person as the natural and protected bearer of economic production takes priority over the collectivity, over the state. Freedom of trade is, together with the system of other political freedoms (e.g., freedom of expression, the press, association, construction, contract, ownership) the fundamental idea of the liberal conception of the state, the law, and the world.

Corporatist construction, however, is . . . the state of affairs of the concentration and leadership of all working and professional groups in the community of the Volk organized into the state . . . the state of affairs, therefore, where freedom and the supposedly natural antagonism of the individual to the state is superseded by the circumstance of the [unity] of people and state, of private and public tasks.

(Schmidt-Leonhardt, "Die Reichskulturkammer," pp. 2–3)

61. Goebbels to Reichskanzlei, 20 September 1933, BAK, R43II/1241.

62. "Kabinettssitzung am 22.9.1933, 4:15 Uhr nachm.," BAK, R53/31.

63. The final version of the law can be found in *RdRKK-1*, 1:1–2, or in the *Reichsgesetzblatt*, 1933, 1:659.

64. "Kabinettssitzung."

65. "Niederschrift über die Kammerbesprechung am 6.3.36," 17 March 1936, BAK, R56I/94.

66. Essentially, the DAF was restricted to propaganda, recreation, and education. Broszat, *Hitler State*, p. 145.

67. Text of agreement in Hinkel, *Handbuch*, p. 37. Even after this agreement had been reached, suspicions persisted. In July 1934, for example, officials in the Kulturkammer believed that the DAF was planning to create new sections for writers and editors. "Niederschrift über die Kammerbesprechung vom 6. Juli 1934," 14 July 1934, BAK, R55/701.

68. Text of agreement of February 1937, in Hinkel, *Handbuch*, pp. 37–40.

69. "Erste Verordnung zur Durchführung des Reichskulturkammergesetzes," 1 November 1933, *RdRKK-1*, 1:2–8.

70. See the explanation in Schmidt-Leonhardt, "Die Reichskulturkammer," pp. 7–8.

71. Gottfried Eberle, " 'Als Verfemte überwintern'—zwei Musiker im 'Dritten Reich': Ein Gespräch mit Cornelia und Hanning Schröder," in Heister and Klein, *Musik und Musikpolitik*, p. 256.

72. Schmidt-Leonhardt, "Die Reichskulturkammer," p. 11. Some time later, when a technical legal problem in the Theater Chamber was traced back to these measures, Schmidt-Leonhardt wrote: "At the time of the creation of the Culture Chamber, the Bühnen-Verein, Bühnengenossenschaft, and countless other existing professional associations were made subsidiaries of the Chamber without impair-

ment of their legal status. The integration of private-law associations into public corporations was somewhat abnormal but [was] accomplished without any possibility of objection" (Schmidt-Leonhardt to Getzlaff, 20 January 1941, BAK, R55/708).

73. By May 1934 the seven chambers comprised a total of 72 *Fachverbände*, broken down as follows: RdbK, 16; RFK, 10; RMK, 6; RPK, 10; RRK, 3; RTK, 12; RSK, 15. See list of *Fachverbände* in *Das Deutsche Führerlexikon*, sec. 2, pp. 121–28. These figures, it should be noted, are not entirely accurate reflections of the number of professional associations that had been incorporated into the chambers. The process of concentration of associations into cartels during the spring and summer of 1933 was carried forward more completely in some fields than in others. The Reichsmusikerschaft, for example, comprised the memberships of several pre-1933 associations but counted as only a single *Fachverband* in the new RMK. Other *Fachverbände* consisted of only one or two pre-1933 associations. Thus, the actual number of Weimar-era professional associations that had been subsumed in the Reichskulturkammer was actually a good deal higher than the number of *Fachverbände*.

74. Leers to Asal, 6 March 1934, GLAK, 235/30990.

75. This explains why in 1945 the Literature Chamber owned 7,650 zloties worth of stock in the Polish railway system. See the RSK Budget for 1945, BAK, R2/4885.

76. Speech of 15 November 1933, in *Goebbels-Reden*, 1:139. "Tagung der Reichskulturkammer. Reichsminister Dr. Goebbels berichtet über den ständischen Aufbau der Kulturberufe." Deutsches Nachrichtenbüro press release, 8 February 1934, BAK, R43II/1241.

77. Speech by Strauss, 13 February 1934, in Wulf, *Musik im Dritten Reich*, p. 194. A similar confidence in the chamber system was expressed by the first president of the Literature Chamber, Hans Friedrich Blunck. In a letter of February 1934 to Nazi writer Hanns Johst, Blunck underscored the "great advantage" that "the new estate order has for German literature." "Self-administration," he wrote, would leave to writers and publishers themselves the responsibility for "self-monitoring and safeguarding the honor and dignity of the profession." Ultimately, "political [*polizeiliche*] interferences" by the state would become obsolete. All problems would be "resolved as internal affair[s] of the profession." Blunck to Johst, 11 February [Hornung] 1934, BAK, NS 8/101.

78. Splitt, *Richard Strauss*, pp. 78–86.

79. For the pertinent documentation see Wulf, *Musik im Dritten Reich*, pp. 85–89.

80. BDC, RMK/Heinz Ihlert. On the importance of the *Geschäftsführer* position see Hinkel to Heydrich, 7 January 1937, BDC, RMfVuP/Heinz Ihlert.

81. BDC, RTK/Otto Laubinger; Wulf, *Theater und Film*, p. 36.

82. Wulf, *Theater und Film*, pp. 282–83.

83. For outlines of Schlösser's career see ibid., p. 35, and Drewniak, *Theater im NS-Staat*, p. 418.

84. Wulf, *Theater und Film*, p. 37, n. 4.

85. Ibid., p. 104. In 1936, Körner could not provide the Propaganda Ministry with a single political reference. See Körner to Hanke, 2 November 1936, BDC, RTK/Körner-GDBA.

86. Lane, *Architecture*, p. 183.

87. Wulf, *Die bildenden Künste*, pp. 43–44.

88. Ibid., p. 284.

89. Ibid., pp. 155–56.

90. Steinweis, "Conservatism."

CHAPTER THREE

1. Splitt, *Richard Strauss*, pp. 189–202.

2. Ihlert to Hinkel, 22 May 1935, BDC, RMK/Richard Strauss. Strauss, it should be noted, complained that it was Ihlert who was attempting to monopolize power in the Music Chamber. See the letters of December 1933 and June 1934 by Strauss to Wilhelm Furtwängler, in Grasberger, *Der Strom der Töne*, pp. 349, 353.

3. Ihlert to Hinkel, 22 May 1935, BDC, RMK/Richard Strauss.

4. Strauss to Goebbels, 4 October 1934, BDC, RMK/Richard Strauss.

5. Splitt, *Richard Strauss*, pp. 212–25; Lowinsky, *A Confidential Matter*; Marek, *Richard Strauss*, pp. 277–79; Wulf, *Musik im Dritten Reich*, pp. 196–99; Prieberg, *Musik im NS-Staat*, pp. 204–8; Drewniak, *Theater im NS-Staat*, pp. 291–94.

6. Quoted in Marek, *Richard Strauss*, p. 279.

7. Quoted in Prieberg, *Musik im NS-Staat*, p. 206.

8. Stang to NSKG Gauobmänner, 20 June 1935, in Wulf, *Musik im Dritten Reich*, pp. 196–97.

9. Reprinted in Lowinsky, *A Confidential Matter*, pp. 99–100 (see also the discussion of the letter's history on p. 117, n. 59). Several documents pertinent to the letter are in BAK, NS 10/111.

10. BDC, RKK/Friedrich Mahling; Prieberg, *Musik im NS-Staat*, pp. 191–92.

11. *Goebbels Tagebücher*, 5 July 1935.

12. Prieberg, *Musik im NS-Staat*, p. 228.

13. An additional factor influencing Goebbels's position toward Strauss involved Hans Friedrich Blunck, president of the Reich Literature Chamber. In December 1933 Blunck had publicly advocated a "concordat" between the German-Jewish community and the Nazi government, an agreement not unlike the one that had been concluded in 1933 between Hitler and the Catholic church. The Gestapo, in a severe letter to the Kulturkammer central office, characterized Blunck's idea as "absurd" and "not consistent with the fundamentals of National Socialism." According to Blunck's own postwar accounts, he objected to plans for the expulsion of the Literature Chamber's Jewish members, and when in 1935 it became clear that he would have to preside over the purge of Jews from his own organization, he chose to resign. "Rückschau, 1933–1947," BAK, Kleine Erwerbung 470/3; "Rede an die Jugend der Westländer," *Europäischen Revue*, December 1933; Blunck, *Unwegsame Zeiten*, 2:205, 212, 242; Gestapo to Hinkel, 20 August 1935, BDC, RSK/Blunck.

14. For a brief biography see Erich Valentin, "Musiker, Mensch und Gelehrter: Peter Raabe zum Gedenken," *Zeitschrift für Musik* 113 (June 1952): 630–34.

15. See, for example, Raabe's article "Vom Neubau deutscher musikalischer Kultur," *Zeitschrift für Musik* 101 (March 1934): 256–73, as well as his *Die Musik im Dritten Reich*.

16. Hinkel to Funk, 22 July 1935, BAK, R56I/18.

17. For a catalog of complaints see Raabe to Schmidt-Leonhardt, 30 October 1939, BAP, Promi 575.

18. On Drewes see *Goebbels Tagebücher*, 22 August, 18 September, 9, 14, 22 October 1937; on "de-Jewification," 9 February 1938; on Furtwängler, 17 April 1940; on Goebbels's estimate of Raabe's malleability ("Der ist doch so leicht zu

haben"), 10 June 1938. On Raabe's attempted resignation and the prospective appointment of Leonhardt see Goebbels to Lammers, 30 September 1940, and Lammers to Goebbels, 4 November 1940, BAK, R43II/1238c.

19. For the pertinent, and quite entertaining, documentation, see BAK, R58/739, and Gestapo to Staatspolizeistellen, 25 July 1935, BAK, R58/1029.

20. "Fachschaft Artistik," no date provided (probably late 1935), T-580, 944/28.

21. RTK to Hinkel, 25 September 1935, BAP, Promi 131.

22. "Gründungsversammlung der 'Fachschaft Bühne,'" Der Neue Weg, 15 September 1935.

23. Laubinger to RTK members, 22 January 1934, Der Neue Weg, 30 January 1934.

24. RMfVuP to RTK, 20 July 1934, Der Neue Weg, 15 August 1934; RTK to GDBA, 26 June 1935, Der Neue Weg, 15 August 1935.

25. Four-page list with heading "Bühnennachweis," BAK, R56I/49.

26. Biographical note on Schlösser, Die Bühne, 15 November 1935.

27. A Nazi since 1928, Frauenfeld had been forced to leave Austria for the German Reich after the failed Putsch of 1934. Frauenfeld oversaw the day-to-day operation of the Theater Chamber from May 1935 until 1941, when he was sent to the Nazi-occupied Soviet Union as Generalkommissar for Crimea with a mission to colonize that area with ethnic Germans. After the war, Frauenfeld was convicted of war crimes for acts committed while in this office. He was also convicted of neo-Nazi activities in West Germany in 1953. BDC, SS/Frauenfeld; Die Bühne, 15 November 1935; Pauley, Hitler and the Forgotten Nazis, p. 221.

28. "Gründungsversammlung der 'Fachschaft Bühne,'" 6 September 1935, in Beilage to Der Neue Weg, 15 September 1935.

29. This conclusion is based on a comparison of Kulturkammer budget documents for the years 1935–1937, contained in BAK, R2/4874–76. It should be noted that the process of financial unification was gradual and not entirely uniform.

30. "Errichtung der Fachschaft Bühne," reprinted in Völkischer Beobachter, 6 September 1935.

31. For an especially good illustration see "Protokoll über die Sitzung des Führerrats des Reichsverbandes deutscher Schriftsteller e.V. am 20. September 1935," 26 September 1935, T-580, 956/81.

32. Legal complications did arise in at least one case. In 1936 the Theater Chamber assigned to Ludwig Körner the task of liquidating the Bühnengenossenschaft. At stake was a considerable portfolio of assets, including a large share in an enterprise initiated in the early 1930s by several cultural Berufsverbände for the purpose of constructing a residential village for artists in Berlin. Körner proceeded very slowly, denying the Theater Chamber and the Propaganda Ministry total access to the funds. Although they experienced great difficulty in collecting evidence, officials in the Culture Chamber and the Propaganda Ministry suspected that Körner had been using Bühnengenossenschaft assets as a sort of slush fund, from which he could dole out favors to favorites in the theater world. As late as 1943, Körner was able to exploit legal technicalities relating to the de facto dissolution of the Genossenschaft in 1935 to delay the formal financial liquidation, and to forestall audits of the portfolio by the Reich Accounting Office. In January 1943 the Propaganda Ministry needed a court order and a raid on Körner's home to lay hands on important Genossenschaft official documents that Körner had kept locked up in a trunk. The extremely complex legal and financial dimensions of this affair are documented in the following files: BDC, RTK/Körner (Leitz folders I-IV); BDC,

RTK/Körner-GDBA; BDC, RTK/Körner-Entnazifizierung; BAK, R55/707–8; and BAK, R36/2400. Several key documents are reprinted in Wulf, *Theater und Film*, pp. 106–10.

33. The Goebbels-Rosenberg dispute over expressionism has been well documented. See Lane, *Architecture*, pp. 176–82; Brenner, "Die Kunst im politischen Machtkampf"; Stefan Germer, "Kunst der Nation: Zu einem Versuch, die Avantegarde zu nationalisieren," in Brock and Preiss, *Kunst auf Befehl?*, pp. 21–40.

34. Troost to Hanke, 19 December 1933; NSDAP Oberstes Parteigericht to RMfVuP, 20 March 1934; Goebbels to NSDAP, Oberstes Parteigericht, 23 April 1934, all in BDC, Oberstes Parteigericht/Paul Ludwig Troost.

35. *RdRKK-2*, RdbK, VIII, no. 1.

36. "Betrifft Verein Berliner Künstler," signed by Hinkel, July 1935, BDC, RdbK/Karl Langhammer.

37. *Goebbels Tagebücher*, 24 October 1935, 16 April 1936.

38. Wulf, *Musik im Dritten Reich*, p. 152.

39. Hinz, *Art in the Third Reich*, p. 38.

40. "Reichskulturwalter Moraller und Hinkel in Leipzig," *Börsenblatt für den deutschen Buchhandel*, 23 April 1936.

41. Schmidt-Leonhardt to Chamber Presidents, 30 October 1937, BAK, R56I/94; "Anträge zum Haushaltsentwurf 1938," Abt. IV-Presse in RMfVuP, 30 October 1937, BAK, R55/166; RKK to Presidents of Chambers, 15 November 1937, BAK, R55/783; *Goebbels Tagebücher*, 26 May 1937, 24 August 1937, 21 September 1937.

42. "Anordnung d. RMfVuP u. Pres. d. RKK über die Aufsicht d. Landesstellenleiter über die Arbeit d. RKK im Reiche," 12 November 1934, *RdRKK-1*, 2:25.

43. In 1937 the Landesstellen of the Propaganda Ministry were redesignated as Reichspropagandaämter.

44. The order creating the Landeskulturwalter made clear that this application of the "personal union" concept was consistent with the progressive "unification of party and state" that was being implemented in all sectors of German life. Although the intertwining of NSDAP organs with the apparatus of the state had begun very early in the Nazi regime—when, for example, the SA was deputized as a police agency in February 1933—it was not until 1 December 1933 that a Law for Ensuring the Unity of Party and State was promulgated. See Broszat, *Hitler State*, pp. 207–10, and Bracher et al., *Machtergreifung*, 1:304–6.

45. "Richtlinien über die Eingliederung der Landeskulturwalter in den Aufbau der RKK," 12 November 1934, *RdRKK-1*, 2:25–27.

46. Roster of leaders of Reichspropagandaämter (Landeskulturwalter) 1939, BAK, R55/407. The document supplies NSDAP membership numbers rather than dates of joining. Membership number 850,000 is used here to distinguish between those who joined the party before and after 30 January 1933. See graph in Kater, *Nazi Party*, p. 264.

47. The following generalized, composite portrait of the activities of the regional leaders is based on examination of a large number of personal files of the regional leaders in the BDC, and on the following documents: Hinkel to Gutterer ("Betr.: Begutachtung von Kulturschaffenden durch die Landesleiter der Einzelkammern"), 16 September 1938, BAK, R55/1008; "Befugnisse und Aufgaben des Landesleiters," 1936, T-580, 952/63; "Anordnung betr. Aufbau und Organisation der RdbK," 10 April 1935, *RdRKK-1*, 2:61–67; "Bekanntmachung betr. Änderung zur Durchführung des Ehrengerichtsverfahrens," February 1938, *RdRKK-2*, RdbK, II, no. 14; Schmidt-Leonhardt, "Die Reichskulturkammer," pp. 26, 28–29, 33; "Prü-

fung bei den Landesleitungen der Einzelkammern in Stuttgart," 11 November 1937, BAK, R55/700; Gerhard Brückner, "Der Landesleiter der Reichstheaterkammer," *Die Bühne*, 24 December 1942.

48. Hinkel to Landeskulturwalter, 30 August 1940, BAK, R56I/26.

49. Such a prerogative for the Gauleiter was not included in the original 12 November 1934 "Richtlinien" for the regional organs of the RKK but was added by Goebbels's "Zweite Anordnung" of 3 February 1938. This new role for the Gauleiter may be regarded as an additional layer of political control over the RKK regional organs.

50. Information compiled by the author from RKK files and the NSDAP main card file in the Berlin Document Center. Party affiliations of the RTK regional leaders could not be established from the fragmentary RTK files. The identities of the regional leaders used for this compilation were drawn from Hinkel, *Handbuch*, pp. 77–81, 108–23, 163–84.

51. Correspondence relating to appointments can be found in BAK, R55/1008.

52. Further evidence supporting this conclusion can be found in a compilation of data regarding the NSDAP affiliations of the employees of the Landeskulturwalter for the Berlin region in late 1938, among whom were included the functionaries subordinate to the Landesleiter of the individual chambers. Of a total of 69 employees, 23 had joined the party before 30 January 1933. ("Aufstellung der Mitarbeiter des Landeskulturwalters Gau Berlin," 10 October 1938, BDC, RKK/Ordner "Personal; Listen," cross-indexed with RKK file of Franz Moraller.)

53. Based on information in budget documents in BAK, R2/4875–85.

54. Schmidt-Leonhardt, "Die Reichskulturkammer," p. 20.

55. *Goebbels Tagebücher*, 19 September 1935, 9 November 1936, 2 October 1937, 9 October 1937.

56. RMfVuP "Nachrichtenblatt," 2 July 1941, BAK, R55/438.

57. Hinkel to RMfVuP, Leiter Pers., 23 May 1944, BAK, R55/163.

58. BDC, SS/Walter Owens.

59. BDC, SS/Erich Kochanowski.

60. BDC, SS/Helmuth von Loebell.

61. BDC, SS/Gerhard Noatzke.

62. Hinkel to Hanke, 17 January 1939, BAK, R55/407.

63. In 1934 Hinkel had appealed directly to Rudolf Hess, hoping that the Führer's deputy could help clear the way for Hinkel's membership. Bormann to Himmler, 24 July 1934, BDC, SS/Hans Hinkel.

64. Hinkel's correspondence with high SS officials contains many references to "urgent personnel questions." For examples see Hinkel's letters to and from Himmler, Karl Wolff, and others, in T-175, 42/2553544–609. The correspondence covers the period April 1937 to July 1943. Also particularly illustrative of Hinkel's efforts to see his assistants promoted within the SS is material in BDC, SS/Walter Owens.

65. Letter (signature illegible) to Alvensleben, February 1939, T-175, 42/2553583; Wolff to Schmitt, 19 July 1939, T-175, 42/2553577; Hinkel to Himmler, 5 May 1942, T-175, 42/2553550.

66. See, for example, Hinkel's undated report in the SS files, T-175, 42/2553590–91.

67. Hinkel himself attributed the cordial relationship between his office and the SD to his own and his assistants' SS connections. Hinkel to Hanke, 17 January 1939, BAK, R55/407.

68. Bay. Staatsmin. f. Unterricht u. Kultur to RMfVuP, 14 November 1933,

GLAK, 235/5931. The letter was probably prompted by the Propaganda Ministry's announcement of 9 November that the First Implementation Decree, and by extension the very existence of the RKK, would become effective on 15 November. See "Zweite Verordnung zur Durchführung des Reichskulturkammergesetzes," 9 November 1933, *RdRKK-1*, 1:8–9.

69. PMfWKV to Universitätskuratoren et al., 7 December 1933, GLAK, 235/39817.

70. Rust to various agencies and ministries, 5 January 1934, *Regierung Hitler*, doc. 306, note 1.

71. Bad. Min. d. Kultur, Unterrichts u.d. Justiz to RMfVuP, 8 December 1933; Sächs. Min. f. Volksbildung to RMfVuP, 30 December 1933; Hess. Staatsmin., Abt. f. Bildungswesen, Kultus, Kunst u. Volkstum to RMfVuP, 30 December 1933; Württ. Kultusmin. to RMfVuP, 23 January 1934, all in GLAK, 235/5931.

72. Reichsmin. d. Innern to Regierungen d. Länder, 9 December 1933, GLAK, 235/39817. The position of the Interior Ministry with respect to this issue must also be understood in the broader context of the civil service policy then being promoted by Interior Minister Wilhelm Frick and his state secretary, Hans Pfundtner. Frick and Pfundtner advocated the maintenance of a cohesive, highly professional civil service that would serve as an elite administrative cadré for the National Socialist state. A conflicting conception of the civil service, popular among so-called Nazi "old fighters," aimed at a higher degree of politicization and accountability to the NSDAP. Goebbels's designs for incorporating civil servants into the RKK must have been perceived by Frick and Pfundtner as an additional threat to civil service autonomy. For more background see Broszat, *Hitler State*, pp. 241–61; Bracher et al., *Machtergreifung*, 2:58–64; and Mommsen, *Beamtentum*, pp. 62–90.

73. RdbK to Bad. Finanz.- u. Wirtschaftsmin., 19 January 1934, GLAK, 237/33824.

74. See, for example, "Zweite Anordnung zur Befriedung der wirtschaftlichen Verhältnisse im deutschen Musikleben," 26 April 1934, *RdRKK-1*, 1:91–92, as well as the reaction thereto on the part of the Culture Ministry in Würrtemburg in Württ. Kultusmin. to RMfWEV, 1 August 1934, GLAK, 235/6346.

75. "Bekanntmachung über die Gliederung der Reichsschriftumskammer," December 1933, *RdRKK-1*, 1:199–204.

76. RMK, Fachverband B "Reichsmusikerschaft," Ortsgruppe Heidelberg, to Besseler, 27 January 1934; Besseler to Bad. Kultusmin., 28 January 1934; RMK, Fachverband B "Reichsmusikerschaft" to Besseler, 5 March 1934, all in GLAK, 235/6346.

77. RMK, Fachverband B "Reichsmusikerschaft," Ortsgruppe Karlsruhe, to Rahner, 6 March 1934, GLAK, 235/6346.

78. Bay. Staatsmin. f. Unterricht u. Kultus to RMfVuP, 25 January 1934, GLAK, 235/5931.

79. RdbK to Württ. Landeskunstsammlung (Stuttgart), 26 February 1935, GLAK, 235/5931.

80. See, for example, the appeal from the Oberbürgermeister of Mannheim to the Bad. Min. d. Kultus. u.d. Unterrichts, 13 March 1935, GLAK, 235/5931.

81. PMfWKV to RMfVuP, 3 April 1935, GLAK, 235/5931.

82. This summary of the negotiating position of the Propaganda Ministry is drawn from "Vermerk," RMfVuP (signed by von Keudell), 9 June 1934, and RMfVuP to Reichsmin. d. Innern, 13 November 1935, both in T-580, 952/63.

83. The Law for the Reconstruction of the Reich of 30 January 1934 (*Reichs-*

gesetzblatt, 1934, 1:75) had stipulated the following: "The sovereign rights of the Länder are hereby transferred to the Reich. Land governments are subordinate to the governments of the Reich." For a discussion of this law see Broszat, *Hitler State*, pp. 112–20, and Bracher et al., *Machtergreifung*, 2:271–79.

84. Hönig to Hinkel, 1 February 1936, BAK, R56I/129.

85. For Rust's position at this juncture see "Betrifft Auswirkungen des Reichs-kulturkammergesetzes," 26 January 1934, BAK, R43II/1251; PMfWKV to RMfVuP, 20 February 1934, *Regierung Hitler*, doc. 306; and RMfWEV to Lammers et al., 12 May 1934, *Regierung Hitler*, doc. 345.

86. "Niederschrift über die Kammerbesprechung vom 6.7.34," 14 July 1934, BAK, R55/701.

87. "Reichstheatergesetz," 15 May 1934, *Reichsgesetzblatt*, 1934, 1:411, also published in *RdRKK-1*, 1:45–48.

88. For the position of the Rust Ministry see RMfWEV to Lammers et al., 12 May 1934, *Regierung Hitler*, doc. 345. For the minutes of the cabinet meeting at which Interior Minister Frick voiced his objections, see "Kabinettssitzung vom 15.3.34," *Regierung Hitler*, doc. 346.

89. "Verordnung zur Überleitung des Kunstwesens auf das Reich," and attached "Vermerk," 9 June 1934, T-580, 952/63.

90. For the minutes of the meeting see "Chefbesprechung," 19 June 1934, *Regierung Hitler*, doc. 369.

91. *Regierung Hitler*, doc. 369, n. 1.

92. See, for example, Lammers to Reichsmin. d. Innern, 31 October 1935, BAK, R43II/1149.

93. For an account of Rust-Goebbels exchanges to 1942, at which point the documentary trail disappears, see *Regierung Hitler*, doc. 369, n. 1. The business continued to be transacted mainly through Lammers in the Reich Chancellery.

94. "Bekanntmachung über Anstalten der bildenden Künste," 29 August 1936, *RdRKK-1*, 5:65.

95. RMfWEV to various ministries and academies, 26 September 1936, GLAK 235/5931.

96. "Anordnung über die Erteilung von Unterricht auf dem Gebiete der bil-denden Künste," 8 October 1936, *RdRKK-1*, 5:68.

97. RMfWEV to various ministries and academies, 19 October 1936, GLAK 235/5931.

98. RdbK, Landesleiter Baden, to Bad. Finanz- u. Wirtschaftsmin., 11 September 1935, and Württ. Finanzmin. to Bad. Finanz- u. Wirtschaftsmin., 12 November 1935, both in GLAK, 237/33824; Bad. Finanz- u. Wirtschaftsmin. to RdbK, Landesleiter, Baden, 2 December 1935, GLAK, 235/5931.

99. "Verordnung zur Durchführung des Theatergesetzes," 18 May 1934, *RdRKK-1*, 1:48–51.

100. Hinkel, *Handbuch*, p. 100.

101. Ibid., pp. 42–43; "Erste Anordnung über den Beruf des Architekten," 28 July 1936, *RdRKK-1*, 4:143–48.

102. Hinkel, *Handbuch*, p. 59.

103. Schmidt-Leonhardt, "Die Reichskulturkammer," p. 36.

104. A Kampfbund colleague of Gustav Havemann, Fritz Stein, had been instru-mental in coordinating the amateur choral societies. Hinkel assigned the task to Stein in early May 1933. Believing the societies to be of great cultural importance, and also of potential utility to the regime, Stein enlisted Propaganda Ministry

assistance in keeping the societies more or less intact, and later in placing them under Music Chamber supervision. Havemann to Hinkel, 30 June 1933; Hinkel to Hess, 3 July 1933; Verbindungsstab d. NSDAP to Hinkel, 13 July 1933; Stein to Erbe, 15 July 1933; Stein to Goebbels, 19 July 1933; DS to Hess, 9 September 1933, all in BAK, R55/1194; Wulf, *Musik im Dritten Reich*, p. 20; Havemann to Hinkel, 12 May 1933, BDC, RMK/Havemann; Stein to Weber, 7 October 1933, BDC, RMK/Fritz Stein; "Erste Anordnung zur Befriedung der Verhältnisse im deutschen Chorwesen," 3 April 1934, *RdRKK-1*, 1:90–91; Antoinette Hellkuhl, "'Hier sind wir versammelt zu löblichem Tun,' Der Deutsche Sängerbund in faschistischer Zeit," in Heister and Klein, *Musik und Musikpolitik*, pp. 193–203.

105. Rosenberg to Goebbels, 20 August 1934, BAK, NS 8/171.

106. Rosenberg to Frick, 10 April 1934, BAK, NS 8/169.

107. Bollmus, *Amt Rosenberg*, pp. 63–71.

108. After the dissolution of the Radio Chamber in 1939, the issue was referred to as the "Seventh Chamber."

109. Rosenberg to Goebbels, 28 August 1936, "Akten-Notiz über Besprechung mit Ministerialrat Hanke im Propmin.," by Urban, 24 November 1936, and draft of agreement, 1936, both in BAK, NS 8/171; Rosenberg to Hess (with attached draft of "Vereinbarung"), 31 August 1936, BAK, NS 8/178; "Reichskammer für Kulturpflege . . . ," 10 July 1936, BAK, R56I/68.

110. *Goebbels Tagebücher*, 15 July 1936, 1 August 1936.

111. Moraller, Hinkel, and Schmidt-Leonhardt to Goebbels, July 1936, BAK, R56I/68.

112. "Akten-Notiz, Besprechung Rosenberg-Ley am 31.1.39," 1 February 1939, BAK, NS 8/193.

113. Propaganda Ministry officials had the audacity to inform Rosenberg that the meetings were combined only after it was learned that the RKK and the KdF, purely by coincidence, had planned their meetings for the same date. Rosenberg to Goebbels, 28 August 1936; "Akten-Notiz über Besprechung mit Ministerialrat Hanke im Propmin.," by Urban, 24 November 1936, both in BAK, NS 8/171.

114. Manuscripts by Hans Hinkel, "Es muss der Künstler mit dem Volke gehen!," November 1936, and "Die Kulturschaffenden tagen," November 1936, both in BAK, R56I/109.

115. *Goebbels Tagebücher*, 15, 24, 26 November 1940, 11, 18 February 1941, 7, 17 March 1941.

116. Rosenberg to Ley, 14 February 1939, BAK, NS 8/193.

117. Hinkel to Gutterer, 23 November 1940, BAK, R56I/93.

118. "Protokoll über die 4. Arbeitssitzung der RKK," 4 June 1941, BAK, R56I/94.

119. *Goebbels Tagebücher*, 26 November 1940.

120. Borrmann to Rosenberg, 19 September 1941, BAK, NS 8/186.

121. Rosenberg to Hess, 7 February 1941; Rosenberg to Borrmann, 13 June 1941, both in BAK, NS 8/185; Rosenberg to Borrmann, 10 September 1941, BAK, NS 8/186.

CHAPTER FOUR

1. Speech of 27 November 1936, in *Dokumente der deutschen Politik*, vol. 4, doc. 54.

2. Drewniak, *Theater im NS-Staat*, p. 39.

3. For discussions of the popularity of these programs see the following SD situation reports in *Meldungen*: "Meldungen aus dem Reich," Nr. 77, 15 April 1940, 4:998–99, and "Meldungen aus dem Reich," Nr. 146, 2 December 1940, 6:1824–27.

4. "Theaterpolitik im Dritten Reich: Ihre wirtschaftlichen und sozialen Erfolge," from *Germania* (Berlin), 22 February 1936, in BAK, NS 15/142.

5. Statistics from Marrenbach, *Fundamente des Sieges*, pp. 334–35. According to the same source, KdF entertainment programs attracted 9.1 million participants in 1934, 23.7 million in 1935, 31.8 million in 1936, and 38.4 million in 1937.

6. See the following reports in *Meldungen*: "Bericht zur innenpolitischen Lage," Nr. 16, 15 November 1939, 3:457; "Meldungen aus dem Reich," Nr. 54, 16 February 1940, 3:768; "Meldungen aus dem Reich," Nr. 82, 26 April 1940, 4:1062–63.

7. Speech by Körner in Breslau, reprinted in *Die Bühne*, 5 April 1939.

8. Baldur von Schirach, "Die Jugend im Theater"; Wolfgang Bech, "Der Veranstaltungsring der HJ—ein neuer Faktor im deutschen Theaterleben," both in *Die Bühne*, 25 August 1940.

9. "Der Erfolg wird unser schönster Lohn sein," *Musik im Zeitbewusstsein*, 22 December 1934.

10. Untitled report on Music Chamber activities from November 1934 to October 1935, BAK, R56I/87.

11. Marrenbach, *Fundamente des Sieges*, p. 334–35; Robert Ley, "Tätigkeitsbericht über die Leistungen der NS Gemeinschaft 'Kraft durch Freude,'" 26 November 1935, BAK, NS22/666.

12. Letters from Propaganda Ministry to oberste Reichsbehörden, 22 May 1934, 27 April 1935, and 8 July 1936; from Finance Ministry, 20 September 1934; and from Reich Defense Ministry, 17 December 1934, with related commentaries, all in *MdRdbK*, 1 March 1937; comments by Ziegler, *MdRdbK*, 1 August 1937.

13. "Tätigkeitsbericht der Reichskammer der bildenden Künste," 7 November 1935, BAK, R56I/87.

14. Speech by Goebbels, 15 November 1935, in *Dokumente der deutschen Politik*, vol. 3, doc. 48.

15. "Jahreslagebericht," 1938, *Meldungen*, 2:114, and "Vierteljahresbericht," 1939, *Meldungen*, 2:275–76.

16. "Tätigkeitsbericht der Reichskammer der bildenden Künste."

17. "Grosser Ausstellungserfolg in Schloss Schönhausen," *MdRdbK*, 7 December 1936.

18. "Motive für Gemälde und Künstlerzeichnungen der Reichsautobahn," *MdRdbK*, 1 July 1938.

19. "Tätigkeitsbericht der Reichskammer der bildenden Künste."

20. Comments by Ziegler, *MdRdbK*, 1 August 1937.

21. Rechnungshof des deutschen Reiches to RKK, 2 July 1936, BAK, R55/713.

22. "Staatsankäufe aus der Münchener Kunstausstellung 1938 im Maximilianmuseum," 20 October 1938, BayHStA, MK 40852. The money used to buy the art came from a Bavarian government account for support of the visual arts that had existed for decades. As late as 1929, the majority of the funds had gone to the support of religious art and church restorations. Under National Socialism, the Bavarian government tended more and more to distribute the funds in smaller allotments and to a far higher number of recipients. By 1938, support for church art had virtually disappeared. Documentation in BayHStA, MK 40851–52.

23. "Verdoppelung des Kölner Fonds für zeitgenossische Kunst," *MdRdbK*, 1 February 1938.

24. RdbK to Leiter d. Landesstelle Baden-Pfalz, RdbK, 19 January 1934; Leiter d. Landesstelle Baden-Pfalz, RdbK, to Bad. Min. f. Kultus u. Unterricht, 25 January 1934; Bad. Min. f. Kultus u. Unterricht to Landesstelle Baden-Pfalz, RdbK, 16 February 1934, all in GLAK, 235/5931.

25. Leiter d. Landesstelle Baden RdbK, to Bad. Min. f. Kultus u. Unterricht, 23 July 1934, and Bad. Min. f. Kultus u. Unterricht to Kreis- u. Stadtsschulämter, 1 September 1934, both in GLAK, 235/5931.

26. Leiter d. Landesstelle Baden-Pfalz, RdbK, to Bad. Min. f. Kultus u. Unterricht, 24 January 1934, GLAK, 237/33824.

27. *RdRKK-1*, 1:7.

28. "Gesetz über Treuhänder der Arbeit," *Reichsgesetzblatt*, 1933, 1:285, also in Noakes and Pridham, *Nazism*, vol. 2, doc. 223. For the broader context of this and other measures involving the Trustees see Bracher et al., *Machtergreifung*, 2:330–38, and Broszat, *Hitler State*, pp. 142–45.

29. "Gesetz zur Ordnung der nationalen Arbeit," 20 January 1934, *Reichsgesetzblatt*, 1934, 1:45; also published in condensed form in Noakes and Pridham, *Nazism*, vol. 2, doc. 227.

30. The origins of the Sondertreuhänder position are briefly discussed in Personalabteilung (RMfVuP) to Dir. II (RMfVuP), 23 April 1941, BAK, R55/129. The transfer of Sondertreuhänder responsibilities from Rüdiger to Hinkel must be understood in the context of a real or imagined jurisdictional conflict. During the early years of the war, Rüdiger continued to serve as Sondertreuhänder even though he had taken up new responsibilities in the German civil administration of several occupied territories. Devoting most of his time to his new duties, Rüdiger increasingly left the economic oversight of the cultural fields to the Labor Ministry bureaucrats who had been assisting him. In early 1941 the Labor Ministry officials undermined a Propaganda Ministry decision concerning the salary of actress Hannelore Schroth. Goebbels was warned by one of his subordinates to resist "this encroachment on your culture-political leadership." Several weeks later, Rüdiger agreed to resign the Treuhänder position. See the letter cited above as well as Leiter der Personalabteilung (RMfVuP) to Goebbels, 24 March 1941, BAK, R55/129.

31. "Anordnung Nr. 8 betr. Einführung einer Mindestgage an den Theatern in Gross-Berlin," 27 February 1934, *RdRKK-1*, 1:161–62.

32. "Siebente Anordnung betreffend den Schutz des Berufes und die Berufsausübung der Architekten," 15 July 1935, *RdRKK-1*, 2:138–51.

33. "Sechste Anordnung über den Schutz des Berufes und die Berufsausübung der Gebrauchsgraphiker (Gebührenordnung)," 16 October 1935, *RdRKK-1*, 4:59–66.

34. "Erste Anordnung betr. den Schutz des Berufes und die Berufsausübung der Kunsthandwerker (Musterzeichner, Patroneure, Vergrösserer und Jacquarkartenschläger)," 28 December 1934, *RdRKK-1*, 1:152–55.

35. "Anordnung über die Unterrichtsbedingungen für den Privatunterricht in der Musik," 27 August 1934, *RdRKK-1*, 1:101–2.

36. "Anordnung über das Verbot der unentgeltlichen Mitwirkung bei musikalischen Veranstaltungen," 29 June 1934, *RdRKK-1*, 1:96–97; "Anordnung zur Befriedung der Wirtschaftlichen Verhältnisse im Deutschen Musikleben," 5 February 1935, *RdRKK-1*, 2:28–32.

37. The basic orders are in *RdRKK-1*, vols. 3 and 4.

38. Hermann Stuckenbrock, "Die praktischen Auswirkungen der Tarifordnung," *Musik in Zeitbewusstsein*, 20 July 1935; "Die Tarifordnungen und die soziale Lage der freistehenden Musiker," *Die Musik-Woche*, 14 March 1936.

39. "Tarifordnung für die Kulturorchester," 30 March 1938, *RdRKK-2*, RMK, X, no. 32. The order took effect on 1 May 1938.

40. On these procedures see Rüdiger to Goebbels, 21 December 1938, BAK, R55/199.

41. Rüdiger to Goebbels, 21 December 1938, and IB (RMfVuP) to Goebbels, 21 December 1938, both in BAK, R55/199 (note Goebbels's handwritten annotation on the latter).

42. "Anordnung betr. Wettbewerbe," 23 March 1934, *RdRKK-1*, 1:124–28, and "Zweite Anordnung betr. Wettbwerebe," 16 May 1934, *RdRKK-1*, 1:128–35.

43. Reichskartell der deutschen Musikerschaft to RMfVuP, 24 July 1933, BAK, R55/1141.

44. Letter to Staatsmin. f. Kunst, Wiss. u. Volksbildung, 28 August 1933, BAK, R56I/67.

45. "III. Anordnung zur Befriedung der wirtschaftlichen Verhältnisse im deutschen Musikleben," 5 February 1935, *RdRKK-2*, RMK, II, no. 5.

46. Karl Heinz Wachenfeld, "Die 'III. Anordnung zur Befriedung der wirtschaftlichen Verhältnisse im deutschen Musikleben'," *Musik im Zeitbewusstsein*, 16 February 1935.

47. "Richtlinien für das Verhältnis der Berufsmusiker zu den Laien-Instrumentalvereinen," 7 May 1934, *RdRKK-1*, 1:92–93.

48. "Richtlinien für die Mitglieder der Fachschaft Volksmusik," 28 October 1935, *RdRKK-1*, 3:45–47.

49. RMK to RMfVuP, 29 August 1935, BAP, Promi 592.

50. RMK to RMfVuP, 25 April 1934, BAK, R55/1183.

51. RMK, Amt f. Chorwesen u. Volksmusik, to RMfVuP, 12 July 1935, BAK, R55/1186.

52. RMK to RMfVuP, 1 August 1935, BAK, R55/1186.

53. RMK to RMfVuP, 27 May 1935; RMfVuP to RMK, 3 June 1935; RMK to RMfVuP, 2 August 1935; RMfVuP to Heller, 7 August 1935, all in BAK, R55/1185.

54. "Anordnung über die Aufnahmeprüfung für Berufsmusiker," 3 September 1934, *RdRKK-1*, 1:103–7; Karl Stietz, "Berufsbereinigung: Prüfungen, Ergebnisse, Folgerungen," *Musik im Zeitbewusstsein*, 20 April 1935.

55. "Nachwuchs und Prüfungsstellen," *Amtlicher Anzeiger der Genossenschaft der deutschen Bühnenangehörigen*, appendix to *Der Neue Weg*, 1 March 1934; Hans Knudsen, "Ein Wort zu den neuen Prüfungsbestimmungen für den Bühnen-Nachwuchs," *Der Neue Weg*, 1 March 1935.

56. "Anordnung betr. Wettbewerbe," 23 March 1934, *RdRKK-2*, RdbK, III, no. 1; "Erste Anordnung betr. die Veranstaltung von Kunstausstellungen und Kunstmessen," 10 April 1935, *RdRKK-2*, RdbK, VIII, no. 1.

57. "Erste Anordnung betr. die Aufnahme und die Ablehnung der Aufnahme in die Reichskammer der bildenden Künste," 1 April 1935, *RdRKK-2*, RdbK, II, no. 1.

58. BDC, RdbK/Erich Schellongowski.

59. BDC, RdbK/Arthur Siuchninski.

60. Blank worksheet, "Für die Ablehnung des Kunsthandwerkers," BDC, RdbK/Maximillian König.

61. "Erste Anordnung betr. den Schutz des Berufes und die Berufsausübung der Architekten," 28 September 1934, *RdRKK-1*, 1:146–49.

62. The letter from Goebbels, dated 8 October 1934, could not be located in the files. Its existence and contents are noted in Min. d. Innern, Baden, to Reichswirtschaftsmin., und Preuss. Min. f. Wirtschaft u. Arbeit, 7 November 1934, GLAK, 235/39816.

63. Wachenfeld, "Die 'III. Anordnung zur Befriedung der wirtschaftlichen Verhältnisse im deutschen Musikleben.'"

64. Karl Heinz Wachenfeld, "Rückblick und Ausblick," *Musik im Zeitbewusstsein*, 26 January 1935.

65. Hermann Stuckenbrock, "Das Schutzkorps der Musikerschaft," *Die Musik-Woche*, 2 May 1936.

66. "Sonderbericht: Bestätigung der Kontrollbeamten der Reichsmusikkammer zu Hilfspolizei-Beamten," 15 April 1937, BAK, R56I/141.

67. "Betrifft: Beerdigung eines Eisenbahnbeamten auf dem Elisabethfriedhof," 14 May 1935, BDC, RMK/Leitz Ordner "St."

68. See the file contained in T-70, 108/3632317–641.

69. Unsigned letter to Städt. Polizei, Weiden, 1 March 1937, T-70, 108/3632321.

70. For an example of a Döbereiner newsletter see "Bericht des Stützpunktleiters Max Döbereiner über am 13.5.1934 vorgenommene Musikkontrollen in Hildenbach und Sichersreath," 15 May 1934, T-70, 107/3631149–50.

71. For correspondence with the police see the file in T-70, 110/3633849–4452.

72. "Vollzug des Reichskulturkammergesetzes," 14 April 1934, and "Die Kontrolle der Musiker . . . ," 14 April 1934, T-70, 108/3632396.

73. RMK-Landesleiter Ostpreussen to RMK-Rechtsamt, 14 February 1936, BDC, SS/Heinz Ihlert.

74. Schlüter to SA Brigade 25, 14 February 1936, BDC, SS/Heinz Ihlert.

75. Industrie- und Handelskammer f.d. Rhein-Mainische Wirtschaftsgebiet to Reichswirtschaftsmin., 26 November 1934, GLAK, 235/39816.

76. Bad. Industrie- und Handelskammer to Bad. Finanz- und Wirtschaftsmin., 5 December 1934, GLAK, 237/33824.

77. *Goebbels Tagebücher*, 3 October 1935.

78. "Erlass des Präsidenten der Reichskulturkammer über das Verbot von Eignungsprüfungen," 29 November 1935, *RdRKK-2*, RKK, I, no. 6.

79. Goebbels's speech of 15 November 1935, in *Dokumente der deutschen Politik*, vol. 3, doc. 48.

80. "Arbeitsrichtlinien für die Reichskulturkammer," 3 January 1939, *RdRKK-2*, RKK, I, no. 29.

81. An aptitude examination had profoundly affected the course of Hitler's life during his Vienna days before World War I. See *Mein Kampf*, p. 20.

82. "Denkschrift über die Regelung des Prüfungs- und Nachweiswesens," by Frauenfeld, 1936, BAK, R56I/128.

83. Frauenfeld to Schlösser, 3 March 1938, BAP, Promi 112.

84. "Vermerk" by Leiter T, 14 February 1940, BAP, Promi 466.

85. Memorandum, Hinkel to Goebbels, 20 November 1942, BAK, R56I/36.

86. Funk to RMK, 25 January 1936, BAK, R56I/18.

87. "Anordnung zur Änderung der III. Anordnung zur Befriedung der wirtschaftlichen Verhältnisse im deutschen Musikleben," 1 March 1937, *RdRKK-2*, RMK, I, no. 6.

88. "Stimmungsbericht," 31 January 1938; "Jahresbericht 1938—Ausweisabteilung," 30 December 1938, both in BDC, RMK/Ordner: "Rundschreiben sowie Tätigkeitsberichte."

89. "Jahreslagebericht," 1938, *Meldungen*, 2:114.

90. "Jahresbericht 1938—Ausweisabteilung."

91. "Anordnung über die Anzeige der Beschäftigung ausländischer Musiker," 29 September 1937, *RdRKK-2*, RMK, XII, no. 12; "Bekanntmachung zur Anordnung über die Anzeige der Beschäftigung ausländischer Musiker," 14 February 1938, *RdRKK-2*, RMK, XII, no. 14.

92. "Akten-Vermerk," 29 July 1938, BDC, RMK/Ordner: "Rundschreiben sowie Tätigkeitsberichte."

93. "Bekanntmachung betr. Ausübung der Architektenberufes," 4 February 1936, *RdRKK-1*, 4:50–51.

94. "Erste Anordnung über den Beruf des Architekten," 28 July 1936, *RdRKK-1*, 4:143–48. Note also the explanation contained in the adjacent letter of 30 July 1936 from the RdbK to the Reich Labor Ministry; "Die neue gesetzliche Grundlage für den deutschen Architektenberuf," *MdRdbK*, 1 October 1936.

95. "Rundschreiben Nr. 107, Betr.: Einsatz der Freischaffenden Architekten," 10 August 1937; "Rundschreiben Nr. 5, Betr.: Einsatz der Freischaffenden Architekten," 11 January 1938, both in BAK, R56I/145.

96. Bund deutscher Architekten, Ortsgruppe Heidelberg, to all members, 1 January 1938, GLAK, 237/33824.

97. "Vierteljahresbericht," 1939, *Meldungen*, 2:276.

98. Schraudolph to Bavarian Cultural Ministry, 19 June 1936, BayHStA, MK 40 896.

99. "Jahreslagebericht 1938," *Meldungen*, 2:115.

100. Correspondence between chamber and ministry, especially chamber to ministry, 3 June 1942, and ministry to chamber, 11 November 1942, in BAK, R56I/129.

101. *Die Bühne*, 20 June 1939.

102. "Mindestanforderungen für die Erteilung der Ausweiskarte der Fachschaft III vom 19 November 1934," AMRMK, 28 November 1934 (implements an order of 17 August 1934); "Anordnung Nr. 47 betr. Zulassung für Bühnenlehrer," 4 October 1935, *RdRKK-2*, RTK, II, no. 14; "Anordnung über die Erteilung von Unterricht auf dem Gebiete der bildenden Künste," October 1936, *RdRKK-2*, RdbK, II, no. 6.

103. A. E. Frauenfeld, "Die Sorge um den künstlerischen Nachwuchs," *Die Bühne*, 5 February 1939.

104. On the proposed curriculum and Goebbels's response see A. E. Frauenfeld, "Betrachtungen über die Errichtung einer Reichstheaterakademie in Berlin," 2 December 1937; Ludwig Körner, "Ausführungen zum Aufbau der Reichstheaterakademie," 27 June 1938; "Vermerk," 13 July 1938, all in BAK, R56III/4; Körner to Goebbels, 12 May 1939 and 7 March 1940, BAK, R55/710. On "Aryanization" see the correspondence in BAK, R56III/21. On war-generated financial complications see Rechnungshof des deutschen Reiches to Propaganda Ministry, 12 December 1942, BAK, R55/708.

105. Hermann Abendroth, "Von der Fachschaft der Musikerzieher," *Musik im Zeitbewusstsein*, 20 October 1934.

106. Heinze, "Bericht über die Schulungswoche," March 1941; Lehmann to Landeskulturwalter-Berlin, 1 April 1941; Holz to Schubert, 13 April 1941, all in Landesarchiv Berlin, Rep. 243, Acc. 1814, Nr. 7.

107. "Die offiziellen Berichte über die Leipziger Schulungswochen, 1937, 1938, 1939, 1940 und 1941," BAP, Promi 239/1.

108. Fachschaft Tanz to RMfVuP, 29 October 1941, BAP, Promi 239/1.

109. "Theateraufstieg in Zahlen," *Danziger Neueste Nachrichten*, 31 January 1936, in BAK, NS 15/142.

110. "Anzahl der an den deutschen Bühnen Beschäftigten," in *Deutsches Bühnen-Jahrbuch*, 1945/48, p. 661. Growth continued in subsequent years, but statistical evidence is complicated by German territorial annexations.

111. "Spielzeitdauer der deutschen Theater (1932–1943)," *Deutsches Bühnen-Jahrbuch*, 1943, p. 797.

112. "Arbeitsbericht des Bühnennachweis," 11 June 1935, BAK, R56I/49.

113. Memorandum by Steinhaus, 19 May 1936, BAK, R56I/91.

114. Prieberg, *Musik im NS-Staat*, p. 263.

115. By way of comparison, monthly wages in Germany in 1938 for an unskilled laborer in the mining industry amounted to about RM 120, while a delivery man in the brewing industry earned around RM 200 per month. Bry, *Wages in Germany*, pp. 457–60.

116. Music Chamber budget, 1938, BAK, R2/4877.

117. "Jahresbericht 1938, Ausweisabteilung," 30 December 1938, BDC, RMK/Ordner: "Rundschreiben sowie Tätigkeitsberichte."

118. Franz Götzfried, "Der Freistehende Musiker: Ein Sorgenkind der Reichsmusikkammer und der Arbeitsämter," *Die Musik-Woche*, 22 August 1936.

119. "In Anwesenheit des Führers sprach der Präsident der Reichskammer der bildenden Künste Professor Adolf Ziegler," *MdRdbK*, 1 August 1938.

120. "Arbeitseinsatz und Umschulung schlecht beschäftigter bildender Künstler," 31 May 1939, BAK, R56I/145.

121. See Hentschel, *Geschichte der deutschen Sozialpolitik*, pp. 136–44; Guillebaud, *Social Policy of Nazi Germany*, pp. 84–93. For an official DAF perspective see *Deutsche Sozialpolitik*, pp. 209–54. That the extension of compulsory pension insurance to some artists was part of a broader trend was underscored by the incorporation of about 4.5 million craftsmen (*Handwerker*) into the system in late 1938.

122. The national system of social insurance inherited by the Nazi regime requires some explanation. There were numerous public or private insurance carriers. When an occupational group was incorporated into the system, all of its members were required to subscribe to a designated carrier. Arrangements regarding payment into the insurance pool as well as collection of benefits varied among occupational groups. The Nazi regime eroded the autonomy of both the occupational groups and the insurance carriers but did not fundamentally transform the fragmented nature of the system. For a general discussion consult Hentschel, *Geschichte der deutschen Sozialpolitik*.

123. For discussions of some of the difficulties inherent to insuring artists see "Die Altersversorgung ist gesichert!," *Deutsches Bühnen Jahrbuch*, 1938, pp. 1–10 (which contains a summary of a speech by Goebbels of 14 June 1937 on the subject); and "Vermerk," by Reimer (RMfVuP), 27 July 1937, BAK, R55/125.

124. *Goebbels Tagebücher*, 5 November 1936.

125. Ibid., 29 January 1937.

126. Ibid., 8 April 1937.

127. Ibid., 29 January 1937.

128. Ibid., 5 June 1937.

129. "Richtlinien für die Gewährung von Unterstützungen aus der Spende Künstlerdank," no date; "Rechenschaftsbericht über die Verwaltung der Spende 'Künstlerdank' vom 27. Oktober 1937 bis 17. Oktober 1938," 17 October 1938,

both in BAK, R56I/117; "Die Spende 'Künstlerdank,' " *Die Reichskulturkammer,* 1 November 1943.

130. *Goebbels Tagebücher,* 3 March 1937.

131. Ibid., 8 April 1937.

132. Ibid., 22, 24 September 1937. The quotation is from the latter entry.

133. Hans Hinkel, "Bericht über die Sondersitzung mit dem Herren Treuhändern," 18 May 1944, BAK, R56I/117.

134. "Neuordnung der sozialen Fürsorge für Schauspieler," Deutsches Nachrichtenbüro release of 7 November 1936, BAK, R43II/1252. Later, while serving as president of the Theater Chamber, Körner was also appointed Sonderbeauftragter für soziale Fragen und Altersversorgung for the entire RKK.

135. "Tarifordnung für die deutschen Theater (Alters- und Hinterbliebenden-Pflichtversicherung)," 27 October 1937, *RdRKK-2,* RTK, III, no. 1.

136. Included in this category were actors, directors, dancers, specialists in costume design and set decoration, and lighting technicians.

137. "Anordnung Nr. 60 betr. Sicherstellung der Altersversorgung," 27 November 1937, *RdRKK-2,* RTK, II, no. 24. Some subscription and discounted tickets were exempt.

138. Goebbels speech, 13 June 1938, Deutsches Nachrichtenbüro release of 13 June 1938, BAK, R43II/1252.

139. Bayer. Versicherungskammer to Mitglieder d. Verwaltungsrates d. Versorgungsanstalt d. deutschen Bühnen, 18 December 1942, BAK, R55/126.

140. Ludwig Körner, "Altersversorgung der deutschen Bühnenschaffenden," *Die Bühne,* 1 March 1937; "Die Grosse Sozialbetreuung der Bühnenschaffenden," Deutsches Nachrichtenbüro release of 24 March 1938, BAK, R43II/1246.

141. "Tarifordnung für die deutschen Kulturorchester," 30 March 1938, *RdRKK-2,* RMK, X, no. 32. The provisions for pension insurance are in paragragh 20. Further specifics about the pension scheme are in "Satzung der Versorgungsanstalt der deutschen Kulturorchester," 30 April 1938, BAK, R55/200.

142. For example, see "Vermerk," prepared in Abt.M (RMfVuP), 27 May 1939, BAK, R55/199; see also Splitt, *Richard Strauss,* chap. 4.

143. Bayerische Versicherungskammer to Mitglieder d. Verwaltungsrat d. Versorgungsanstalt der deutschen Kulturorchester, 8 March 1944, BAK, R55/200.

144. Ludwig Körner, "Zur Altersversorgung," *Die Bühne,* 8 March 1940.

145. Goebbels quoted in "Die Altersversorgung für Bühnenschaffende ist gesichert!," p. 5.

CHAPTER FIVE

1. In the original German: "die Förderung der schöpferischen und leistungswilligen Kräfte und die Ausmerzung unwürdiger und schädlicher Elemente." Pfundtner and Neubert, *Das neue Deutsche Reichsrecht,* I. öffentliches Recht, d) Kulturwesen, 6: Reichskulturkammergesetz.

2. *Schwarzbuch,* p. 75.

3. Ibid., p. 406. The figures for Prussia are condensed from more differentiated statistics provided in the *Schwarzbuch.*

4. Institut zum Studium der Judenfrage, *Die Juden in Deutschland.*

5. Chief among them are Adam, *Judenpolitik im Dritten Reich,* and Schleunes, *Twisted Road to Auschwitz.* Improvisation and vacillation clearly emerge as main

characteristics of the policy even in studies that do not emphasize that point, such as the standard work by Hilberg, *Destruction of the European Jews*.

6. *Schwarzbuch*, pp. 419–20.

7. Ibid., pp. 410–11.

8. Ibid., pp. 409–10, 416.

9. "Satzung," Reichskartell der deutschen Musikerschaft, 22 June 1933, BAK, R55/1150.

10. Brunisch to Dehmann et al., 28 September 1933, BDC, OPG/Paul Ludwig Troost.

11. *RdRKK-1*, 1:4.

12. Drafts in BAP, Promi 162.

13. Dahm, *Das jüdische Buch*, pp. 46–49; Adam, *Judenpolitik im Dritten Reich*, p. 172. Schacht's pragmatic position reflected fears that existed also on the grassroots level in some Nazi circles. In June 1933, for instance, the NSBO cell in the Ullstein publishing house, a Jewish-owned enterprise, appealed to Hitler, requesting that Ullstein not be subjected to a party-led boycott. The writer could "not believe that the party desires that 19,000 brave German workers and employees (not counting family members) should be eliminated in order to affect three Mr. Ullsteins." Nationalsozialistische Betriebszelle des Verlags Ullstein to Reichskanzlei, 21 June 1933, BAK, R43II/600. Note also the indication at the top of the first page that Hitler had been made aware of the substance of the document.

14. Adam, *Judenpolitik im Dritten Reich*, pp. 88, 122–24.

15. Paragraph 6 of the RKK Law, *RdRKK-1*, 1:2.

16. It is interesting to observe that as late as 1941 the compendium of laws by Pfundner and Neubert omitted any mention of "Aryan" ancestry in its annotation of Paragraph 10. *Zuverlässigkeit* was to be understood as "moral reliability" (*moralische Zuverlässigkeit*), and *Eignung* as "purely professional ability" (*rein fachliche Befähigung*). Pfundtner and Neubert made this assertion even though Paragraph 10 had already been in use for years as the RKK's chief weapon against "non-Aryans." Pfundtner and Neubert, *Das neue Deutsche Reichsrecht*, I. Öffentliches Recht, d) Kulturwesen, 6: Reichskulturkammergesetz (1.DVO), notes 2 and 3 to Paragraph 10. Even more curiously, the 1943 edition of *Das Recht der Reichskulturkammer* provides no annotation whatsoever for Paragraph 10. *RdRKK-2*, RKK, I, no. 4.

17. "Rundschreiben an die Herren Vorsitzenden der Landesbezirke des BDA," 24 November 1933, BDC, OPG/Paul Ludwig Troost.

18. BdA Hauptverwaltung to Bundesbezirk Bayern, 11 January 1934; NSDAP Oberstes Parteigericht to Propaganda Ministry, 20 March 1934; BDC, OPG/Paul Ludwig Troost.

19. Wismann to Hinkel, 22 June 1935, BDC, RSK/Heinrich Wismann. This document contains a recollection by Wismann, a Literature Chamber official, of a discussion with Schmidt-Leonhardt in "January or February" 1934.

20. Speech of 7 February 1934, Deutsche Nachrichtenbüro release of 8 February 1934, in BAK, R43II/1241. The German terms used by Goebbels were "*unzuverlässig oder ungeeignet*" ("unreliable or unfit"), a direct reference to the language of Paragraph 10.

21. Article from *Frankfurter Zeitung*, 6 March 1934, quoted in Wulf, *Theater und Film*, p. 260.

22. Dahm, *Das jüdische Buch*, pp. 60–61.

23. Ibid.

24. Ibid., p. 63.

25. "Anordnung Nr. 18 betr. Anmeldung der Bühnenlehrer," 3 May 1934, *RdRKK*-1, 1:173; "Anordnung Nr. 26 betr. Standesordnung für die deutschen Tanzlehrer," 29 July 1934, *RdRKK*-1, 1:185–91.

26. Music Chamber to Propaganda Ministry, 30 July 1934, BAK, R55/1174.

27. Bayerische Politische Polizei to Polizeidirektionen et al., 11 March 1935, BayHStA, Reichsstatthalter Epp 669.

28. Statements by Farkas and Römer, 17 July 1935, BDC, RMK/"Schr-Schu."

29. Kontrollabteilung, Landesmusikerschaft Berlin-Brandenburg, to Landesleiter RMK, 17 August 1935, BDC, RMK/"Krin-Krue."

30. Schneider to Bad. Kultusmin., 5 August 1934, GLAK, 235/5931.

31. Circular letter from Reichsmusikerschaft, 15 June 1934, T-70, 112/3636874; "Fragebogen für die Aufnahme von Nichtariern," filled out by Hermann Levi, 23 May 1934, BDC, RMK/Heinz Ihlert.

32. "Statistik über nichtarische Mitglieder," 18 June 1934, T-580, 961/122.

33. Memo "betr. Frau Johanna Glock," 30 December 1935, Wachenfeld to Glock, 29 January 1936, BDC, RMK/Heinz Ihlert.

34. Hinkel to Goebbels, February 1936, Hinkel to Lutze, 7 February 1936, BDC, RdbK/Paul Gruson.

35. BDC, RdbK/Felix Simmenauer.

36. BDC, RMK/Manfred (Israel) Kropf.

37. Bühnennachweis memoranda, April–August 1936, BAK, R56III/15.

38. Sixty-one-page list, no heading, attached to letter, RdbK to Propaganda Ministry, 8 June 1938, which identifies list as "Liste sämtlicher bisher aus meiner Kammer ausgeschlossener Juden, jüdischer Mischlinge und mit Juden Verheirateten," BDC, unlabeled Leitz Ordner.

39. "Liste der aus der Reichsmusikkammer ausgeschlossnen Juden und jüdischen Mischlinge," 1936, 379 pp., BDC, unlabeled Leitz Ordner.

40. Seventeen-page Fachschaft Bühne list; three-page Fachschaft Artistik list; one-page Fachschaft Tanz list, all attached to RTK to Propaganda Ministry, 2 July 1938, which describes the lists as "drei Listen über die aus der Reichstheaterkammer ausgeschlossenen Juden, jüdischen Mischlinge und mit Juden Verheirateten. . . ." BDC, unlabeled folder.

41. "Ströhmänner des Judentums," *Der Angriff*, 27 July 1935.

42. Speech by Goebbels, 15 November 1935, *Dokumente der deutschen Politik*, 3:48.

43. Goebbels to Chambers, 27 June 1935, BAK, R56V/102.

44. "Aus der kulturpolitischen Pressekonferenzen," 1 July 1937, BAK, ZSg. 102/62.

45. "Nichtarische Mitglieder der Reichsfachschaft Komponisten," 1937, Ihlert to Hinkel, 4 June 1936, BDC, Ordner: "Entjüdung der Einzelkammern."

46. "Nichtarische Mitglieder der Reichsfachschaft Musikalienverleger," 1937; "Nichtarische Mitglieder der Reichsfachschaft Musikalienhändler," 1937, both in BDC, Ordner: "Entjüdung der Einzelkammern."

47. "In der Kammer tätige Voll-, Dreiviertel- u. Halbjuden," 1937, BDC, Ordner: "Entjüdung der Einzelkammern."

48. *Goebbels Tagebücher*, 4 November 1937.

49. Ibid., 4 September 1935, 5 October 1935.

50. Ibid., 5 May 1937.

51. Ibid., 4 September, 5 October 1935; 2 July, 11 December, 5 May, 5 June, 21

September, 9 October, 4 November, 24 November, 15 December, 16 December 1937; 13 January, 9 February, 18 May, 27 July 1938; and 26 January 1939.

52. Ibid., 3 February 1937.

53. The significance of this trend must also be considered against the broader background of the dismissal of important "moderates" from the military and the Foreign Office in late 1937 and 1938, the subsequent radicalization of German foreign policy, and Germany's accelerating military preparations for war. This context is important notwithstanding differences of interpretation between historians who see the general radicalization of the regime in the late 1930s as the result of conscious planning and those who see it as frantic improvisation.

54. BDC, Ordner: "Juden-Komponisten, Nichtarisch, Versippt, Sta-Z."

55. Compare "In der Kammer tätige Voll-, Dreiviertel- u. Halbjuden," 1937, BDC, Ordner: "Entjüdung der Einzelkammern," with the sixty-one-page RdbK expulsion list, BDC, unlabeled Leitz Ordner.

56. "Vermerk" by Zscintzsch, 13 June 1938, BAK, R21/209.

57. "Niederschrift Nr. 30 über die Arbeitssitzung in der Reichstheaterkammer," 1 July 1937, BAK, R56III/14.

58. "Kontrollbericht" by Woschke, 23 March 1936, BDC, RMK/"St."

59. BDC, RdbK/Georg Pniower.

60. BDC, RdbK/Sally and Louis Rochelson.

61. Von Ikier to Adler, 22 July 1939, BDC, RdbK/Adler.

62. Karrasch to Walter, BDC, RMK/Ordner "W."

63. Letter to RTK, 4 May 1938; "Vermerk" by Woschke, 26 April 1938; interrogation report, 27 April 1938, BAK, R56III/13.

64. On Hitler's personal involvement see *Goebbels Tagebücher*, 26, 30 November, 3 December 1937.

65. "Vermerk" by Hilleke, with attached draft of law and justification, November 1937; "Vermerk" by Hilleke, December 1937, both in BAK, R55/1416.

66. "Anordnung des Präsidenten der Reichskulturkammer über die Teilnahme von Juden an Darbietungen der deutschen Kultur," 12 November 1938, *RdRKK-2*, RKK, III, no. 11; also published in *Völkischer Beobachter*, 14 November 1938.

67. Raabe to Propaganda Ministry, 17 November 1938, with attached "Bekanntmachung"; memo by Schmidt-Leonhardt, 6 December 1938, both in BAK, R55/1416.

68. Order by Ihlert, AMRMK, 25 May 1937; "Aufruf zur Einreichung des Ariernachweises!," *Die Bühne*, 15 April 1937; "Praktische Winke für den Abstammungsnachweis," *MdRdbK*, 1 February 1937.

69. Ihlert to RMK Landeskulturwalter Südhannover-Braunschweig, 22 July 1939, BDC, RMK/"Reichsmusikkammer."

70. "Ausschlüsse von Mitgliedern," *MdRdbK*, 1 May, 1 July 1939.

71. RMK Landesleiter-Berlin to RMK, 4 October 1939, BDC, RMK/"Rundschreiben sowie Tätigkeitsberichte."

72. "Zum Recht der jüdischen Mischlinge nach dem Stande von Mai 1938" (Informationsdienst Rassenpolitisches Amt der NSDAP Reichsleitung, Nr. 48, 10 June 1938), BAK, R56I/114.

73. Dahm, *Das jüdische Buch*, p. 134.

74. Ibid., p. 136.

75. Hilberg summarizes the categories as follows: *Mischlinge* of the second degree: Persons descended from one Jewish grandparent. *Mischlinge* of the first

degree: Persons descended from two Jewish grandparents but not belonging to the Jewish religion and not married to a Jewish person on 15 September 1935. Jews: Persons descended from two Jewish grandparents belonging to the Jewish religion or married to a Jewish person on 15 September 1935, and persons descended from three or four Jewish grandparents. (Hilberg, *Destruction*, 1:80.)

76. Dahm, *Das jüdische Buch*, p. 136.

77. Goebbels to Chamber Presidents, 3 January 1939, BAK, R55/163.

78. "Kultur Pressekonferenz," 8 June 1939, BAK, ZSg. 102/62.

79. Individual case sheets in BDC, Ordner: "Entjüdung der Einzelkammern."

80. For example, in 1939 the Propaganda Ministry ordered the Theater Chamber to remove references to persons with special dispensations from the *Deutsches Bühnen-Jahrbuch*, a standard reference work for the theater profession. Propaganda Ministry to Theater Chamber President, 3 March 1939, BAP, Promi 112.

81. *Goebbels Tagebücher*, 27 July 1938.

82. "Tagesmeldung," 25 May 1939, BAK, R58/992. Note that this document is from the files of Department II/112 of the SS Security Main Office, which had jurisdiction over "Judaism and Freemasonry."

83. This summary of the Güden case is based on the following documents, all in BAK, R55/125: Personalabt. (RMfVuP) to Staatssekretär, 29 July 1943; Personalabt. (RMfVuP) to RKK (von Loebell), 2 August 1943; Flügel to Staatssekretär, 12 August 1943; Flügel to RKK (von Loebell), 17 August 1943; Personalabt. (RMfVuP) to Staatssekretär, 20 August 1943; RKK (Hinkel) to Flügel, 20 August 1943; Personalabt. (RMfVuP) to Prause, 28 August 1943. After 1945, Hulda Güden (known more commonly as Hilde Gueden) rose to stardom and performed regularly in Vienna, Salzburg, London, and New York. She also made numerous recordings. *New Grove Dictionary*, 7:783.

84. One official commented when reviewing the case, "Everybody knows that such trials last for months, indeed years." Flügel to Staatssekretär, 12 August 1943, BAK, R55/125.

85. The involvement of a Turkish diplomat was significant because Turkey was not only a neutral country in the war, but also an important supplier of chrome to Germany.

86. Güden also asserted in defense of her racial credentials that she had once been received by Hitler at a tea party. The Propaganda Ministry tried to confirm this claim with Martin Bormann and two of Hitler's adjutants, Julius Schaub and A. D. Albrecht. All denied that Hitler had received Güden individually, although they did not rule out the possibility that she had met him at some kind of artists' reception in Munich or Bayreuth. Personalabt. (RMfVuP) to Prause, 28 August 1943, BAK, R55/125.

87. The documentation on which this description of events is based dates from 29 July to 28 August 1943, during the so-called "45 Days of Badoglio" (26 July–8 September 1943). During this period Mussolini was imprisoned, and the Italian government, now led by Marshal Pietro Badoglio, arranged an armistice with the Allies, which was signed on 3 September. On 10 September the Italian forces defending Rome fell to the Germans, who then occupied the city until its liberation by the Allies in June 1944.

88. According to Hinkel, results of the SD investigation had not been received because "the connection with Italy is interrupted for now." Hinkel to Flügel, 20 August 1943, BAK, R55/125.

89. Note Goebbels's January 1939 guidelines for RKK membership policy for *Mischlinge*, quoted earlier in this chapter.

90. The present discussion of Hinkel's role in supervising the Jüdischer Kulturbund is based largely on Dahm, "Kulturelles und geistiges Leben," and Akademie der Künste, Berlin, *Geschlossene Vorstellung*.

91. In German: "Sonderbeauftragte für die Überwachung und Beaufsichtigung der Betätigung aller im deutschen Reichsgebiet lebenden nichtarischen Staatsangehörigen auf künstlerischem und geistigem Gebiet."

92. Dahm, "Kulturelles und geistiges Leben," p. 108; Adam, *Judenpolitik im Dritten Reich*, p. 106.

93. The formulation is Dahm's, "Kulturelles und geistiges Leben," p. 112.

94. Ibid., p. 111.

95. "Hans Hinkel Zeugenschrift," ZS 1878, February 1960, Institut für Zeitgeschichte, Munich.

96. Freeden, *Jüdisches Theater*, p. 40.

97. "PG 287," *Allgemeine Wochenzeitung der Juden in Deutschland*, 26 February 1960.

98. Dahm attributes the change of mind not to foreign policy considerations but rather to Goebbels's fear that the SS-SD would seize upon the shutdown of the Reichsverband as an opportunity to expand its power over Jewish policy. Dahm's case for this interpretation, however, is circumstantial, without supporting documentation. Dahm, "Kulturelles und geistiges Leben," p. 224.

99. Hinkel, *Judenviertel Europas*, p. 16.

100. See documentation in BAK, R58/984. On the power rivalry see Dahm, "Kulturelles und geistiges Leben," pp. 224–25.

101. Adam, *Judenpolitik im Dritten Reich*, pp. 258–63.

102. Correspondence in T-175, 42/2553576–610.

103. Hinkel to Himmler, 16 September 1940, T-175, 42/2553564.

104. Boelke, *Kriegspropaganda*, p. 431.

105. Ibid., p. 492.

106. Adam, *Judenpolitik im Dritten Reich*, pp. 256–57.

107. Zimmermann, *Verfolgt, vertrieben, vernichtet*, pp. 23–42; Kenrick and Puxon, *Destiny of Europe's Gypsies*, pp. 72–74; Huttenbach, "Romani Porajmos," pp. 35–36.

108. AMRMK, 1 May 1939, T-70, 109/3632755–56.

109. The lists begin with the issue of 15 February 1940, T-70, 109/3632796–98.

110. Landeskulturwalter Südhann.-Braunschweig to NSDAP Kreisleitung Göttingen, BDC, RdbK/Wilhelm Lange.

111. Lane, *Architecture and Politics in Germany*, p. 184.

112. Hochman, *Architects of Fortune*.

113. BDC, RdbK/Hannah Höch.

114. Gottfried Eberle, " 'Als Verfemte überwintern'—zwei Musiker im 'Dritten Reich': Ein Gespräch mit Cornelia und Hanning Schröder," in Heister and Klein, *Musik und Musikpolitik*, pp. 253–64.

115. BDC, RdbK/Carola Gärtner.

116. BDC, RbdK/Alfred Gravenhorst.

117. BDC, RTK/Hanns Minnich. For further cases of permissiveness toward convicted ex-communists see the BDC Visual Arts Chamber files of Kurt Deinert and Alois Hies and the Theater Chamber file of Friedrich Philipp Benz.

118. Schrade to Reichsminister, 3 August 1944, BDC, RTK/Rudolf Brunner.

119. The internationalist and secretive nature of the Masons led many Nazis vaguely to suspect Freemasons as participants in Jewish-led conspiracies. In *Mein Kampf* Hitler wrote that in Freemasonry the Jew "has an excellent instrument with which to fight for his aims and put them across. The governing circles and the higher strata of the political and economic bourgeoisie are brought into his nets by the strings of Freemasonry, and never need to suspect what is happening" (p. 315).

120. *Goebbels Tagebücher*, 12 August 1937.

121. RSK (Gruppe Buchhandel) to RSK (Berlin), 3 June 1938; "Aktennotiz" (signed by Ihde), 18 June 1938; "2. Nachtrag zu der Handakte: Grundfragen der Kammerzugehörigkeit und der Berufsausübung," 1938; "Zugehörigkeit von Beamten zu Freimaurerlogen . . ." (copy of RdSchr. d. RuPrMdJ, 2 September 1936), all in T-580, 939/1. Although this documentation reflects an official clarification of Freemason policy only for the RSK, it is likely that the same or very similar guidelines applied in the RKK as a whole.

122. For a recent example see Giles, " 'Most Unkindest Cut.' " On Nazi policy toward homosexuality see Jellonnek, *Homosexuelle unter dem Hakenkreuz*, and Plant, *Pink Triangle*.

123. For example, the membership file of Werner Kelch, a Dramaturg in Essen, contains an index card with the following remarks: "The chief of the Security Police and of SD-IV C 4 c—B.Nr.1275/42—reports (on 14 January 1943) in response to our inquiry: 'Dr. Kelch has no convictions.' In this connection they further observe: Although nothing is known about Dr. K. and others with regard to homosexuality, such an accusation has been made against them." BDC, RTK/Dr. Werner Kelch.

124. This is not to say, however, that employers exercised the same restraint. In one case in 1944 in Erfurt, a theater invalidated the contract of its intendant, who had been arrested, but not convicted, on sodomy charges. The Theater Chamber approved this measure and instructed the theater to reinstate the intendant with back pay in the event of an acquittal. BDC, RTK/Joachim Poley.

125. The directive itself could not be located. But a letter of 3 August 1944 to Goebbels from Schrade, the Kulturkammer's Geschäftsführer, refers to an "internal directive" of the ministry in effect as late as 1942, according to which Paragraph 175 convictions carrying sentences of six months or less should not constitute grounds for automatic exclusion from the Kulturkammer. BDC, RTK/Rudolf Brunner.

126. BDC, RdbK/Egon Adam.

127. BDC, RTK/Edgar v. Pelchrzim.

128. BDC, RTK/Boris Greverus.

129. Plant, *Pink Triangle*, pp. 145–48.

130. *Goebbels Tagebücher*, 27 July 1937.

131. Ibid., 21 January 1938.

132. "Aktennotiz, Betr: Besprechung mit SS-Oberführer Hinkel," July 1938, BAK, R58/984.

133. Plant, *Pink Triangle*, p. 116. For a copy of the order, dated 29 October 1937, see Spangenberg, *Karriere eines Romans*, p. 84.

134. E.g., BDC, RTK/Nico Eckert.

135. "Sonderbericht," 15 April 1937, BAK, R56I/141.

136. BDC, RMK/"Pusc-Rabe."

137. BDC, RMK/"W."

138. BDC, RdbK/Adam Seitz.

139. For a recent study of Nazi persecution that attempts to deal with numerous categories of racial, social, and political victims, see Burleigh and Wippermann, *Racial State*.

140. E.g., dismissals listed in "Wochenschau," *Der Neue Weg*, 1 April 1933.

141. Dussel, "Provinztheater in der NS-Zeit." Dussel's article focuses on Coburg, Karlsruhe, Bielefeld, Dortmund, and Ingolstadt, 1919–44.

142. Armin Zweite, "Franz Hofmann und die Städtische Galerie 1937," in Schuster, *Nationalsozialismus und "Entartete Kunst,"* pp. 261–64.

143. Schlotterer to Hinkel, 4 August 1933; Hinkel to Schlotterer, 8 August 1933, both in BAK, R56I/121.

144. Reichsdramaturg to DBV, 25 January 1934, GLAK, 235/30990.

145. Schlösser to Preussischer Theaterausschuss, 9 March 1934, BDC, RKK/ Rainer Schlösser.

146. "Künftig einheitliche Regelung bei Verboten von Theateraufführungen," *Die Bühne*, 30 January 1934.

147. "Theatergesetz," 15 May 1934, *RdRKK-2*, RTK, I, no. 1; "Das neue Reichs-theatergesetz vom 15. May 1934," *Die Bühne*, 15 June 1934.

148. Theater Chamber president Otto Laubinger wanted to place far more com-prehensive official controls over the appointment of artistic personnel, but Goebbels refused, maintaining that it was important to avoid "extensive encroachments into the prerogatives of theater operators." Laubinger to Goebbels, 16 August 1934; memo by Schmidt-Leonhardt, 28 August 1934, both in BAP, Promi 464.

149. "Erste Verordnung des Reichsministers für Volksaufklärung und Propa-ganda zur Durchführung des Theatergesetzes," 18 May 1934, *RdRKK-2*, RTK, I, no. 2; "Ablehnung von Zulassungsanträgen," *Die Bühne*, 1 April 1935; "Ständige und gelegentliche Theaterveranstaltungen," *Die Bühne*, 1 March 1936.

150. RMfVuP to RTK, August 1938, BAK, R55/707.

151. Goebbels to Reichsstatthalter, 23 October 1936, BayHStA, Reichsstatthalter Epp 669.

152. Correspondence between RTK and Badisches Staatstheater, 1935–39, GLAK, 57a/245.

153. See the Bühnennachweis memoranda on licensure process in BAK, R56III/15.

154. The very extensive pertinent documentation is in BAP, Promi 166–235.

155. "Die erste Tagung der Landesleiter in der Reichstheaterkammer zu Berlin vom 23. bis 27. Oktober," *Die Bühne*, 1 November 1936.

156. Schlösser to Abt. X, 13 April 1939, BAP, Promi 112.

157. Schlösser to DBV, 8 April 1935, GLAK, 235/30990.

158. Hans-Günter Klein, "Viel Konformität und wenig Verweigerung: Zur Kom-position neuer Opern, 1933–1944," in Heister and Klein, *Musik und Musikpolitik*, p. 145.

159. Minister d. Innern to Bezirksämter, Polizeipräsidien, Polizeidirektionen, 12 December 1934; Generaldirektion d. Bad. Staatstheaters to Bad. Min. d. Unter-richts u. d. Justiz, 13 December 1934, both in GLAK, 235/39894.

160. RMfVuP to Landesregierungen, 15 March 1935, GLAK, 235/39894. As late as April 1936, the Ministry noted that in several cases licenses had been denied to amateur groups on grounds of substandard artistic quality. The Ministry reiterated its position that licenses should be refused only in cases of the "political objections

to the content of the works or the person of the operator." "Erlass des Reichs-ministers für Volksaufklärung und Propaganda an die Landesregierungen betr. Vollzug des Theatergesetzes," 7 April 1936, *RdRKK-2*, RTK, I, no. 11.

161. Geheime Staatspolizeiamt to Staatspolizeistellen, 28 June 1935, BAP, Promi 478.

162. On policy toward the church in general see Conway, *Nazi Persecution of the Churches*; for an assessment of Catholic artistic programs from a Nazi point of view see "Jahreslagebericht 1938," *Meldungen*, 2:43.

163. Geheime Staatspolizei, Staatspolizeistelle Koblenz, to Landrat Bad-Kreuz-nach, 7 October 1937, BAP, Promi 478.

164. RMfVuP to Landesstellen, 8 February 1937, BAP, Promi 478.

165. RMfVuP, Abt. VI (Theater), to Minister, 7 October 1938, BAP, Promi 478. Note Goebbels's handwritten annotation—"as in the Reich!"—to the question of whether this procedure should be used in the recently annexed Austria.

166. Reichspropagandaamt München-Oberbayern to RKK, 11 November 1937, BAP, Promi 478.

167. Schlösser to Goebbels, 23 December 1937, BAP, Promi 478. Note Goebbels's handwritten annotation—"ja!"—to Schlösser's request for permission to prohibit the performances.

168. "Vermerk," by Kleinschmidt (RMfVuP Abt. VI), 14 December 1938, BAP, Promi 478. In 1934 a special tercentenary season of the Oberammergau passion play attracted huge audiences, and Hitler even graced the event with his presence. The regularly scheduled 1940 season was canceled because of the war. Friedman, *Oberammergau Passion Play*, pp. 114–30.

169. "Keinesfalls erlaubte Musikalischer Werke," 1 September 1935, T-70, 108/3631758.

170. Hinkel to Schlösser, 20 September 1935, BDC, RKK/Rainer Schlösser.

171. "Anordnung über Verlag und Betrieb von Emigrantenwerken," 10 October 1935, *RdRKK-1*, 3:37–38.

172. "Erste Anordnung betr. Veranstaltung von Kunstausstellungen und Kunst-messen," 10 April 1935, *RdRKK-2*, RdbK, VIII, no. 1.

173. Education Ministry announcement, 6 June 1935, BayHStA/MF 68 364.

174. BDC, RdbK/"Ausstellungen, 1936–38" (dates on folder are incorrect).

175. *Völkischer Beobachter*, 10 February 1933.

176. Prieberg, *Musik im NS-Staat*, p. 278.

177. *Goebbels Tagebücher*, 10 December 1936.

178. Prieberg, *Musik im NS-Staat*, pp. 275–76.

179. "Notenbeschaffungsaktion 1938"; Draft [*Entwurf*] of letter, RMK to or-chestras, 1938; "Notenbeschaffungsaktion 1939"; RMK to RMfVuP, 6 October 1939; Vermerk, Abt. M, 4 December 1940, all in BAP, Promi 575.

180. Kater, *Different Drummers*, p. 44.

181. Ibid., p. 46; Kater, "Forbidden Fruit?," p. 19.

182. "Anordnung über schädliche u. unerwünschte Musik," 18 December 1937, AMRMK, 15 January 1938.

183. "Haushalt der Reichsmusikprüfstelle," 1942, BAK, R55/854.

184. "Unerwünschte Musik," AMRMK, 1 September 1938.

185. "Anordnung zum Schutze musikalischen Kulturgutes," 29 March 1939, *RdRKK*, RMK, 8:14.

186. Correspondence in BAK, R56I/16.

187. "Aus der kulturpolitischen Pressekonferenz," 13 April 1939, BAK, ZSg. 102/62.

188. "Erste Liste unerwünschter Musikalischer Werke," AMRMK, 1 September 1939.

189. See also "Zweite Liste unerwünschter musikalischer Werke," AMRMK, 15 April 1940.

190. "Bekanntmachung des Präsidenten der Reichsmusikkammer und des Präsidenten der Reichstheaterkammer über Entartung im Tanzwesen," 13 May 1939, *RdRKK*-2, RTK, II, no. 45.

191. Kater, "Forbidden Fruit," pp. 21–28.

192. "Aus der kulturpolitischen Pressekonferenz," 11 February 1937, BAK, ZSg., 102/62.

193. "Bericht Nr. 26 über die Sitzung der Reichstheaterkammer," 5 May 1937, BAK, R56III/14.

194. *Goebbels Tagebücher*, 7 March 1937.

195. Goebbels to RTK, 8 December 1937; Goebbels to Landesregierungen, 8 December 1937, both in BayHStA, MA 105 400.

196. *Völkischer Beobachter*, 4 February, 4 March 1939; see also Finck, *Witz als Schicksal*, p. 64.

197. Mario-Andreas von Lüttichau, " 'Deutsche Kunst' und 'Entartete Kunst': Die Münchener Ausstellungen 1937," in Schuster, *Nationalsozialismus und "Entartete Kunst*," pp. 83–118.

198. The catalog is reproduced in full in Schuster, *Nationalsozialismus und "Entartete Kunst."*

199. Dagmar Lott, "Münchens Neue Staatsgalerie im Dritten Reich," in ibid., p. 292.

200. Lederer to RdbK, September 1937, BAK, R56I/145.

201. "Tag der bildenden Kunst in Naumburg," *MdRdbK*, 1 April 1938.

202. RdbK to RMfVuP, 3 June 1938; Memorandum (Abteilung IX), 15 June 1938; Memorandum (Abteilung IA), 25 June 1938; Vermerk (IB), 15 August 1938, all in BAK, R55/76.

203. "Gesetz über Einziehung von Erzeugnissen entarteter Kunst," 31 May 1938, *RdRKK*-2, RdbK, X, no. 2.

204. Lott, "Münchens Neue Staatsgalerie," p. 297.

205. RMfVuP to Bayer. Staatsmin. f. Unterricht u. Kultus, 12 August 1942, BayHSta, MK 40 849. Goebbels and Hitler both inspected the collection of confiscated works in Berlin. See Abt. BK to Dr. Lucerna, 15 April 1942, BAK, R55/698.

206. RdbK budgets, 1938–41, BAK, R2/4877–80.

207. "1. Vierteljahresbericht," *Meldungen*, 2:275.

CHAPTER SIX

1. "Aufruf, Deutsche Künstler," 8 August 1940, BAK, R56I/108.

2. Reference is made to usage of this epithet in "Meldungen aus dem Reich," Nr. 263, 26 February 1942, in *Meldungen*, 9:3372.

3. Min. d. Innern to RMfVuP, 14 November 1939, BAK, R43II/1252a.

4. "Bericht zur innenpolitischen Lage," Nr. 16, 15 November 1939, *Meldungen*, 3:457.

5. RMfVuP to Min. d. Innern et al., 21 December 1939, with attached note, 6 January 1940, BAK, R55/712.

6. "Meldungen aus dem Reich," Nr. 26, 8 December 1939, *Meldungen*, 3:548–49.

7. "Meldungen aus dem Reich," Nr. 54, 16 February 1940, *Meldungen*, 3:768.

8. "Meldungen aus dem Reich," Nr. 82, 26 April 1940, *Meldungen*, 4:1062–63.

9. Hinkel, "Die soziale Lage der Kulturschaffenden," 1940, BAK, R56I/108.

10. "Sitzungsbericht, betr.: Soziale Betreuung," 8 May 1940, BAK, R56I/94.

11. File: "Kriegseinsatz der Architekten und Ingenieure," BAK, R56I/16; RdbK to Landesleiter Berlin, 7 June 1944, BDC, RdbK/"Reichskammer."

12. Hans Hinkel, "Gemeinschaft von Schwert und Leier: Kraft durch Freude für unsere Soldaten," 1940, BAK, R56I/108; "Statistik-Wehrmachtsbetreuung," October 1939–February 1940, BAP, Promi 261.

13. RKK Budget, 1941, BAK, R2/4880.

14. "Unser Kulturschaffen im Kriege," *Deutsche Allgemeine Zeitung*, 5 August 1942.

15. Documentation in BAK, R56I/84.

16. Hans Hinkel, "Gemeinschaft von Schwert und Leier: Kraft durch Freude für unsere Soldaten," 1940, BAK, R56I/108.

17. "Fronttheater," *Die Bühne*, 20 January 1940; "Schauspieler und Soldat," *Die Bühne*, 23 February 1940.

18. Hinkel to Goebbels, 24 July 1942, BAK, R56I/28; "Anordnung des Präsidenten der Reichskulturkammer zur Regelung des Einsatzes von Kulturschaffenden im Rahmen der Truppenbetreuung," 21 March 1932, *Völkischer Beobachter*, 25 March 1942.

19. "Nationalsozialistische Kulturarbeit während des Krieges," 1943, BAK, R56/110.

20. "Theaterstatistik für 1942/43," *Die Bühne*, 29 March 1943.

21. "Unser Kulturschaffen im Kriege: Umfassender überblick durch Staatssekretär Gutterer," *Deutsche Allgemeine Zeitung*, 5 May 1942.

22. "Meldungen aus dem Reich," Nr. 44, 24 January 1940, *Meldungen*, 3:681–82; "Meldungen aus dem Reich," Nr. 45, 26 January 1940, *Meldungen*, 3:690; "Meldungen aus dem Reich," Nr. 80, 22 April 1940, *Meldungen*, 4:1037–38; "Meldungen aus dem Reich," Nr. 96, 13 June 1940, *Meldungen*, 4:1250; "Meldungen aus dem Reich," Nr. 140, 11 November 1940, *Meldungen*, 5:1754–55.

23. "Meldungen aus dem Reich," Nr. 140, 11 November 1940, *Meldungen*, 5:1754–55; "Meldungen aus dem Reich," Nr. 164, 20 February 1941, *Meldungen*, 6:2022–23; "Meldungen aus dem Reich," Nr. 189, 26 May 1941, *Meldungen*, 7:2344–46; "Meldungen aus dem Reich," Nr. 361, 22 February 1943, *Meldungen*, 12:4834–36; "Meldungen aus dem Reich," Nr. 370, 25 March 1943, *Meldungen*, 13:5011–14.

24. "Meldungen aus dem Reich," Nr. 370, 25 March 1943, *Meldungen*, 13:5011–14. Also BDC, RdbK/Möbelhandlung Smeent.

25. Benecke (Deutscher Gemeindetag) to Oberbürgermeister of Erfurt, 16 March 1944, BAK, R36/2399.

26. For a discussion of this problem and several examples see "Meldungen aus dem Reich," Nr. 179, 17 April 1941, in *Meldungen*, 6:2207–10.

27. For two basic measures see "Anordnung des Sondertreuhänders der Arbeit für die kulturschaffenden Berufe zur Überwachung der Gagengestaltung bei Verträgen mit Bühnenschaffenden im Deutschen Reich," 20 February 1940, *RdRKK-2*, RTK, III, no. 11, and "Anordnung des Sondertreuhänders der Arbeit für die kultur-

schaffenden Berufe zur Überwachung der Gagengestaltung bei Verträgen mit Künstlern im Rahmen des Truppenbetreuung," 8 May 1941, *RdRKK*-2, RKK, III, no. 35.

28. "Vermerk," 17 September 1941, BAK, R55/131.

29. "Bericht über die Tagung des Ausschusses für Theaterverwaltungsfragen," 11 November 1943, BAK, R36/2404.

30. "Mehr Sorgfalt bei Engagementsabschluss," *Die Bühne*, 25 September 1942; "Ordnungsstrafe," *Die Bühne*, 12 December 1942.

31. BDC, RTK/Wilhelm Richter-Constantin.

32. "Bericht über die Tagung des Ausschusses für Theaterverwaltungsfragen," 15 June 1944, BAK, R36/2404.

33. "Vermerk," 5 March 1942, BAK, R55/129.

34. Wehrmachtsbefehlshaber Norwegen to OKW-Inland, 27 April 1941, Bundes-archiv-Militärarchiv Freiburg, RW6 (OKW-Allgemeines Wehrmachtsamt), 176.

35. "Auszug aus dem Tätigkeitsbericht für Monat Februar, Gau Pommern," 1944, BAK, R56I/37.

36. Ley to Goebbels, 8 May 1944, BAK, R56I/37.

37. On salary inflation see Sondertreuhänder to Bormann [undated draft, proba-bly October 1941]; Leiter d. Personalabteilung (RMfVuP) to Staatssekretär, 15 October 1941; Leiter d. Personalabteilung (RMfVuP) to Hadamovsky, 18 October 1941, all in BAK, R55/199.

38. "Vermerk," Leiter T, 22 April 1942, BAP, Promi 112.

39. "Ausschluss aus der Reichstheaterkammer," *Die Bühne*, 25 April 1942.

40. Gutterer to Goebbels, 25 October 1939, BAK, R55/124.

41. "Meldungen aus dem Reich," Nr. 89, 20 May 1940, *Meldungen*, 4:1161–62.

42. RMfVuP to theaters and orchestras, 8 April 1941, GLAK, 235/5737.

43. "Aus der kulturpolitischen Pressekonferenz," 21 August 1942, BAK, Zsg. 102/63.

44. "Ausschlüsse," *Die Bühne*, 20 November 1943.

45. "Ausschlüsse," *Die Bühne*, 20 April 1944.

46. Hinkel to Goebbels, 11 March 1944, BAK, R55/125.

47. Haus der Deutschen Kunst to Bormann, 5 May 1943; Bormann to Lammers, 9 May 1943; Goebbels to Lammers, 25 May 1943, all in BAK, R43II/1242b.

48. Präs. d. Gauarbeitsamts u. Reichstreuhänder d. Arbeit, Ostpreussen to Sondertreuhänder, 21 September 1944, BAK, R56I/106.

49. RMK, Kreismusikerschaft Darmstadt, to Sondertreuhänder, 28 June 1944, BAK, R56I/106.

50. Präs. d. Gauarbeitsamts u. Reichstreuhänder d. Arbeit, Thüringen to Son-dertreuhänder, 3 June 1944, BAK, R56I/106.

51. RMfVuP to RTK et al., 8 December 1939, BAK, R55/131.

52. RTK to Bühnenleitern, 11 January 1940, BAK, R55/131.

53. "Meldungen aus dem Reich," Nr. 357, 8 February 1943, *Meldungen*, 12:4769–70.

54. "Betr: Genehmigung für die Verpflichtung ausländischer Bühnenkünstler," *Die Bühne*, 20 April 1943.

55. Landeskulturwalter Gau Steiermarck to RTK, 27 January 1944, BAK, R56III/26.

56. RTK to Landestheater Salzburg, 17 February 1944, BAK, R56III/26.

57. Wagner to RTK, 18 August 1944, Städtische Bühne Thorn to RTK, 24 August 1944, BAK, R56III/26.

58. Oberbürgermeister Mülhausen to Abt. Prop., Zivilverwaltung Strassburg, 27 November 1943, BAK, R56II/4.

59. Sondertreuhänder to Gauarbeitsamt-Thüringen, 24 June 1944, BAK, R56I/106.

60. "Meldungen aus dem Reich," Nr. 273, 2 April 1942, *Meldungen*, 10:3571–72.

61. A list of sects prohibited by the Gestapo between 1933 and 1938 contained 34 different groups. Included among them were Jehovah's Witnesses, Anabaptists, and Seventh-Day Adventists, as well as numerous obscure groups, such as the Community of Divine Socialism, the Study Group for Psychic Research, and the Bahai Sect. In June 1941 Heydrich ordered a new Gestapo offensive against "Astrologers, Occultists, Spiritualists, Followers of the Occult Theories of Rays, Fortune Tellers, fake or otherwise (no matter which type), Faith Healers, Followers of Christian Science, Followers of Anthroposophy, Followers of Theosophy, Followers of Ariosophy." Conway, *Nazi Persecution of the Churches*, pp. 370–74, 378–82.

62. "Liste der aus der Reichsmusikkammer ausgeschlossenen Nichtarier bezw. mit Volljuden Verheiratete (von August 1940–April 1941)," "Liste der aus der Reichstheaterkammer ausgeschlossenen Nichtarier bezw. mit Volljuden Verheiratete (von August 1940–April 1941)," BDC, RKK/"Entjüdung der Einzelkammern."

63. Lists, "Reichsmusikkammer," 21 January 1943; "Reichstheaterkammer," 21 January 1943; "Reichskammer der bildenden Künste," 1943, all in BDC, RKK/"Entjüdung der Einzelkammern." On the compilation of the lists see RKK-Hauptgeschäftsführung to Chamber Presidents, 11 December 1942, T-580, 952/63.

64. For example, compare the section on "Ausschlüsse und Ablehnungen" in *Die Reichskulturkammer*, December 1944, with BDC Kulturkammer files for Heinrich Ludwigs, Otto Ninow, Alfred Oleszkiewicz, Max Haag, and Inga Kannenberg.

65. Letter to Fernbach, 31 July 1944, BDC, RTK/Carl Fernbach.

66. BDC, RTK/Klare Gille.

67. Hinkel to Graener, 10 August 1943, BDC, RMK/Paul Graener.

68. BDC, RTK/Felicitas Albers.

69. BDC, RTK/Ruth Rosenmann.

70. Memo, Reichsminister f. Wissenschaft, Erziehung und Volksbildung, "betr.: Schutz des deutschen Kulturgutes gegen Abwanderung (Mitnahme von Umzugsgut bei der Auswanderung von Juden)," 15 May 1939, BayHStA, MK 40 839.

71. "Verfahrensordnung der Reichskammer der bildenden Künste als Ankaufstelle für Kulturgut," 6 May 1941, *Reichsgesetzblatt*, 1941, 1:245; Deutsches Nachrichtenbüro release, 27 May 1941, BAK, R43II/598.

72. RdbK budgets, 1942–44, BAK, R2/4881–84.

73. BDC, RdbK/Anna Schlesinger.

74. BDC, RdbK/Paul Richter.

75. BDC, RdbK/Hans Oppenheimer.

76. BDC, RdbK/Valentin Zietara.

77. "Organisatorische Massnahmen (Reichstheaterkammer)," March 1938; Frauenfeld, "Bericht über die Dienstreise nach Wien und Graz, vom 25.8–10.9.1938"; Abt. X (Musik) to Goebbels, 14 March 1938, all in BAP, Promi 112.

78. "Verordnung des Reichsministers für Volksaufklärung und Propaganda und des Reichsministers des Innern über die Einführung der Reichskulturkammergesetzgebung in den eingegliederten Ostgebieten," 29 December 1939, RdRKK-2, RKK, I, no. 20.

79. Propaganda Ministry to Chamber Presidents, 9 March 1940, BAK, R55/1426.

80. See, for example, the case of Polish musician Raoul Koczalski as discussed in RMK to Brückner, 19 March 1940, BAK, NS10/111.

81. "Ungültigkeitserklärungen," *Die Bühne*, 25 August 1940.

82. In January 1940 the Literature Chamber warned new applicants in the annexed territories that "according to experience, the production of ancestry documents is very time-consuming. It is therefore necessary to begin therewith immediately." "Eingliederung des Schriftums der eingegliederten Ostgebiete in die Reichsschriftumskammer," 27 January 1940, *RdRKK-2*, RSK, I, no. 70.

83. Music Chamber President to Propaganda Ministry, 29 July 1940, BAK, R55/1426.

84. Propaganda Ministry to Chamber Presidents, 5 December 1940, BAK, R55/1426.

85. "Ansiedlung von Wehrmachtangehörigen in den neueingegliederten Ostgebieten," 1941, BDC/Research File 307.

86. For a more thorough discussion see Steinweis, "German Cultural Imperialism."

87. "Verordnung des Reichsministers für Volksaufklärung und Propaganda und des Reichsministers des Innern über die Einführung der Reichskulturkammergesetzgebung in Protektorat Böhmen und Mähren," 21 January 1941, *RdRKK-2*, RKK, I, no. 23.

88. German efforts to persuade Czechs to apply for Reich citizenship proved disappointing. See Mastny, *Czechs under Nazi Rule*, p. 134, and Brandes, *Tschechen unter Deutschem Protektorat*, 1:160.

89. RTK to Theaterveranstalter, 23 May 1940, GLAK, 235/39894.

90. "Betr.: Neger und Negermischlinge," *Die Bühne*, 25 August 1941.

91. RTK-Fachschaft Artistik to RTK Graz, 20 May 1942, BAK, R56I/15.

92. BDC, RTK/Michael Silitsch.

93. Adjutantur der Wehrmacht beim Führer to Chef der Oberkommando der Wehrmacht, 20 July 1942, BAK, R55/1281.

94. AMRMK, 15 September 1939.

95. "Bekanntmachung über die Spielplan- und Programmgestaltung der deutschen Bühnen, Varietes, Kabaretts und Kleinkunstbühnen," 1 September 1939, *RdRKK-2*, RTK, II, no. 49.

96. "Kulturpolitische Pressekonferenz," 20 September 1939, BAK, ZSg. 102/62.

97. "Der Reichsdramaturg," *Die Bühne*, 29 March 1943.

98. "Aus der kulturpolitischen Pressekonferenz," 25 April 1941, BAK, ZSg. 102/63.

99. "Kulturpolitische Pressekonferenz," 20 September 1939, BAK, ZSg. 102/62.

100. For example, see correspondence between Reichsdramaturg and Baden State Theater, GLAK, 57a/249.

101. Dussel, "Provinztheater in der NS-Zeit," p. 82.

102. Polizeipräs.-Berlin to RTK, 10 February 1940, BAP, Promi 239/1.

103. Fachschaft Artistik to Polizeipräs.-Berlin, 15 January 1940, BAP, Promi 239/1.

104. Toepfer, "Nudity and Modernity in German Dance."

105. Schlösser to Goebbels, 14 March 1940, BAP, Promi 239/1.

106. Gutterer to Schlösser, 21 March 1940, BAP, Promi 239/1.

107. "Vermerk," by Keppler, 23 March 1940, BAP, Promi 239/1.

108. Goebbels to Reichspropagandaämter, 12 April 1940, BAP, Promi 239/1.

109. Körner to Fachschaft Artistik Betriebsführer, 6 January 1941, BAP, Promi 239/1.

110. E.g, letters from Polizeipräs.-Berlin to RMfVuP, 31 May 1940 and 29 October 1940, and Reichskriminalpolizeiamt to RMfVuP, 29 October 1942, all in BAP, Promi 239/1.

111. Theaterabt. memo "Betr.: Schönheits(Nackt)tanz," 26 April 1941, BAP, Promi 239/1.

112. AMRMK, 15 February 1940.

113. "Kulturpolitische Pressekonferenz," 20 September 1939, BAK, ZSg., 102/62.

114. AMRMK, 15 July 1941.

115. AMRMK, 15 August 1941.

116. AMRMK, 15 July 1941.

117. AMRMK, 15 January 1940.

118. AMRMK, 15 April 1940.

119. AMRMK, 15 January 1940, 15 March 1940.

120. "Bestimmung über die Prüfung von Neuerscheinungen der Unterhaltungs- und Tanzmusik," 25 April 1940, *RdRKK-2*, RMK, VIII, no. 16.

121. AMRMK, 15 August 1941.

122. "Aus der kulturpolitischen Pressekonferenz," 26 February 1942, BAK, ZSg. 102/63.

123. "Meldungen aus dem Reich," Nr. 307, 10 August 1942, *Meldungen*, 11:4054–57.

124. AMRMK, 15 January 1943.

125. "Meldungen aus dem Reich," Nr. 164, 20 February 1941, *Meldungen*, 6:2023; "Meldungen aus dem Reich," Nr. 189, 26 May 1941, *Meldungen*, 7:2345.

126. "Meldungen aus dem Reich," Nr. 116, 19 August 1940, *Meldungen*, 5:1483–85.

127. "Anordnung über den Vertrieb minderwertiger Kunsterzeugnisse," 1 October 1940, *RdRKK-2*, RdbK, X, no. 17.

128. "Meldungen aus dem Reich," Nr. 189, 26 May 1941, *Meldungen*, 7:2346.

129. BDC, RdbK/Johannes Meissner.

130. BDC, RdbK/P. Lindhorst.

131. BDC, RdbK/Adolf Friedrich.

132. Meister to Gall, 14 April 1944, BDC, RdbK/Leonhard Gall.

133. On the role of the chamber's local officials see Reichswirtschaftsmin. to Reichsverteidigungskommissare et al., 20 February 1943, BAK, R43II/662.

134. "Die Arbeitseinsatz- und Stillegungsaktion," *Die Reichskulturkammer*, 1943, no. 3.

135. "SD Berichte zu Inlandsfragen," 20 December 1943, *Meldungen*, 15:6172–75.

136. "Führerinformation," Nr. AI467, 11 August 1944, BAK, R43II/666b.

137. "Bericht über die Tagung des Ausschusses für Theaterverwaltungsfragen," 15 June 1944, BAK, R36/2404.

138. Drewniak, *Theater im NS-Staat*, pp. 346–47.

139. "Verwaltungsbericht über die erste Hälfte des Geschäftsjahres 1944/45," BDC, RTK/Karl Löser.

140. "Der totale Kriegseinsatz der Kulturschaffenden," *Die Reichskulturkammer*, August/September 1944.

141. "Führerinformation," Nr. AI462, 9 August 1944, BAK, R43II/666b.

142. Deutscher Gemeindetag to Reichsstatthalter, 28 September 1944, BAK, R36/2389.

143. Drewniak, *Theater im NS-Staat*, pp. 352–53.

144. "Liste von Künstler," n.d., BAK, R56I/33.

145. "Führerinformation," Nr. AI467, 11 August 1944, BAK, R43II/666b.

146. "Bericht über die Schliessung der Theater und Kleinkunstbühnen im Gau Magdeburg-Anhalt," 1944, BAK, R56III/2a.

147. "Anruf von Obgruf. Schaub," 29 September 1944, BAK, R56I/93.

148. BDC, RTK/Margot Devens de Wet.

149. BDC, RTK/Ehrentraut Grüner.

150. BDC, RMK/"Nick-Oekl."

151. BDC, RTK/Johann Pössenbacher.

152. BDC, RTK/Katrina Rudolph.

CONCLUSION

1. See the explanation of the term in Jarausch, *Unfree Professions*, p. 7.

BIBLIOGRAPHY

UNPUBLISHED DOCUMENTS

Bayerisches Hauptstaatsarchiv, Munich
 MA: Staatskanzlei
 MF: Finanzministerium
 MInn: Innenministerium
 MK: Kultusministerium
 MWi: Wirtschaftsministerium
 Reichsstatthalter in Bayern
Berlin Document Center
 NSDAP Kartei
 NSDAP Oberstes Parteigericht
 Reichskulturkammer Personal Files
 SA Personal Files
 SS Personal Files
Bundesarchiv, Abteilung Potsdam
 Reichsministerium für Volksaufklärung und Propaganda (Promi)
Bundesarchiv Koblenz
 NS 8: Kanzlei Rosenberg
 NS 10: Persönliche Adjuntar des Führers und Reichskanzlers
 NS 15: Beauftragter des Führers (Amt Rosenberg)
 NS 22: Reichsorganisationsleiter der NSDAP
 NS 26: Hauptarchiv der NSDAP
 R 2: Reichsfinanzministerium
 R 18: Reichsministerium des Innern
 R 21: Reichsministerium für Wissenschaft, Erziehung und Volksbildung
 R 22: Reichsjustizministerium
 R 32: Reichskunstwart
 R 36: Deutscher Gemeindetag
 R 43: Reichskanzlei
 R 53: Stellvertreter des Reichskanzlers
 R 55: Reichsministerium für Volksaufklärung und Propaganda
 R 56: Reichskulturkammer
 R 58: Reichssicherheitshauptamt
 Sammlung Schumacher
 ZSg. 102: Sammlung Sänger zur Pressepolitik des NS-Staates
 ZSg. 103: Presseausschnitt-Sammlung Lauterbach
 ZSg. 117: Presseausschnitt-Sammlung Hauptarchiv der NSDAP
Bundesarchiv-Militärarchiv, Freiburg
 RW 6: OKW, Allgemeines Wehrmachtsamt
Institut für Zeitgeschichte, Munich
 ZS 1878: "Hans Hinkel Zeugenschrift"
Generallandesarchiv Karlsruhe
 57a Badisches Staatstheater

233 Badisches Staatsministerium
235 Badisches Kulturministerium
236 Badisches Innenministerium
237 Badisches Finanzministerium
Landesarchiv Berlin
Rep. 243, Acc. 1814: Berliner Institute und Körperschaften aus dem
Geschäftsbereich des Reichsministers für Volksaufklärung und Propaganda
1933–1945
National Archives, Washington
Microfilm T-70: Records of the Reich Ministry for Public Enlightenment and
Propaganda
Microfilm T-175: Records of the Reich Leader of the SS and Chief of the
German Police
Microfilm T-580: Captured German Records Filmed at Berlin (American
Historical Association)
YIVO Institute, New York
Berlin Collection, folder G-54 (RKK-Fragebogen)

PUBLISHED DOCUMENTS

Akademie der Künste, Berlin. *Geschlossene Vorstellung: Der Jüdische Kulturbund
in Deutschland 1933–1941*. Berlin: Edition Hentrich, 1992.
Boelke, Willi A., ed. *Kriegspropaganda 1939–1941: Geheime Ministerkonferenzen
im Reichspropagandaministerium*. Stuttgart: Deutsche Verlags-Anstalt, 1966.
Brenner, Hildegard, ed. *Ende einer bürgerlichen Kunstinstitution: Die politische
Formierung der Preussischen Akademie der Künste ab 1933*. Stuttgart: Deutsche
Verlags-Anstalt, 1972.
Dokumente der deutschen Politik. Edited by Paul Meier-Benneckenstein and
Alfred Six. 9 vols. Berlin: Junker und Dünnhaupt, 1935–44.
*Meldungen aus dem Reich: Die geheimen Lageberichte des Sicherheitsdienstes der
SS, 1938–1945*. 17 vols. Edited by Heinz Boberach. Herrsching: Pawlak, 1984.
Noakes, Jeremy, and Geoffrey Pridham, eds. *Nazism, 1919–1945: A
Documentary Reader*. 3 vols. Exeter: University of Exeter Press, 1983–88.
Nungesser, Michael, ed. *"Als die SA in den Saal marschierte. . . ."*: *Das Ende des
Reichsverbandes bildender Künstler Deutschlands* (Catalog for an exhibition of
the educational department of the BBK Berlin, in the Staatlichen Kunsthalle
Berlin, 4–23 December 1983). Berlin: Bildungswerk des BBK Berlins, 1983.
Regierung Hitler. Part 1: 1933–34. Edited by Karl-Heinz Minuth. Akten der
Reichskanzlei. Boppard: Harald Boldt, 1983.
Rühle, Gerd. *Das Dritte Reich: Dokumentarische Darstellung des Aufbaues der
Nation. Das erste Jahr 1933*. 2d ed. Berlin: Hummel, 1934.
Scholder, Klaus, ed. *Die Mittwochs-Gesellschaft: Protokolle aus dem geistigen
Deutschland 1932 bis 1944*. Berlin: Severin und Siedler, 1982.
*Das Schwarzbuch: Tatsachen und Dokumente. Die Lage der Juden in Deutschland
1933*. Published by the Comité des Délégations Juive. Paris: Edition du Rond-
Point, 1934. Reprint, Frankfurt: Ullstein, 1983.
Teut, Anna, ed. *Architektur im Dritten Reich, 1933–1945*. Berlin: Ullstein, 1967.
Thomae, Otto, ed. *Die Propaganda-Maschinerie: Bildende Künste und
Öffentlichkeitsarbeit im Dritten Reich*. Berlin: Gebrüder Mann, 1978.

Wulf, Joseph, ed. *Die bildenden Künste im Dritten Reich: Eine Dokumentation.*
Gütersloh: Sigbert Mohn, 1963. Reprint, Frankfurt: Ullstein, 1983.
———. *Literatur und Dichtung im Dritten Reich: Eine Dokumentation.*
Gütersloh: Sigbert Mohn, 1963. Reprint, Frankfurt: Ullstein, 1983.
———. *Musik im Dritten Reich: Eine Dokumentation.* Gütersloh: Sigbert Mohn,
1963. Reprint, Frankfurt: Ullstein, 1983.
———. *Theater und Film im Dritten Reich: Eine Dokumentation.* Gütersloh:
Sigbert Mohn, 1964. Reprint, Frankfurt: Ullstein, 1983.

OFFICIAL PUBLICATIONS

"Berufszählung: Die berufliche und soziale Gliederung der Bevölkerung des
Deutschen Reichs." Heft 2: "Die Erwerbstätigkeit der Reichsbevölkerung."
Statistik des Deutschen Reichs, vol. 453 (2).
Das Deutsche Führerlexikon, 1934/35. Berlin: Otto Stollberg, 1934.
*Deutsche Sozialpolitik: Bericht der Deutschen Arbeitsfront, Zentralbüro, Sozialamt
(Zeit: 1. Januar 1938 bis 31. Dezember 1938).* Berlin: Verlag der Deutschen
Arbeitsfront, 1939.
Dreyer, Ernst Adolf. *Deutsche Kultur im Neuen Reich: Wesen, Aufgabe, und Ziel
der Reichskulturkammer.* Berlin: Schlieffen, 1934.
Hinkel, Hans, ed. *Handbuch der Reichskulturkammer.* Berlin: Deutscher Verlag
für Politik und Wirtschaft, 1937.
Ihlert, Heinz. *Die Reichsmusikkammer: Ziele, Leistungen und Organisation.*
Berlin: Junker und Dünnhaupt, 1935.
Jahrbuch der Berufsverbände im Deutschen Reiche (52. Sonderheft zum
Reichsarbeitsblatt). Berlin: Verlag des Reichsarbeitsblatts, 1930.
Marrenbach, Otto, ed. *Fundamente des Sieges: Die Gesamtarbeit der Deutschen
Arbeitsfront von 1933 bis 1940.* Berlin: Verlag der Deutschen Arbeitsfront,
1940.
Die Organisation der Reichskulturkammer. "Stand vom 1. April 1936." Berlin:
n.p., 1936.
Pfundtner, Hans, and Reinhard Neubert, eds. *Das neue Deutsche Reichsrecht:
Ergänzbare Sammlung des geltenden Rechts seit dem Ermächtigungsgesetz mit
Erläuterungen.* Berlin: Spaeth und Linde, 1933 and periodic updates.
Schmidt-Leonhardt, Hans. "Die Reichskulturkammer." *Grundlagen, Aufbau und
Wirtschaftsordnung des nationalsozialistischen Staates.* Edited by Fritz
Müssigbrodt. 3 vols. Vol. 1: *Die weltanschaulichen Grundlagen des
nationalsozialistischen Staates,* pt. 2, sec. 20. Berlin: Spaeth und Linde, 1938.
Schrieber, Karl-Friedrich, ed. *Das Recht der Reichskulturkammer: Sammlung der
für den Kulturstand geltenden Gesetze und Verordnungen, der amtlichen
Anordnungen und Bekanntmachungen der Reichskulturkammer und ihrer
Einzelkammern.* 5 vols. Berlin: Junker und Dünnhaupt, 1935–37.
Schrieber, Karl-Friedrich, Alfred Metten, and Herbert Collatz, eds. *Das Recht der
Reichskulturkammer: Sammlung der für den Kulturstand geltenden Gesetze und
Verordnungen, der amtlichen Anordnungen und Bekanntmachungen der
Reichskulturkammer und ihrer Einzelkammern.* 2 vols. Berlin: de Gruyter,
1943.
Statistisches Jahrbuch für das Deutsche Reich, 1928–1941/42. Edited by
Statistisches Reichsamt, Berlin.

MEMOIRS, DIARIES, PUBLISHED CORRESPONDENCE, COLLECTED WRITINGS, AND SPEECHES

Blunck, Hans Friedrich. *Unwegsame Zeiten: Lebensbericht.* Vol. 2. Mannheim: Kessler, 1952.

Finck, Werner. *Witz als Schicksal.* Hamburg: Marion von Schröder, 1966.

Geissmar, Berta. *Musik im Schatten der Politik.* Zurich: Atlantis, 1945.

Goebbels, Joseph. *The Goebbels Diaries.* Edited by Louis P. Lochner. New York: Doubleday, 1948.

———. *Goebbels-Reden, 1932–1945.* 2 vols. Edited by Helmut Heiber. Düsseldorf: Droste, 1971, 1972.

———. *Die Tagebücher von Joseph Goebbels: Sämtliche Fragmente.* Teil I: *Aufzeichnungen 1924–1941.* 4 vols. Edited by Elke Fröhlich. Munich: K. G. Saur, 1987.

Grasberger, Franz, ed. *Der Strom der Töne trug mich fort. Die Welt um Richard Strauss in Briefen.* Tutzing: H. Schneider, 1967.

Hinkel, Hans. *Einer unter Hunderttausend.* Munich: Knorr und Hirth, 1938.

Hitler, Adolf. *Reden und Proklamationen, 1923–1945.* 2 vols. Edited by Max Domarus. Neustadt a.d. Aisch: Verlagsdruckerei Schmidt, 1965.

———. *Sämtliche Aufzeichnungen, 1905–1924.* Edited by Eberhard Jäckel and Axel Kuhn. Stuttgart: Deutsche Verlags-Anstalt, 1980.

———. *Mein Kampf.* Translated by Ralph Mannheim. Boston: Houghton Mifflin, 1943.

Kaes, Anton, ed. *Weimarer Republik: Manifeste und Dokumente zur deutschen Literatur 1918–1933.* Stuttgart: Metzler, 1983.

Lowinsky, Edward, ed. *A Confidential Matter: The Letters of Richard Strauss and Stefan Zweig, 1931–1935.* Translated by Max Knight. Berkeley: University of California Press, 1977.

Pois, Robert, ed. *Race and Race History, and Other Essays by Alfred Rosenberg.* New York: Harper and Row, 1970.

Wagener, Otto. *Hitler: Memoirs of a Confidant.* Edited by Henry Ashby Turner, Jr.; translated by Ruth Hein. New Haven: Yale University Press, 1985.

CONTEMPORARY PERIODICALS AND SERIALS

Allgemeine Musikzeitung
Der Angriff
Der Auftakt
Börsenblatt für den deutschen Buchhandel
Die Bühne
Deutsche Allgemeine Zeitung
Deutsche Kultur-Wacht
Deutsche Musiker-Zeitung
Deutsches Bühnen-Jahrbuch
Germania
Kunst und Wirtschaft
Mitteilungsblatt der Reichskammer der bildenden Künste
Mitteilungsblatt des Kampfbundes für Deutsche Kultur
Musik im Zeitbewusstsein

Die Musik-Woche
Neuer Theater Almanach
Der Neue Weg
Reichsgesetzblatt
Die Reichskulturkammer
Völkischer Beobachter
Zeitschrift für Musik

SECONDARY WORKS

Adam, Uwe Dietrich. *Judenpolitik im Dritten Reich*. Düsseldorf: Droste, 1972.

Barkai, Avraham. *From Boycott to Annihilation: The Economic Struggle of German Jews, 1933–1943*. Translated by William Templer. Hanover, N.H.: University Press of New England, 1989.

Baumgärtner, Raimund. *Weltanschauungskampf im Dritten Reich: Die Auseinandersetzung der Kirchen mit Alfred Rosenberg*. Mainz: Matthias-Grünewald, 1977.

Beck, Earl R. *Under the Bombs: The German Home Front, 1942–1945*. Lexington: University Press of Kentucky, 1986.

Biddiss, Michael D. *Father of Racist Ideology: The Social and Political Thought of Count Gobineau*. New York: Weybright and Talley, 1970.

Bigot, Hervé. "La chambre du culture allemande dans le régime totalitaire du III reich." Thesis, University of Paris, 1937; Paris: Les Editions Domat-Montchrestien, 1937.

Blaich, Fritz. "Wirtschaft und Rüstung in Deutschland, 1933–39." In *Nationalsozialistische Diktatur: Eine Bilanz*, edited by Karl Dietrich Bracher, Manfred Funke, and Hans-Adolf Jacobsen, pp. 285–316. Bonn: Bundeszentrale für politische Bildung, 1983.

Boll.nus, Reinhard. *Das Amt Rosenberg und seine Gegner*. Stuttgart: Deutsche Verlags-Anstalt, 1970.

Bowen, Ralph H. *German Theories of the Corporative State*. New York: McGraw-Hill, 1947.

Bracher, Karl Dietrich. *The German Dictatorship*. Translated by Jean Steinberg. New York: Praeger, 1970.

Bracher, Karl Dietrich, Gerhard Schulz, and Wolfgang Sauer. *Die nationalsozialistische Machtergreifung*. Cologne: Westdeutscher, 1960. Reprint, 3 vols., Frankfurt: Ullstein, 1973–79.

Bramstaed, Ernest K. *Goebbels and National Socialist Propaganda, 1925–1945*. East Lansing: Michigan State University Press, 1965.

Brandes, Detlef. *Die Tschechen unter Deutschem Protektorat*. 2 vols. Munich: Oldenbourg, 1969, 1975.

Brenner, Hildegard. "Die Kunst im politischen Machtkampf der Jahre 1933/34." *Vierteljahreshefte für Zeitgeschichte* 10 (January 1962): 17–42.

———. *Die Kunstpolitik des Nationalsozialismus*. Reinbek: Rowohlt, 1963.

Brock, Bazon, and Achim Preiss, eds. *Kunst auf Befehl?: Dreiunddreissig bis Fünfundvierzig*. Munich: Klinkhardt und Biermann, 1990.

Broszat, Martin. *The Hitler State: The Foundation and Development of the Internal Structure of the Third Reich*. Translated by John W. Hiden. London: Longman, 1981.

Bry, Gerhard. *Wages in Germany, 1871–1945*. Princeton: Princeton University Press, 1960.

Burleigh, Michael, and Wolfgang Wippermann. *The Racial State: Germany 1933–1945*. Cambridge: Cambridge University Press, 1991.

Chamberlain, Houston Stewart. *Die Grundlagen des neunzehnten Jahrhunderts*. Munich: Bruckmann, 1899.

———. *Richard Wagner*. Munich: Bruckmann, 1904.

Childers, Thomas. *The Nazi Voter: The Social Foundations of Fascism in Germany, 1919–1933*. Chapel Hill: University of North Carolina Press, 1984.

Cocks, Geoffrey, and Konrad H. Jarausch, eds. *German Professions, 1800–1950*. New York: Oxford University Press, 1990.

Conway, John S. *The Nazi Persecution of the Churches*. New York: Basic Books, 1968.

Cuomo, Glenn R. "Purging an 'Art-Bolshevist': The Persecution of Gottfried Benn in the Years 1933–38." *German Studies Review* 9 (February 1986): 85–105.

Dahm, Volker. "Das jüdische Buch im Dritten Reich. Teil 1: Die Ausschaltung der jüdischen Autoren, Verleger und Buchhändler." *Archiv für Geschichte des Buchwesens* 20 (1979): 1–300.

———. "Kulturelles und geistiges Leben." In *Die Juden in Deutschland 1933–1945: Leben unter nationalsozialistischer Herrschaft*, edited by Wolfgang Benz, pp. 75–267. Munich: C. H. Beck, 1988.

———. "Die nationalsozialistische Schriftumspolitik nach dem 10. Mai 1933." In *10. Mai 1933: Bücherverbrennung in Deutschland und die Folgen*, edited by Ulrich Walberer, pp. 36–83. Frankfurt: Fischer Taschenbuch Verlag, 1983.

———. "Die Reichskulturkammer als Instrument kulturpolitischer Steuerung und sozialer Reglementierung." *Vierteljahreshefte für Zeitgeschichte* 34 (January 1986): 53–84.

Diller, Ansgar. *Rundfunkpolitik im Dritten Reich*. Munich: Deutscher Taschenbuch Verlag, 1980.

Drewniak, Boguslaw. *Das Theater im NS-Staat: Szenarium deutscher Zeitgeschichte*. Düsseldorf: Droste, 1983.

Dussel, Konrad. "Provinztheater in der NS-Zeit." *Vierteljahrshefte für Zeitgeschichte* 38 (January 1990): 75–111.

Eichenauer, Richard. *Musik und Rasse*. Munich: Lehmann, 1937.

Eksteins, Modris. *Rites of Spring: The Great War and the Birth of the Modern Age*. Boston: Houghton Mifflin, 1989.

Ellis, Donald W. "Music in the Third Reich: National Socialist Aesthetic Theory as Governmental Policy." Ph.D. diss., University of Kansas, 1970.

Field, Geoffrey G. *Evangelist of Race: The Germanic Vision of Houston Stewart Chamberlain*. New York: Columbia University Press, 1981.

Freeden, Herbert. *Jüdisches Theater in Nazideutschland*. Tübingen: Mohr, 1964.

Friedman, Saul S. *The Oberammergau Passion Play: A Lance against Civilization*. Carbondale: Southern Illinois University Press, 1984.

Gaber, Bernhard. *Die Entwicklung der freischaffenden Architekten: Dargestellt an der Geschichte des Bundes Deutscher Architekten (BDA)*. Essen: Bacht, 1966.

Gay, Peter. *Weimar Culture: The Outsider as Insider*. New York: Harper and Row, 1968.

Giles, Geoffrey J. " 'The Most Unkindest Cut of All': Castration, Homosexuality and Nazi Justice." *Journal of Contemporary History* 27 (January 1992): 41–61.

————. *Students and National Socialism in Germany.* Princeton: Princeton University Press, 1985.

Grosshans, Henry. *Hitler and the Artists.* New York: Holmes and Meier, 1983.

Guillebaud, Claude W. *The Social Policy of Nazi Germany.* Cambridge: Cambridge University Press, 1941.

Guttsman, W. L. *Workers' Culture in Weimar Germany: Between Tradition and Commitment.* New York: Berg, 1990.

Heiber, Helmut. *Joseph Goebbels.* Berlin: Colloquium, 1962.

Heister, Hanns-Werner, and Hans-Günter Klein. *Musik und Musikpolitik im faschistischen Deutschland.* Frankfurt: Fischer, 1984.

Hentschel, Volker. *Geschichte der deutschen Sozialpolitik, 1880–1980.* Frankfurt: Suhrkamp, 1983.

Herterich, Fritz. *Theater und Volkswirtschaft.* Munich: Duncker und Humblot, 1937.

Hilberg, Raul. *The Destruction of the European Jews.* 2d ed. 3 vols. New York: Holmes and Meier, 1985.

Hinkel, Hans. *Judenviertel Europas: Die Juden zwischen Ostsee und Schwarzem Meer.* Berlin: Volk und Rasse, 1939.

Hinz, Berthold. *Art in the Third Reich.* New York: Pantheon, 1979.

Hochman, Elaine S. *Architects of Fortune: Mies van der Rohe and the Third Reich.* New York: Weidenfeld and Nicolson, 1989.

Hugo Riemanns Musik Lexikon. 11th ed. Edited by Alfred Einstein. Berlin: Max Hesse, 1929.

Huttenbach, Henry. "The Romani Porajmos: The Nazi Genocide of Gypsies in Germany and Eastern Europe." In *The Gypsies of Eastern Europe,* edited by David Crowe and John Kolsti, pp. 31–50. Armonk, N.Y.: M. E. Sharpe, 1991.

Institut zum Studium der Judenfrage. *Die Juden in Deutschland.* Munich: Franz Eher, 1938.

Jarausch, Konrad H. "Die Not der geistigen Arbeiter: Akademiker in der Berufskrise, 1918–1933." In *Die Weimarer Republik als Wohlfahrtsstaat: Zum Verhältnis von Wirtschafts- und Sozialpolitik in der Industriegesellschaft,* edited by Werner Abelshauser, pp. 280–99. Stuttgart: Franz Steiner, 1987.

————. *The Unfree Professions: German Lawyers, Teachers, and Engineers, 1900–1950.* New York: Oxford University Press, 1990.

Jellonnek, Burkhard. *Homosexuelle unter dem Hakenkreuz: Die Verfolgung von Homosexuellen im Dritten Reich.* Paderborn: Ferdinand Schöningh, 1990.

Kater, Michael. *Different Drummers: Jazz in the Culture of Nazi Germany.* New York: Oxford University Press, 1992.

————. *Doctors Under Hitler.* Chapel Hill: University of North Carolina Press, 1989.

————. "Forbidden Fruit?: Jazz in the Third Reich." *American Historical Review* 94 (February 1989): 11–43.

————. *The Nazi Party: A Social Profile of Members and Leaders, 1919–1945.* Cambridge: Harvard University Press, 1983.

Kenrick, Donald, and Grattan Puxon. *The Destiny of Europe's Gypsies.* New York: Basic Books, 1972.

Kershaw, Ian. *The Nazi Dictatorship: Problems and Perspectives of Interpretation.* London: Edward Arnold, 1985.

————. *Popular Opinion and Political Dissent in the Third Reich: Bavaria, 1933–1945.* Oxford: Oxford University Press, 1983.

Koehl, Robert L. *RKFDV: German Resettlement and Population Policy, 1939–1945*. Cambridge: Harvard University Press, 1957.

Köhler, Gerhard. *Kunstanschauung und Kunstkritik in der nationalsozialistischen Presse: Die Kritik im Feuilleton des "Völkischen Beobachters" 1920–1932*. Munich: Franz Eher, 1937.

Koshar, Rudy. *Social Life, Local Politics, and Nazism: Marburg, 1880–1935*. Chapel Hill: University of North Carolina Press, 1986.

Künstler im Klassenkampf (Catalog for a special exhibition of the Museum für deutsche Geschichte, April–June 1988). Berlin, DDR: n.p., 1988.

Lane, Barbara Miller. *Architecture and Politics in Germany, 1919–1945*. Cambridge: Harvard University Press, 1968.

Lebovics, Hermann. *Social Conservatism and the Middle Classes in Germany, 1914–1933*. Princeton: Princeton University Press, 1969.

Lehmann-Haupt, Hellmut. *Art under a Dictatorship*. New York: Oxford University Press, 1954.

Ludwig, Karl-Heinz. *Technik und Ingenieure im Dritten Reich*. Düsseldorf: Droste, 1974.

Marek, George R. *Richard Strauss: The Life of a Non-Hero*. New York: Simon and Schuster, 1967.

Martersteig, Max. *Das Deutsche Theater im neunzehnten Jahrhundert: Eine kulturgeschichtliche Darstellung*. Leipzig: Breitkopf und Härtel, 1904.

Mastny, Vojtech. *The Czechs under Nazi Rule: The Failure of National Resistance, 1939–1942*. New York, 1971.

Mommsen, Hans. *Beamtentum im Dritten Reich: Mit ausgewählten Quellen zur nationalsozialistischen Beamtenpolitik*. Stuttgart: Deutsche Verlags-Anstalt, 1966.

Mosse, George L. *The Crisis of German Ideology: Intellectual Origins of the Third Reich*. New York: Grosset and Dunlap, 1964.

———. *Germans and Jews: The Right, the Left, and the Search for a "Third Force" in pre-Nazi Germany*. New York: Howard Fertig, 1970.

Müller-Hill, Benno. *Murderous Science: Elimination by Scientific Selection of Jews, Gypsies, and Others, Germany 1933–1945*. Translated by George R. Fraser. Oxford: Oxford University Press, 1988.

Die Musik in der Geschichte und Gegenwart. 16 vols. Kassel: Bärenleiter, 1949–79.

The New Grove Dictionary of Music and Musicians. 20 vols. Edited by Stanley Sadie. London: Macmillan, 1980.

Newhouse, Martin J. "Artists, Artisans, or Workers?: Orchestral Musicians in the German Empire." Ph.D. diss., Columbia University, 1979.

Pauley, Bruce. *Hitler and the Forgotten Nazis: A History of Austrian National Socialism*. Chapel Hill: University of North Carolina Press, 1981.

Peukert, Detlev J. K. *Inside Nazi Germany: Conformity, Opposition, and Racism in Everyday Life*. Translated by Richard Deveson. New Haven: Yale University Press, 1987.

Phelan, Anthony, ed. *The Weimar Dilemma: Intellectuals in the Weimar Republic*. Manchester: Manchester University Press, 1985.

Plant, Richard. *The Pink Triangle: The Nazi War against Homosexuals*. New York: New Republic Books, 1986.

Prieberg, Fred K. *Kraftprobe: Wilhelm Furtwängler im Dritten Reich*. Wiesbaden: Brockhaus, 1986.

――――. *Musik im NS-Staat.* Frankfurt: Fischer, 1982.

Raabe, Peter. *Die Musik im Dritten Reich.* Regensburg: Bosse, 1935.

Rämisch, Raimund. "Der berufsständische Gedanke als Episode in der nationalsozialistischen Politik." *Zeitschrift für Politik* 4, Heft 3 (1957): 263–72.

Rathkolb, Oliver. *Führertreu und Gottbegnadet: Künstlereliten im Dritten Reich.* Vienna: Österreichischer Bundesverlag, 1991.

Rave, Paul Ortwin. *Kunstdiktatur im Dritten Reich.* Hamburg: Gebrüder Mann, 1949.

Reich, Nathan. *Labor Relations in Republican Germany: An Experiment in Industrial Democracy, 1918–1933.* Oxford: Oxford University Press, 1938.

Rothfeder, Herbert P. "A Study of Alfred Rosenberg's Organization for National Socialist Ideology." Ph.D. diss., University of Michigan, 1963.

Schemann, Ludwig. *Gobineau und die deutsche Kultur.* Berlin: Teubner, 1934.

Schleunes, Karl. *The Twisted Road to Auschwitz.* Urbana: University of Illinois Press, 1970.

Schreiber, Georg. *Die Not der deutschen Wissenschaft und der geistigen Arbeiter: Geschehnisse und Gedanken zur Kulturpolitik des deutschen Reiches.* Leipzig: Verlag von Quelle und Meyer, 1923.

Schultze-Naumburg, Paul. *Kunst und Rasse.* Munich: Lehmann, 1935.

Schulze, Hagen. *Weimar: Deutschland, 1917–1933.* Berlin: Severin und Siedler, 1982.

Schuster, Peter-Klaus, ed. *Nationalsozialismus und "Entartete Kunst": Die "Kunststadt" München 1937.* Munich: Prestel, 1987.

Smelser, Ronald. *Robert Ley: Hitler's Labor Front Leader.* Oxford: Berg, 1988.

Sontheimer, Kurt. *Antidemokratisches Denken in der Weimarer Republik.* Munich: Nymphenburger, 1962. Reprint. Munich: Deutscher Taschenbuch Verlag, 1978.

Spangenberg, Eberhard. *Karriere eines Romans: Mephisto, Klaus Mann und Gustaf Gründgens.* Munich: Ellermann, 1982.

Splitt, Gerhard. *Richard Strauss, 1933–1935: Ästhetik und Musikpolitik zu Beginn der nationalsozialistischen Herrschaft.* Pfaffenweiler: Centaurus Verlagsgesellschaft, 1987.

Stark, Gary. *Entrepreneurs of Ideology: Neoconservative Publishers in Germany, 1890–1933.* Chapel Hill: University of North Carolina Press, 1981.

Stein, Leon. *The Racial Thinking of Richard Wagner.* New York: Philosophical Library, 1950.

Steinweis, Alan E. "Conservatism, National Socialism, and the Cultural Crisis of the Weimar Republic." In *Between Reform, Reaction and Resistance: Studies in the History of German Conservatism from 1789 to 1945,* ed. Larry Eugene Jones and James N. Retallack, pp. 329–46. New York: Berg, 1993.

――――. "German Cultural Imperialism in Czechoslovakia and Poland, 1938–1945." *International History Review* (August 1991): 466–80.

――――. "The Professional, Social, and Economic Dimensions of Nazi Cultural Policy: The Case of the Reich Theater Chamber." *German Studies Review* 13 (October 1990): 442–59.

――――. "'Unreliable and Unfit': The Nazi Purge of Jews and Other 'Undesirables' from German Cultural Life, 1933–45." *Holocaust Studies Annual* 1991 (forthcoming).

――――. "Weimar Culture and the Rise of National Socialism: The *Kampfbund für deutsche Kultur*." *Central European History* 24 (1991): 402–23.

Stern, Fritz. *The Politics of Cultural Despair: A Study in the Rise of the Germanic Ideology*. Berkeley: University of Califonia Press, 1961.

Struve, Walter. *Elites against Democracy: Leadership Ideals in Bourgeois Political Thought in Germany, 1890–1933*. Princeton: Princeton University Press, 1973.

Toepfer, Karl. "Nudity and Modernity in German Dance, 1910–30." *Journal of the History of Sexuality* 3 (July 1992): 58–108.

Turner, Henry A., Jr. *Big Business and the Rise of Hitler*. New York: Oxford University Press, 1985.

Viereck, Peter. *Metapolitics: The Roots of the Nazi Mind*. New York: Knopf, 1941. Reprint, Capricorn Books, 1965.

Wagner, Richard. "Das Judentum in der Musik." *Sämtliche Schriften und Dichtungen*, 5:66–85. Leipzig: Breitkopf und Härtel, 1912.

Wardetzky, Jutta. *Theaterpolitik im faschistischen Deutschland*. Berlin, DDR: Henschelverlag, 1983.

Wasmuths Lexikon der Baukunst. 5 vols. Berlin: Ernst Wasmuth, 1929–37.

Weber, Alfred. *Die Not der geistigen Arbeiter*. Munich: Duncker und Humblot, 1923.

Welch, David. *Propaganda and the German Cinema, 1933–1945*. Oxford: Clarendon Press, 1985.

Zimmermann, Michael. *Verfolgt, vertrieben, vernichtet: Die nationalsozialistische Vernichtungspolitik gegen Sinti und Roma*. Essen: Klartext, 1989.

INDEX